THROUGH
ANCIENT EYES

Seeing Hidden Dimensions
Exploring Art & Soul Connections

THROUGH ANCIENT EYES

Seeing Hidden Dimensions
Exploring Art & Soul Connections

Updated Second Edition 2018

NEIL HAGUE

Quester

First published in 2002 by
Quester
54 Church Street
Hungerford
RG17 0JH

Copyright © 2002 Neil Hague
Reprinted in 2003

Republished 2018

Cover Design: Neil Hague
Opposite image: by the author, *Shadow Walking* © 1995

British Library Cataloguing-in Publication Data
A catalogue record for this book is
available from the British Library

ISBN 0-9541904-0-8

This book is dedicated to all of the artists, the seers,
the independent-minded individuals,
who throughout history, have strived to offer alternative visions of reality.

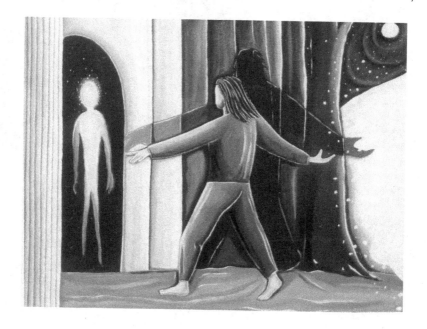

For Camille and Seth, and the next generation.

Other books by Neil Hague

Journeys in the Dreamtime - *Keys to Unlocking the Imagination, Exposing the Untold History of Art*

Kokoro - *The New Jerusalem & the Rise of the True Human Being*

Moon Slayer - *The Return of the Lions of Durga*

Aeon Rising - *Battle for Atlantis Earth*

For more information please visit:

www.neilhague.com

Acknowledgements

I would like to thank several people who, over the years, have been influential to my self-discovery. They are: Dan Budnik, Stephanie, Rob, Ayem, Gary, Mark and Simon. A special thanks to David Icke... our friendship over the past twenty years triggered many ancient memories. In recent years, I also want to thank Mel, Karen, Patrick and Rita for helping me to find other pieces to the puzzle called life. Thank you to my family for allowing me the space to question, grow and evolve my ideas.

A special thank you to Wendy for your proofreading skills and friendship.

I also wish to acknowledge William Blake, Cecil Collins and all of the artists mentioned in this book for sharing their inspiration with the world.

Kind regards to the National Gallery, Tate Britain and the British Museum in London, for when I've felt the need to immerse myself in both ancient and modern archetypes.

I am very grateful to the following people and organisations.They are:
Poet Tree Publishing and Black Hawk Music for their permission to quote from John Trudell, *Rich Man's War*. Pheonix House Publishing for their permission to quote from Ben Okri, *A Way of being Free*.

I would also like to thank Mark at the *Wingmakers* website for his support and permission to quote from its philosophy.

Special thank you to:

The Whitworth Art Gallery, University of Manchester for their permission to use, *Europe*, plate 1, *Ancient of Days*, by William Blake.
The British Museum for permission to use *the Four Zoas, Milton*, plate 32, by William Blake.
The National Gallery, London for use of *The Annunciation with St.Emidius* (1486) by Crivelli.

I wish to acknowledge all of the authors whose works are briefly quoted or referred to in the text and in the notes and references.

If inadvertently, I have overlooked anyone, I hope I will have used their work appropriately and that they will accept my thanks.

Neil Hague

Contents

They will return again.
All over the Earth,
They are returning again.
Ancient Teachings of the Earth,
Ancient songs of the Earth.
They are returning again.
My friend, they are returning.
I give them to you,
And through them
You will understand,
You will see.
They are returning again
Upon the Earth.

Crazy Horse
Oglala Sioux (1842-77)

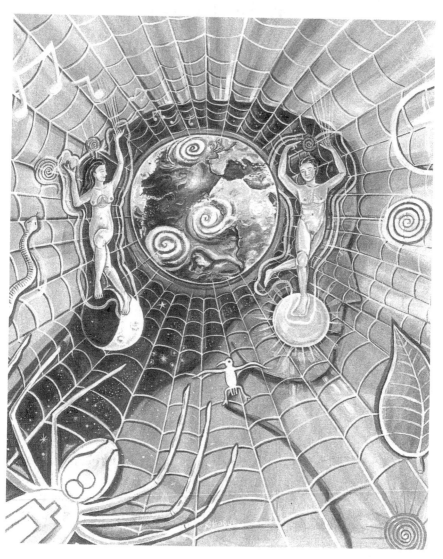

Awake! Awake, O sleeper of the land of shadows,
wake! Expand!

William Blake (1754-1824)
(Jerusalem, 4)

Through
Ancient Eyes

*Earth is an immense institute of learning, with humanity enrolling here
aeons ago. Some have said our teachers came from many planets and
stars, not forgetting the Earth herself.
In this great school not all teachers worked together, some of
humankind listened to Earth, others bowed in front of extraterrestrial
visitors and some slavishly followed man-made gods.*

*In this vast tapestry of teachings not all that was said has happened
and events that occurred were not always mentioned.
From the great school of life on Earth have come many schools of
thought, sometimes educating, often enlightening, but mainly indoctri-
nating. Some told truths, others told lies and myths were created.*

*In this work I have looked twice at everything. I have seen the Earth
from the inside and from the outside looking in. I have listened to the
ist's and the ism's, to all religions and political systems.
And through many complications, limitations and the vast smoke
screens around us, only simple feelings held strong within my heart!*

*Real truths cannot be lied about-that is why love and creativity have
passed the test of time.*

Neil Hague

Introduction

A Reflection on Art

"Artists can do something more:
they can vanquish the lie"
Alexander Solzhenitsyn

Sixteen years ago I published the book you are about to read. It was written after years of living in London and travelling between France and the UK throughout the 1990s. You could say this book came about because of the images I have made over the years. It was as if each image had a profound story to tell, one that considered a universal language beyond our general understanding of communication. The process of making images, including the finished image itself, often imparted a wisdom, a form of information that was expanding my view of how I see life. Almost twenty years on, since I started to cement this book into existence, I still feel the urge to create and make manifest information through my art. The knowledge I received while making this book came through a variety of archetypal forms. Much of what you are about to read can be found in the languages and art forms of earth's ancient indigenous cultures. These archetypes are still as active in the collective ancient psyche as they were for our ancestors. Why? Because they are part of a sacred language, a form of communication as ancient and timeless as the universe itself.

Three archetypes that have constantly appeared within my images are the 'wanderer', the 'magician' and the 'fool'. In truth they are all one archetype and they all have a history that stretches far into our past. In this book I will attempt to unravel the mysterious qualities relating to these three symbols which continually appear in native art and culture. The book is an attempt to unravel these archetypes and the many other symbols that have appeared within my art. The knowledge contained within the `original archetypes' is universal, they know no boundaries and that is why archetypal symbols appear in very different cultures across the world. You could say that our ancient ancestors had a greater understanding of the earth, the heavens and their immediate environment than we often do today. However, we are rediscovering our connections with the universe in all its forms and the original archetypes which abound in nature are aiding us in this process.

For me, there is nothing new about the New Age 'movement', despite some alternative ideas that have grown out of it. All knowledge and discoveries

have always come from humanity's ability to express its creative force to the maximum. Whether we express our creativity in a painting, lovemaking, music or even baking a cake, this eternal power we hold is both ancient, timeless, it is the 'beginning and the end'. This eternal power is invested to a certain degree through the many actions we make on a daily basis. I believe we act on certain clearly-defined levels, or dimensions, all of the time. We act alone and together; we act through creation as in the cake-baking scenario; we act through organisation as well as through the arts; we act through will and we act through silence. Through each of these dimensions we are ourselves and we move through any combination of these levels as we see fit. Understanding this is the key to the realisation of our eternal power as multidimensional beings. Unlocking the imagination and opening our minds is part of this awakening process and my own belief is that any creative act is an awakening, especially when we allow it to take us on a journey. Where we travel to when being creative is the heart or home of our multidimensional self. Painting and writing have been part of the process of getting to know my own heart and the 'internal workings' of my soul. In this way all art, in its pure essence, is a metaphysical experience and in my view art is more than just a 'process'. I would suggest that art is not about art because aesthetics by themselves have no meaning. Just as the same way life can have no meaning when wonder and magic are excluded from it, so that daily living becomes a purely one dimensional experience. In this book I will attempt to offer a multidimensional view of life, creativity and the enigma of the human soul. At the same time I have made every effort to de-link the words 'soul and spirituality' from immediate religious connotations, because I will be looking at ancient teachings predating any organised religion. Throughout the process of writing, I have had to remain open-minded about a great number of things, and I would ask you, the reader, to do the same. I have also learned to suspend my conditioned views on how we 'should' see the world, and through doing so I have rediscovered the ancient world of the esoteric and its connection with art and science through nature.

Many times I have considered where my art might fit in today's growing spectrum of modern art. I can easily say, I don't think it does! If I was to describe my paintings, I would say they dwell between the primeval state of native symbolism and a personal visionary world, an inner world where I often see my images as narratives taking form in our linear reality. I consider my paintings as oracles with messages from other levels of creation, born into a modern world that quite often misunderstands them. However, this is not a new complaint by a 'misunderstood' artist, or another would-be visionary seen as 'mad' by his critics. Instead I would suggest it is part of a giant symptom that pervades our civilisation, of which the common cause is rooted in apathy and what can be called the 'ordinary-man-and-woman-in-the-street' syndrome. In effect it is the 'norm' ideology which has created a society that does not understand its own creativity, because at its core it is designed to programme and produce the 'useful' person, which of course is the opposite of an artistic, creative and diverse individual. Real creative ener-

gy, which works through diversity and the spirit within, is often automatically overlooked, and therefore all art is either considered unimportant or a luxury that only the talented do. So if we were to ask the current princes of culture (men of finance, military leaders, politicians) what use is the artist? The reply mostly would be to say 'No use!'. Often looking at the Spiral or Sun King you have painted they say: "How much is it worth?", while never seeing the potential to feel and discover all things great being ruled by mammon alone. Most people do not know how to relate to the greatness of 'creation', for many the television can be greater than an open plain or star-scattered sky. If acts of creation are seen merely as items, only to be bought or sold, then all art forms will be perceived in an imbalanced way. I believe the real purpose behind art is to give back to humanity the wonder of life, to inform and draw back a 'veil' that keeps us from knowing who we really are. All art gives the individual, and therefore society, a window to view its soul, its movement and ultimately heal our lives. The refusal to incorporate links between the soul and art within most academic institutions, has provided the populace with a segregated and elitist view of art. Yet, to the ancients art was used as a tool for accessing our multidimensional selves and expressing the god force within. It was seen not only as a tool for evoking feelings, but could be used as a 'portal', transporting the viewer into other levels of awareness! For many ancient mystics, like some of the more open-minded scientists of today, these inner and outer worlds share the same space as the *world* we all live in and they are accessible to us through our artistic endeavours (see figure 1).

Many of our ancestors bear witness to some form of dramatic change on earth. In fact every century has had an age of change, whether it be expressed through scientific discoveries or artistic Renaissance, when science, spirituality and art are united. Change in any form brings about opportunity to renew our current culture and lifestyles, to elevate ourselves to another level of understanding. In this book I want to address both the personal and collective journey through the use of our greatest gift, our creativity. Art, myths, symbolism and ancient earth mysteries are constant reminders of the trials

Figure 1:
The 'Inner and Outer' worlds of the 'Human Experience'.

All art can be used to access our multidimensional selves and 'open our eyes' (ancient eyes) to *all* possibility.

© Neil Hague 2012

and tribulations the collective human mind has faced on its journey through space and time. The 'earth changes' we are currently facing, which could include major topographical disturbances some time in the near future, are more about remembering our true potential, our multidimensional self. The changes now unfolding within us, and the world around us, represent an inner fight against old limitations and a release of unlimited creative potential. Looking within ourselves is a constant reminder that we must continue to search and question the world we think we know so well, so as to unveil the real person behind our eyes.

Through my art I have attempted to allow the mysterious world of archetypal forces a vehicle for expression. To do this I have had my head in universal myths and legends for many years, which have given me greater insights into the forces behind what we call 'inspiration'. At the same time, I have attempted to explore knowledge that empowers the imagination and gains understanding of the creator within. Without acknowledging the invisible realms of the imagination, we see ourselves as just physical energy; matter that is separate from the forces of creation and therefore un-whole. I believe our imagination is not just a state of being it is the essence of who we *really* are.

Within the pages of this book I offer keys for transforming our lives and activating the creative energy that connects us to the rest of creation – across the earth, between the sun, the moon and amongst the stars. A lot of new information has come to me since first drafting this book in the late 1990s and therefore parts of the original book have been omitted and edited to better reflect new insights that have crossed my path.

Through Ancient Eyes is an attempt to offer alternative perspectives, that place creativity *with* spirituality, on one level, while suggesting that both areas are inseparable. All our native ancestors knew that our creative power through art, dance, ritual and magic was intricately linked with the cycles in nature; both earthly cycles and cosmological cycles. This book is about my own growth and circles of learning within a changing earth. As a creative individual I have come to understand this growth is really about human consciousness, its mystery and what symbolic language runs within me. Throughout the course of this work I have desired to connect with the truth at the centre of my own personal web. These are my visions and this book is dedicated to working with that truth by seeing *through my ancient eyes*! May all people come to know their truths, so collectively, we can celebrate our multidimensional uniqueness.

Neil Hague
2018

Archetypes, Aliens and Symbols
A Quest Through Art for Ancient Wisdom

"I believe in everything until it's disproved. So I believe in fairies, the
myths, dragons. It all exists, even if it's in your mind. Who's to say that
dreams and nightmares aren't as real as the here and now?"
John Lennon

Creation is a very big word and a highly underestimated act in our society. For myself it is also a journey, an experience, in which we travel and explore continual possibilities on the road to new discoveries. When we are absorbed in the act of creating, one almost feels a form of wandering in the corridors of time taking place. Being creative places us in the 'moment', making us part of an all-encompassing consciousness often called God. In many ways, if we are to understand our creative power, we need to come to terms with the idea of a 'personal journey'. Facing the creative wilderness in its many different disguises can be like starting a long mysterious journey, whether we are travelling through a dense forest, or around the circles in our mind. Creativity in its widest sense allows us, as participants, to journey through the wilderness of the world and bring back personal 'prizes', in the form of all art created from within.

In the great cultures of the past, contact with powerful creative forces in nature (archetypes) was accessed through canonic ritual and elaborate ceremonies. Priests and artists alike, so to summon these archetypes, performed a diversity of dances, chants, paintings and other forms of art. As an artist, I believe many of these original archetypes are surfacing once again within the collective psyche. You could say we are undergoing a transitional period in art, as well as in other areas of our lives, where the death of current culture and status quo will bring about a New Age and a more awakened society. By awakened, I mean one that is more open to archetypes found in the symbolic language of earlier civilisations. Sadly, the 'Digital Age' and the pending rise of 'Artificial Intelligence' is the main block to this 'awakening'. The shamans, priests and sages, who were the real artists across diverse cultures, sought to communicate this sacred language through what are called the 'original archetypes'. Narratives, sequences and symbols found on cave walls and temples all over the ancient world, illustrate quite graphically our ancestors' relationship with both visible and invisible forces found in nature. Images of all-seeing eyes, animal-gods, circles, pyramids, spiders' webs, along with the depiction of celestial bodies in the heavens, provided our ancestors with a powerful archetypal knowledge. So did the mysterious

beings encountered by shamans and holy people who ventured into 'unseen' dimensions as they sought to communicate with higher forces in nature. In this chapter, I will be exploring the hidden language of both archetypes and 'interdimensional beings' (the gods) through various symbols, myths and legends; all of which provided source material for many artists over thousands of years. By exploring the world of archetypes, I will present my vision of the world, which is not static in its view. Like the imagination, it is 'ever-changing', moving and shaping my existence. What some choose to call God (or the creative forces behind the universe), I see as a magnificent mind that creates in the name of love; and this all-encompassing *oneness* is beyond words, human form, Bibles and all religion. In this chapter, I want to present some very ancient and alternative views on creation, reality and the many mysteries that surround us.

Storytelling and the Opposing Forces of Creation

As an artist or an image-maker, I have always been fascinated by creation myths and the stories (images) they conjure in the mind's eye. The more I studied the diversity of creation myths, the more I realised that over tens of thousands of years, the idea of 'creation' (for many native peoples) involved the 'telling of stories' personifiying many solar, lunar and planetary bodies. These stories, when brought to life through various art forms, allowed a personal communication and interaction with what native peoples term the Creator (God). It dawned on me that the old storytellers across various native cultures were the first real 'explorers' and 'frontiers people'. They united the inner (spirit) and outer (physical) worlds through their tales and stories, which formed the many myths and legends of the Ancient World. What we call myths and legends are actual 'history' to many of our native ancestors. This history, which goes back far beyond the conventional view, is still kept alive through many archetypal forms and ceremonies.

Everything in the Ancient World was a repository of stories: the sun, moon, silence, a talking tree, singing water, a dancing leaf, a spider's web or a giant stone in the sand, all are impregnated with narratives. To most native or Pan cultures (nothing to do with cooking), the Sun and Earth, for example, were perceived as living, powerful beings, both unique expressions of the Creator in their own right. Unlike later patriarchal pillars of authority, indigenous creation myths were provided by a matrilineal (feminine) structure, which usually described 'creation' as being orchestrated by both a male and a female spirit. Why is the creator (God) always a 'He' anyway? To native cultures, this creative operation was known as an 'emergence', or birthing process from the womb of the creator, from the inner place of all possibilities. Fertility, and the opposite forces of 'male and female', namely 'life and death', 'sky and earth', 'summer and winter', 'yin and yang', were (and still are) part of the beliefs of many traditional native people (see figure 2).

Since the beginning of time we have had opposite forces shaping the world and many stories from ancient civilisations explaining this dualistic process. In what was Mesopotamia, Zoroastrianism mythology says that god twins,

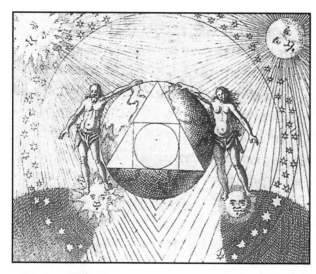

Figure 2: The Opposing Forces of Creation.

A 16th Century Alchemical illustration, showing the polarisation of life on Earth.
The same image captures the idea of a world of separation (duality), which according to ancient people like the Hopi, is the name for the current world that we live in.

Courtesy of Dover Pictorial Archives Series *Symbols, Signs & Signets.* Ernst Lehner

'Ahura Mazda', came out of the light to oppose 'Ahriman' who lived in the dark. Their creator was the god Zurvan (time) who lived in the void. In Central America we find the story of the hero twins, Hunahpa and Xbalanque, who were tasked with ridding the earth of monsters, giants and demons. Similar themes are expressed in Native American Hopi Indian stories of Spider Woman's twin sons, Poquanghoya and Palongawhoya, who they say helped create the 'first people', while trapping destructive spirits within the Web of Life. The story of Adam and Eve and the Garden of Eden also relates to a much earlier time on earth recorded by many ancient civilisations. As does the serpent in this story, which is symbolic of the creative/destructive force that was trapped within the web of worlds influencing our physical reality. The serpent can also be seen as a destructive force that became the ancient 'predator', or one who causes devastation within the realms of our soul. As a predator, it is also regarded as the 'destroyer of worlds', a theme supported by various cosmological myths. More on the 'Predator' later in the book.

Sexual intercourse is also an act of the opposite forces of male or female coupling to produce harmony. Sexual energy is just one of many manifestations of the vital forces in nature. In ancient times 'sexual energies' were used by initiates for spiritual growth. The eastern art of Tantra and the many fertility rites practiced by native people were done to celebrate and harmonise the opposite forces in nature. Many Pagan celebrations of fertility and dance have their roots in civilisations that pre-date the Egyptian and Sumerian civilisations. The May Pole Dance of Pagan Europe, for example, can be found illustrated quite graphically on the temple walls at Denderah in Egypt. It shows the ceremony of 'climbing the pole' for Min, who was the Egyptian version of the Greek god, Pan. Both deities are flute players, protectors of crops and sowers of seeds and are related to the Mesoamerican deity commonly known as Kokopelli, who is the 'god of life'.

Storytelling is still an important part of our society through the medium of cinema, movies, animation and novels. These current forms of storytelling, like the ancient tribal storytellers, all use the 'opposites of creation' within their plots, subplots and movie scripts. Opposing forces appear in movies like *Star Wars* through to the *Harry Potter* books, which show a continual battle between light and dark, or good and evil. This religious ideology is called 'dualism', and many ancient civilisations had stories that carried themes of opposing forces. As humans, we seem to be obsessed with the duality of nature, rather than its holistic aspects, which instead ask us to view our world from a wider perspective. Films like *Star Wars,* with its almost religious-like symbolism, show us that Darth Vader (evil) and Skywalker (good), are actually part of the same force (excuse the pun).

Numerous ancient myths (stories) tell us how opposing forces have shaped and birthed different worlds on earth. The cycles of evolution captured through the imagination of our ancient storytellers quite often reinforced catastrophic events that changed our world many times over. The Native American Hopi, who will be mentioned a lot throughout this book, say that four known worlds have emerged on earth covering hundreds of thousands of years of evolution. According to the Hopi, each world was separated by a climatic change, both geographically and spiritually. In fact, it was these catalytic changes that provided the source for a multitude of myths, mysteries and legends, many of which have common themes of ancient gods and lost civilisations existing on earth, long before recorded official history.

The Aztecs, Hindu, Maya and the Hopi, all believed that the universe operated in great 'cycles' or 'suns', since the creation of the human race. According to the Aztecs, each sun lasted 4000 years, with exception to the 'fourth sun' which lasted 5000 years; each 'sun' was said to have been destroyed through either flood, wind or fire. Ancient Mexican texts, like the *Vaticano - Latin Codex,* describe how each sun saw a different stage in the evolution of humans, which included advanced beings, giants, dolphins and monkey people repopulating the different worlds. I have often felt that ideas behind films such as *Planet of the Apes,* are based on the 'evolutionary cycles' (world ages) as told by the ancient people of earth.

The Hopi are one of the oldest tribes in America and in their story of creation, their Creator was Tiaowa. Their Creator is nothing like the 'father god' of Judeo - Christian theology. Instead, Tiaowa was an immense infinite mind, without gender. Tiaowa's first creation, according to the Hopi, was said to be Sotuknang, whose responsibility was to make the 'infinite', 'finite'. Sotuknang, like Tum of Ancient Egyptian mythology, did this by creating a vortex of 'nine universal kingdoms': one for Tiaowa; one for himself and seven universes for the life yet to come. Another creation of Sotuknang was 'Spider Woman', the weaver of the 'Web of Life' which contained many realities. The Web of Life can also be seen as the 'matrix' of different worlds, all of which are woven together to form the myriad of stars, suns and planets in our universe.

The Web of Life

The web has been used by many native cultures to describe the delicate connection between all life forms on earth and how we are connected to the universe as a whole. A connection that comprises not only the physical balance of all creatures, but also a structure for the creative life force or spirit, that exists within us all. The Web of Life is expressed through art, ritual, storytelling, painting, singing, dancing, lovemaking, and all forms of creativity. Some of the crop circle formations that have appeared since the early 1990s, are to some researchers, other-worldly visual manifestations of an *invisible* web-like infrastructure. Some of the circles of course are created by 'hoaxers' and 'government agencies', to discredit the genuine patterns and messages they contain. The mysterious circles and geometric shapes that appear in crop circles, are in my view, part of an 'ancient language' that is neither new, or supernatural, but can be found amongst the petroglyphs (rock art) of our ancestors. These crop formations, as with much rock art and fractal imagery, are reminding us of the 'mysterious power' that designs our universe, providing 'perfect symmetry' for everything from a galaxy, to the human cell structure.

The web can be seen as part of a 'higher breathing cosmos', a consciousness speaking through the earth, calling to our 'ancient eyes', asking us to realise the creative mystery at work behind all life. Becoming aware of this invisible web is a major step towards healing the manufactured divisions or polarity in society, through empowering our own unique creativity. The Web of Life is not only an infrastructure for the interweaving of all life forms, but is symbolic of the creative process within every life, or strand within it. The concept of a web is not a new ideology, and is not to be confused with 'The Net' or 'Blocking Frequency' caused by 'artificial intelligence', something I will look at later in the book. The web represents both creative and destructive principles within all things; depending on how it is used, it can be the difference between an all-encompassing freedom or a predator's prison, of which the latter seems to be a dominant force on earth.

The spider's web is symbolic of how, within nature (and throughout this universe), knowledge can be used to do good or bad. Our creativity and the energy that fuels it can be enlightening or destructive. Both choices are only states of mind. This ultimately relates to how we *perceive* and interact with other life on this planet, how we respect (or in most cases have no respect for) the very earth we walk on. A Native American Chief, named Chief Seattle, expressed this understanding of the web, when in an 1854 speech, *'No Quiet Place'*, he addressed the President of the United States. He said:

> *Every part of this earth is sacred to my people. Every shining pine needle, every sandy shore, every mist in the dark woods, every clearing, and humming insect is holy in the memory and experience of my people. The sap which courses through the trees carries the memories of the red man... This shining water that moves in the streams and rivers is not just water but the blood of our ancestors. If we sell you land, you must remember that it is sacred, and you must teach your*

children that it is sacred. This we know. The earth does not belong to man: man belongs to the earth. Whatever befalls the earth befalls the children of the earth. Man did not weave the web of life; he is merely a strand in it. Whatever he does to the web, he does to himself.[1]

Today more urgently than ever before, I feel we need to realise our individual part in the web of life, and to do this we need to be open minded to the many mysteries contained within it.

Father Sky, Mother Earth

In most creation myths, the sun was an archetype that represented a 'divine' creative energy to our ancient ancestors. The Hopi Indians of North America called the sun the 'face of Tiaowa' (a divine being), of which nothing on earth could survive without. The Hopi described the earth as the 'mother' or 'receiver' who births all life (inspiration), providing total sustenance and stability. The sun (sky) and the earth had both male and female qualities, which can be observed in much Egyptian, African, Celtic, Indian and Greek legends, art and symbolism. In the patriarchal civilisations that followed the ancient goddess civilisations, the sun and the moon (symbolic of the opposite forces of nature) became deities and demi-gods, priest kings and queens to rule the masses. In fact, the use of sun and moon symbolism in the ancient world was more about portraying royal bloodlines said to have descended from ancient deities (star gods), some of which could have been extraterrestrial in origin? Accounts within creation myths from across the globe talk of star beings intermingling and living with humans in the ancient world. According to ancient tribes of earth, like the Hopi, there are said to be many different species that came from the stars. Much rock art and hieroglyphics are symbols that speak of the interaction between humans and what tribes like the Seneca, Abenaki and other Native American tribes call the 'Little People'. For example, the Ubaid people, the Argives and the Quichés, all have mythical accounts of gods that represented the stars, planets and the sun. These 'beings' (star gods) were said to be 'time keepers' who came to earth in ancient times. In Native American mythology, Sumerian art and Biblical texts, there are recurring themes of marriage between star beings (the gods) and the daughters of humanity. In *Genesis,* we have similar themes of the 'Sons of the Gods' marrying 'daughters of men':

When men began to increase in number on the earth and daughters were born to them, the sons of God saw that the daughters of men were beautiful, and they married any of them they chose. The Nefilim were on the earth in those days and also afterwards – when the sons of god went to the daughters of men and had children by them. They were the heroes of old, men of renown. Genesis 6:1-4

Ancient accounts from all over the world talk of gods coming from the skies and even today, when the word 'God' is mentioned, people often look

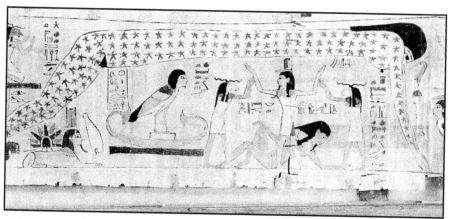

Figure 3: Geb, the Earth God and Nut, the Sky Goddess.
The star-scattered body of Nut arches over a reclining Geb (the earth).

up, to the sky – to the heavens. In ancient times it was said that the sky gods bore children from this coupling and their offspring were revered for their superhuman abilities. These children (offspring of the gods) became the famous goddesses of myths and legends from around the world. In ancient Greece for example, Circe was said to be the daughter of the sun god Helios, or Apollo. Bast was the daughter of Ra the Egyptian sun god and Aphrodite, the daughter of Zeus. In Scandinavian mythology, El (Hel) was the daughter of Loki (the god of mischief); El was said to be born from the pairing of Loki and the giantess Angrobida, who then cast her into the underworld (a parallel reality), where she would rule what is known as 'Niflheim' in Scandinavian legend. El or Hel was the ancient (virgin) mother goddess found in Egypt, Greece, Mesopotamia and Phoenicia, to name but a few. Many 'daughters of the gods' were said to have 'dark and light' qualities and Hel (El), like the Egyptian Goddess Bast, represented the sun's creative and nurturing aspects. Her sister, or opposite, called Sekhmet, represented the sun's destructive force; one that often drives our world through negative use of creative power, fuelled by war.

Ancient cultures like the Phoenician, Sumerian, Indian, Egyptian and Greek, all had myths and stories that told of the universe evolving from the 'union of opposite qualities' (or a mystical wedding) of father (sky, heaven) and mother (earth). The Egyptians had deities for these opposites of creation, called 'Geb and Nut' (male and female), see figure 3. In Native American (Navajo) creation story, it was said that the sky was 'attracted' to the earth and thunder was the mating call of the sky. In the eyes of the Navajo, the rain was a life bringing force that entered the Earth and brought forward new life from the female womb of Mother Earth. The Yoruba people of Nigeria believed the primitive earth to be covered in marshland until the 'Supreme Being', Ol-orun, sent the god Orisha Nla (the sun) down from heaven to create dry land. The legends of Polynesia also tell of the god Tangora, who pulled the earth from the great waters whilst fishing. Much of these stories

(myths) can be seen to illustrate a general theme of a sky father impregnating an earth mother, bringing forth life and creating (shaping) the world. On another level these themes could be symbolic of a possible courtship between extraterrestrials (gods) and humans recorded in art, texts and oral tradition throughout the ancient world.

Inner Earth and Creation Chambers

All across the world there have been many wonderful discoveries found in caves, caverns and subterranean tombs. Tales of underground worlds, symbolised through labyrinths, abound in folklore across every continent. For our ancestors, it seems that these subterranean regions harboured strange worlds containing otherworldly entities or beings. Religious texts like the *Torah* and the *Old Testament*, for example, both contain many allusions and references to a real 'underworld,' complete with polar openings, and alternate cavern-realms which consist of many separate regions. The *Old Testament* makes very distinct mention of these 'realms' in the books of *Genesis, Isaiah, Job* and *Ezekiel*. Also mentioned at length are cryptoid creatures ranging from dragons to hairy humanoids, which are translated as satyrs in the later King James version of these texts. Much art, hieroglyphs and pictographs (native petroglyphs) tell of our mysterious past and the relationship with god-like creatures in their underground worlds.

The Hopi Indians, who can be linked to the ancient Anasazi, are also said to have 'lived underground' before coming to settle on the surface. The Sioux say they too, emerged from underground at a place in the Black Hills known today as the 'Wind Cave'. The Navajo or Dineh meaning 'the People', also talk of four dark underworlds having no sun[2] and their passage through these different worlds is illustrated in their art and rituals. Like the Aztecs of South America, they were said to have emerged from 'seven sacred caves' before coming to live on the surface. In the *Quran* it is said there are 'seven portals' that lead to seven divisions of Hell. And in ancient Greece (Arcadia), many gods were said to have been born and lived in caves. The Greek god, Pluto or Hades, was said to reign over a vast underworld 'Kingdom of the Dead' and various goddesses were also worshipped in caves underground, or under waterfalls. The king of the gods, Zeus, was said to have been born in a cave. I visited the so-called birth place of Zeus in the early 1990s on the Island of Crete, and while there, I was amazed by the sheer size and depth of what seemed like only the beginning of a vast underground tunnel network. In his painting, *The Golden Bough*, J.M.W. Turner hints at the many myths associated with the underworld. Turner chose Lake Avernus, near Naples in Italy as the setting for the legend of *The Golden Bough*, because of the Lake's ancient reputation as the entrance to the 'Kingdom of the Dead' and the 'underworld'. In the painting, the lake is an old volcanic crater, with underground vents, from where the god Aeneas would travel to visit his father Anchises (the King of Dardanus), the patron of the labyrinth.

Caves and labyrinths are associated with tales of monsters like the Minotaur to the Piasa monster of Native American myth. Rock paintings

near Alton, Illinois, for example, show the Piasa, a dragon-like, cave-dwelling creature having antler-like horns and glowing red eyes. The Balroc in Tolkien's work of fiction, *Lord of the Rings,* as well as the 'Lord of Shadows' from Disney's *Fantasia,* seem to depict similar creatures who surface from the bowels of the earth. The underground monster theme can be found in Norse folklore, too. Niflheim, the Norse underworld, was the place ruled by the evil goddess Hel; her name would inspire later religious belief in a 'fiery under-world', a place where souls go to be punished. The same deity also appears in Japanese Shinto belief, as the goddess Senga-Sama who lived in under-ground caverns inside Mount Fuji. The Lakota Sioux of North America, also have legends of what they call Unktehi, a gigantic goddess (sea-bull) or cow-like creature, who was said to live underwater. These creatures were said to be constantly at war with the thunderbirds, which again is symbolic of the tussle between 'above and below'- the opposing forces of creation. On anoth-er level, many tales and legends of gods battling each other can be remnants of advanced races and different deities fighting for control of the planet's resources (including people) in ancient times.

The labyrinth is another symbol for the womb (underworld) or the house of the goddess or 'Serpent Mother'. For the Hopi, symbols of snakes and labyrinths represent the 'Serpent Mother'and the inner earth. Interestingly, various symbols of the goddess, such as the sun, stars and the double axe, found in Native American art, can also been found on pottery and artifacts all over Crete. Artistic styles like that of the Mimbres pottery of New Mexico, strikingly resemble the Kamares style of ancient Crete, named after the 'cave sanctuary' on Crete's Mount Ida. This is just one of many examples, spanning great distances in the prehistoric world, suggesting that a possible global belief system (centred around goddess worship and inner earth chambers) existed globally. The cave was also associated with the mountain and many temples were hollowed out of mountains in ancient times. In Thai legend, for example, it is said that the 'waters of the world' pour into the cavern at the foot of the 'Cosmic Mountain' and emerge from its peak to form the celestial river - the stars.

Caves are also an aspect of female fertility and the 'birthing process', which is why so many ceremonies, rituals and art have been created within them. The cave is also where the shamanic artist did his/her work, and the ancients were initiated into 'secrets' contained within the mystery schools. Queen bees, symbolic of the goddess and fertility, were also worshipped in underground chambers. Beehives, like the labyrinth, are both symbols of goddess worship, especially the Sumerian goddess Ashtoreth, or Ishtar. The cave, symbolic of the womb, was also a place where prehistoric people lived and animals hibernated in the winter months. The bear, another symbol of the goddess Ashtoreth (the feminine – birthing aspect), was considered a god by many tribal peoples. Bears only emerge from the cave (womb) to be reborn when the sun climbs higher in the springtime sky. Bear cults relate to an ancient epoch, one that speaks of a time when human-bear hybrids (and other gods) influenced native civilisations. Mythology is teeming with

accounts of these god-like creatures, and much bear symbolism was a known indicator of 'goddess worship' and shamanic practice in ancient times. A fantastic palaeolithic cave, named Chauvet, was discovered in the Ardéche region of France in 1993. It contains some of the most prodigious drawings and rock paintings of animals (including bears) ever seen. Along with the rock paintings, a block of stone was discovered, an altar, on which a bear skull had been deliberately placed over 25,000 years ago.

The relationship between heaven (the stars) and earth (native people) can be found woven into scores of myths and legends. Ancient tribes, such as the Dogon of Mali in Africa, claim their gods originate from the star constellation Sirius, giving them knowledge of the stars. The Egyptians depicted Sirius in much of their temple art, and in various aboriginal and native American myths, there are constant themes of people being abducted by, or marrying, star people. The colour red is also associated with Sirius and its use can be seen amongst the aristocracy, priesthoods and on insignias of the world. The 'red carpet' treatment given to royalty and 'Hollywood stars' is just one example of ancient traditions that go back to a time when the gods (from the stars) were worshipped on earth. In many accounts, strange gods were said to have come from the constellations of Orion, Sirius and the Pleiades situated in the sign of the Bull. I depict many of these strange 'beings' in my artwork and for more information on what we think of as 'alien', see my books *Journeys in the Dreamtime* and also the *Kokoro Trilogy*.

The Cult of the Bull, the Dog & the Fish Gods

According to Robert Temple, in his book *The Sirius Mystery*, the ancient Egyptians revered Hathor (the sacred cow), and Anubis (the dog) as symbols (or code) for Sirius. In African legend, this star is known as the 'Wolf Star' or the 'Eye Star' by the Bozo tribe. Temple even proposes that the body of the Sphinx is a dog; not a lion. I don't agree, but, I can see why some may think the Sphinx is a dog. The writer, Robert Bauval, connected the Sphinx to Leo (the lion), through a correlation of Leo with the Sphinx in 10,500BC.

The Dominican Order of priests founded by Saint Dominic (Domini Canis 1170-1221), also used the 'star' and the 'dog' as a symbol for their connection with Sirius. So did many artists, like Fra Angelico and Fra Bartolommeo, who belonged to this order. In truth, the Dominicans and the Jesuits, like other Christian brotherhoods, were the ancient Egyptian priesthood under different names. Even their brethren monks and friars would shave the centre of their heads, just as the earlier Egyptian priests of Anubis (the jackal) had done before them. The shaved head was a symbol for worshipping the fallen sun - Saturn (more on this later). Native American myths, like the 'Wolf tribe' of Pawnee legend, talk of wolves 'that walked on two legs' in ancient times. As I will explain in the next chapter, I believe there is a connection between the stories of 'werewolves' and other strange, secretive priesthoods, hiding behind Christianity. Dogs and wolves in certain ancient cultures, were symbolic of the accompanying 'spirit guide' who would travel with the initiate in the early part of his journey towards self-discovery.

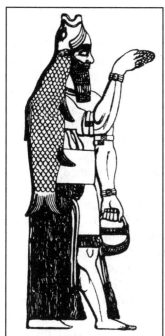

Figure 4: Oannes.
The Babylonian/Sumerian Sirian star-god of science and letters.
Courtesy of Dover Pictorial Archives Series *Symbols, Signs & Signets*. Ernst Lehner

The focus on constellations such as Sirius, Orion, Pleiades and Arcturus can be found in many ancient cultures and secret societies. The beings that came from Sirius, according to the Dogon people, were amphibious or fish-like. Vishnu, one of the Indian trinity, was said to be born of a fish (a solar fish god). Ancient Akkadian cylinder seals, found in what is now Iraq, also depict what look like half-human, half-amphibian creatures. Many of these gods are depicted as 'giants' holding beasts, like lions, by their legs, or flying in what look like winged discs. What is interesting to the inquisitive mind is that these ancient star gods can be found across huge geographical areas and are often depicted in the same way by native peoples, who today, are an ocean apart. One god, named 'Viracocha' by the South American tribes (a half-amphibious, half-bearded Caucasian deity), also appears in Sumerian records as Oannes or Enki (see figure 4). The Inca portrayed Viracocha as the 'Crabman', who the Spanish also referred to as the 'Foam of the Sea'.[3] His symbol was the conich shell and the rising sun, both of which look the same visually. Indeed, both emblems can be found in the logos and insignia of the power structures controlling politics, the military and religion today! Viracocha, a `Supergod', is accredited with bringing culture and civilisation, and quite possibly was also the root of the 'Father God' religions. It seems the worship of strange superhuman gods, goddesses and heroes was a common part of life for the ancients; and when one studies mythology in detail, it becomes clear that what appear to be different deities, are actually the same gods or goddesses but with a slightly different name. Many symbolic representations of the 'same ancient mother goddess', for example, were depicted through deities such as Isis, Ishtar, Diana, Aditi, Mary and Artemis. All are the same goddess! The masculine version was represented through gods (archetypes) like the Green Man, Enki, Pan, Osiris, Odin, Sokar, Dyonisis, Xochipilli, Poseidon, Cernunnos and more recently, Jesus. As we shall see later in the book, all these heroes are the 'same' god with a different name.

The Atlantis Connection

Plato, the Greek philosopher and high initiate of the ancient secret mystery school network, talked also of Atlantis and how it sank catastrophically ending what was known as a Golden Age. According to Plato, who was born in 427BC, Atlantis was the centre of a great empire founded on maritime skills.

He also states how this civilisation ruled over many other islands in the sea beyond the Mediterranean.[11] It seems the source of his information was passed on from a scholar named Solon, a prominent and respected Athenian, who told the same story to Critias, a relative of Plato. Apparently, it was Solon who devised the legal system used in Athens at the time of Plato. Solon was said to have first received knowledge of Atlantis from the Egyptian priests in the city of Sais (connected to the goddess Neith) who, according to their stories, the chief god and founder of Atlantis was a titan named Poseidon. Ancient records claim that Poseidon (like Oannes) was a star-god who came down from above and chose to marry from the native population; and through his wife Cleito, they had a son whom they named Atlas (or Hercules), who became the first King of Atlantis.[12]

The state religion of Atlantis was said to be founded on sun worship and later the 'Cult of the Bull', which included 'bull sacrifice'. Today, in Spain, this ancient ceremony still remains in its modern form. According to researcher Gene Matlock, through his translations of the Sanscrit language, the Pani-Hopi tribes helped by Indo-Phoenicians, migrated to the Gulf of Mexico, which was then an Atlantean state. Some of the 'Pani' tribes are said to have migrated to the Great Plains (Nebraska/Dakota) to become the buffalo-worshipping 'Pawnee'. In his book, *The Last Atlantis Book You'll Ever Read*, Matlock explains how the Uto-Aztecan word for Buffalo was 'Bisonte' (Bison); both Aztec and Hindu words like 'Pishan' relate to the sacred cow or buffalo. Even the Hindu god, Shiva, was depicted as a bull. Similar themes of bull and cow worship can be likened to the Unktehi of Sioux legend and the Minotaur of Minoan legend. All of which seemed to have been part of an expansive ancient religion centred around specific gods and sun worship. At the same time, Atlantis seems to have been a civilisation that could have ruled over adjacent cultures, through a central state and organised religion. Large temple cultures that emerged as Sumeria and the Mayan (South America), along with ancient Egyptian civilisation, all seemed to have shared common cultural beliefs in star gods, like Poseidon, Osiris and Atlas. Could all this have been inspired by a 'global' Atlantean culture? In fact, the famous American psychic, Edgar Cayce (1877-1945), once said: "The Red man is the Atlantean. Take an Aztec, a Maya, Hopi, Cherokee and a Cheyenne and you're looking at an Atlantean." All of these ancient tribes, like the Tibetans, and various other aboriginal tribes, have one thing in common: they talk of their ancestors once living on a great continent destroyed thousands of years ago. The Hittite civilisation of Bronze Age Turkey, for example, also featured the god, Atlas, in their worship. The Greek god, Zeus, like Atlas, was depicted quite often with a bull's head, another connection to the ancient Cult of the Bull. From a more cosmological point of view, the bull and the gods associated with Atlantis, came to represent the Age of Taurus. The 'era' following the Age of Taurus was the Age of Aries, represented by the 'ram'; and from ram we also get penta*gram*, py*ram*id and *Ram*eses, to mention just a few examples. This transference of power, from one age to the next, through the ritual killing of the horned god by a new king of the gods, was worshipped

through the Cult of Mithra all across Persia and later the Roman Empire. The ritual killing of the bull by Mithra can be seen quite graphically on numerous sculptures showing the 'Tauroctony' surrounded by the zodiac. I will come back to the symbolism associated with Mithra, the Bull and Saturn, when I look at Orion symbolism in a later chapter.

Sun Birds & the Bearers of Culture

There are many representations of non-human beings and their connection to the gods in the form of sun, saturn, moon and the earth deities. One common theme is fertility and the 'androgynous nature' of various solar deities, often depicted as birds. The eagle or phoenix are two good examples of the types of symbols used to suggest the creative powers of the sun and stars. In Sumerian texts and Indian myth, eagles and birds, were actual representations of the gods. Vishnu of Indian legend, for example, was often depicted riding the great bird-god, Garuda. The phoenix also was an important symbol in eastern mythology and can be found on seals and logos of various political, military and religious organisations. The Great Seal of the United States is a depiction of the eagle (phoenix), or Bennu bird, which is found in Egyptian myth. The phoenix or Bennu was said to have powers of resurrection and is an ancient symbol for the new sun (re-birth), or the coming of a 'new era'. Birds such as the swallow and the hawk were also sacred in the ancient world and they were considered 'messengers' of the gods. Some birds, like the crow and blackbird in native American belief, were considered carriers of secrets, omens and universal laws. The gods themselves were said to be able to change into birds (and animals) and this is why certain birds and animals are revered in native or aboriginal cultures.

In the native tribal lands of what became Europe and America, effigies of the gods were carved in wood, stone, and scraped into hillsides. For the ancient artists and shamanic priests who created these effigies, they represented the fertility, magic and the creative power behind the universe. One god called Kokopelli, or Mahu (the mysterious hunchback flute player deity of the Hopi indians), represented 'fertility', 'music' and the 'healing arts' (see figure 5 overleaf). Images of Mahu often show him as a solar deity emerging from the head of the god of Death. Mahu's symbol can be found etched on cave walls from the Hopi lands, throughout Canada and into Northern Europe. His name is said to mean Koko (wood) and pilau (hump), and he is also called the `Sun That Moves' by the Hopi. Another deity connected with the sun and fertility rites was Xochipilli of the Aztecs, also known as the 'Flower Prince'. He, like the Goddess Bloedwedd of Ancient Britain, was another fertility god connected with maize, feasting, music, dance and poetry. In certain circles, it is understood that flowers refer to 'mind altering plants' and 'hallucinogenic drug' use. However, I tend to feel they relate to 'herbal lore' and the 'healing arts' in general, which was primarily centred on goddess worship. One statue of Xochipilli on the slopes of the sacred volcano Popocatapetl, shows him in a seated posture with an expression of 'awe' on his face; some have said that he is 'stoned'. Or could it be more to do with

Figure 5: Kokopelli (Blue Monkey).

The sacred monkey can be found in art all over the world. He was regarded as a god, sage, both wise and foolish by various ancient cultures. In China, the word 'sun' means 'monkey', and this deity was regarded a heavenly `hero' who would do battle with demons. He is also the `Pied piper' archetype.

© Neil Hague 1997. Acrylic on paper.

him expressing a heightened state, through spiritual awareness? Just as many sculptures of monks, troubadours and pilgrims, which can be found on Gothic cathedrals and castles across Europe, they too show similar expressions of awe and wonder. Maybe they were 'stoned', too?

The androgynous nature of what I call 'Sun Beings', seems to be a common feature in ancient civilisations. Various gold pectorals or pendants from the Tairona Civilisation of the Northern Andes (600 BC), also depict male and female solar deities. Some are represented as insect deities like Kokopelli, Panaiyoikyasi and Kunwánlelenta, who are Hopi guardians of creative power, beauty and the environment. Others are depicted in a meditative seated position holding batons, symbolic of wands and magical powers. In the Yucatan Peninsula in Mexico, the Sun God, Xipe-Totec (pronounced shee-pee-toltec), can be found on jungle temple murals holding wands and batons. Another Mayan sun god called Xiuhtechutl (pronounced shey-tee-coat-lee), who represents fire on earth, also carries wands so he could 'create fire'. The 'baton', 'wand' or 'staff' represented the power to travel through 'different worlds', use magic and heal the sick. These objects only became tools associated with witchcraft and wizardry after the Christian hierarchy demonised Pagan practices in Europe and elsewhere. Anyone who posed a threat to the power and authority of the Roman Catholic hierarchy had to be removed, and in the name of a so-called loving Father God, grotesque genocide was visited on millions of native people who happened to hold different views to that of the Christian priests. When the early church evolved in the first part of the last millennium, it symbolically took this staff (including all its beliefs) from the native goddess (Pagan) religions, replacing it with a 'Father God' religion. On a capital stone in the Knights Templar Cloister of Le Puy cathedral in France, one can find a Romanesque sculpture called the *Quarrel for the Crook* (figure 6). It depicts a monk and a nun, or priestess (sym-

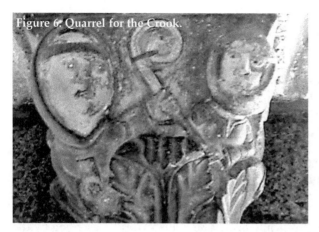

Figure 6: Quarrel for the Crook.

bolic of the father god and goddess religion), fighting for the same staff of power. Behind them are devils laughing heartily, symbolic of the real force behind orthodox Christianity. As we shall see, religions like Christianity, are founded on Pagan beliefs right down to the very last detail.

The mystical union between male and female creative power, relates to the 'heights of spirit', the 'depths of matter' and the esoteric knowledge contained within the 'Tree of Life'. This tree is symbolic of the knowledge 'given to the ancients' at the beginning of what the Hopi call 'Tuwaqachi', the Fourth World.[4] The Tree of Life, also called the 'Tree of Buddha', is the same tree in the Sumerian story of the 'Garden of Edinu', later translated as Eden. Another archetype relating to the Tree of Life is the *'Mythical Origins of the Red and Blue'*, a narrative recorded in numerous traditions, not least the texts and codices' of the Aztecs and their ancestors, the Toltecs, of South America. The 'red and blue' symbolism relates to archetypes, heroes and myths based around the principles of 'duality'. In its simplest form, Blue relates to the stars (above) and red is symbolic of the Earth races (below). Both colours are said by the ancients to 'spring' from the centre of the 'Celestial Cross' or 'Tree'. Both are primary colours and can be found in other 'dualistic myths', through to the costumes of ancient gods and various superhero characters; *Spiderman* and *Superman* are just two examples. The 'red and blue' symbolism also relates to the Orion constellation, something I will detail in a later chapter.

The Tree of Life, also considered the 'bearer' of knowledge (the apple), represents the 'time frame', 'place' or 'structure' from whence this knowledge comes. It is often called the 'Sephiothic Tree' in the Kabbalah, and is symbolic of different worlds, dimensions and directions said to extend from God. The inner roofs of almost all Gothic cathedrals depict the Sephiothic Tree within their architecture. The columns arching upwards meeting at 'ten points' on a central axis, are meant to represent the different worlds (dimensions) of 'spirit' and 'matter'. The Kabbalah is also very much a symbol for Gnostic understanding of how the world was created. It is often used in alchemical imagery to depict the 'path' of the Demiurge, a subject I will return to in more detail.

The giant redwood trees of North America, like the great oaks of druidic Britain, are still revered for their 'temple-like' appearance and many more esoteric qualities besides. In Navajo mythology, the legendary 'bearers of cul-

ture' are the male and female 'Yei' – supernatural (telepathic beings) that supposedly populated the earth in the beginning.[5] In the Navajo creation story, Paul G. Zolbrod talks of the Yei:

> *The Holy [Yei] people are unlike the earth-surface people, who come into the world today, live on the ground for a while, die at a ripe old age and move on. These are intelligent people who can perform magic.... And they can travel swiftly by following the paths of the sunray.* [6]

The Yei like many other gods are said to have provided humanity with power, magic and fertility rites, symbolised in many native images as 'lightning' and the 'evergreen tree'; symbols often shown in the hands of these beings. In rock art, could the Yei also be a 'personification' of electromagnetic forces that shape the physical world? The Fourth World, described by the Hopi Indians in their creation myths, relates to the peak of an advanced Golden Age (possibly Atlantis), before it was destroyed by geological catastrophes.

A common theme in many native cultures is that the opposites of creation (the Yei), provided powerful creative `forces' utilised by humanity, to 'shape' and 'empower' life on earth. Combined holistic and visionary ideas came out of the ancient understanding that 'everything is connected to everything else', and *all* is an expression of the 'same source'. The ancients called it the *'law of one'*. Practiced in the Golden Age, the law sought to explain how every living thing was connected to 'prime source', the infinite Creator. Creativity, relationships with people and nature, were considered expressions of the highest source in many ancient earth cultures. The Web of Life and inner-spaces that can be seen as the fine gossamer threads of spirit, were celebrated through many diverse acts, using art, ceremonies and ritual. The shaping of our world (or web) through either creative or destructive acts, influenced by archetypal forces (dwelling on invisible frequencies), are still central to many tribal people's beliefs. In truth, archetypal beings are merely other versions of ourselves. How we respond to the creative forces surrounding us depends on what archetypal forces we choose to connect with. That choice, as always, is one between love and fear.

Art, Ancient Landscapes and the Dreamtime
Many indigenous cultures, especially the Native American and Celtic tribes, used symbolism of the web as a means to convey the love and power of what they termed the 'Creator'. The most famous story is the legend of 'Grandmother Spider'; she was considered part of (even a personification of) the Creator to the ancients. Grandmother Spider in her various forms, was said to have 'appeared' out of the centre of creation, to weave the web of the universe.[7] According to various Amerindian myths, she was a Goddess whom the 'Great Mystery' chose to weave the original webs of both invisible and tangible worlds. She was said to have made the 'skeletons' or 'blueprints' of 'connecting circles' that hold together the 'flesh' and 'realities' of *all*

life forms. Symbolic versions of this deity appear in films like the *Matrix* as represented in the character of the 'Oracle'. The matrix is another name for the 'webs' that are woven to create reality. Grandmother Spider, or 'Thinking Woman', was a symbol for the 'infinite possibilities' of creation; she was regarded both as the dreamer and the dream itself. It is said by the Hopi that Spider Woman was the creation of 'Sotuknang' in the First World of Tokpela.[8] In this ancient world, Spider Woman created twins who took up their positions at each of the earth's magnetic poles. One twin travelled the earth forming solid matter and shaping the topography, while the other filled the earth with sounds. This story of the twins is a stunning allegory for ancient understanding of the earth being a 'sphere' and how electromagnetic forces shape the world through sound; a knowledge that was not available to European scientists prior to the middle of the 19th Century.

In Peru, the mysterious Nazca Lines cover over thirty miles of desert and can be dated to around the second century BC. At Nazca, the ancients scored away the top surface of the land to reveal a lighter subsurface creating many drawings, including a goddess-like figure of a giant spider, a spider monkey and a humming bird. Alongside these images are hundreds of other animals, along with birds, runways, zig-zags and spiral formations. On surrounding hillsides many other strange humanoid creatures can be seen, which are symbolic depictions of giants, creator gods and, according to some researchers, there could be actual earth diagrams of specific star constellations. Some of these images certainly look similar to constellations such as Orion, Gemini and Cancer. One particular figure at Nazca, known to the locals as the 'Owl Man' (or El Astronauta), stands 29 metres high on the southern end of Pampa de San Jose. Its arms are interesting, as one points to the star Arcturus, and the other points to the earth. The ancient artists that placed the figure there seem to be telling us something about the connection between the heavens and earth.

In many ways these mysterious works of art reflect an advanced understanding of mathematics, astronomy and symbolism left by a civilisation of artists for future generations to comprehend.[9] All of these works are so large they can only be seen in their entirety from 1,000 feet in the air! Why would native people create such imagery that can only be viewed from these heights? Erich Von Daniken puts forward many theories in his books, which relate to ancient spaceship landing bases, some of which could be true. Especially when we consider the Egyptian *Pyramid Texts* which contain replicate images of flight and aviation.[10] Whatever the case, the image makers behind projects such as the Nazca Lines, seemed to have a higher dimensional perspective, which could have included humanity's ability to fly in some distant Golden Age. The knowledge which allowed wonders like the Nazca Lines, the Baalbek Trilithon, the Great Pyramid at Giza, Easter Island and other amazing creations to be built with such precision and scale, I feel, can only correlate with the efforts of an 'advanced race' who exercised an advanced science in ancient times.

In the timeless place of Tjukuba, or the Dreamtime of the Australian

Aborigine, giant totemic beings were said to have emerged from within the earth and out of the skies, to shape the land. In Aboriginal mythology, the Dreamtime was considered to be a long-ago creative era, a 'timeless zone' of mythic multi-dimensions. Everything within it, mountains, hills, trees, water holes and caves were more than topography, but 'real', living spiritual landscapes.

Similar stories are told in the Americas, especially in the landscape of Arizona located around Canyon de Chelly, where Spider Rock juts 800 feet above the desert floor. I visited Canyon de Chelly in 2010 and it was certainly a 'place of magic' where immense forces had shaped the landscape. In the Navajo lands of Keres country, in New Mexico, stands Monument Valley (another place I have visited), which is said to be the remnants of an 'ancient landscape when dreamtime forces shaped the land. These natural, giant red rock formations, according to Indian elders, speak of 'creator gods', 'giants' and 'otherworldly' forces. In May 2012, I visited a place called Aramu Muru, in Peru, which also had 'strange magic' embodied within its red rock formations. It is a 'stargate' with immense electromagnetic energy. Over twenty people, including myself, witnessed the appearance of a genie-like face through a rainbow and cloud formation as we gathered to focus on the ancient star gate. To our amazement, a 'being' appeared in the clouds above the petrified rock formation called the 'Devil's Gate', following a ceremony performed to anchor 'higher consciousness' at this sacred site. Both the petrified red rock formation, and the ethereal face that appeared, are aspects of 'ancient forces' that have shaped our world and still continue to affect the physical world (see figure 7).

Images on the Akkadian cylinder seals of Mesopotamia, 2250 BC, also show giant sun and water deities emerging from within the earth and walking across mountains, creating topography. Native American 'oral traditions' suggest that the areas of land around the Four Corners in the USA (both on

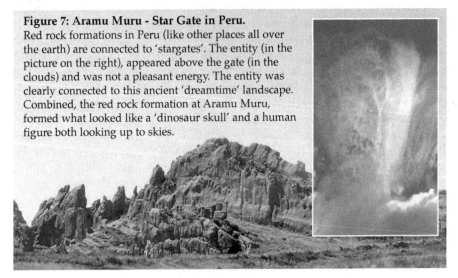

Figure 7: Aramu Muru - Star Gate in Peru.
Red rock formations in Peru (like other places all over the earth) are connected to 'stargates'. The entity (in the picture on the right), appeared above the gate (in the clouds) and was not a pleasant energy. The entity was clearly connected to this ancient 'dreamtime' landscape. Combined, the red rock formation at Aramu Muru, formed what looked like a 'dinosaur skull' and a human figure both looking up to skies.

the surface and the masses of underground catacombs), are remnants of those ancient worlds called the 'Motherland'. Some authors say, these lands eventually became Lemuria and Atlantis. The Hopi and Navajo elders say that the Motherland was a time when 'immortals' and 'multidimensional' god-beings (like the Yei), walked the earth at the time of the Third Age on earth. The Four Corners, where Utah, Colorado, Arizona and New Mexico meet, is also known by native peoples, as a place where alien races (especially the Greys), have interacted with humans to this very day. The famous Roswell cover up around Area 51 and the many UFO abductee stories, which have been made public over the years, serve only to scratch the surface in terms of what is really going on 'underground'!

Ghosts and Interdimensionals

Our ancient ancestors understood that creation consists of infinite dimensions of life vibrating at different speeds, and everything has its opposite nature. The different frequencies of our electromagnetic spectrum within 'visible light' illustrate the concept of polarisation. Different frequencies are said to be sharing the same space as each other and when we move the frequency dial or access our 'ancient eyes', then we can *see* interdimensional 'beings' (like the example in figure 7) operating on other levels of creation. These 'beings' are the gods, giants and strange creatures that appear in folklore across every continent. They are the 'now-you-see-them, now-you-don't' ghosts, UFOs and mysterious cryptids like Bigfoot and the Loch Ness Monster. When people witness any of these beings, they don't actually disappear, instead, they leave the 'frequency range' a person is accessing. All animals, especially cats, see the different frequencies more naturally than we do, which is why shamans dress as specific animals, so to engage with, or see, *into* these 'interdimensional' worlds. In Native American tradition, the ancestors of the Kwakiut tribes of the North West Pacific Coast, were actually said to be animals and intelligent beings who could assume human shape and see into different dimensions. The Kachinas (Katsina) of Hopi tradition are also said to represent invisible supernatural beings. As Alfonzo Ortiz's translation of the story of the Hopi 'snake dance' in the *Tewa* reads:

> *After the young man had travelled further, the Deer-Kachina-Cloud god appeared, also in human form. Again the youth did not recognise him as a god, and again the god scolded him and urged him to go back. 'I have horns,' the god said, 'and I am the gamekeeper of your people.' Whereupon he also transformed himself into his supernatural form and then back to a man.* [11]

According to native peoples, ceremony and sacrifice was demanded by certain interdimensionals; some of these beings were considered malevolent in nature. Images and sculptures of supernatural beings are widely depicted as the 'horned' gargoyle serpent creatures found on both Aztec temples and almost every Gothic cathedral. The creatures that overlook Paris sitting along the Chimeras gallery of Notre-Dame are especially especially significant. In

England, I have seen what looks like Bigfoot carved in sculptural decoration in the porch of Peasenhall Church, Suffolk. Do we really believe the Arch Druids of the Knights Templar and similar Christian brotherhoods commissioned the inclusion of these creatures for 'decorative' purposes? More than likely these 'interdimensionals' were carved out of stone for the same reasons the Nootka and Tinglit tribes of North America would carve their Totem poles. It was done to represent and manifest the supernatural beings they believed to be part of their ancestral spirit. Like the mask-wearing shaman who wished to communicate with unseen forces, he or she needed to become that 'physical version' of the entity, to attract it to this dimension; especially if the intention was to access the frequency and knowledge of the beings' manifesting. On that note, it makes one wonder what energies are manifested by some of the ancient temples and cathedrals, especially those covered in scenes of death, including the crucifixion and other devil-like figures that seem to dominate lesser scenes of war, bestiality and orgies, including the abduction of children!

A Hopi man I met in London who was researching petroglyphs as physical evidence for a central land mass, explained to me how tribal people would have followed both animals and 'gods' great distances in ancient times. He also spoke of the existence of a pre-historic land mass and a religious belief centred on certain 'star beings', some of whom are drawn on cave walls in exactly the same way in countries that are now an ocean apart. His findings not only amaze, but also explain how our past is intricately connected to interdimensionals and alien (non-human) life from star systems, such as the Pleiades, Orion and Sirius. The common themes illustrated so far in this chapter seem to suggest that a central land mass once existed from which a global civilisation influenced migrating nomadic tribes across a very wide region.

Star Ancestors

The Hopi Indians believe they descend from Orion, Sirius and the Pleiades. Tom Pela, one of the Hopi elders, said Sasquatch or Bigfoot is a 35,000 year-old ancestor of humans. Bigfoot, according to the Hopi and Sioux, is a powerful 'earthbound monkey god' found on every continent. In Sumerian legends he is the Stone Age monkey-man known as Enkidu (see figure 8). Some say Bigfoot is a survivor of many evolutionary changes by living underground, in caves and in other ancient places. Paul Werner Duarte of the Olmec people (now Mexico), also claims there are many species of extraterrestrial (and interdimensional beings) that have influenced evolution (creation of earth races) over hundreds of thousands of years. He lists some of them in a fantastic book called *Star Ancestors* (2001). Duarte says: "The Greys, the Katsina people, the Nordics and Angelics have been closely involved with human affairs since ancient times." According to the Hopi there are 300 different Kachina (Katsina) and one of their homes is said to be the San Francisco Peaks, a place where many strange cloud formations are said to

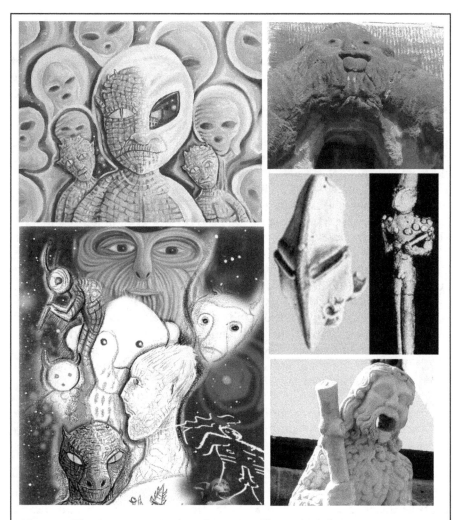

Figure 8: The Ancestors, Katsina, Greys, Nordics and Bigfoot.

Above left: A visionary depiction of Grey alien race. *Left:* The gods were also referred to as the 'Shining Ones' or 'Anunnaki' in the Sumerian Tablets. *Top right:* Bigfoot (or Enkidu) at Wrexham Cathedral, North Wales, UK. *Middle right:* Reptilian figurines from the Ubaid culture 3000BC. *Bottom right:* A Woodwose at Moulin Cathedral, France. © Neil Hague 2002

sometimes conceal UFOs inside lenticular clouds. I know this may sound fantastic to some readers, but I feel there must be more to know about our evolution and mysteries like UFOs and the so-called 'missing link', which establishment science refuses to address fully. In countries like India, men and women have been born with horns or tails, which is obviously connected to what mainstream science calls 'Junk' DNA.[12] All so-called 'alien life' has

to be connected to our noncoding DNA.

Ancient drawings of the Mokèlé-mbèmbé creature[13], which have been found in the Pergouset Ice Age caves of France, shed light on a very different understanding of our evolutionary past. These long necked, stegosaurus-like creatures can be seen depicted amongst more recognisable animals and scenes of daily life. Similar images are also found on the 'Palette of Namer' from the Royal Dynasty of Egypt dated 3100 BC. These highly decorative plates show the same creatures depicted on the cave walls at Pergouset, being held on long leads by humans, possibly giants. The only logic behind these images, juxtaposed with the realism of other animals and people portrayed around them, strongly infers and leads to the conclusion that our ancient ancestors had actually witnessed these creatures. Similar themes of humans and dinosaurs co-existing on earth are also seen amongst the huge collection of stone carvings owned by Dr. Janvier Cabrera who lives in Ica, 150 kilometres from Nazca in Peru. His collection of stones and clay sculptures are shrouded in mystery and scientific uncertainty, in terms of their age. It is said these particular artifacts come from secret caves under the famous Nazca desert and depict ape-like humans riding on the backs of dinosaurs, using telescopes, along with thousands of strange alien-like creatures. In his book *Arrival of the Gods*, Erich Von Daniken writes about these artifacts saying their source of origin is unclear and the underground catacombs from whence they came are a guarded secret by the native indians (including the Cabrera family). Daniken says in his book:

> *To argue about the age of various collections won't at present get us very far. What astonishes me, though, is that in the last four years various discoveries have come to light which call into doubt current theories about the continuous evolution of the human race.*[14]

If you doubt the existence of extraterrestrials (or interdimensionals) then consider this for a moment. According to science our sun is only one of some 100 billion stars in this galaxy alone! Scientists, including Sir Francis Crick the Nobel laureate (who with James Watson discovered the double helix of DNA), says there is an estimated 100 billion galaxies in our universe; he believes there are at least 'one million planets' in our galaxy that could support life as we know it! Millions of people have seen UFOs and at least fifteen million Americans have seen them since the 1970s. At this point we need to ask ourselves why the ancients aligned their temples and monuments with scientific precision to specific constellations? Why do monuments from Egypt to Cambodia reflect the patterns of the stars? When we look at the art and symbolism in the temple/monument interiors, or in prehistoric caves only a 'manacled mind' would dismiss the possibility of advanced beings (possibly extraterrestrial) interacting with people of earth within and before the great civilisations. Added to this are the multidimensional worlds and frequencies constantly referred to in ancient texts like the Egyptian *Book of the*

Dead and the Gnostic *Nag Hammadi*, to name but a few. Are we really to believe that our planet is the only one that can harbour life? We need to open our ancient eyes folks, to 'all possibilites'.

The Wingmakers
Strange, hieroglyphic rock art, symbols and artifacts found in New Mexico, also support similar themes to do with beings from other worlds and how they left their mark in our reality. Particular artifacts located in underground chambers were discovered in 1973 and immediately covered up by the US Government,[15] which led to one of the most intriguing scientific and anthropological discoveries ever made. The discovery included 23 chambers and connecting tunnels, inside of which were found wall paintings, various alien technologies and strange, encoded hieroglyphs. Once analysed, the whole discovery turned out to be a form of 'time capsule' left by an advanced race of artists and scientists. According to the original website, the find was so controversial that it was quickly taken under the wing of a secret, unacknowledged department of the US National Security Agency; the project itself became known as code name *Ancient Arrow*. The secret organisation that quickly hijacked the find was the Advanced Contact Intelligence Organisation (ACIO), privileged with complete anonymity until one of its members defected and told the story to an independent journalist (so the website said).

When artifacts from each of the chambers were carbon dated it was initially assumed the ETC, or Extraterrestrial Time Capsule, was left behind by visitors to Earth in the 8th Century AD. However, it wasn't until 1997 that an encoded language found within the artifacts (one of which was an optical disk), did the 'data' become accessible to the ACIO. Once the data was translated, by reducing the wall art to their closest facsimile found on ancient Sumerian texts, and by placing the 23 hieroglyphs (words) in the same order as the ancient arrow chambers, the disk was eventually unlocked. It was determined the 'time capsule' was actually designed and built by a 'future' version of humanity, who were adept at interactive time travel. They called themselves: 'Wingmakers'. The art that is placed on the now very commercial website, does seem to have a certain energy that conveys time travelling through portals and into different dimensions of colour, shape and form. Personally, I am dubious about its 'origins'; it could all be total nonsense, designed to 'market' specific products. However, 'time travel' *is* possible through creative acts, as I will come to later in the book.

There are many more examples of stories, legends and art forms (from all over the world), which suggest the basic theme of humanity interacting with 'advanced beings' (possibly operating on different dimensions). Twenty-nine thousand year-old rock paintings from Itolo in Tanzania, show what appear to be Grey aliens. Aboriginal petroglyphs from Kimberly in Northern Australia, show strange beings called the 'Lightning Brothers' and the 'Wandjina', which can be found on cave walls dating back 5000 years. In fact, drawings of the 'Ant People' made by the Hopi are remarkably similar to the

Greys with their large heads and small, stocky bodies. Could it be that certain advanced races existed on earth in ancient times with ET connections? If so, were these 'aliens' the famous hero gods who became the templates for later religious 'saviour' figures? How can evidence of UFOs be present in prehistoric art through to various Renaissance paintings? Especially the work of Paolo Uccello (1396-1475) and the later paintings by Aert De Gelder, who depicts a disc-like craft 'beaming light' onto John the Baptist, in his painting *The Baptism of Christ* (1710). 10th Century translations of the Sanskrit text, the *'Prajnaparamita Sutra'*, also show cylindrical-like ships (UFOs) with portholes, travelling through the sky. It seems clear our ancestors knew that esoteric art (and the use of hidden symbols in art), can provide 'portals' transporting the viewer into different dimensions (or levels of awareness). Interestingly, the Egyptian *Book of the Dead*, along with the *Coffin Texts*, also addresses numerous portals to inner-worlds, all guarded by a specific god or strange entity.

Ancient Creator Gods

Do we really know everything that there is to know about the nature of our world? The most honest answer would be: No. Yet the pillars of authority through science and religion, along with many other isms, encourage us to assume that we do know everything there is to know. In many ways, we are like ants traversing the surface of our world, or fish that swim within their ocean, oblivious to what goes on above the surface of their reality. Imagine if some of those fish (symbolic of people) proposed that there was an unseen world above the surface, or if an ant talked of another place beyond the colony; they would be scoffed at and considered 'mad' by other members of the tribe, shoal or colony. The subjects I am about to write of, especially in the next few chapters, are not the crazy ideas of an eccentric individual; they can be found by anyone who wishes to look a little more deeply into the mysteries of the past.

From an overwhelming amount of evidence, it seems an 'advanced race of gods' ruled a more primitive planet in ancient times. The ruling gods, giants (titans), have been recorded through ancient art, texts and architecture across every continent. It could have been that the 'gods' built the great wonders of the world and instigated the 'teaching of art', 'science' and 'culture' across a wide geographical area. As we have already seen, native oral tradition, as well as ancient texts, talk of beings (possibly extraterrestrials) coming from the skies (or appearing in our three dimensional world). On one level, 'sky beings' could relate to the 'appearance of comets' and planets in the earth's biosphere; and on another level, to the possible interaction between interdimensionals and native earth people. From Egypt to the Americas, the gods were worshipped through an advanced science, centred on the 'movement of the stars' and the knowledge of the precession of the equinoxes. It is evident from the wealth of research out there, that specific deities were the 'founders' of what we now call 'civilisation'.

The Maya of Central America (Mexico) say their advanced knowledge was

handed down to them by the 'creatures of the plumed serpent', their saviour god Quetzalcoatl, also called Balam-Quitze or the Jaguar who smiles. In Egypt, the same was said of their god, Osiris, who could see great distances without having to move. Osiris was quite clearly a 'super god' who seemed to have been worshipped under different names all over the ancient world. According to the *Popol Vuh*, the sacred book of the ancient Quiché and Maya, the gods or first humans:

> *Were endowed with intelligence; they saw and instantly they could see far; they succeeded in seeing; they succeeded in knowing all that there is in the world.....Great was their wisdom; their sight reached to the forests, the rocks, the lakes, the seas, the mountains and the valleys.*[16]

In both Sumeria, Egypt and Central America the gods became known as 'civilisers of the world' and were worshipped for their 'superhuman' abilities. These gods were said to have lived openly amongst the ancients before the Age of Cancer 10,800 to 3113 BC. After the catastrophic deluge, recorded in numerous civilisations, these gods then went underground into catacombs said to stretch great distances across the earth.

The Mayans of South America say that Venus ushered in the Fourth Age when it appeared in the earth's atmosphere as a blazing comet (3113 BC). The many references and legends of Lucifer ('the bringer of light'), could relate to this event. In recent times, science has confirmed this 'characteristic' of Venus as a comet or wandering planet. The Russian-Jewish psychiatrist and writer, Immanuel Velikovsky, caused outrage among the scientific establishment in the 1950s, by suggesting that the earth had been through enormous upheavals when Venus (a large comet) careened through part of the solar system, colliding with Mars, before settling into its present orbit. When Venus was photographed by Mariner 10, many of Velikovsky's descriptions proved correct, including what appeared to be a 'comet-like tail'. The Mayans, like their ancestors the Lacondons, say that they are survivors of the great Atlantean culture, who according to their oral traditions, were told to study Venus by advanced beings that once occupied Atlantis. The Mayans (along with the Sumerians), constructed calendars based on witnessing such events in the heavens. Ancient civilisations like the Mayans, made a calendar based on the orbit of Venus in relation to sunspot activity on earth. The same calendar, symbols and gods (also shared by the Mayans), were connected to the Tibetans, the Babylonians and the Chinese cultures in the same 'new era' on earth; an epoch that began a period of sacrifice and worship in the temple. Oannes, was the mysterious amphibious bearded Caucasian creature, often depicted with a tail, who also appeared at the beginning of the 'new age' ushered in by Venus. The Babylonian Calendar also marked 3113 BC as the 'beginning of a new cycle' when the god Oannes (Thoth, Mercury, Virachoca) mentioned earlier, emerged to found the Sumerian civilisation at the same time.

From a more scientific point of view, the 'traversing of worlds' could relate

to what scientists term 'hyperspace'. The physicist, Michio Kaku, was one of the first to pioneer such ideas. Hyperspace, or multiple dimensions referred to by Kaku, could be 'parallel worlds' connected to our world. Different dimensions are not stacked like a chest of drawers, but overlap and intersect, creating multiple connecting worlds. It is said, when the fourth world (dimension) was 'overrun' by 'demonic forces' in ancient times, the gods took physical form to create the 'occult' mystery schools. These 'schools' then went on to create temple structures, secret societies and 'religions', based on the highest knowledge once kept 'alive' in the temples of Atlantis. The Babylonian and Egyptian civilisations (both possibly colonies of Atlantis), were responsible for the creation of *all* orthodox religion as we know it. The fourth dimensional 'gods', often referred to as 'mirror people' in Chinese mythology, had one objective: to create a 'network of magicians' who could invite their fourth dimensional masters (through ritual and possession), into our physical world. The creatures or demons that entered our reality (in ancient times) are still with us! They are the archetypal gods (entities) made into mythical figures often with religions founded in their names. What people do when they give their minds away to religious belief systems, is 'form a pact' at the level of the psyche (soul), with fourth dimensional entities. Some of these entities are not at all what we consider them to be, and most have 'dual aspects', just as all nature is dualistic.

Venus and the Sun that Moves

An American photographer (with connections to the Hopi), whom I met several times over the past twenty years, told me a story that would change my view of religion and the so-called saviour figures that abound in ancient cultures. This occurred at a private viewing of my paintings to which I'd invited several friends. Here I was, surrounded by friends and my paintings, when he shared with us this beautiful tale of how the age we are now living in was created at the time of what the Hopi call the 'Sun that Moves'.

After a catastrophic deluge (recorded in numerous cultures), there was said to be a long period of darkness, when the light of the sun vanished from the sky. This could have been due to Venus (then a large comet) making contact with the earth's atmosphere. According to Mexican and Hopi myths (who incidently don't have records of Venus as a planet before this period), the 'gods' gathered together at Teotihuacan 'the Place of the Gods' (the Heavens) to decide who would be the next Sun *for* Earth. In this creation myth, the gods decide that someone from within their 'celestial' council will have to be sacrificed by throwing themselves into the 'sacred fire' (a central 'galactic sun'). The ancients depicted this fire as a 'coptic cross inside a circle', the same cross that would eventually be used in Christian religious symbolism the world over. To these gods, whomever passed through the fire would bring the sun back to the world of mortals. The ancient drama went on to explain how two gods, 'Nanahuatzin' and 'Tecuciztecatl', came forward from within the council, both volunteering to jump into the fire. One is said to have burned quickly, the other roasted slowly on the embers at its edge. After

a long wait, it is said that Nanahuatzin (a hunchback) emerged as the sky started to glow in the east, bringing with him the great sphere of the sun. Tecuciztecatl also rises in the east making the gods worry that the world will be too bright, at which one god throws a white rabbit in the face of Tecuciztecatl, who then becomes the moon. Here we have a Hopi story that hints at an ancient epoch when 'two suns' rose in the sky. Creation stories like these are basically telling us that the heavens are a construct (an illusion), and that the moon, sun and planets are being guided (even created) by a greater mind; just as computer programmers construct objects and players in their games! Could the sun and moon be aspects of a sophisticated computer programme (the 'game of the gods'); and are we players caught up in the game?

Similar stories relating to the sun and moon being guided by the gods, can be found in Chinese mythology, which says that the monkey and the rabbit jump into the sacred fire, after which the rabbit is rewarded for his bravery and placed in the Moon Palace. The same symbolism and codes can be found in the story of Pacal Kin, the spiritual leader of the Mayan civilisation, who was also said to have arrived from 'nowhere' with his mother, 'White' Quetzal and his wife, Lady Lotus Flower.[17] Did the Moon arrive out of nowhere? More on this later.

According to legend, Pacal became the male leader of the Mayan civilisation after thousands of years of female guidance, and it is said that his mother trained him from when he was thirteen years of age. I believe the characters and numbers in this story relate to the unique relationship between the Earth, Venus and the Moon; as both Venus and the Moon settled into their new orbits at the beginning of what the Mayans called the 'Fifth Age'. The arrival of these spiritual beings can be likened to Venus (also called the Evening/Morning Star) and the moon as seen from earth between 8 and 5,000 years ago. Interestingly, planets like Venus and Mercury perform retrograde motions, also known as 'kisses', while they orbit the Sun in relation to the Earth. These motions create geometric patterns and Venus, through its motions, according to astronomers and geometers, like John Martineau, form the 'five-petaled lotus' through its 'dance with the earth' around the sun. This pattern is said to form every 'eight earth years' and every 13 Venusian years; exactly the same timespan Pacal Kin was being prepared to rule the next age on earth. At this point, the Fifth Age (a new age back then) was ushered in by a god who was given many names across different cultures. To the Aztecs he was Quetzalcoatl, to the Egyptians he was Osiris and often depicted as a bearded, caucasian, male god. As a dualistic god, Quetzalcoatl was called the 'plumed serpent', another sun deity who seems to have mysteriously appeared simultaneously all over the ancient world to work miracles and heal the sick. Artifacts and statues of this caucasian (serpent) god have been found in places as far apart as the Corichancha Temple in Peru, to the Assyrian reliefs of ancient Mesopotamia. This god (or the extraterrestrial race he belonged to), initiated a belief system based around a miracle-working saviour, who would always return to usher in a new world (see figure 9 overleaf).

In ancient Inca tradition, it is said that a mysterious race of beings called the 'Viracochas' created the previously mentioned Nazca lines and they were also depicted as Caucasian, bearded `supergods'.[18] To the Inca and conquering Spanish, Viracocha also meant 'Foam of the Waves' and like Oannes, the bearded fish god of Babylonian myth, he too was said to have brought laws and instruction on how the native population should live. In many South American legends these mysterious 'martian gods' were credited with ushering in the long lost Golden Age through performing miracles and teaching a science now long forgotten. That lost science, I feel, was used in making the endless prehistoric standing stone formations all over the world. In many accounts, the Viracocha were said to use a 'heavenly fire' that could lift huge blocks of stone and many mysterious feats were associated with these hero figures (gods). Research even suggests that the Viracochas arrived from Mars when it too collided with the giant comet that became Venus. All the attributes given to the mysterious Caucasian (Nordic) bearded gods of the prehis-

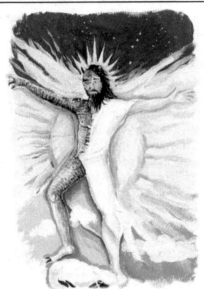

Figure 9

Quetzalcoatl, the Venusian Caucasian Serpent God.

Left: My rendition of Viracocha (Inca); Tammuz (Babylon); Mithra (Persia/Rome); Quetzalcoatl (Mesoamerica) and the later Jesus figure. He is the universal sun god, the 'giver and taker' of life. In my view, Jesus and Lucifer are the same deity. They are both 'bringers of light', both are symbols of 'death' and 'resurrection', and like many other dualistic deities, both are based on the ancient belief in a 'Supreme Being' splitting into two. More on this in *Chapter Four.*

© Neil Hague 2001. Acrylic on paper.

Right: **The God of Life & Death.**

A Bronze Age petroglyph photographed at Los Almos, near New Mexico. It shows the duality of what the Hopi and Hindu legends describe as the 'duality' or the 'splitting of the Supreme Being'. It depicts the 'God of Life' (Kokopelli) or Nanahuatzin, rising from the head of the 'God of Death', Masau'u, who carries a staff and faces West. The flute-playing Kokopelli, represents the sun and higher dimensions; while Masau'u, represents the lower worlds, (Underworld) and the moon.

© Photograph courtesy of Dan Budnik

toric world were associated with the many saviour gods that would emerge much later in places like Meso-America (Quetzacoatl), Phoenicia (Baal), Babylon (Thammuz) and Rome (Mithra).

The Royal Race

In 1850, tens of thousands of clay tablets dated 4000 BC were discovered 250 miles from Baghdad. They are one of the greatest historical finds imaginable; yet, 170 years after they were discovered, they are still ignored by conventional history and education. Why? Because they demolish the official version of events. On the tablets are images and texts which relate an advanced understanding of the 'nature of life' from within the civilisation of Sumeria. One of the most famous translators of these tablets was the late American scholar Zecharia Sitchin, who read Sumerian, Hebrew and Aramaic.[19] According to Sitchin, the tablets are evidence the Sumerian and Ubaid cultures (predating biblical times), had knowledge of 'flying ships'; battles taking place in the heavens between different Gods; the creation of homo sapiens (test-tube babies) and intricate details of star systems, including our solar system.[20] The tablets depict the solar system with all the planets in their correct positions, orbits and relative sizes, and their accuracy has only been confirmed in the last 100 years, when planets (like Chiron) were observed for the first time. Amongst many other revelations, the tablets describe the colour and nature of Neptune and Uranus in ways only recently confirmed by scientists in the last twenty years! So how did these civilisations come to have this knowledge? Conventional science and history accepts that civilisations like Sumeria and Egypt were very 'advanced' and started at a 'high level' in terms of science and understanding of astronomy. The reason for 'having advanced knowledge' is clearly depicted on the tablets.

The Sumerian tablets talk of an 'alien race' called the AN.UNNAK.KI (translated as those who came from Heaven to Earth) and they are often referred to as the 'Watchers' in texts like the *Book of Enoch*. The Anunnaki-Nefilim, or Watchers, are also described as fallen angels in other ancient texts like *Genesis*; ancient records show them with wings. It seems the Sumerian tablets, in part, inspired the biblical accounts of *Genesis* and *Exodus*, including the creation of Adam and Eve. According to Sitchin, it was said the Anunnaki came to earth an estimated 450,000 years ago to mine the planet's resources, mainly gold. To do this they created a 'human slave' or 'worker bee' to perform such tasks for them. The tablets talk of two gods named 'Enki' and 'Ninkharsag' who were given the task to 'make' this worker bee; in doing so, these gods created many Frankenstein-like human-animal hybrids as they strived for genetic perfection. Many of the hybrid creatures became the gods of later civilisations on earth. As I have already mentioned, Bigfoot is believed by many ancient earth cultures, to be an ancestor of the original human, before human DNA was stripped from twelve strands and reduced to two. The Sumerian Tablets say that the Annunaki breakthrough came with the creation of homo sapiens (a being the Sumerians called LU.LU or 'one who has been mixed'). The Sumerian Tablets, like the later Akkadian

stories, explain how the Annunaki hierarchy, which was ruled by the father god AN or Anu, granted 'Anu-ship' (Kin = blood) to certain humans who would go on to rule and control as god-kings in Sumeria and Egypt. All this eventually led to the concept of 'divine right to rule' and of knowledge being imparted to a chosen elite. These hybrid god-kings also became the rulers of the Near and Middle East and are often referred to as the 'Dragon Kings'.[21] The Anunnaki are the 'gods' in the *Old Testament*. Every time the word God is used in the *Old Testament* it is translated from a word meaning 'gods', plural; 'Elohim' and 'Adonai' are two examples. In the Ancient Indian *Vedas*, the same beings are known as the Nagas or Serpent gods who are also attributed with similar feats mentioned in the Sumerian Tablets. In Buddhism they are referred to as the 'snake guardians' of the 'doorways'. The Egyptian name for their gods, the Neteru, literally translates as 'watchers' and they too said their gods came in heavenly boats or sky rockets.

The *Nag Hammadi Library* or *Gnostic Gospels* refers to a Royal Race and their hybrid rulers as the 'Organisation', said to be the intelligence behind the ancient temple structures. The Organization became known as the 'Illuminati', whose 'initiates would become the chiefs and priests of the highest order. These initiates would go forward into the world to bring either peace or destruction. The latter depended on which part of the ancient order the initiate belonged to. The difference between the two factions of the Organisation was the difference between forces of light (love) and darkness (hate). In the words of the *Gnostic Gospel*: "The darkness works to anaesthetise the intelligence and spread the cancer of mind blindness."[22] I will come back to the Gnostics later in the book as their texts are paramount to understanding so much about our plight and connection to the stars.

In simple terms, the high priests of the Anunnaki infiltrated the ancient mystery schools with one agenda, to keep hidden the truth about 'who we are' and what humanity is truly capable of achieving. To hide knowledge, the 'Illuminati' created religions based on mythical heroes and placed their middlemen (priests) in charge of the masses. To stop people rebelling against control by the priests, religious schemes and themes were hatched to sell the promise of an afterlife. However, there was always a catch, the people had to 'do as they were told' to get into paradise. Initiates of the ancient Egyptian mystery schools became followers of the Anunnaki through their worship of 'Shasu' the 'angry desert god' and they too, were worshippers of the sun and the serpent. A brotherhood of elite priests (with its blood ties to the Anunnaki gods), eventually became the kings, priestesses and pharaohs of the ancient civilisations of Sumeria and Egypt. The chiefs of various Native American Indian and African tribes also had this type of 'kinship' with a Royal Race from the stars.

In Persia and surrounding areas of Media, the same royal bloodlines also became the dragon dynasty, otherwise known as the 'descendants of the dragon'. In Egypt, the priests of Mendes founded the Royal Court of the Dragon in 2200 BC. This court (or cult) still continues today, 4000 years later, as the Imperial and Royal Court of the Dragon Sovereignty, now headquar-

tered in Britain.[27] In Celtic Britain, the tribal 'king of kings' were referred to as 'Pendragons' and dragon or serpent symbology, can be found in every ancient civilisation. Dragon symbolism especially, can be linked to positive and negative types of leadership. Even in today's world, one will find the ancient royal dragon depicted on flags, statues and on logos of the ruling classes. According to many researchers, wherever these elite bloodlines went, they created their own mystery schools, which can be traced back at least as far as Atlantis. The priests of Atlantis, said to be direct descendants of star beings, bird people and various extraterrestrial races (see figure 10), created a network of secret societies. Our connection with 'star races' is the 'secret of secrets' passed on through the ancient mystery schools to this day. Symbolism found in Egyptian art, through to the later Knights' organisations of the Middle Ages (including Freemasonry), are still based on our connection with specific constellations, hero-gods and goddess archetypes.

Shamans, Star People and Shapeshifters

Traces of secret societies can be discovered among the ruins of aboriginal cultures, like that of the Maya and Quichés of South America, as well as the already-mentioned Sumerian civilisation. In his book, *The Masters of Wisdom,*

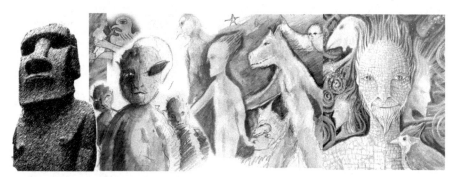

Figure 10: The Chuhukon or 'Star People'.
The Chuhukon are said by the Hopi to be the ancestors of the Atlanteans, who came from the constellations of Sirius, Orion and the Pleiades.
© Neil Hague 2002. Sketch book work.

J.G. Bennett writes how the Russian mystic, Gregori Gurdjieff, told him that the mystery schools went back at least 30,000 to 40,000 years and this, says Gurdjieff, he learnt from cave drawings in the Caucasus Mountains. From my own meditations, research and inspired artwork, I believe many extraterrestrial races have seeded the 'genetic diversity' we call life on earth. Some of these 'creatures' were once the dominant species on earth (like dinosaurs), and some cryptids come from within deep caverns of our planet. According to indigenous people's traditions, birds, reptiles and amphibious creatures are all said to have played a major part in the evolution of our human species. Native elders talk of the ability to 'shapeshift', once common to the shamanistic clans, coming from the genetic mix of 'human and star being', especially when one genetic code 'overrides' the other. While performing certain rit-

uals, shamans or initiates had a reputation of being able to shapeshift into certain animals (gods) because of their kinship (blood relationship), and their 'original' genetic source. In Roman times, for example, it was believed powerful witches could turn themselves into animals, especially wolves. According to the Greek historian Diodorus Siculus (44BC), the ancient Danaan brotherhood of initiates and magicians called Telchines, on the Island of Rhodes, could also shapeshift into any form.[23] Such a process is known as 'lycanthropy'. In Indian mythology, the Naga are supernatural serpents who can change shape, from human to cobra and back again. Danté who was from post-Roman aristocracy, in his work *Inferno*, also refers to serpents that change back and forth, between human and serpent form.[24] The 'Thunder Beings' and their offspring in Native American myth, were also said to be symbolic of this extraterrestrial blood connection too; the word 'Zulu', for example, is said to mean 'Royalty from the Stars'.

Gods and Serpent Kings

Alongside the myths and legends of the superhuman Caucasian gods there was another group of deities, worshipped and recorded as the 'Shining Ones' or the 'Watchers', mentioned in texts like the *Book of Enoch* and the *Dead Sea Scrolls*. As we have already seen, the same gods were also known as the Anunnaki of Sumerian history and the Naga in Ancient India. These are the race of titans, giants and dragon gods of which records can be found all over the prehistoric world. According to the Aztecs, this giant race was said to have lived on Earth at the time of the First Sun (Age), which was destroyed by water.[25] In much art (and oral tradition), these gods are depicted as a serpent race, or the Itzamma (lizard) gods, who are said to preside over the 'Underworld'. In Mayan art and sculpture the same gods are often shown as large serpents rearing up to spew forth their descendants, the kings that would rule the earth. The Sumerian clay tablets also show detailed descriptions of how the Anunnaki gods interbred with human women to create a hybrid race (a fusion of human genes). Their offspring were known as the Nefilim, Rephiam, Emim and Anakim, who were also a giant race, recorded in art forms all over the world.[26] Bones of giants have been found in Minnesota, North America and Africa and I have actually seen bones of a giant in a 13th century crypt underneath a church in St. Bonnet le Chateau in France. And, of course, there are people who are over eight feet tall living in America and Africa to this day.

The Sumerian texts call the Annunaki the AB-GAL, or the 'masters of knowledge', who go back to ten priest-kings before The Flood. In many ancient traditions the Nefilim, being the offspring of the gods, became the kings, pharaohs and pendragons of the connected Empires of Sumeria, Phoenicia, and later Britannia. All these civilisations worshipped the same goddess called Semiramis and Barati; the latter became the legendary *Rule Britannia* archetype, the goddess of the foam of the sea. With a bloodline directly from the gods, the elite were said to be destined to 'rule' the more primitive population. In truth, this is the real source and genealogy for the

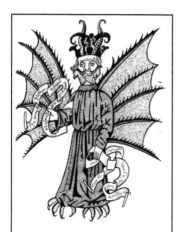

Figure 11: Wotan or Wodan.
A 14th Century illustration of an Illuminati Priest.

'divine right to rule', which came through the lineage of Pharaohs and monarchs and continues today through presidents and world leaders.

According to *The Oxford Illustrated History of British Monarchs*, all Anglo Saxon kings proudly claimed descent from Wodan or Wotan (Mars), the Germanic God of War.[27] Wodan was the consort of the Dragon Queen El or Hel (more on her later), and one of the older names for this 'star god' was Bodo, which means 'The Serpent Footed' (see figure 11). In India he was also known as Budh (similar to Buddah) and was revered on Wednesday or Wodens-day. If the idea of today's monarchs and presidents being related to ancient kings and pharaohs sounds a bizarre notion, then I quote an article titled, *Victory is in the blood for 'aristocratic' Republican*, in the UK *Guardian*, at the time of George Bush Jr.'s bid for the presidency in 2000. *The Guardian* stated:

> The company, which publishes books on ancestry, aristocracy and history, has predicted the outcome of the presidential race for almost 200 years. It says the candidate with the most royal blood has always been the victor. Mr Bush has direct descents from William the Conqueror, Henry II and Charles II, according to Burkes Peerage.[28]

The article also went on to predict that even though Mr Gore's ancestry boasted a lineage back to two Holy Roman Emperors, according to Harold Brooks-Baker publishing director of *Burke's Peerage*, Mr. Bush would become President. According to the same organisation, at least 33 of the first 42 Presidents of the United States have been related to King Alfred the Great (849-899 AD) and Charlemagne (742-814 AD), the famous monarch of France. Some researchers have even taken that same bloodline back to Ramses II (1295 - 1228 BC). The latest President, Donald J. Trump, is a direct descendant of Hakon V, King of Norway according to Icelandic genealogist, Oddur F. Helgason. Trump is also related to Queen Margrethe II of Denmark, Icelandic President Guðni Th. Johannesson of Iceland. And the dynasty keeps on... You might ask, whatever happened to democracy? I would question the fact that we have ever had a real democracy, but to dwell on that particular strain of thought cannot be covered in the course of this book. However, there are many books and sources on this strand of the subject, for anyone interested in delving deeper in that direction (see the bibliography section).

Stories of serpent gods coming by boat to the the Americas from the East can be found amongst the Inca, Aztecs and Mayan traditions. According to legend, the god Quetzalcoatl fled via the 'Eastern Sea', preceded by his atten-

dants who had been changed into bright birds.[29] Central American gods like Tezcatilpoca and Quetzalcoatl (both serpent deities) were said to be locked in a conflict that went on for an immense span of years. In Mayan myth the hero twins, 'Hun Hunahpu' and 'Vucub Hunahpu', are great game masters who love to throw dice and play ball in their 'masonry ballcourt'. Themes of ancient forces of 'good and evil' doing battle can be found woven into the attributes of many sun and serpent gods, some of which seem to relate to 'battles across the stars'. The underworld or the place of fright, through which the souls of god-kings had to journey, is also a constant theme in many ancient cultures. In fact, what was called the Copán ball game of the Maya was actually a 'symbolic game' for the sun (or the head of the God Hu Hunahpu), moving in and out of the underworld.[30] It's possible that the modern day predecessor eventually came to Europe in 1528, beginning what we now call football. In my view, football (soccer) is a perfect example of polarity-based games, where the footballers are often worshipped like gods. The end result of these battles between the gods seemed to be one of evil winning and taking the spiritual reins of power on earth.

In Central American myth, the cult left behind after legendary battles (at the beginning of what the Mayans call the Fifth Sun or Tonatiuh), was the 'Cult of the Serpent', the demander of war and 'human sacrifice'. The most graphic example of mass human sacrifice was found on the northern coast of Peru at Huanchaquito-Las Llames, where 140 children's mummified corpses (and 200 young llamas) were unearthed, dating back to 550 years.[31] Instead of revelling in the ancient wonders, arts and sciences brought by earlier star gods (consciousness), a new breed of worship was centred on death, demigods and the underworld from where they had re-emerged after the Flood. In ancient Egyptian history (*The History of Manetho* 300BC), the chronicler Eusebius writes that: "... after the original gods, demigods reigned in Egypt for 1255 years and again another line of kings held sway for 1,817 years." According to the *Manetho*, Egypt was ruled by gods, demi-gods and their kings for almost 25,000 years. Yet, for the latter period of 5,000 years, Egypt and its dynasties were said to be ruled by the 'spirits of the dead' and 'demons' of the underworld.[32] The same is said in Hindu history, which claims the Dark Age of Kali Yuga has ruled for 5,000 years, beginning in 3102 BC. From my own research, art and meditations, I feel these spirits are representative of the strange beings found in folklore (the elfs, trolls and fairies) who are said to dwell both in the astral (etheric world), or the Underworld. The Maya called these interdimensionals the 'Lords of Xiballba', the rulers of the Underworld – the lower fourth dimension. The Lords of Xiballba would go on to take over the mystery schools which had their origins in Atlantis. The priest kings and the descendants of the gods on earth, took the ancient star religions of Atlantis, along with its esoteric, astrological and astronomical knowledge (including the stories of their reptilian gods), and buried them in symbolic fables. Therefore, real knowledge and history of the 'gods on earth' was only understood by chosen initiates, while rigid beliefs of orthodox religions was disseminated for the masses to swallow.

Religions like Judaism, Christianity and Islam were founded in the lands occupied by the Sumer Empire, situated between the rivers Tigris and the Euphrates. Over thousands of years, the many ancient gods became 'one angry god' as the plural was turned into a singular force. The first line of *Genesis:* "In the beginning God created the heaven and the earth" actually reads in Hebrew: "In the beginning the gods created the heaven and the Earth". The singular El derives from the plural Elohim and terms like 'Yahveh' or 'Elohim' were translated as 'Lord' and 'Lord God' to hide this truth. The Bible states, unambiguously, that everything good or evil results from the gods. In *Isaiah* we are told: "I am the Lord and there is none other. I form the light and create darkness, I make peace and create evil, I the Lord do all these things" (*Isaiah* 45:6-7). If viewed from the idea that an ancient bloodline of priest kings (who had blood ties to the gods/demons of the ancient world), actually created a singular god to cover their tracks, considering what is written in the above text of *Isaiah*, were these malevolent gods (beings) behind all war, tyranny, killing, sacrifice, and crusades? I would say: quite possibly. If so, are their modern ancestors, in the guise of world leaders (and the secret societies to which they belong), still pursuing war today? Look around and ask who are the instigators of all ills, war, famine, suffering and injustice in the world? The truth is: it is not you or me; we are all fodder for the god-kings who have exercised their power on an unsuspecting humanity for thousands of years. How the demigods and rulers of earth have convinced the masses to follow them in creating 'pockets of hell' on the planet is through one very ancient method - 'mind control'. We also give our power away by 'externalising' everything and when we do this, we give others permission to forge the world in their liking. Very often that world is diabolical in its attitude to others, only because we allow the 'demons' to create havoc through their masters and initiates here on earth. Our view of ancient history including the confusion between religious doctrine (control) and spirituality (individuality), is due to the priesthood and its 'fables' that began in Babylon. Over thousands of years we 'bought' the big lie, that God CONTROLS everything. Put it this way, the 'gods' have certainly 'controlled' *our minds* for a very, very long time.

Hero Worship and the Post-Flood World

Sources like the *British Edda*, a 12th century text found in Iceland, and the already-mentioned Sumerian Tablets, describe how an advanced race of beings (possibly extraterrestrials), survived the great deluge, an event that is recorded in numerous texts, as well as cultural traditions throughout the world. Around this time, Neolithic communities apparently appeared from nowhere, often at great heights, like Machu Picchu in Peru and the ancient city of Cutal Hüyük in central Turkey. When we consider the influx of advanced knowledge in places like Ancient Egypt and Central and South America, it is absurd to believe these sophisticated centres suddenly appeared from 'nowhere'. Yet a cataclysm might suggest that these civilisations were merely carriers of an advanced knowledge once held on an earli-

er land now lost beneath the waves. Survivors of this famous inundation could have fled, each carrying a story of disaster with them, entering the oral tradition in the countries of refuge. Eventually, tales of a lost civilisation and its reason for demise would have reached the likes of Plato in Ancient Greece, who talked about it extensively. As Michael Baigent says of places like Cutal Hüyük in his book *Ancient Traces* (1998):

This highly sophisticated culture suddenly erupted upon fertile highland plains as though transported mysteriously from elsewhere.[33]

Worthy of note is the synchronicity of the Hindu, Egyptian and Babylonian calendars which all commence a new cycle from a point of 11,500 to 11,000 BC. At the same time, these dates also correspond closely to the melting of the last glaciers 12,000 years ago, which could quite easily have caused a flood of that magnitude. Egyptian historians also say the legendary 'reign of the gods' commenced 10,000 years ago. At this time the god, Thoth (another symbol for the moon), arrived in the Nile Delta bringing to Egypt knowledge of 'art' and 'hieroglyphics', all of which must have been a product of an earlier 'advanced' civilisation.[34]

From this point in our ancient history the birth of the 'hero god' found its way into the legends and oral traditions of cultures who were trying to remember life before the Flood, a time when the gods, giants, titans and heroes were said to have come to earth. For the 'beings' that survived the great flood, many were revered as deities, which set the scene for hero-worship and the creation of various religious blueprints. Some gods, like the aforementioned Anunnaki, were actually giants and this is quite clearly depicted on the cylinder seals, showing these figures lifting lions and other ferocious beasts off the floor with their bare hands. Descendants of Noah in the *Book of Enoch* were also said to be a race of giants or titans and the writer Homer (8-9th century BC), wrote that: " The heroes were exalted above the race of common men". In Egyptian legend, the sun god Horus, or Haru, is said to have come from the term 'Heru' (hero) which means 'Sun God on Earth'. The Sun, as we shall see in a later chapter, was one of the main sources of inspiration behind hero worship and religion. Others relate to the possible miraculous feats carried out by extraterrestrials or advanced human beings. All forms of religion, whether monotheistic or polytheistic in nature, are derived from those two ancient aspects of hero worship.

As hero worship grew amongst tribal people through the vehicle of religion, various saviour figures appeared under different names, in different locations and at different times. However, when one digs a little deeper into the anatomy of these hero figures, they all have a common heritage rooted in sun cycles, and how the sun affects the Earth (the goddess). There are at least 30 to 40 known saviour figures, from Apollo to Jesus, recorded in ancient texts and all of them carry the same attributes. One constant theme is that the hero son is born to a virgin goddess on the 25th December. This is more to do with the Sun's power in relation to nature's cycles than a man, or god, sav-

ing the world. In the oral traditions of native Pan (Atlantean) cultures, the same attributes were attached to supernatural beings aiding the earth in her solar cycle. Many aboriginal stories, legends and rituals involve human interaction with what can be described as extraterrestrial and strange inter-dimensionals in ancient times. At the same time, our ancestors seemed to have had a natural fascination for 'good versus evil' archetypes as told through their myths and legends; many of which talk of battles between super hero-like gods and giants. Quite often these themes are connected with the imaginary worlds of *Marvel Comics* as super heroes. In fact, some of the *Marvel* heroes are actually based on ancient hero gods: 'Thor', 'Spiderman' and 'Loki' are just three examples. In the early days of the Internet, I saw a website that took 'god figures' and hero worship into the realms of secular religious belief in a very perceptive and humorous way. The website was called the *Jesus Christ Superstore*. On it were found superhero toy figures, including God himself with flowing white beard and Jesus with a nail-throwing cross, to describe just a few. What this site did, with humour, was to show these mythological heroes for what they really are: 'characters', figures; based on archetypes in nature created through the imagination of ancient 'illuminated' priestshoods.

The Sun and the Serpent

In Celtic myth, giants called the 'Formorians', were said to have fought and were defeated by the Tuatha de Danaan of Ancient Ireland. In Greek mythology, a race of earthbound giants fight with Zeus (Jupiter) and a common theme of the battle between gods and giants can be found in numerous works of art. The battle of Moytura, in Celtic lore, was a struggle between the 'old order of gods' and the 'Blar' or Balor (the God of Light), also a new solar god, Lug SamilDanach. Scenes of the biblical final judgement and the colourful *Vedas* of ancient India, are among many art and texts depicting battles between giants, demons (including serpents) and sun gods, like Indara or Zeus. Similar battle scenes are found on temple murals at Cacaxit in Mexico, which show bird and jaguar people (symbolic of the sun and serpent gods), battling it out, as with the same battles between Gilgamesh and Humbaba of Sumerian legend. I have utilised these myths (legends) in my illsutrated graphic novels called the *Kokoro Chronicles*. See **neilhague.com** for more information.

In the *Gilgamesh* epic, Humbaba was said to be a forest giant with fiery breath, terrible jaws and eyes that blazed with the power of death (possibly a dragon). For all *Marvel comic* fans, he was a sort of cross between the *Thing* and the *Incredible Hulk*. The battles between gods and giants at Ragnarok, in Norse Mythology, are also part of the same theme of an old order of heroes fighting a new bunch of deities. Their 'battles' are compared to the cataclysmic upheavals that shook the earth on both a physical and spiritual level, events that could possibly happen once again at this time. In Viking myths, it is said the body of the Frost Giant Ymir, birthed the 'nine worlds' (or dimensions) and a vortex, which supported the 'World Tree'. The 'tree' in

this story can be likened to the web-like matrix, which contains the records of all life force, archetypes, past, present and future worlds. It seems many battles took place in the sky and underground between different gods (possibly aliens), all symbolic of the tussle between 'heaven and hell', 'good versus evil', the 'Jedi's against the Sith', as well as many other pairs of opposing forces down the ages. In fact, if St. Michael or Jesus had ever possessed a 'light-saber', just imagine what could have been written of the fight between the sun gods and the devil, or Darth Maul demon figure?

In religious terms, the most famous portrayal of the duals between good and evil, is that of St. George of Cappadocia (Ancient Turkey) slaying the dragon. Similar legends also depict St. Michael (a Phoenician deity), casting the serpent into the abyss. St. George inspired many artists and writers. John Ruskin, the leading English art critic (and artist) of the Victorian era, even founded the 'Guild of Saint George' in the early 19th Century. Many well-known artists were connected to the Guild Orders, not least the Guild of St. George and the Order of the Garter. However, the original source for St. George seems to have been inspired by legends of the 'hairy human' or 'Woodwose' often depicted in religous iconography. The most famous depictions of the 'hairy St. George' can be seen on the misericords of Chester Cathedral (see figure 12). There are also many other depictions of the 'hairy human' (often called the human angel) in other places. The story of King Ursus (Sigisbert VI), who was known as Prince Ursus (or the 'Bear Prince'), between 877AD and 879AD, is one example. The same prince appears on a mural above the font in Wrexham Cathedral in North Wales, and it seems to me, that the hairy human (woodwose) was possibly the original bloodline of the kings on the British Isles.

The 12th Century *Edda*, through the translations of Lawrence Augustine Waddell in his book, *The British Edda* (1929), also describes battles between

Figure 12: George and the Dragon.
The Woodwose or 'hairy human angel' was the precursor of St. George.

different gods, heroes and villains. The *Edda* tells how the son of Indara (whose name was also Miok or Michael), or Thor in Norse-Germanic legend, won victory over the son of the Dragon Queen Hera (El). In the *Edda*, El's son was Balder or Set (Seth) and in Egyptian myth, another name for the sun god Ra was George (who also won victory over El the Matriarch). The battles between Ra and Set are often described as the *War of the Gods* in Sumerian accounts. Fairy tales, like *Snow White and the Seven Dwarfs*, are symbolic interpretations of 'El' and the 'dwarfs', which are symbolic of the elf and troll races said to live

within the earth and in the 'astral world'. Sun gods like Thor, Indra and Ra (proved to be the same figure by Waddell) were depicted holding an axe or hammer, symbolic of the 'House of the Serpent Goddess' and the labyrinth (lower astral worlds), the place where many dynamic battles were said to have taken place. In the *Edda*, Thor is called Zig or Ygg, which according to Sumerian inscriptions translated by Waddell, is spelt Zagg or Zakh. This is said to be the origin of the word Jack or Jacque. Fairy tales like *Jack and the Beanstalk* (*Jack the Giant Slayer*) are also symbolic of the spectacular battles between these sun and serpent deities (energies).

Thor - The Son of the Father

In Norse mythology, Thor is a hammer-wielding god associated with thunder, lightning, storms, oak trees, strength, the protection of mankind, and also hallowing, healing and fertility. In Germanic mythology, Thor was called Uunor (in Old English) and Donar (in Old High German), both meaning 'thunder'. Thor is also Zeus (Jupiter), the god who rebels against his father Odin (or Saturn) to continue the 'order of the gods'. Thor is also Ba'al or Bel, referred to in the *Old Testament*. Ba'al was a god of the Levant and a Jupiter-figure worshipped by the Pre-Christians and the Phoenicians as a 'Christ figure'. The word Ba'al can be translated as 'lord', 'owner', 'master', or 'husband', which referred to a group of deities. Thor is a 'star-sun god' and was worshipped in Egypt (and in Israel) as 'Moloch' and also as the star 'Remphan' (Chiun) to a lesser degree. Thor is the classic mythic hero who saves the day from a long line of saviour gods. He is said to go fishing for Vritra a 'great serpent', which lies at the source of major rivers, seas and power of the oceans; virtually every culture has a preserved memory of a 'thundergod', a towering and tumultuous figure whose modus operandi is generating lightning and the hurling of death-dealing thunderbolts from the sky.

Authors and researchers David Talbot and Wallace Thornhill put forward compelling evidence in their books '*Electric Universe*' (2007) and *Thunderbolts of the Gods* (2005), to suggest many gods, heroes and myths relate to the true 'electrical nature of our universe'. They say,

> *The transitional states of plasma discharge answer directly to the mythical metamorphosis or 'shape-shifting' of archaic gods and monsters.*

Electromagnetic 'plasma' expressed in its many forms (seen from the earth) would have provided our ancestors with vivid imagery and experiences (see figure 13 overleaf). According to Talbot and Thornhill, 'plasma' has reshaped our universe and continues to do so. The movements of planets (wanderers) and electromagnetic forces they interact with could have been seen (like we see the Aurora Borealis, Northern lights) on a larger scale in an ancient epoch. Even within the earth's Ionosphere, we have 'plasma phenomena' called 'elves; sprites' and 'blue jets', which are more 'distant' elec-

© Neil Hague

Figure 13: Battle of the Planets.
Earth and Mars in action unleashing the
'thunderbolts of the gods'.

tromagnetic forces. Lightning is a discharge when too much electricity builds up in the atmosphere, triggering electrical connections and responses at 'higher altitudes' known as elves, sprites, gnomes and jets. The sun and planets are electromagnetic creatures, and plasma is the force that 'drives' the celestials. Plasma can be seen at times due to the impact of solar flare activity on one level, down to the electrical impact of the lightning within the earth's atmosphere. It's not too much of a leap of the imagination to picture forces 'aligning' to create 'giant electromagnetic' upheaval in the solar system. Parallel worlds could also be the source of such energy and upheaval if they came in contact with each other. *Marvel* movies such as *Thor - The Dark World* and the battles between planets such as Mars and Venus (argued extensively within the work of scientist Immanuel Velikovsky), could literally have been seen from the earth! What the ancients saw would have impressed greatly on their minds. So much so, that they may have created gods to preserve such narratives. The deeply 'scarred face' of the Aztec god Xipe (the god of war) and the planet Mars can be juxtaposed. When Mariner 4 took photographs of Mars in 1965, it showed Mars' hemispheric scar called Valles Marineris which is four times deeper than the Grand Canyon, and stretches almost 3,000 miles across the face of Mars. The Grand Canyons on Mars and Earth were caused by celestial upheaval, **not** gradual erosion!

Battle of the Giants
In British Columbia, Canada, and across the Montana plains in the United States, Native American elders talk of a 'white race of giants' who in ancient times, lived on 'White Man's Island' in what is now the Atlantic Ocean.[35] These giants were said to be led by a goddess called 'Scomat', or 'Sheila na Gig', whose people were known as the 'Oak Clan', or the 'Tree People'. The island in this myth has been linked in part with Atlantis, or the Dragon Land, areas which became Ireland after the Flood. In fact, there is a place set in the beautiful waterlands of Lough Erne in Ireland, which is home to powerful sculptures of shamans and Sheila na Gigs, adding gravitas to the original myth. The mysterious land of Scomat appears in the work of Geoffrey of Monmouth in his *Histori Regum Britanniae*, in the 12th Century. Another name for the British Isles was Albion, and a race of giants were said to live

on the British Isles, ruled by Gog and Magog. The same race supposedly fought Brutus of Troy, the first King of Britain.

Albion appears in many legends as a 'giant' or 'god-like' being, inspiring artists and poets like William Blake, especially in his epic poem, *Jerusalem*. Albion is also a symbol for the imagination in Blake's work, an attribute of humanity that elevates and frees us from the restrictions of the physical world. According to astrophysicists, giants, could be the true origin of a 'cosmic human being' (or forces that are unseen to the five senses). William Blake even depicts the 'five senses' as primeval druid-like giants in his illustrations to Danté's *Divine Comedy*. Could a race of giants or gods (living on Albion in ancient times) have inspired what became the widespread druidic religion? Legends of wizards (like Merlin) could have also been connected to earlier myths. There are certainly lots of stories implying geographical connections between white-skinned Celtic clans and red-skinned Native American clans. Apart from obvious similar customs and rituals like the sweatlodge, both ancient Celts and Native American tribes celebrated the same festivals (under different names) and often used the same names for earlier lands (gods) after the destruction of Atlantis. For example, in American Indian mythology, Atlantis and Lemuria were known as the 'Mother Lands'. The Greeks called Atlantis 'Itzamana', which also means 'Dragon Land' or the 'Old Red land'; and 'Itz', a Mayan word, is used to describe a magical substance coming from copal smoke, used to transport initiates into other dimensions. Even Native Algonquin indians use the name 'Pan' for the Atlantean continent, a name also given to the horned goat (dragon god) of ancient Greece. I also feel that the story of *Peter Pan* and *Never-Never-Land* is another symbolic story for Atlantis and parallel dimensions connected to that Golden Era. The Lakota stories of Spider-man, star people arriving in sky boats (space ships); the African (reptilian) Chitauri; the Windigo creatures of Chippewa legend; the Watchers (see figure 14) and the Hopi Kachina race, are examples of 'interdimensional' gods. All probably lived more openly amongst humans at the time of Atlantis and the Mother Lands (Mu).

Figure 14: The Watcher.
A depiction of the 'tree giants'.
Neil Hague © 1995. Oil on Canvas

Watchers, Wizards and Stealing Fire

The general theme of chosen initiates interbreeding with, and being granted Kin (blood) ship, by alien races is recorded all over the world. The story is echoed in ancient myths, not least the Hopi who talk of 'Grandmother Spider', who stole fire (knowledge) from the gods (possibly Anunnaki) and gave it to the chosen few at the end of their Third Age.

In South America, the Jaguar Gods were

thought to be the original owners of fire, who refused to share it with others. Also, in Kayua mythology, the toad and a white rabbit (the dragon and sun deities), steal his fire (symbolic of his knowledge, eyes and powers of seeing). In Navajo myth, it is said that the Coyote (a Trickster god), also stole the flame from the 'giant' fire gods of Atlantis. The coyote, like the jaguar, both get involved with another creature (the anteater), who can take out his eyes and juggle with them. By taking up the challenge of taking out their own eyes, coyote and jaguar (to compete with the any-eater), 'lose an eye', symbolic of the loss of 'true sight'. In Scandinavian mythology, the same theme is echoed with the god Odin (Wodan), who casts one of his eyes into Mimirs Well in return for a drink of wisdom – the sacred knowledge of life. The Adam and Eve story is connected to this myth, as we shall see in a later chapter. Odin was said to gain insight by hanging upside down from the 'Cosmic Tree', which became the image of the *hanged Man* in the *Tarot*. Both stories are symbolic of the vision and knowledge gained from seeing the world from another perspective. Eye symbolism in art (from all around the world) relates to the 'eye of the gods' and the power of visionary sight on one level; on another, it is connected to the 'Eye of Providence' symbolism associated with Orion and Saturn. The eye is also a symbol for the 'microcosm-macrocosm' and much alchemical illustration explains this concept as we shall see.

In Cherokee legend, it was 'Sutaliditis', 'Sulis' (or 'Sun Woman') who held the original 'fire source' and existed at the 'seventh height', the highest knowledge.[36] The Sun was considered a 'cloak' worn by Sutaliditis. This goddess would became the Christian Mary and Indian, Aditi-figure worshipped in caves and at temples built on rocks and near natural springs; and places like Bath and Glastonbury in the UK, are ancient places of worship to the goddess Sutaliditi (Sulis). In his painting, *The Great Red Dragon and the Woman Clothed in Sun,* Blake depicts Sutaliditis (Mary) at the feet of a horned dragon, another symbol for the 'battles' between the sun and serpent deities. Blake's image is an illustration for *Revelation* showing Mary (the Woman of the Apocalypse), with child, about to be attacked by the Dragon (the beast of *Revelation*). Another name for the sun goddess was the 'Grandmother of the Sacred Fire' who was so important that no ceremony could be attempted without her presence. According to Cherokee legend, many attempts were made by the priestly shamanistic clans to ambush (steal) Sutaliditis's sacred fire or flame! This flame is the 'eternal flame' held by the Statue of Liberty and used as a Masonic symbol to represent the theft of light (knowledge) by those in the mystery schools. The Zulu also talk of a Sun goddess called 'Lanaga' (the longing), who was the 'keeper of the sacred fire' and for them, she was the original sun for earth in an ancient epoch, one that was 'taken away' when the earth moved.

The shamanistic clans, or Yunwitsansdi (the Little People), were said to have been aided by 'spirit helpers' in the theft of Sutaliditis's knowledge. According to Cherokee myth, two magicians, one of whom turned into a monstrous horned serpent with a deadly stare, were sent to try and capture Sutaliditis.[37] According to the story, one of these creatures killed Sutaliditis's

daughter instead (symbolic connections to the child of the Woman Clothed in Sun, mentioned in *Revelation*); the other serpent called Uktena, which is similar to the Unktehi of Sioux mythology, became so enraged and dangerous that he was 'conjured upwards' to another plane by 'the Little People'. It is said that Uktena still reside in this dimension, coming forth only for wizards and magicians. The Little People in the story are symbolic of the 'interdimensionals' depicted on temples, cathedrals and cave walls by the shamans who have seen these 'beings'. The 'upper-plane' in the story could refer to the 'Lower Fourth Dimension', a 'frequency' constantly sought in ceremony and ritual by those in the secret societies going back to ancient times. In the end, trying to capture the sacred fire by dark forces, leads to the knowledge (light) 'being lost', symbolic of the 'veil coming down' and what religions call, the 'Fall'.

Similar stories and themes are also found in the *Book of Enoch* and in tales of heroes; of the Greek god Prometheus, who also was said to have stolen fire (knowledge) from the gods, giving it to select humans. I'll come back to the Prometheus story in another chapter as it is connected to much symbolism I want to discuss in depth. Similiar themes of the theft of fire occur in creation stories, myths and sand paintings of the Navajo, showing Coyote 'stealing fire'. In these legends Coyote (the trickster god), like Reynard the fox in European myth, takes knowledge of 'eternal life', passing through the house of the Sun and the Moon, where he delivers fire or knowldege to the house of the first man and woman. The narrative and symbolism associated with 'fox' and 'fire', is where the internet giant Mozilla 'Firefox' stems from. And 'smokeless fire' especially, is connected to otherworldy forces. The same themes are given to the rabbit in Chinese mythology and the Hopi deity, Kokopelli. All of these stories are symbolic of the knowledge taken from a 'higher source' (or advanced beings) and used by elite brotherhoods to create esoteric symbolism and religions since ancient times.

One of the most common symbols for the 'theft of knowledge' from the gods, is the lighted 'Olympic' torch, or the 'Eternal Flame'. It's a symbol still used by a brotherhood operating behind the scenes in politics, banking and the 'pillars of society'. In ancient Greece, the twin gods (the pillars), called the Dioscuri, were often depicted as torch-bearers and in the 'Cult of Mithra' they are known as 'Cautes and Cautopates', who accompany Mithra (the Sun) on his journey through the heavens. The torch-bearers in many cases are representations of celestial divinities created by a brotherhood of 'mythmakers' focusing on the Sun and its movement through the equinoxes. In ancient Greece, the brotherhood were known as the Pythagoreans (or Stoics of Asia Minor), who through their knowledge of the stars, planets and other natural phenomena, created mythical characters to represent the 'division of the celestial equator'. The torch, which was another symbol for the Sun and its passage through the northern and southern hemispheres (depending on which way the torch was held), represents the transference of knowledge from one world age to the next. Like a baton being passed in the 'Games of the Gods', this 'knowledge' (as always), was kept secret by the elite brother-

hoods, the Freemasons and the mystery schools throughout antiquity.

Eyes, Trees & Owls

Eye symbolism can be found in every ancient culture and is linked to the Watchers described in the *Book of Enoch*, who were said to have had eyes like lasers! In relation to the Watchers one text reads:

> *And there appeared to me two men very tall, such as I have never seen on earth. And their faces shone like the sun, and their eyes were like burning lamps.*
> (*Second Book of Enoch* 1:4-5)

Eye symbolism in much religious art represents the 'windows of the soul', the fire (spirit) and the 'eye of the heart'. Eye symbolism can be found almost everywhere in the ancient world; it appears on monasteries, temples, cave walls and religious artifacts, to name but a few. In Nepal Tibet, for example, the eyes on monasteries are representations of the watchful eyes of Buddha – the 'all-seeing god'. In ancient Egyptian art and belief, eyes were symbols of the sun god, Horus, who was said to have lost 'one' eye through his epic battle with the god, Set. The eye in this narrative represents both 'loss of sight' and the 'all-seeing, all-knowing' vision given to elite priesthoods by the gods. Eye symbolism also leads us to the truth that *everything* we 'see' is constructed out of wave forms (light), and 'reality' is deciphered by our brains and influenced by our minds! In the gospel of *Matthew* it is written:

> *The light of the Body is the eye. If your eye be single your body will fill with light.*
> Matthew 6:22

We see everything only because of light and how our eyes are the lenses that can be tricked into 'believing' what we see!

Owls are also associated with eye symbolism and visionary sight. To many indigenous cultures, the owl symbolised 'death' and the 'hidden', 'darker qualities' of nature. Owls are associated with the Watchers and their eyes are symbolic of the ability to see in the dark. In Hebrew lore, for example, the owl represented 'blindness' and 'desolation' and was the symbol of the cruel goddess Lilith, or Ishtar. The Greek goddess of war, Athene, was also said to have owls, along with the goddess Hecate, who was often shown alongside her owls. In her positive mode Athene, Hecate or Minerva was the patroness of arts, crafts and wisdom, which explains once again how knowledge and creative power is 'neutral'; it is the 'intent' behind any symbol that decides the outcome of its use.

The reverence of trees was also expressed in many parts of the world by secret brotherhoods, such as the Druids and the Naddred. J.R.R Tolkien's *Lord of the Rings* is absolutely littered with themes that relate to a very ancient order of magicians. The Druids, like the Chaldeans, revered the oak for its magical ability to attract mistletoe and they became the carriers of the mystery school tradition in Britain, Ireland, France or Britannia; Eire and Gaul.

The Druids also made use of eye symbolism; the Watchers or Titans mentioned in the *Book of Enoch* were often symbolised as trees, due to their height and the advanced knowledge they were said to harbour. Trees in general were used throughout esoteric societies as symbolic carriers of sacred knowledge imparted to the ancients when the gods lived amongst humanity on earth.

In Scandinavian lore it is said the 'Yggdrasil Tree' revealed the Runic mysteries to the God Odin, and in Native Central America, the Mayans climbed the 'Mayan Tree' as a ritual. For the North American Dakota Sioux this tree was the 'Sun Dance Tree' to whom twelve initiates would endure sacrifice to the Sun. In Chinese and Hindu versions of the zodiac, it is called a 'Year Tree' with twelve terrestrial branches from which hang different animals (the constellations). Ancients of the mystery schools were 'initiated' into the knowledge symbolised by the Tree of Life, and many temples can be found to align with the specific constellations of the zodiac, notably Orion. In its most common form it is the Tree of Knowledge found in the Garden of Eden; or the Kaballah (which means abstract tree), the place from where all knowledge comes. However the symbolism is read, it seems that a common theme of 'ordering' and 'imbuing' advanced knowledge (the arts and sciences), around specific gods, archetypes, planets and constellations was practiced globally. The global belief systems that grew out of the Tree of Knowledge, initially through paganism, eventually became the beliefs centred on 'hero gods' and religions set up in their name. It seems clear to me that hero god recycling was an 'art form' performed by priests, who wished to maintain a particular hold on the people at large. The subtle control of the population is done through symbolism, which is the language used to communicate the mysteries.

Symbols are the Sacred Language of the Universe

Symbols, especially within the mystery schools of antiquity, are a device for connecting people to the original archetypes. Ancient cultures used their own rich symbolism to evoke archetypes, energies and specific deities during celebrations and rituals as part of their everyday life. The use of symbolism, to set free or 'imprison' the psyche, is a natural part of our human desire for knowing who and what we really are. Symbols form the ancient language of the gods and can speak directly to our subconscious mind. At an even higher level, certain symbols, like the 'circle' and the 'spiral', exist purely to remind us of our connection with the 'soul of the world'. The ancient language of symbols reminds us, deep within our psyche (our soul), we are endowed with a gift of 'seeing'; a gift we need to utilise. Symbolism of the purest and highest source, which we see but also *feel*, can expand our consciousness beyond everyday reality.

For the Egyptians, the symbol was a scrupulously chosen pictorial device designed to evoke an idea or concept in its entirety. Many civilisations, like Egypt, knew that the heart synthesises and the mind analyses, so their sages devised a 'sacred language' that bypassed the intellect, and instead, spoke

directly to the 'intelligence of the heart'. In this way, true symbolism is a scientific language – a deliberate means of evoking understanding, as opposed to conveying information. Once we focus on these symbols it becomes easier to notice archetypes as they have journeyed throughout history and within 'art movements'. The Symbolist movement, for example, across Europe and America in the mid-19th Century, expressed the same ideology through many diverse painters, poets and writers. The use of symbols and archetypes through art history hardly gets talked about in schools and colleges. But they should be talked about! They are more important than the actual artists themselves.

The Circle

Obvious examples of power symbols are the circle and spiral, which appear throughout indigenous native art. The circle is a symbol of oneness, unity and represents the wholeness inherent in all life. To indigenous cultures the circle was more than just a pattern or shape, it also represented the power and knowledge of how the universe creates, evolves and changes. The circle reminds us of 'patterns in nature', through to the life patterns within ourselves. We are all circles, the world is also a circle, which constantly reflects our state of being (awareness). In its simplest form, the circle is made up of two parts: the inner, which is who we are, and the outer: which is the world around us; the inner is our 'personal world' and the outer is symbolic of 'what influences us'. It's our job as both 'spirit' and 'matter' to *expand* our consciousness beyond the rim of the circle separating us from the rest of creation.

Circles, domes, ovals, spirals, squares, labyrinths and pyramids are a few examples of symbols containing knowledge used for creating the foundations of communities, religious beliefs and even governments. All our modern councils, including the more clandestine global bodies, are modelled on the use of ancient archetypal symbols, like the circle. However, these symbols hold a deeper, mysterious and more spiritual significance to our native ancestors. Throughout history (over many thousands of years), cultures evolved through the use of science and creativity to develop profound systems of knowledge. Through dreams and inspiration our ancestors forged links with either 'positive' or 'negative' versions of the 'original archetypes' and symbols. For example, the priesthoods of ancient Babylon, through their ceremonies and rituals, linked to other dimensions (and what lived in those dimensions); knowing our fears and weaknesses, the priests proclaimed themselves the 'fathers' of what we know now as (organised) religion. These 'founding fathers' then set rules, drew up calendars, stole time and twisted the true meanings of certain symbols so to assert control over the populace. Conversely, native tribal people from Alaska to Australia maintained within their lives a 'perception' of universal symbols being intricately woven into the structure of all life. In other words, the symbol was not used to abuse power, but to celebrate it in its application towards a better comunity or tribe. This idea was summed up well by the Oglala Sioux medicine man, Black Elk,

when he said:

> *You have noticed that everything an Indian does is in a circle, and that is because the power of the world always works in circles, and everything tries to be round ...The sky is round, and I have heard the earth is round like a ball, so are the stars. The wind in its greatest power, whirls. Birds make their nests in circles, for theirs is the same religion as ours ... Even the seasons form a great circle in their changing, and always come back again to where they were. The life of a man is a circle from childhood to childhood, and so it is in everything where power moves.* [38]

Celebrating the circle by *seeing* it expressed through the natural world gives humanity a deep sense of its own creativity. The circle is the archetype that inspires us while asking us to value the 'mysterious' side of reality. I will dedicate a whole chapter to this understanding later in the book.

The Spiral

The spiral is also a circle to which the dimension of time has been added. It is a symbol that embodies the movement of galaxies, stars, moons and suns (captured brilliantly by Van Gogh in his work *Starry Night*), to the life force in our DNA. For many ancient cultures, like the Hopi for example, the spiral represented both a spiritual and physical journey and was used to explain migration. The spiral can also describe the microcosm for our individual soul movement or personal creativity as we journey through life. For artists like Van Gogh it was how he saw the stars move, while accessing his 'inner' sight. The spiral represents the 'motion' and 'evolution' of the universe, consciousness, cells and even hair growth (see figure 15). From a wider perspective the spiral can symbolise eternity, as it turns forever experiencing itself.

As a power symbol the 'mystical spiral' often appears as a protecting serpent or dragon, which coils around the 'World Tree' or 'World Mountain'. This is the same Tree of Knowledge the initiate has to 'climb' (like Jack up the Beanstalk) to enter into different levels of awareness. The spiral also forms

Figure 15: Spirals (As Above, So Below).
A view of our galaxy compared to hair growth and a typical native depiction of the spiral. The spiral is a symbol that can aid us in 'seeing' how nature finds its natural home in geometry and higher-dimensional space.

the 'mountain of Purgatory' that Danté (in his work, *Inferno*) and Virgil, climb as they ascend out of hell. I will go into the spiral symbolism in more depth at the end of the book, suffice to say here, it is symbolic of the quester's journey out of darkness and into the light.

The dragon coil, or spiral, can also be seen carved and painted into many ancient works of art. One particular Indian myth illustrates how the sun god, Vishnu, devises a plan to preserve 'cosmic order' by insisting on the cooperation of demons to activate the universal opposing spiralling forces of creation. The demons and gods thus haul the cosmic serpent, which is wound around the world axis, turning the 'Milky Ocean' producing immortality. On another level, this story relates to the creation of 'opposite forces', 'duality' and the world as an illusion (trapped in time). In this sense, the spiral becomes the coils of manifestation, the Veil itself we need to 'see through' if we are to find our truth - our inner self.

The Labyrinth

The spiral is also represented as a labyrinth by many ancient cultures, the earliest known is said to be in Egypt, which is dated to 19th Century BC. However, labyrinths can be seen on the plains of Nazca in Peru and according to researchers like Maurice Cotterell, they are another symbol for the sun, its light and the cosmic cross. The labyrinths in Minoan Crete, to the rock engravings of Palaeolithic times, are all reminders of our human preoccupation with the hidden order of the cosmos. The symbolism of the labyrinth is one of the inner cosmos, which could also be seen as the 'individual life', 'the temple', a 'town' and the 'womb' of the 'mother archetype'. Some say the labyrinth is a symbol for consciousness as it journeys through the maze called life. At Chartres cathedral, in France (which was a huge druid centre), a labyrinth can be found built into its floor. The labyrinth in this context is symbolic of the spiralling development of consciousness, or the 'revealer' and 'concealer' of the cosmos.

The ideas of initiation within inner chambers, secret groves and 'masonic lodges' (temples), are all symbolic of that hidden knowledge (contained within the labyrinth). The labyrinth is a symbol for the 'breathing cosmos' for anyone who decides to 'go within' and confront their innermost being. Like Theseus facing the Minotaur in Greek legend, the labyrinth is symbolic of facing our own fears on the journey to our inner self. In terms of art and art therapy, one of the many archetypal images that constantly appear are the spiral and the labyrinth. Jung after years of research wrote:

> ... *we can hardly help feeling that the unconscious moves spiral wise around a centre gradually getting closer.*

In the Minion legend of *Theseus and the Minotaur*, it was Ariadne's golden thread, whose windings created the world and enabled Theseus to escape from (or to unravel) the Labyrinth. We too, can 'unravel' the clues, mysteries

and hidden knowledge of life by embarking on our inner journey, to the centre of our heart. William Blake explains how the 'thread' or 'clue' when followed, can lead us to our centre, to the innermost point of our being. He wrote in his poem, *Jerusalem*:

> *I give you the end of the golden string,*
> *only wind it into a ball,*
> *It will lead you in at Heaven's gate*
> *Built in Jerusalem's wall.*

The labyrinth is symbolic of the Web of Life when associated with Ariadne's thread, and the creator within is the 'spider' or 'weaver' at the centre of our web. In its reversed form, the spider becomes the predator (the Minotaur), or the destroyer of life. In Persia and Rome, the Gorgon was often depicted at the centre of the zodiac on coins dated between 253–60 AD.[39] The Gorgon was another symbol for the reversed (negative) nature of our 'inner power' which can be used to destroy life. Entering the inner worlds of our being, while testing our endurance (our knowledge), is symbolic of 'journeying' within the labyrinth of the soul. The Dervish spiral dances performed by Sufi mystics of Islam, are also symbolic of that guiding, spiraling energy. On a higher level, the labyrinth is a two-dimensional vortex representing our winding (wandering) through space and time; or our journey into many different worlds of the soul.

The Pyramid
The pyramid is another powerful symbol that explains the 'structure' of our society. Like the circle, the pyramid has very obvious ancient, esoteric roots to Egypt and beyond. It is a common symbol found in many ancient civilisations, the most famous of which are the pyramids of Egypt. Even though the pyramids of Giza are the most commonly talked about, the biggest pyramid found is the Great Pyramid of Cholula - an ancient Aztec temple in Puebla, Mexico. It has a base four times larger than Giza's Great Pyramid of Khufu and nearly twice the volume. Pyramids all over the world continue to baffle 'the experts' and engineers in terms of how they were physically built. Pyramids are the epitome of 'science and art' and symbolically speak of 'power' and how power (energy) can be harnessed to do great work. When pyramid knowledge is used creatively but for 'negative' reasons, it becomes a vehicle for secrecy, compartmentalisation and control.

The attunement to symbols like the pyramid, broadens the whole understanding of not only art, but also our history in general. If, for example, we consider art as a 'manifestation of energy' we can look back on our ancestors' art and see two forms of expression taking place continuously. The first expression is the artist who uses 'form' for its own sake, like the pyramid. This expression is more about the love for 'formula' rather than spontaneous creativity. Another example of this is what has been described as Classical

Art. The second type of expression the artist uses is form to 'express emotion' or 'states of being', and *not* form for its own sake. Children fit into this category of artists who express the energy of 'feeling' very easily. Gothic structures are examples of this type of art too, with their thin, drawn-out, almost organic-like shapes that twist and reach up to the sky. Gothic art belongs to the 'unconscious', while Classic art belongs to the conscious realm - the rational construction of beauty. Both these archetypes, through art, have much in common. They utilise a primordial symbolism, a 'sacred language' used by the ancients. It is worth remembering that what we call 'art history' is really the struggle between these great psychological types; sometimes between artists, sometimes between schools or movements, but more commonly between the nature of a single artist. Importantly, both art types have helped fashion how we view the world. How we imagine, through shaping, conceptualising and creating, is important in helping us understand more about our place in the world and how we see our past, present and future. John Berger in his book, *Ways of Seeing* (1972), also writes of the importance of being able to see through the medium of art, liberating our fears of the present; thus demystifying our past. He writes:

> *When we see a landscape, we situate ourselves in it. If we saw the art of the past, we would situate ourselves in history. When we are prevented from seeing it, we are being deprived of the history which belongs to us.*[40]

In many ways both history and art are being mystified by the same privileged elite (most of whom own all the great works of art), while designing a history to justify their role as the ruling classes. Art schools all over the world perpetrate the biggest crime by presenting art, and its history, to students as if it is something that has no bearing on who they are as individuals. Art students are encouraged to make art from the 'head' and not from the 'heart', and far too much 'modern art' falls into 'intellectualising', almost a shallow self-indulgent process. When the dogma called 'self-expression' takes precedence over the imagination, symbolism and the more profound forms of communication are lost. Art as a spiritual device is hardly ever considered and by limiting art history to groups of individuals and how they affect one another, has created a 'hierarchical bloodline' (timeline) of image makers which make the rest of us look like 'outsiders'. The term 'outsider art' is exactly that! On another level, 'artist-worship' as I call it, is society's deeper attempt to recognise the spiritual leader or shamanic role of the artist. If we take on a spiritual role as individuals, through using any art form, we too, can demystify the past, present and future for ourselves. The use of symbolism in prehistoric art through to canonic architecture tells us much more than we know about our history and the current structures of today's society. Artists since ancient times have often endeavoured to make public the 'hidden', the often forgotten symbolic language of the gods.

Symbols Through Art & Gnosis

The history of art is filled with records of mankind's attempt to express the 'absent' and the 'transcendental' through symbols. Intimate relationships between symbols, spirituality and religion are found all over the ancient world, from the tombs of the Egyptians to the Renaissance paintings of Europe. In Ancient Egypt and Mesopotamia for example, stonemasons inscribed statues of priest-kings and noblemen with the names of their owners believing that the statues would provide eternal resting places for the spirits after death. The Minoan civilisation of Crete and the Celtic courts of Ireland, also made extensive use of spirals, wavy lines and geometric icons on tombs, pottery and metalwork. Many of these symbols, which represented the sea and the elements on a physical level, were also expressions of the relationship between humanity and the cosmos. As we have already seen, the spiral was not only regarded as a talisman to ensure safe passage for travellers on the land or by sea, it also held profound meanings for many ancient cultures. The spiral expressed their understanding of life, their spiritual journeys, their evolution, their timelessness and the passage of time itself from a much wider perspective.

In ancient India and the Near East, certain symbols were believed to hold visual power that could alter consciousness. This I believe to be a major character of symbols in art, whether they offer a Christian viewpoint or special part of a tribal ritual, they come from the same source of energy. Erotic couplings of Hindu gods for example, symbolise the diversity of creation through fertility and sexual union. Landscapes and the natural world are also full of highly potent symbols. Every part of the landscape symbolised an aspect of mankind. In many tribal goddess cultures, for example, water was considered the blood of the mountains; grass and trees, their hair; caves, the womb; clouds and mist, their clothing. Mountains to the ancients were symbolic of the spiritual height we must climb to be closer to the Creator. On another level, shamanic landscapes (a term coined by the researcher Paul Devereux) also exist all over the Americas in the shape of effigy mounds, geoglyphs and abstract, geometric patterns on the Earth. The 'seven liberal arts' (or what is known as sacred geometry), practised by the ancients, was part of an advanced knowledge understood by the many mystery schools that evolved in prehistoric times. The skies were also full of 'signs and symbols' for our native ancestors. In civilisations like Egypt, South America and what is now Cambodia, star maps and specific constellations were copied with mathematical precision onto the earth. These places were marked by pyramids, temples and monuments, even scraped into the surface (as we have seen with the Nazca lines of Peru) all across the ancient world. Gothic cathedrals were designed by brotherhood initiates, high-ranking priests and secret fraternities (the Knights Templar), who also had access to the knowledge of 'symbols' and 'sound' (acoustic resonance). Manley Palmer Hall, in his book, *Masonic Orders of Fraternity* (1950), explains how the builders of temples and cathedrals were bands of wandering craftsmen who never mingled with other people. Instead, these builders and craftsmen enjoyed extra-

ordinary privileges, being priests and monks themselves, and they created an apprenticeship system of 'secrecy' which protected their knowledge of art and geometry. I would go further to say that the master masons, and higher ecclesiastical hierarchy, were actually artist-magicians who practised ancient forms of sorcery; evident when observing the art, sculpture and architectural detail commissioned by these fraternities. Of the 'brotherhood' of artists, Hall says:

> *Thus it came about that the early Church employed pagan artisans or those of doubtful orthodoxy when some elaborate structure was required. So great was the power of these builders' associations and so urgently were their skills required that it was deemed advisable to ignore religious nonconformity.*[41]

It is quite obvious that the master craftsmen behind the temples of organised religion were secretly worshipping their own Pagan deities, all rooted in Gnosticism and Manichaeanism; while offering the public another version of Paganism called Christianity. Gnostic and Manichaen sects emerged in the formative days of Christianity and were persecuted as heretics by the Orthodox Church. The burning of the great library at Alexandria was a deliberate attempt to destroy the evidence of Gnostic belief. As I will show in a later chapter, the Gnostic texts not only oppose more orthodox doctrines, they offer insight into the true nature of reality. Gnostic and Manichaen beliefs surfaced again in 11th Century France with the Cathars, who tragically, were destroyed by the orthodox Roman Catholic hierarchy (see figure 16). Saint Augustine of Hippo (354-430 AD), the father figure of Christianity, was publicly accused by leading Gnostics of involvement in Pagan Manichaen rit-

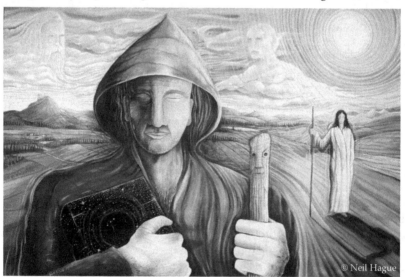

Figure 16: The 'Gnostic Cathars' of France.
The wandering Cathar priests (many of which were women), taught gnostic beliefs about 'duality'; that people should live a simple life with no posessions. Their motto was: 'be perfect'; hence, why they were often referred to as 'the parfait'.

uals.[42] Priests, like Augustine, and other `artist monks' who drew up the plans for temples and cathedrals, understood how esoteric symbols can change, alter or manipulate the human psyche. To the masons who built the cathedrals they were considered 'books of stone', teeming with esoteric symbolism. Their stone narratives spoke of duality and correspondences – an ancient magical form of cognition (also used by alchemists and the Masonic Orders).

The high-ranking Freemason, Baron Emanuel Swedenborg (1688-1772), used principal symbols in his mystical philosophy, which would go on to inspire artists, poets and other Theosophical groups. 'Correspondences'[43] considered the mystical union formed by the sun (king), the moon (queen) and the star (Holy Spirit), a 'triangle template' that has been used in most alchemical or religious doctrine. We can follow the sun/moon, king/queen, masculine/feminine, left/right thread in many esoteric areas. The great cathedrals of Europe are steeped in symbolism refering to Correspondences and duality; many of which have 'twin towers', representative of the solar-lunar relationship to Earth. This relationship is also referred to as the 'Alchemical Wedding' and how the Sun and the Moon appear to be the same size from the surface of the Earth. The ratio used by astronomers and geometers to calculate this Correspondence is 3:11. This ratio translates to 27.3%, which can be observed by noting how long it takes the Moon to orbit the Earth: 27.3 days. At the same time, the Sun's average rotation period of a sunspot cycle is also 27.3 days. It's a 'celestial synchronicity' that seems to defy any natural occurrence on earth, apart from knowing that the dimensions of the Great Pyramid at Giza also fit within the perfectly constructed earth-moon relationship. When geometers have drawn 'moon to earth' based on this ratio of 3:11, the resulting geometry is the 'circle squared' (see figure 17). The unique system of measurement is achieved by taking the centre of the Moon (as a circumference) and drawing a circle that is equal to the perimeter of the 'Earth Square'. The ancients understood this relationship and hid it in the definition of the mile.[44] Esoterically speaking, artists like Da Vinci and William Blake used Correspondences many times within their art. Da Vinci even

Figure 17: The Circle Squared.
The geometry of two circles (in the diagram above), is exactly the same ratio of our earth and moon: 7920:2160 miles. And the geometry of the pyramid, created out of the earth and moon relationship, is exactly proportionate to the Great Pyramid at Giza.

said: "The face [a circle] forms a square in itself." In one illustration by Blake, for his poem *Jerusalem*, he depicts the sun and the moon separated by a third central figure, who places 'Masonic-style' compass dividers (the triangle/pyramid) on the earth. In this image we are being told about sacred geometry (earth measure) and the secret societies that designed and built the great temples. Blake also lived through the period in which Swedenborg's work (and theosophical, clandestine groupings) were being published.

Towers, Columns and Trees

Through skillful manipulation of perspective, the towering steeples of many cathedrals, like Chartres in France, were often made to *appear* higher and nearer to the 'creator gods'. On another level, the towers and columns can be seen as symbolic representations of various worlds constituting a mystical view of the universe. Chartres Cathedral in Northern France (a place I have visited many times), has a plenitude of sculpture representing ancient sun and moon symbolism. The Cathedral is a 'book of stone' containing knowledge about the stars (astrology), mythology, demons, and Pagan deities; in a quite elaborate and deliberate manner. For example, the West Towers of Chartres (which were the first to be built), display sun-moon and masculine-feminine principles. Facing the west, the left-hand (north) tower is 365' high, while the right hand tower is 28' shorter in height. The left tower can be seen to represent the number of days in a solar year, while the 28' shortfall of the right tower, represents the number of days in a lunar month.[45] One cannot help but see that the foundations of Christianity (like all the major religions), have at their core, symbols, myths and the many gods originating in Paganism; inspired by earlier advanced civilisations of Sumeria, Atlantis and Lemuria. The multi-horned headdress of the Akkadian sun and water gods depicted on cylinder seals dated, circa 4000 BC, are remarkably similar to the spiked steeples later used in the architecture of Gothic cathedrals. These huge effigies of worship were an attempt to formalise and contain Pagan beliefs, so to 'centralise' religious **control** over a diversity of pagan spiritual beliefs, which is why cathedrals and churches, like much earlier temples, are littered with Pagan symbolism. The patrons and secret society networks that built Europe's finest cathedrals, were worshipping their own deities rooted in Paganism. The columns and pillars in most cathedrals are meant to be symbolic of the giant tree trunks of ancient forests and groves, viewed as temples by native peoples (Pagans) and the secretive druidic orders that created these buildings (see figures 18 and 19). Architect, Antoni Gaudí illustrated this knowledge perfectly with his designs for the Sagrada Famíllia Cathedral in Barcelona with its obvious 'forest of columns'. Many more examples show there are two types of knowledge operating through much religious symbolism, one for the initiated eye and ear, and another literal account purposely designed for the masses to swallow!

Searching through common themes in 'Western art' we find recurring subjects in the work of artists and craftsmen, all of whom lived at different times and in different countries. What becomes clear through reading about the

Figure 18: The Giant Redwood Groves of California, USA.

Figure 19: The interior of Rouen Cathedral, France.

I have always found it remarkable how sunlight filtering into a cathedral can give the same effect as sunlight entering the forest and groves of the ancient world.

subjects and symbols in art, is that the most ancient forms of 'seeing' were a gradual attempt to unravel and rediscover our connection with the creator. The language of symbols is ancient; it is a form of communicating with 'higher dimensions'. Of course religion has played a major part in providing artists with subject matter, but more often than not, the State, or pervading religious hierarchy, has 'dictated' this subject matter. Amongst all the various types of canonic imagery, one finds symbols, clues and subjects that speak of a hidden knowledge which can be traced back to ancient times. What all symbols have in common is their ability to 'unlock the hidden', the 'secret' and, in some cases throughout our dark history, the 'forbidden universal language' of all time. Symbols can also speak to us on different levels; in their purest form they speak of ancient truths, while lifting the veil that prevents us from knowing our divine origins. The following quote is from the *Gospel of Saint Philip*, echoing this point about the power of symbols:

> *Truth did not come into the world naked, but it came in types and images. One will not receive the truth in any other way... The bridegroom must enter through the image into truth.*[46]

As we search for our own truths, reflecting on the tapestries in time that formulate our history, it is worth remembering that *his*tory is only the making of someone else's story, or experiences. And it is usually the conquerors and not the conquered who write the official storyline. Symbols through art act as an original mark, sign, or statement helping us to see behind the smoke

screens of officialism. There is a spiritual side to all art, and by spiritual I don't mean religious - the two are not the same thing. Religions have always 'used' the creativity of artists to present archetypes (narratives), communicating esoteric views of a particular church. All 'organised religion', through hierarchy, has offered a 'perverted' view of spirituality over the centuries. I will give you one example. Today in the 21st Century, we still have images and sculptures of a dying 'man' nailed to a cross, which in my opinion signify only the negative, perverse and the opposite message of what this man is reputed to have wanted humanity to achieve. At this point it does not matter whether you believe if these saviour gods existed or not, it is the effect of the imagery that is important. So why present such a torturous and brutal image to the world? What kind of effect does it evoke, especially in children? In my view, this imagery has generated deep within us much guilt, fear, sadness and the emotional garbage known as 'original sin', so much so that over the centuries we have come to fear being the rebel, the healer, the artist and teacher of our own individual paths. What all religion has done, often through fundamentalist attitudes, is to create a single, centrally-controlled view of how we 'see' the world. Historically, this view was imposed (often brutally) on alternative cultures that happened not to see the world in quite the same way. Through elaborate architecture 'spirituality' was 'formalised' (merging Pagan beliefs with the so-called `new religion': Christianity). In other words, all beliefs were placed under 'one roof'.

For a long time, we have rarely been given the opportunity to know the world as our ancestors knew it and, even though more and more holistic views are now available, people still 'buy' into dogmatic belief systems. The new Age is full of them, too. I personally do not have a problem with what anyone chooses to believe, so long as that choice is reciprocated in kind and I am granted the same respect. However, this is not always the case, especially when so-called `independent' institutions (like the BBC) give no-questions-asked free air time to 'orthodox religious' views within their programmes. I don't know about you, but I have always found it a disturbing idea that there is supposed to be some cloud-riding God up in heaven, who can't quite make up 'his' mind (always male) on which religion he wants his followers to believe. Could it be that all the seemingly different religions have one thing in common - a 'desire to frighten' and 'control' people's minds? I would suggest so! Is there really any difference between strict Roman Catholic Nuns pressuring and frightening small children into believing a certain doctrine, or a Muslim Cleric using fear, guilt and pressures of the family to enforce certain beliefs? No. In the end it all comes down to *control*, which is the opposite of allowing freedom of thought and respect for others' beliefs.

I believe art in its purest form can help us to nurture our own truth, thus seeing our own way through the jungle of limitations created to clutter our minds. Contact with cosmic forces, or what can be perceived as some almighty Creator, has to be an individual experience and not necessarily through some 'biblical middle man'. For me, the very thought of lumping

everyone under a particular belief system is always repugnant and sterile to the creative heart. Spirituality, like painting, needs to be a personal expression of our inner self, or what has become known within the self-help movement as the `I' – our multidimensional persona. In simple terms, `I' is for 'imagination' and how we *imagine* (shape our world).

Seeing and feeling are part of an ancient language which gives us the *'insight'* to look 'beyond' the everyday world. Symbols encourage us to see with our imagination and to formulate individual beliefs. Why take on somebody else's story or version of the Creator and make it your own? If we are inclined to journey spiritually, why not experience the Creator *within* for ourselves? Why take somebody else's word for what is unique to everyone? Symbols have also been used to hide truths and create belief systems, something I will look at shortly. In the next few chapters, I want to explore the hidden worlds of spirit, symbolism and how we can create our own unique language of the soul. The purpose of any 'weaver' or 'creator' is to do just that. To be able to really know more about ourselves, we have to let our imagination run free, interact with nature and connect with the universe. Most of all we must desire our freedom to create and think as we see fit, while respecting others' rights to do the same. When I have lectured on art, I like to tell students that it is good to discover historical artists, but it is more important to get to know your own soul and the archetypes that move within us all. This process of soul discovery is at the core of creating a web of diversity through our own personal mythology and symbolism, as it was for our ancestors. I believe we will transform how we see this planet and the structures we hold so dear to us only when we discover our unique mythology. Let us now turn ourselves 'upside down', 'close one eye' (in shamanic terms) and look at some of the illusionary structures preventing us from accessing our 'ancient eyes'.

Sources:

1) *No Quiet Place*. Pickpockets Press. No 13. 1993.

2) *Navajo - Walking In Beauty*. Chronicle Books.USA. 1994. p17

3) Cotterell, Maurice; *The Lost Tomb of Viracocha*. Headline Book Publishing. 2000. p47

4) In the Hopi Story of Creation, like the Mayan and Aztec myths, four known worlds are said to have existed on earth. Hopi, *Following The Path Of Peace*. USA 1994

5) Allen, Paula Gunn; *Grandmothers of the Light*. The Women's Press. 1992

6) Zolbrod, Paul G; *Diné Bahané*. University of New Mexico Press 1984. p48.

7) Bryant, Page; *The Aquarian Guide to Native American Mythology*. 1991 p140

8) *Way of Peace, The Hopi*; Chronicle Books. 1994. p12

9) See the 30 years of work and the book *Secret of the Desert* by Maria Reiche, German Geographer & Mathematician

10) Allen, James P., Peter Der Manuelian. *The Ancient Pyramid Texts*, 2005. p.70, Utt.261

11) Translated from the *Tewa* by Alfonzo Ortiz. Source:
www.geocities.com/SoHo/Museum/4786/P455-457.htm

12) Doctors in India have removed two horns growing out of a woman's head. The 40 year-old still has two other horns protruding from her scalp. See source: www.ananova.com/news/story.php?datafile=sm_375920.insdat&menu=news.scienceanddiscovery

13) The earliest official records of these creatures were made by a German Captain - Baron Von Stein Zu Lausnitz, prior to the First World War, in the swamps of the Cameroon. Cited in: Baigent, Michael. *Ancient Traces.* 1998. p60

14) Daniken, Eric Von; *Arrival Of The Gods*. Element Books. 2000. p74

15) See the article *Wing Makers* in *Nexus* April 1999 for more information on these artifacts and the cover-up, code name *Ancient Arrow*. *See* also the website. www.wingmakers.com

16) *Popol Vuh;* Cited in *Fingerprints of the Gods*. 1995. p167

17) Red Star, Nancy. *Star Ancestors, Indian Wisdomkeepers Share the Teachings of the Extraterrestrials.* Destiny Books. 2000. p113

18) Hancock, Graham; *Fingerprints of the Gods*. Century. 1995. p48

19) Information about the Sumerian Tablets are from the Zecharia Sitchin series of books collectively known as the *Earth Chronicles*. Published by Avon books.

20) The Hopi also talk of flying ships that could travel great distances in a short space of time. *The Book of the Hopi*

21) Hancock, Graham & Faiia, Santha. *Heaven's Mirror, Quest for the Lost Civilisation.* Channel 4 Book. 1999. p316

22) Collins, Andrew; *The Ashes of Angels, the Forbidden legacy of a Fallen Race.* Signet Books, London, 1997. p268

23) Pinkham, Mark Amaru; *The Return Of The Serpents Of Wisdom*. (Adventures Unlimited). 1997. p41

24) Danté 51, Inferno; *The Six Footed Serpent Attacking Angolo Brunelleschi.*

25) Hancock, Graham; *Fingerprints of the Gods*. Century. 1995. p57

26) Bouly, RA; *Flying Serpents and Dragons, The Story of Mankind's Reptilian Past.* The Book Tree. p187

27) *The Oxford Illustrated History of British Monarchs,* 1988. p79

28) Article: Victory is in the blood for 'aristocratic' Republican. *The Guardian*. 6th November. 2000

29) *New Larrouse Encyclopedia of Myth*. 1935. p 437

30) *The Sacred Symbols of the Maya*. Thames and Hudson. p71

31) www.dailymail.co.uk/sciencetech/article-5535565/Ancient-Peruvian-child-sacrifices-treasures-uncovered-tombs.html

32) Hancock, Graham. *Fingerprints of the Gods,* Century. 1995 p107

33) Baigent, Michael; *Ancient Traces*. Penguin Books. 1999. p159

34) Berlitz, Charles; *Atlantis The Lost Continent Revealed.* Macmillan.1984. p149

35) Allen, Paula Gunn; *Grandmothers of the Light*. The Women's Press 1992. p49

36) Ibid, p85

37) Ibid, p89

38) McFadden, Steve. Words spoken by Black Elk (1863 - 1950). *The Book of Native American Wisdom.* Element Books. 1994

39) Ulansey, David. *The Origins of the Mithraic Mysteries*. Oxford University Press 1989. p119

40) Berger, John; *Way Of Seeing*, 1972. p 11

41) Hall, M. P. ; *Masonic Orders Of Fraternity, The Adepts (part 4),*The Philosophical Research Society, Inc. Los Angeles, California. p13

42) Ibid, p64

43) A 'correspondence' is a close similarity, connection, or equivalence. There is a simple correspondence between the distance of a focused object from the eye and the size of its image on the retina.

44) Martineau, John. *A little Book of Coincidence*. Wooden Books. 2001. p30

45) Deveruax, Paul; *Encyclopedia of Ancient Earth Mysteries*. Cassel 2000. p44

46) Fontana, David; *Symbolism*. Pavilion Books. 1992. p5

Shadow Walking
Seeing Through Illusions

"The worst realities of our age are manufactured realities.
It is therefore our task as creative participants
in the universe to re-dream our world.
The fact of possessing imagination means that
everything can be re-dreamed.
Human beings are blessed with the necessity
of transformation."
Ben Okri

Every aspect of our lives is governed by what we perceive as reality. All schools of thought become reality for us when we choose to foster a particular mindset, be it educational, political, economical, religious, and so on. Some would say this is a natural state of the mind, a part of being human. If this is true, what category of the mind does the 'individual' fit into, someone who casts aside the various off-the-peg beliefs, to forge a more open mind? Individuals who come along and challenge thought, the system and traditional views, are they not expressing another human trait, one that is based on individual 'vision' and exploration? History has shown us that we either follow or kill those individuals who offer us their vision, especially when they challenge the pervading status quo. The followers usually create belief systems in the name of their visionary and those who are killed become icons, leaders or often, a god of some description. All humanity (save a minority of cases) likes to take other people's theories, opinions and doubts and make them their own. Yet even though we do this, surely it is nonsensical to take someone else's 'word' for what is unique to every individual? As a creative individual, I have come to prefer experiences born out of my 'creations' for providing insight into who and what I am.

As an artist and teacher, I have also found there is much talk and theorising expounded by specialists, most of whom are addicted to 'logic' and 'abstract' notions, that can only hinder development of self knowledge. I believe that this self knowledge comes through the ability to find our own visions, through one's own imagination. We are discouraged by many aspects of a 'grand system' to think differently and not to challenge the system we inherit. Even when we feel intuitively that some other version of the truth may be the one for us, we fight it, even rationalise it because we've been encouraged to do just that in the collective human mind. At the same time we unknowingly prevent others from discovering themselves, by policing each

other's thoughts while demanding everyone else conform to the so-called `norms' in life. But what are these norms? They are the shadow realities, the institutional 'phantoms of the mind', which are followed, quite often blindly and without question, in all areas of our lives. They are the `programmes' set by a system that creates rigid beliefs, imposed quite often through fear and indoctrination, with only one real directive: to keep us from knowing who we really are. Instead, we are *all* conditioned to see the shadows, the reflections of who we really are, as the real us.

According to ancient belief, the 'shadow' was an expression of the base desires in all life and it was associated with the dark deeds and cruelties people have inflicted upon each other. The shadow realties I will be illustrating in this chapter are based on an ancient understanding of the Web of Life and how it can be manipulated to limit the imagination. Who or what is doing the manipulation lurks in the shadows and, having a predator's mind, wishes to keep humanity as a `shadow' of its true self. In other words, the Web of Life (the world we experience) can become a self-imposed trap, an illusion that we all pay homage to by the way we see, think and therefore, act.

When we choose to look behind the façade of the system we call 'normal' life, it becomes possible to see the puppet masters, the hidden hand, (the pied piper archetypes) which manipulate our thoughts and emotions. At a much higher level, we have created a collective thought form that pipes out a belief system promoting 'limitation' in all its forms and we've been dancing to the same tune for a very long time. Like the pied piper, the system we have created can lead us away from looking at who we really are, and therefore, finding out what we can do to create a different reality. Some will say that they are happy with the world as it is, but is it really a sane, loving and free world we are living in? To answer that question all we need to do is look around us, at the global chaos, terror and uncertainty that we call daily living. In many ways we have convinced ourselves that this world is sane, and that the sacrifices and limitations we endure are the only way to live. We then sing this song to our children, as loving parents do, whose children sing it to their children and the conditioning goes on from generation to generation. In reality, we are part of that Web of Life and therefore we are also the creators of the illusionary `norms' and limitations we call daily living. How we see through these illusions depends on how we continue to fashion our children's future. In this chapter, I look at some of the illusions, where they come from and how I feel we can break free of them.

Mind-Forged Manacles

For hundreds of years we have been conditioned to rely on the expert's view, be it scientific, economic, political or in the form of a religious leader, to provide orientation, definition and purpose in our lives. In extreme cases some of us give our creative power away every day to all of these structures. This state of mind might as well ask others to paint our pictures, sing our songs and dance our dances, then again many of us do just that. At the same time we are constantly given limited views of how to see the potential in life by

the same institutions that dictate to us a very narrow understanding of the universe. The main reason has been to hide from us the truth and knowledge of how creation actually operates, that we are also co-creators who can shape the world of illusions to our liking. In all cases, both orthodox religious and establishment scientific schools of thought are part of the same mentality. Both camps rely on the 'suppression' of alternative knowledge that would otherwise dismantle the very structures they uphold. Both 'religion' and 'science' have nurtured what I call the 'fear-of-death' culture, when in actual fact, if we consider our ancestors' lives through their beliefs, their art and ceremonies, they were in 'awe' of the mysterious aspects of life and death.

Science denies there is a soul, while religion promotes the existence of the soul (in its own liking); yet both have no real evidence to prove either theory. Being told you are a 'sinner', or that you are a 'slab of meat' with no eternal qualities, is so at odds with the esoteric systems of knowledge practised by our ancestors. The mysterious sciences employed by the ancients to build great works of architecture (intricately reflecting the patterns of the heavens), came not from fearing death or through the science of limitation. Instead, our ancestors from the collective amnesia point called 'pre-history', to the time up until the temple culture began (around 3000 BC), celebrated the 'power of creativity' through the fusing of art and science (magic). Ancient art of this kind was utilised to 'see' into other dimensions.

It was from the 3rd Century BC that we saw a rapid decline of the great 'fathers of science' and Greek civilisation that was probably the most advanced for its time. This was the period on earth that saw the decline of the Roman Empire as much of Europe and the Mediterranean area descending into ignorance and fear, giving us the 'Dark Ages'. At this point in history, orthodox Christianity was born to spread its creed across the Western world. Christian and Muslim empires seemed to answer all the questions, through texts like the *Old Testament*, rather than the remarkable 'scientific' insights of much earlier advanced civilisations. Throughout the Dark Ages, the Christian hierarchy (like other regimes) were burning at the stake and imprisoning anyone who said the earth was round and/or orbited the sun. The genius scientist, Giordano Bruno, would eventually be tortured and burnt at the stake for proposing theories ahead of his time. Bruno, like the sages of Greece and Eygpt, upset the Roman Catholic heirarchy with his visions of an after-life, without the need of a middle man (the church). In the 21st Century, we have mass killings perpetrated by fundamentalists from all religious backgrounds. The same mentality, which I believe 'invented' The *Old Testament* and all the admonitions contained within it, is activating the same destruction, pillaging, looting, killing and so on, today. The amazing thing is that people 'flock' to churches and admire the God (gods) who ordered it all. The same gods in the guise of 'world leaders' from all religious backgrounds, who do not seem to fully understand 'love' and 'peace'; for if they did, there would be no suffering in the world, caused by intolerance and fundamentalist mindsets.

The fundamentalist rabbi or priest (or president), will always believe he is

different from the fundamentalist ayatollah. In truth, they are not different; they are the same! Fundamentalists will always defend their dogma, to the extent of crushing other's views. Mind control is the common denominator between mainstream science and religion. Both believe in hierarchy, both release half-truths and have their 'thought police' stamp out any contrary views or genuine opposition.

At the time of the crusades, and throughout the Middle Ages, controlling the masses was done through instituting a reign of terror using the Inquisition. Today, families suffer untold mental, emotional and physical damage at the hands of politicians and priesthoods from all religious backgrounds. All of which use 'guilt and fear' as their main tool to control our thoughts and behaviour. Children are raised to fear each other in 'trouble spots' all over the world, when they could easily be raised to accept each other's differences and live amongst each other in peace. Choosing spirituality over dogma is an individual process, no matter what one chooses to believe. Pressuring children to believe a certain dogma and to see others as not being equal, based on religious, political or even economical distinctions, is a great oversight that urgently needs addressing in our society. Yet mind control was, and still is, the real purpose behind any form of terror-based belief. Organised religion, with its angry fire-and-brimstone gods demanding an eye for an eye and a tooth for a tooth, are all the inventions of ancient emperors and priests. In today's world, these 'authority figures' still want a frightened and terrorised public at their mercy. Have we not learnt anything? Through the desire to control others' views and lives, over many centuries, we have created a 'dogma police'. This force is created in the minds of people, who quite unknowingly, in most cases, wish to convert others to their dogma, be it scientific, religious or political.

Destructive Dogmas

Mainstream science, which has only been with us a few hundred years, says that all is a cosmic accident heading for oblivion, where survival is the only goal. The same belief system has generated a total physical and mechanical view of life which seeks to condemn and marginalise people who stretch their vision beyond the this-world-is-all-there-is dogma. At the same time, classical science, which has given us the potential for construction and catastrophe, has helped to foster ruthless competition and cruelty amongst all of us. We are, in fact, the single most dangerous species on this planet. We build machines, big guns, even bigger bombs, giving us a technological hold on the planet and its resources. I would suggest that from the pillars of authority through secular science and religion, has come one of the most destructive (opposite of creative) beliefs on this planet: that humanity has been given dominion over the rest of creation, to control and plunder all of nature as it sees fit. This way of thinking ultimately separates us from the rest of creation, including each other, while alienating us from the earth. It is this knowledge that is at the heart of our own desire to 'create' or 'destroy' – to dwell in the shadows or the light.

Europe from the 14th Century onwards, especially in Italy (the centre of religious control), saw a revival of interest in the arts and natural sciences. It heralded the end of the Dark Ages through the Renaissance; but the conflict between Church and Science has persisted, even to this day. Dogma has been the ancient tool by which we have separated science from spirituality, art from nature, art from metaphysics, but on a more personal level, abetted and imposed a separation from self and other. Control of our minds is in part achieved through endless dogmas that still persist in the 21st Century, intent on destroying our children's futures through yet more scientific acts of war and religious intolerance. Since the creation of religions, political states of both tribes and nations are persuaded to hold opposing dogmas. Once we are polarised in our views as people then it becomes easy to manipulate conflict and control through `divide and rule' which is exactly what has been happening to us since ancient times. Extremists have destroyed ancient knowledge through the burning of great esoteric libraries in the name of God, while materialistic science and 'machine technology' has produced a very 'analytical', spiritless view of the world.

The 'machine age' born out of the Newtonian view of life, changed our relationship with the world, as we became observers, analysts and managers. Today, more than ever before, we are seeing and operating from 'outside nature'. Western philosophy since, René Decartes (1596-1650) defined the earth and the universe as a 'machine', a concept that scientists, and writers like Francis Bacon, extended to include all living organisms. The yoke of philosophers and scientists like Descartes, who asserted only what could be shown to exist should be accepted as reality, has taken its toll on the minds and imagination of people. And, in truth, this has been the doctrine of establishment science ever since. Alternatively, ancient civilisations did not transfer the idea of a machine to the diverse creations all around them. Instead, nature was alive with the spirit of life. Science has shown us that the intellect without wisdom is a very dangerous attitude. Eighty thousand men, women and children were killed within two days in 1945 when scientists reached the culmination of their development of atomic warfare. These atrocities were perpetrated on Hiroshima on the 6th of August, and Nagasaki on the 9th of the same month. Even where there have been positive achievements by scientists, the overall contribution of mainstream public science, has been to 'suppress' human understanding, or use its knowledge for destruction or greed; and where there is greed and control, one will also find corruption and tyranny. As history reminds us, many religious tyrannies have murdered and imprisoned men and women who expounded different views about creation, to that of the pervading status quo. For examples of this see every crusade and imposition throughout history, waged against cultures having alternative lives to that of the `chosen-one' mentality. The attempts to control our minds, and therefore our spirituality, by priesthoods of all denominations, still continues today.

From the establishment scientific and religious cornerstones of contemporary society, over many centuries, I believe we have developed, en masse, a

very narrow view of creation. The removal of alternative knowledge from our societies, by religious, political and scientific authorities, has meant that many ancient indigenous people's knowledge was denied to the masses. Acts of genocide on indigenous people by the ruling classes, ensured future generations did not have access to alternative views and the mysteries of past generations. When we are starved of any kind of knowledge, we become separated from our true potential, which ultimately affects how we relate to other life forms respectfully. More importantly, limitation in its many forms affects how we use our own minds and individual powers to 'create realities' here on earth. Creativity, like the imagination, if nurtured, can create realities that bring individual freedom of thought. On the other hand, ignorance brings only darkness to the mind – whereas knowledge equals freedom. This thirst for knowledge, freedom and information, I feel, is stronger now than it has ever been. The Internet is very much a physical manifestation of our collective desire to know more and to make connections with people from all over the world. Yet networking in cyberspace is not the same as having a 'community' spirit. Even on the Internet you are isolated and the information received can be terminated at any time.

We are on the threshold of both great opportunity and great danger at this time, as the defenders of dogma and the mind controllers in all camps hold on to their beliefs against a hurricane of change. For centuries we have been encouraged to polarise everything, so that we choose Heaven or Hell, Capitalism or Communism, Christian or Muslim, left or right, life or death. In truth, both poles are always part of the same force, a projection of the original oneness, from where we *all* come. The separation of `oneness' gives us a multitude of worlds (dimensions) to experience evolution and the dimensions in which we operate, both as a spiritual and physical beings, are littered with benevolent and malevolent 'thought-forms'. Quite often these thought forms solidify and become dogmas and when we give our creative power away, through seeing only black and white realities, we develop very lazy minds, which can lead to apathy and a one-dimensional view of life. Over a very long period of time we have been fed a lot of nonsense that was always designed to keep us in this state of polarity, so that we hardly question the 'system' that controls our lives. We also believe too much of what we are told by the `official line', without checking the facts. And we hardly ever ask the magic question: *why?* Children, who are free from the conditioning dogma eventually breeds, always ask: "Why?" to any rule or regulation hindering their play or imagination. While writing this book I have constantly asked the question: Why? in relation to so many established beliefs we have inherited from the past. In the pages that follow, I want to examine some of these views and the 'vehicles' by which we limit our potential.

Another Brick in the Wall
Marshall McLuhan was only half right when he said back in the 60s: "School is an interruption to a child's education". Irrespective of the thousands of good people who give their lives to the future of our young, I strongly

believe the education system (like other institutions), to be part of a conditioning device which often uses fear and ruthless competition as its main tools. Our children are put under tremendous pressure to constrain their natural imaginative faculties for the more rational, intellectual modes of living and thinking. So much so, that the creative spirit within us becomes depleted and drained later on in life. The rock group Pink Floyd expressed the same concept in their song *Another Brick in the Wall*. So did John Lennon with *Working Class Hero*, which illustrates the dangers inflicted by fear, confusion and institutionalised minds. Supertramp echoed the same points within their *Logical Song*, which also suggests how the structure of schooling teaches dependency, cynicism and logical thinkers.

As a college lecturer, with a passion for teaching art, I soon realised that `schooling' is not the same as 'educating'. Instead, schooling creates a system that demands our kids conform and fit neatly into different specialist blocks of efficiency. Ultimately, schooling affects society by dividing life into many manufactured realities or compartments, which then perceive themselves to be different or separate from each other. What I am trying to say is that the way certain subjects (or professions) are taught could be more holistic in approach. By being holistic and encompassing different areas, like history, mythology, science and art, as an example, students get to see a wider picture, rather than just one category. When we view these categories (blocks) from a wider perspective, without the necessary insight into how all these areas (blocks) are connected, then we see only a fraction of the knowledge we could see; symbolically, we see only 'structure' (the wall) and nothing else. In some cases this wall is a 'mental prison' that many young people try to kick and push down because of their frustration of not being 'allowed' to be more creative with their days. Therefore school becomes the 'nanny figure' policing our young; often 'dumbing them down'. Through this type of structure or wall, real education or self-awareness has very little meaning while we are only learning one particular technique, or focusing on one profession. In other words, if we concentrate for too long on any technique or profession, then we miss out on wider experiences elicited through pure creativity. The nature of any 'programme' (no matter what the subject) is the opposite of 'spontaneity' and the vital learning brought about through unconsciously leaping into the unknown. Instead, the structure behind `schooling' is more about breaking down ideas into fragments, which become subjects; the subjects in turn are 'assessed' through units, and units in turn become abstract sequences. All of these fragments, which are delivered through tasks and homework, actually make the classroom more 'teacher proof'.

Inside this wall-like system students studying the arts and the creative spectrum are given limited funding, support and/or encouragement from the governmental resources; while scholarships, research grants and sponsorship are plentiful for would-be lawyers, scientists or economists. In simple terms, this system decides what and who is most important and valued in society. But this all makes sense when we realise what forces are pulling the strings from behind the scenes. On another level it encourages left brain

logic, rather than a more right brain artistic, (intuitive) process; the latter of which is an important tool for discovering who we are. In the movie *Mr Holland's Opus*, actor Richard Dreyfuss explains this dilemma and frustration that the system creates by its prioritising of certain subjects. He says: "A country that considers arts expendable is an expendable country." [1]

If we are honest about this 'system', we soon realise that increasingly, schoolteachers have less and less autonomy in the classroom and aren't allowed to do what theyknow intuitively is best for each student; they are discouraged from seeing their students as one-of-a-kind, creative individuals. The two-faced aspect of 'schooling' in which teachers are forced to act as 'principals', when they are merely agents of the system, is ludicrous. Where teachers are 'pretending' that insignificant work (such as homework) is more important than human development, then this is one of the main reasons why teaching is held in such low regard in the 21st Century. In the press we hear statements professing how much teachers are valued and how important individual pupils are. But in practice teachers are ignored, maligned and even derided (I should know). Both pupils and teachers have been 'assessed to death', and that is why the teaching profession is in such a dismal, appalling state, explaining why so many teachers eventually choose to leave the profession. No one is actually questioning how useful testing is, but a lot of private firms over the years have made a substantial amount of money from 'collecting data', consultancy work and printing endless paperwork for purposes of assessing. I think it was Oscar Wilde who once said: "Examinations consist of the foolish asking questions the wise cannot answer". I think he was right! The real crisis in schools is not about Maths or English (numeracy and literacy), which incidentally can drastically improve if taught in more creative and realistic life situations, it is more about having 'meaning'. Both teachers and pupils are so bogged down with increased compartmentalization, meaningless tasks and endless assessment, that they have **no time** for nurturing real creativity. Teaching should, and must be, a creative process; teachers 'need' to be creative to teach in a meaningful way. Yet, if teachers are creative, there is a danger that pupils will perhaps think for themselves, and even question the system!

The education system was never created to foster individual, creative and pioneering young people. History is full of pioneers and hardly any of them stayed in school or college long enough to feel the effects of its constraints. Schooling as we know it today was the master plan of wealthy industrialists, designed to systematise the rearing of our young; to turn them into unquestioning workers; the effects of which we see all around us, hidden within centrally controlled curriculums (in Britain, inspired not least since the Jimmy Callaghan years). It is said of the Ancient Egyptians that they too, had no formal education, were mainly illiterate and were only basically numerate, as might be required by a particular trade. I could be describing today's education system, designed for 'working class'. Like the ancient Egyptians, we too acquire skills and knowledge through handed-down stories, quite often containing inaccurate facts. Egyptian lessons, much like today's school-struc-

tures, were taken up with copying and re-copying of texts, chanting by rote within a very narrow curriculum that did not advance beyond reading, writing and arithmetic.[2] On a deeper level, we haven't really left Egypt, with its rulers and slaves and systems of control. In my view, 'drawing' as another form of language, needs more encouragement in schools. It should be elevated to the same prominence of the so-called three R's (reading, writing and arithmetic) in Britain and throughout the world. Development of our language, through drawing from an early age, helps to foster individuality and imagination, something that the insitutions that run our world fear most of all! It is probably why art is being phased out of the national curriculum in the UK and in other countries. Dare I say more?

What They Don't Tell You at School

Through the system we inherit, it is easy to see how a cocktail of naiveté and arrogance eventually develops within people. It's a state of mind that presumes everything presented to us by the status quo is correct, factual and the only view worth knowing about! History and religious education are only two of many subject areas presented in this way. How history or religion is presented, from within the schooling process, shapes and moulds the perceptions of our young, so they hardly ever question the official line. For example, too much fiction in religion is taught as factual, when in truth it is just another view or opinion.

What we also bravely call science has nothing to do with the real meaning of the word `science' itself, which is the seeking of knowledge. Instead, we have almost another religion, practised by men in white robes, who have a dogma to defend and a salary to keep against any new discovery that would potentially topple their world. Not to mention loss and deprivation of status should any professor or 'academic' decide to denounce the official line for any new revelation occurring within his or her chosen field. History, science and religion are the three key subjects used with full effect by this system, to control how young people see the world. Who or what controls the system we have inherited, can only be uncovered and exposed by wanting to see behind the 'smokescreens', shadows and illusions conjured up by the pillars of authority. As George Orwell wrote in his book, *1984*: "Who controls the past, controls the future. Who controls the present controls the past." I believe this is the dilemma we currently face. A desire to find out who actually controls the world we live in, will reveal a very different version of the past we have been 'sold'.

When anyone challenges traditions or beliefs, people seem automatically to assume it is an attack on them personally; this is not true. Quite often we choose to believe in a certain religion which others, in less tolerant situations, are forced to believe. Beliefs are no more than an 'agreement' on reality, they are not necessarily facts! What we forget is that any belief we 'take on' comes from outside of us. It is the belief, often created thousands of years ago, that is being questioned. In much the same way, just as supporting (quite often religiously) a football team, or buying a certain brand, is no more of an attack

on who we really are deep within our soul. When law and religion are inter-twined to keep people from debating beliefs or challenging divisions in soci-ety, then we are walking in the shadows, a very dark and dangerous road.

For example, in Britain our children are taught by law in schools that the Christian story is an actual fact and not a story that Christians choose to believe. The same can be said of other religions that also impose their views as fact. Personally, I don't have a problem with anyone choosing to believe any story regarding religious belief; however; when a particular belief is imposed by law on every child in any country, without considering the facts and consequences of how religious dogma can negatively impact children's minds, then ought we not be surprised at the lack of intolerance in the world? Fostering intergenerational intolerance and division through fear and guilt is not enlightening. Even in Britain, where school curriculums are tolerant towards other religious doctrines, do our kids really need to be reminded of God or Jesus every morning in assembly? By enforcing religious archetypes on impressionable young minds, often from the age of four in some schools, we are subliminally imposing a certain belief system.

All religious education dealing with early Christianity should mention how Constantine *invented* Roman Catholicism. In June 325 AD, the Roman Emperor, Constantine, pulled together 318 bishops in a place called Iznik near Nicaea, in Turkey, to decide the very foundations of the Christian Church. It is said that Constantine arrived after murdering his wife (nice guy!) and highjacked the proceedings. When a bitter argument broke out amongst different factions, instigated by what later became the Arian belief (named after Arius 280-336 AD), Constantine forced a motion that would become the 'Nicene Creed'. Indeed, it is the very creed that set out the rules for what would become Roman Catholicism. These all-embracing doctrines were put together by 'appallingly ignorant priests', who could not decide on the burning question of the day, which was whether Jesus was part of a trin-ity of gods or god himself. In the end, Constantine decided for the people and swore to kill anyone who disagreed! This is the mentality that founded Christian doctrine and its brutal imposition upon hundreds of thousands of people. Constantine achieved this end by passing power over the Western Empire (a dictatorship) to the Roman Popes that would follow.[3] Jesus, like other ancient saviour gods before him, became the classic example of how hero-worship within Pagan mythology could be recycled, creating yet anoth-er thought-controlling belief system. However, to make sure that students never find out about the Council Of Nicaea, and the later appallingly sexist articles of faith, provided by the Church of England, there is a priest or other religious representative on almost every board of governors in most schools in the UK.

One of the tragic outcomes of religion, in my view, is that the priesthoods using the Nicene Creed, created yet another saviour-god who would forgive all sins (no matter how terrible), as long as it was agreed to accept the priests' worldview. The invention of a saviour-god is so at odds with the idea of tak-ing responsibility for one's actions on earth (as you sow, so you will reap),

that many a vile act throughout history, including the ritual abuse of children by priests, has been allowed to continue unfettered. The 'institution' often breeds arrogance, sexism and 'perversion' at the highest of levels.

While writing this chapter, another article in *the UK Guardian* newspaper, revealed that members of an order of Roman Catholic monks have been accused of physically and sexually abusing young boys at St. Ninian's residential school in Scotland for over twenty years.[4] In Aix-en-Province and Caen in France, other news stories tell of Bishops protecting clergy who were said to be involved in Paedophilia.[5] The stories seem never to end! The breathtaking hypocrisy within religion quite often beggars belief. So much so, that the Church, with its moral high ground, is so desperate to spread its views that a film was commissioned, not so many years ago, called *An Absence of Stones*; made especially for schools in Britain. The film's aim was to convince and persuade teenagers of the relevance of the Bible to their lives. It contains references to drugs and violence, with the Judas figure portrayed as a 'drug-taking schoolgirl' who betrays Jesus for a `hit' of cocaine! Instead of a crucifixion scene, Jesus is murdered by a school friend and is resurrected in a Leicestershire beauty spot. You couldn't make it up. Associating religious beliefs and heroes with the effects of drug taking is a desperate and bizarre combination to offer our young. Yet why change the `habit' (excuse the pun) when that is exactly what the priests and founding fathers of religion did, when writing their texts.

What is bravely taught as science in schools and universities suffers the same controlling mechanisms used by religion to achieve its ends. It, too defends a dogma interested only in keeping the lid on any new discoveries that might bring the 'religion of materialism science' to an end. The world of 'mainstream' science is controlled by 'orthodox materialists' who defend a dogma called this-world-is-all-there-is (five senses). If any new scientific evidence comes to light it has to run the gauntlet of 'politically correct scientists', who in their priest-like manner worship at the shrine of Einstein's Theory of Relativity. Again, this type of control makes sure that no constructive scrutiny comes to the attention of science students or the public in general; even when a tidal wave of overwhelming evidence for life after death exists. When anything new is discovered through investigative science, like in the case of outstanding engineer, Ronald Pearson BSc., the old knee-jerk reaction by the establishment is to marginalise and push out anything that challenges the status quo.

Break On Through to the Otherside

Since 1933, there has been significant breakthrough in measuring the etheric[6] and matter through subatomic particles called quarks and leptons.[7] Ronald Pearson, like many other open-minded individuals, has pioneered work in what has become quantum physics. These types of ongoing discoveries show us that 'everything taking place within an atom' is also happening within smaller primary particles at sub-quantum level.[8] Pearson's mathematics have

shown that when primaries of positive and negative energy collide, they multiply, hence creating a third force, a son and heir. What scientists like Pearson revealed, is that 'all matter is energy vibrating at different frequencies'. Once we can understand that solid objects are vibrating subquantum particles (which cannot be seen even under the most powerful microscope), it gives rise to a no-longer fantastic idea that a life force (the soul) driving the physical body on earth, continues vibrating when that body dies! Couple this scientific discovery with the fact that the mind (our thoughts) and the physical brain are not the same, leads us to a greater understanding of how we operate on different levels of awareness. Rather like television and radio signals sharing the same space as us, these signals cannot be seen or touched, only 'decoded' by sophisticated devices; we too are transmitters and decoders of a multitude of frequencies. Scientific breakthroughs of this nature, which are peer-pressured out of the mainstream scientific arena, deserve as much attention in universities as some of the now largely out-of-date theories. Yet, the establishment narrative rolls on unquestioningly, denying information to the young. No independent broadcasting authority in Britain gives air time to new discoveries because it would destroy the basis of science as taught in our schools and universities. I cringe every time Professor Brian Cox is wheeled out in the UK to 'reinforce' the mainstream view of life in the universe. Science, like religion, needs to move on, be exposed and 'grow up' in its attitudes towards the many mysterious aspects of life. We as people deserve a world that truly reflects immense changes happening around us today. Scientist Carl Sagan summed this up well when he said:

> *The suppression of uncomfortable ideas may be common in religion and politics, but it is not the path to knowledge, it has no place in the endeavour of science.*[9]

Surely if we are to educate our young we must ensure they receive a more rounded holistic view of the world that does not censor the truth or belittle new ideas, but instead, encourages the young to be more fearless of the institutions of the mind? Both mainstream science and politics, like religion, through dogma and limitation, conditions our children to fit into particular ideologies. These in turn add another generation of minds to existing oppressive regimes and systems, which eventually breed division; and we wonder why there is so much killing tit-for-tat warfare in the world! Voltaire once said: *"People who believe absurdities commit atrocities"*, which is exactly what we are doing now. If, for a minute, we were truly interested in giving our children the wisdom of real education regarding the mysteries in life, then we will have to be more serious in pursuing self-knowledge, understanding and freedom of the mind.

Soul Loss – Why We Need to Experience Our Creativity

In many ways the society we have inherited is based on over-logical and

solely rational political/scientific/religious structures. These mindsets are purely masculine on the surface and allow little room for the more balanced female/male and therefore, the artist within. In my opinion, a civilisation based totally on the dominance of masculine power structures, with an obsession for suppressive technologies, relates to the immense destruction of our environment. All torture, war, famine and imposition is an expression of the 'macho' mindset. Fritjof Capra in his book, *The Web of Life* (1996), points out that the exploitation of nature has gone hand in hand with the exploitation of women, who are identified with nature – the mother, throughout all ages. A civilisation based on mechanical and mediocre lifestyles, serving but not contributing, observing but not participating, is lacking the creative spirit needed to create a balanced world. Krishnamurti also echoed this view when writing about art, beauty and the significance of life. He said:

> *Great artists and great writers may be creators, but we are mere spectators. We read vast numbers of books, listen to magnificent music, look at works of art, but we never directly experience the sublime; our experience is always through a poem, through a picture, through the personality of a saint. To sing we must have a song in our hearts; but having lost the song, we pursue the singer. Without an intermediary we feel lost; but we must be lost before we can discover anything. Discovery is the beginning of creativeness; and without it, do what we may, there can be no peace or happiness for man.*[10]

Soul loss can be observed around us on a daily basis, by what we feel about ourselves on the inside, we reflect in the world around us. Billboards, ugly office blocks, concrete and 'endless plastic' can only be the foundations of a 'spiritual desert'. At the same time we have created generations of young people who are addicted to brand names, who become 'material creatures' competing for limited resources. The obsession with tablets, cell phones and the 'brand names' that 'push' these products, have a lot invested in creating the 'new artificial world order'. Our education systems, like the media industry, are to blame for much of this. So are the multinational businesses that have a lot invested in turning out controlled fodder in order to keep the system alive. The obsession with 'centralisation' is in part, also a by-product of the corporate world, so much so, that 'Centralise' is now a buzz word in every area of our lives. Do we really believe that centralised control is a natural state of being? Do we really like the idea of a nanny state? A society obsessed with centralised control is a society frightened of individuality and diversity, with no real trust for ourselves. At the same time our world is fashioned through the eyes of authority as a dangerous, imperfect world that must be given structure for it to survive. As a creative individual I always feel a shiver go down my spine when I hear the word: 'Centralisation'. This mentality does not understand freewill, selfreliance, creative spontaneity and compassion; it is instead a predatory mentality; domineering in nature.

I believe humanity has spirit and grace, our inner nature seeks organic relationships with earth's natural beauty, which reveals wholeness consistently;

in many forms. I see it, humanity an 'un-whole civilisation' does not live to its full potential when it is denied its creative spirit. And in many ways today, we have a 'plastic civilisation', one that reflects a 'robot' nation of passive observers, while everything around us gets managed out of our hands and into the hands of the few. At the same time, many people have bought into the 'one world'/'one religion'/'one central government', ideology. We even accepted the need to be watched by Big Brother through constant surveillance; to the extent we now enjoy watching others being watched in 'reality show' television programmes like *Big Brother* and *Goggle Box*! It's all insane! Our young are growing up in a society saturated with Social Media platforms, CCTV, and cell phones all connected to a Smart Grid (Artificial Intelligence), with micro-chipping of humans becoming reality. No one seems to want to question this type of 'monitoring' as it is accepted more and more as part of the 'normal' way of life. Instead, we accept the paranoia of ideas promoting the notion that no one can be trusted, or that we need to be protected by a 'nanny state' at all times and in every place we go. As the award winning (now retired) New York teacher, John Taylor Gatto, suggests in his book, *Dumbing Us Down* (1992):

> *Surveillance is an ancient imperative, espoused by certain influential thinkers, a central prescription set down in The Republic, in The City of God, in New Atlantis, in Leviathan, and in a host of other places. All these childless men who wrote these books discovered the same thing: children must be closely watched if you want to keep a society under tight central control. Children will follow a private drummer if you can't get them into a uniformed marching band.*[11]

That 'private drummer' is the most important aspect of our lives, especially in our early years; it is symbolic of the inner self, our intuition, our imagination. It is an area of our being that needs nurturing more than any other, if we are to access our creative power and free our minds.

Is it really a true reflection of the human spirit to desire some almighty god, king, president or leader to make all decisions for each and every one of us? Do we really need to be scrutinised like some untrustworthy experiment of the gods themselves? I believe we have been sold this story of the leader and follower for so long that we actually think it is the only option available. Art and creativity in all its forms is our own personal link with the force known as the Creator. All art, architecture and media (especially television) in various forms, reflect back to us what we as a society are feeling within. You could say the `god force' is reflecting back what we are feeling at the level of our soul. I believe this creative force transcends all man-made religious boundaries, no matter what or whom we choose to worship. What we believe should be our own personal experience, which can become our prison or our freedom, depending on the 'parameters' we set in our minds. Damage to the soul occurs when our beliefs are imposed on others, through 'control' of how we think, live, eat, vote and so forth; all of which seems to be a common symptom of living in the world today.

The last time Western civilisation experienced a high magnitude of growth in art and science together was during the Renaissance. After this period, only a few individuals, despite immense personal struggle, have broken through to offer a glimpse of the mysterious acts of creation inherent within the human mind. The Renaissance was symbolic of a `new age' that came about after several hundred years of war and holy inquisition. It set the scene for what was an obvious reaction to spiritual suppression by the Church and State. On another level, the Renaissance brought to the surface underground streams of creativity and science, which flourished in the memory of earlier civilisations such as Greece and Egypt. Leonardo da Vinci and artists like Van Eyck, to name just a few, were in effect Fifteenth century equivalents of today's major film directors, who still revel in ancient archetypes and use the latest technology to produce their work. At the time of the Renaissance there was a remembrance of the truth that art, the esoteric and real science are all part of the same source! Court artists of that period, especially Van Eyck, exercised esoteric knowledge, which included access to advanced ancient systems of geometry. One only has to look at Da Vinci's studies to realise he was not only a `master' draftsman, he was using knowledge of the sacred sciences, like geometry and early photography, to create studies, inventions and plans that reflect a higher understanding of knowledge not readily available to the masses at that time.

Da Vinci was allegedly a Grand Master of one of the oldest secret societies called the Prieuré de Sion (Sion=Sun) based in Paris. He was patronized by Francis I the first King of France, whose mother, Louise of Savoy, owned Château d'Amboise where Da Vinci was buried. The Savoy and House of Valois bloodlines (the lineage of Francis I), adopted the Salamander (fire-lizard) as their emblem. Like other masters of the order, Da Vinci (and his patrons) would have had access to sacred geometry used in the building of castles and ancient temples, some of which appear in his studies of *Vitruvian Man*, which illustrates the Golden Mean; a system explaining the correlation between the human being, time, space and the planets in our solar system.

Despite the correlations, work of artists like Da Vinci, may convey the intensity, but never the magnitude of our distant ancestors' art. This is probably because the art of the ancients, through structures like the Pyramids in Egypt, reveal to us the cosmic, alchemical connections much more vividly. Art, spirituality and science from the Renaissance period onwards became more disconnected just as astrology and astronomy would be separated from each other as fundamentalism took hold. That is why, today, the impact of great art and architecture, like the Sphinx and the Pyramids (from a period when art, science and spirituality were connected), can still be felt; yet the greatest of modern Western art remains 'inaccessible' to many people. This is also mainly due to how we 'perceive' our own 'magic' and how we form relationships with the soul in all life, including what we create personally. When anyone attempts to show connections between art, science and spirituality today, people who do not fully appreciate what artists like Da Vinci, or even the sages of Egypt were trying to communicate, often brand these artists as

'occultist' or eccentric. Artists like Blake were even labeled 'mad'!

Finding your 'Daemon'

Over thousands of years, creativity was experienced as a personalised and intimate agency, a place from where both 'good' and 'evil' were derived. To the Ancient Greeks, it was the daimon (daemon), or guardian angel, that was the 'source' of creative expression and individual destiny sought through one's soul. In Ancient Rome, the same creative expression was related to the concept of 'genius' (from the Latin *genii*), which is the 'guiding spirit', protector or patron. Creative forces were seen to be connected to everything in nature, with different guiding spirits moving and inspiring how we interacted with the world. With the removal of alternative knowledge, and the real understanding of our past, by the Church and the Holy Roman Empire, these natural forces became 'demonised'. In other words, the sensual creative world of nature became the savage shadow-side in the eyes of orthodox 'fatherhood' religions. The burning of the fantastic esoteric libraries in Alexandria, Egypt, and the removal of native wisdom from Alaska to Australia by extremists, separated humanity further from the knowledge and perception of *who we are* and what we can achieve.

The 'veil of tears' that closed off much knowledge of the ancient world came down with so much terror and torture during the Middle Ages, that today, in our deepest memories, we are still feeling its effects in our psyche. Our fear of death, fear of the gods and fear of the unknown, was driven into the depths of our soul by institutions that, in my humble opinion, still breed ignorance and arrogance. In many ways, through no fault of our ancestors, people do not know how to relate to the mysteries in life, or even their own personal magic. Too often we 'strain at a gnat and swallow a camel', when it comes to accepting information given to us by the pillars of authority. Our unique natural power and magic can actually make us feel inferior, especially when we are conditioned to 'play it down' or 'shut it off', through fear of what others might think of us. In a similar way, many people do not know how to relate to their dreams, they fear their shadow sides and the wider, more mysterious aspects of life. Can you imagine what would have been lost to us if our ancient ancestors had not utilised both their dreams and nightmares; or if Da Vinci, Blake, Van Gogh, the Symbolists or the Surrealists had not listened to their 'deamons'? The key is to not live inside the dreams of others, but instead live our own dreams and visions. The artist within us needs to reconcile with all of its qualities, both the angel and the demon, so to uncover the whole self.

In my work, I have often felt what I describe as the 'ancestor spirit' passing through me when I draw or paint. I see this spirit as part of a collective wisdom forged by ancient artists and creative forces one can 'tap into' spontaneously. Creative wisdom is always moving and never takes on fixed meanings, just like the process of creation itself. We suffer soul loss when we become 'fixed' in our perspective or try to contain our creative energy. As Socrates once said in Plato's *dialogues*: "Everything is generated from a flow-

ing stream of change, that keeps things fresh."

The Uniform Mindset

The state of 'soul loss' is one of 'desiccation' when our guiding spirits and the currents of creativity no longer run through us. When this happens we become purely 'system servers', cut off from the spirit of creation, or what Renaissance scientists like Giordarno Bruno called: 'shadows of the cosmic fire'. System servers are people who prefer to adopt a 'uniform of the mind' rather than foster their own uniqueness. Nothing holds back our individual (unique) creativity more than a 'group' mindset.

If people wish to free themselves mentally from the daily 'system serving' mechanics, the illusion that keeps us locked into the 'shadow reality', then we need to be able to re-establish our creative imagination and the 'shaman'-seer within us. Real creative energy works through diversity, and if we look at humanity from a wider perspective, the mind still finds it hard to celebrate creative diversity and uniqueness. Instead we become fearful of being anything but the normal 'uniformed' citizen, someone who keeps their head down despite all of the magic they have to offer. As Albert Einstein once said: "Nothing in the world makes people so afraid as the influence of independent-minded people."

People say that it is not possible for everyone to celebrate his or her uniqueness, as the lack of responsibility would create sheer chaos. You only have to turn on the news or walk down any street and see the blank faces of frustration, to notice we already live in a chaotic world. The way in which we respond to the world as individuals is an indicator of how much chaos we choose to feel. The raw state of chaos needs to be channelled creatively, individually and this is one of the first steps of seeing through our 'ancient eyes'. At the same time, we need desire which comes through direct inspiration and through staring the primal void (chaos) in the face. By facing chaos we can use its energy to shape our individual world, before something creates an order out of the 'manufactured chaos' we see every day. What do I mean? There is an element of the insect, of the mechanical, in humanity. This state is represented by the ant, one who does not question the order to which it belongs. People are ant-like inasmuch as we follow orders and work for the good of the colony or state. In its routine mode, this mentality encourages a totalitarian view of life, which in extreme cases can become fascism. Soldiers, police, civil servants and other 'uniforms of the mind', etc., all perform tasks like that of the ant. In other words, their uniforms often 'override' their true personality. Our uniforms come in many shapes and sizes of the mind and can be found in every area of society, but they have one common theme: to wear a uniform, one must hand over one's unique sense of individuality. Some of the 'literal' uniforms we wear, especially religious uniforms, look like 'fancy dress' (see figure 20 overleaf). As stated at the beginning of this chapter, it is the 'norm' or 'useful' man/woman ideology that has created a society that asks too little of itself, too little of culture and that is why we ask practically nothing of the artist, the creator within ourselves.

Figure 20: The Uniform Mindset.
Welcome to the fancy dress party, what have you come as?

As I see it, the 'ordinary-man-in-the-street' ideology creates no culture, its main function is to be utilitarian just like that of the ant. This can also be observed in the way millions of us adopt rigid belief systems, and in extreme cases, allow the erosion of our liberties by a system addicted to war. Too many people see their only reason for living is to work, not grumble and simply serve the system (their masters). In fact, the whole master/serf system of medieval Britain was based on this principle. Scandinavian mythology tells of a god of light called Heimdall, who was said to stand between Heaven and Earth and was the creator of the master and serf system.[12]

Whenever we give our creative power away we allow the uniformed society (herd mentality) to dominate the world, and in this frame of mind, we can be frightened into accepting or believing anything. The herd mentality asks us to be completely passive; for example, watching television (tell-a-vision), which is the opposite of getting our own visions. At the other end of the scale, the herd mentality manifests as 'liberal progressives' who, it seems, want to eradicate freedom of speech. In other words, when we are in a passive mode we become fixed in the face of chaos, and while there, we fear our own creative power. We can also be 'used' for others' bidding. Facing our fears, through our creativity, helps us to 'shape or channel' the energy into the world around us. Real creative chaos is the fuel by which we, as individuals, can 'see through' illusionary structures preventing us from accessing our true potential. If we allow others to create chaos in the world only to then reshape the world to their liking, we walk a very dangerous path. A path that ultimately leads to regimentation, or tyranny, on all levels of the soul. Liberal progressives everywhere seem to almost 'regimented' in their tropes against freedom of speech today. A mind that gives its power away is always going to be easy prey for the forces that manipulate the illusionary 'us-against-them' scenario which becomes the classic 'divide-and-rule' principle. Who, or what takes our minds, depends on the beliefs we decide to 'buy' into. If we conform to mental slavery of any kind, we are limiting our experience within the realms of the soul.

The artist within us all is really a sensitive instrument through which an individual, community or civilisation can contemplate itself; evolve, grow and change. As I see it, a purely political, religious and scientific civilisation,

as we know it today, lacks 'wholeness' when it refuses to embrace real individual creative *diversity*. Individuality of this nature is born of the spirit of life, without dogma or imposition of thought. When we undertake a personal journey to find wholeness and balance as individuals, we cannot overlook art and creativity in its purest form, as that vehicle in which we traverse those inner worlds.

Shadow Realities and Illusions

The shadows of the mind are the manufactured realities that we as humans get hooked into, both individually and collectively. The shadow realities, as I call them, are in fact part of that larger matrix of illusions that mesmerise us and keep us focussed only on this physical reality. Yet in reality nothing is solid or fixed, and the illusion we create (through how we think or perceive), is part of a beautiful hologram created by the infinite mind. I see our creative mind as our 'infinite connection' with this hologram (physical reality), while our spiritual heart is the real us, the core of our very being. Looking from 'outside' of this holographic reality, through meditation and creativity, I see people as 'luminous mirrors' reflecting light. What we reflect is our innermost desires, which through inspiration are expressed as thoughts and feelings. All of our thoughts, emotions and inner feelings contribute to the grand illusion called life.

From within this matrix we forge a world that is so real to us, that we only see beyond it, if we actually step out of it! In other words, the system itself can become our one dimensional view of the world. In the Warner Brothers' film *The Matrix*, Neo is shown the matrix (depicted as a computer programme) by his mentor, Morpheus. The matrix projects an illusory reality, a veil, pulled over the human eye. This illusion is filled with everyday people, businessmen, teachers, lawyers, politicians and such who uphold the illusion (the system). I believe our thoughts, desires and experiences, whether good or bad, are also part of this matrix which is often described as the Web of Life. As creative individuals I feel it is our task to penetrate the 'matrix' and go beyond it into other dimensions.

One tool of the matrix is 'patriotism', which in extreme cases generates the ability for humanity to go to war with each other. I see patriotism as an illness of the mind that allows one belief, or dogma, to be played off against the other (within the confines of the illusion). Across the world today, as throughout history, we are seeing the manipulation of people through patriotism with the increase in 'terrorism'. Patriotism is one of the greatest tools for keeping people in the shadows. When people become frightened, or thrown into a state of terror, they manifest the shadow of their true selves. The shadow reality expects us to foster a view of life that is about separating everything into categories and applying ready-made labels, while never realising our power to *see*, with our 'ancient eyes', the bigger picture beyond the illusions of the matrix. As creative people, we need to be able to see the shadow parts as well as the lighter aspects of our lives. To do this we have to see beyond the wall of illusions. Once the desire for finding new vision is in

place, then anything, within the realms of the imagination, becomes possible! For example, the idea of educating within any context should be about integration of 'all knowledge', so that we can 'develop perception' based on self-understanding and the spirit that moves within us. If we view our life as an 'unconnected aspect' of energies and forces surrounding us, then we ultimately fall into the trap of thinking there is no shadow world, no illusion or prison in which the mind can become trapped. What the shadow reality does is to trick us into believing that 'this world is all there is' and only the experts have the answers; we then defend those shadows against anyone who challenges their normality. In this mode we become prisoners in a 'prison without bars', convincing ourselves we are free, when in truth, we are anything but free! Like fish living in their underwater universe, will we ever grasp what is going on above (or below) the surface of our three dimensional reality?

Hand in hand with education, the media industry also helps to set the so-called `norms' of acceptable thought and behaviour within our society. These norms are illusions, or shadows, moving across a wall built by our collective minds. They are the 'denizens' in the cave of Plato's *Republic*, which continue to 'mesmerise' and prevent us from turning around to see the mysterious fire creating the system of `shadows' we call reality. Like the shaman or seer, for those who choose to turn around and stare into the fire (their inner fire), a bigger picture begins to unfold.

Plato's Cave - A Personal Way of Seeing

In Plato's *Republic*, several old men are chained facing the wall of a cave. They can't see anything behind them; they only sense the light and feel its heat, which is symbolic of a distant memory of higher dimensions (vibrations of a higher source). Behind the men is constant activity including sounds created by strange beings, objects, and people going about their worldly routine. Fixed in their view, the old men (prisoners of the cave), observe the flat shadows moving across the surface of the cave wall (cast by the ongoing activity) and believe them to be real. They associate the sounds they hear with the shadows they see, presuming the shadows were making the sounds. Just imagine how laughable it would seem for people to defend so rigidly those shadows (symbolic of belief systems) cast on the wall of the cave. Over time we would hear the defenders of `cave shadow' dogma say: "These shadows must be real". Priests of the cave shadow dogma would eventually emerge, proclaiming they have seen these mysterious beings and objects that have created their shadow world. And many initiation ceremonies needed to communicate with the shadow-gods would be performed under the guidance of the priests. Yet, in reality, all that is required is to *see* with their own eyes, symbolic of turning around to face the 'shadow-casters' for themselves. Other priests would denounce those mysterious shadow-gods for their 'one god' (the fire), 'casting' the shadow world, whilst trying to convert others to their belief. Secret Societies worship the source of that fire and use its knowledge to prevent others from actually seeing beyond the cave. Eventually,

`cave-shadow' science would try and disseminate the fire and separate it from the mysterious beings who live and dance in its heat and light. Some individuals, through genius, would eventually realise there is also another light coming from beyond the 'cave shadow world', a light symbolic of higher vibrations and dimensions. What would happen to the once prisoner-of-the-cave who ventured out of the shadow-reality and into the world represented by that light? On seeing the world outside of the cave in all its brilliance, the individual would be forced to leave behind all the dogma he/she once perceived to be real. As with the chained denizens in Plato's *Republic,* if we, for one moment, could free our mind and focus our 'mind's eye' (our imagination), we might just see what and who is creating the fantastic illusion called life on earth. We might then just discover what we are; it simply depends on what we perceive to be real! A personal paradigm-shift would be experienced, something we as a species (or as individuals) have gone through many times on earth.

In the process of turning around to see the fire, and the light casting the shadows, we must then look a little further, towards who or what made the fire; we have to ask did 'it' come from a place beyond the entrance of the cave? Seeing in this manner evokes a wider understanding of our role in the universe. This perspective is an ancient one stemming from several philosophies, as well as being rediscovered by anthropologists like José Argüelles[13] and other scientists working in 'system theories'. In the end we have come full circle, as the equipment needed to rediscover the complexity in nature is showing us today how simple and ingenious the universe really is.

The holistic view is comprised of seeing everything as *one.* Yet, even within this philosophy, people can get attached to several parts of the puzzle, announcing that they have found `oneness' while going no further in their search for the wider picture. Parts of the New Age, along with Old Age religions, fall into this trap of 'pitching their tents' and looking no further down the never-ending road to enlightenment. When we think we know all there is to know, then we are confirming that we know nothing at all. As the Greek philosopher, Socrates once said: "Wisdom is knowing how little we know". Our wisdom is something that grows from experiencing, learning from that experience and then moving onto 'new experiences'; not repeating the experiences! If we rigidly defend any belief system, we are more than likely generating our own form of soul loss through apathy and one-sided vision. One could also say this apathy directly relates to current structures that society holds so important, even though they destroy the sense of self on a daily basis. The foundations of these structures and the system made up of politics, religion, education, the media, banking, the military industrial complex, at their highest levels – *are all based on a corruption of power.* None were intended to nurture freedom, love and creativity. It is through this 'system' of elite power, where the quite often 'insane' structures set values and 'norms' of acceptable thought and behaviour, that we do the most damage to our soul.

Urizen and the Fear of Change

William Blake, the great English visionary artist, depicts 'systems of power' and their effects on us in his book *Europe: A Prophecy* (1794). For Blake, the creator of rules and laws attributable for all the ills of the world, through war and suffering, is personified by his mythological figure, Urizen (which in Greek means to bind). Urizen's presence appears in a print entitled: *The Ancient of Days* (see figure 21). In Blake's prophetic works, Urizen is the creator of the old order of laws, or the brazen book of 'unchangeable laws'. These laws are copied by Kings, Priests (and today's politicians) to enforce and assert rule over the masses.[14] The results of Urizen's laws are depicted and illustrated graphically throughout Blake's book. On its pages we are shown the 'scaly' figure of 'War' and 'Death' with his sword. 'Famine' is depicted as a mother mourning over her dead child. 'Mental' and 'Physical captivity' is a scene which is not too dissimilar to the chained denizens in Plato's *Republic*.[15] Blake also used other mythological characters, like that of Orc to represent the hidden forces rising up in the wake of revolution and war, a name that likely inspired J.R. Tolkien's creatures of the same name in the *Lord of the Rings*. The opposite side of Orc was Los, who represented a renegade force, a fallen angel, who for Blake was connected to the imagination. *The Ancient of Days* a frontispiece for *Europe*, was inspired by the

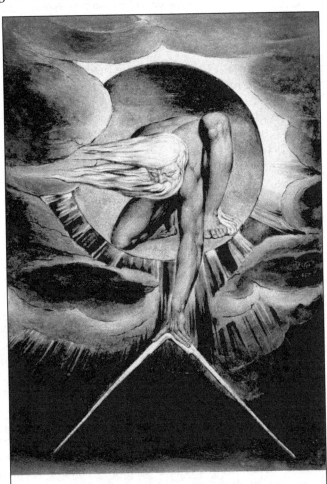

Figure 21: *'Europe'* Plate 1: Frontispiece, *The Ancient of Days* (1794). By William Blake
© Courtesy of the Whitworth Art Gallery, The University of Manchester.

tyrannical events of Blake's time, which essentially are no different to the global regimes we are witnessing today. The politics of `Europe', and what has become a unified, controlled 'Superstate' in our time, could be very much at home in the writings of Blake's prophecies.

The image of Urizen is often taken to be God and that's understandable from the Christian collective view of the Creator, as depicted in the 13th Century *Bible Moralisée*, or by Renaissance artists like Michelangelo (who quite possibly inspired Blake's composition). But through the eyes of Blake we have another vision that illustrates the separation of humanity *from* God by the 'Church and State', through the restraining powers and 'laws' set out by Urizen! The Urizen figure is a god called the 'Demiurge' by the Gnostics, a topic I will address in the following chapters. In Blake's painting, this mighty deity leans out of the sacred fire (or Sun) and, like an architect or `master architect mason', he divides time and space, creating the illusion of the material, physical world. As the creator of religious laws, he binds us to the world of separation, the world of shadows outlined in Plato's *Republic*. Holding the almost pyramid-like point of the compass, he creates the 'parameters of thought' that keep us in mental slavery. Urizen is the embodiment of another Father-God-figure and the personification of the planet (dwarf star) Saturn, or Chronos. Another version of *The Ancient of Days* is portrayed at the entrance to the bloodline-controlled (Rockefeller) GE building in New York with the words: 'Wisdom and knowledge shall be stability of thy times' (See Figure 22). The god of Freemasonry (Urizen in another form) is known as the 'Great Architect' of the Universe; along with the 'compass', 'eye' and 'pyramid', all are symbols connected to Orion and Saturn (see Figure 23).

Blake uses similar compositional themes in his sketch for *Newton* (1793) who is also depicted as a god-like figure, sitting on the seabed, symbolic of his limited, scientific view of the world. Like a 'being' from another dimension, Urizen peers out from a parallel universe, via a porthole, while at the same time his hair is blown by the winds of change. Was Blake unknowingly capturing what physicists would not discover until the 20th Century – that higher dimensions,

Figure 22: Chronos on the General Electric building in the Rockefeller Center, New York.

Figure 23: The Freemasonic Great Architect of the Universe.

including parallel universes, can occupy the same space as our reality?

Whether we agree or disagree on the ideology of separation or mental servitude, matters not. That's life! But a world full of 'norms' all agreeing with each other, not only allows corruption and killing to continue (through lack of vision), it also provides the very platform for our policing each other into a state of apathetic, mental and spiritual uniformity. Diversity and unity, I believe, can be achieved simultaneously, when freedom for every living thing becomes the common goal. So what stops us humans from achieving this goal?

The Predator Consciousness

From within a patriarchal pyramid structure, symbolised by the compass in Blake's *Ancient of Days*, we have been conditioned to believe in leaders and followers, the chosen few and the ordinary, and I believe, it is this paradigm that urges people not to take responsibility for their own creative power. When we always look to our leaders to protect us and secure our livelihood, then this ultimately manifests as a lack of creative imagination, while fearing our own power to change life on earth. If we fear our own power, then we are denying a natural, creative flow of energy that stems from 'who we are'. When we are in denial we stem this flow and this for me, is why people are fearful, or can be unhappy, frustrated (even angry), with how their lives are being shaped by the system. All insurance, which grips the planet so tightly financially, and the global money system as we know it, can be seen as an expression of our level of fear and insecurity. Our 'fear of money' and what in reality should just be a form that eases the restrictions of barter, has escalated into an immense tool for 'controlling' and creating the `haves and have-nots' in society. In our so-called civilised Western world, everything we buy is artificially inflated; keeping us locked into servicing debt through borrowing or earning more money; which ultimately 'orders our time' and forces us to create realities needed to sustain ourselves. The 'housing market', especially in the UK, was, and is designed to create servitude, divison and the illusion of 'freedom'. At the same time children are dying on a daily basis all over the world because of the insanity of how wealth is distributed. Instead of wealth being controlled and distributed locally in African and South American countries for example, it is controlled globally, which will always widen the gap between the seriously rich elite (the 1%) and the extreme poor. It's called globalisation!

The same symbolism and knowledge used by the few in maintaining the structure of control, again is based on ancient esoteric knowledge and the manipulation of the Web of Life. I see the force behind globalisation as a 'Predator Consciousness' wanting to keep its food line open. Living in fear itself, it creates a system (a web), trapping its prey into 'thinking certain thoughts', 'feeling certain emotions' and 'committing certain acts of destruction'. Those thoughts and emotions feed the Predator Consciousness in all its shapes and forms. What it looks like, and how it operates, has been recorded and written about in many books, and in art, since ancient times. Blake refers

to this Predator Consciousness often as the 'great dragon' or 'serpent' in his illuminated books, not least his works *America: A Prophecy,* and *Europe: A Prophecy.* Some writers say it is the consciousness of a specific extraterrestrial race; could this be true? On the other hand, religious people may regard it as the 'beast' (or mindset) who is more often than not, depicted as a serpent in canonic art and mythology. Gnostic writings, predating Christianity, describe the Predator Consciousness as 'Archons' or 'Pernicious Angels' born of the chaos that became our solar system. In Islamic writings, they are called the Jinn (genies) that influence the human world (see figure 24). Whether you choose ancient 'reptilian gods', 'demons' or even Darth Maul from the *Star Wars* epic, all of these depictions I call the 'Predator Consciousness'. But in truth, so are we. How the 'web of life' is harnessed depends on how *we* use our imagination and our thoughts to create realities here on earth. If we

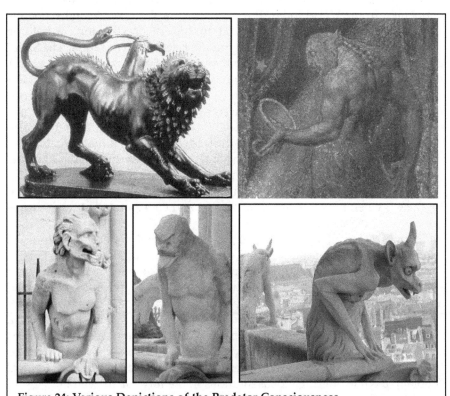

Figure 24: Various Depictions of the Predator Consciousness.
Above left: The Chimera is a hybrid creature embodying the Predator Consciousness and is symbolic of the 'beast' feeding off 'chaos'. Native cultures, through to artists like William Blake, have all captured their individual visions of the Predator Consciousness. Astrophysicists call these 'beings' pernicious angels or 'glueons', which are nuclear by nature. *Above right. Ghost of a Flea,* by William Blake (1819). *Bottom:* The three photographs above were taken at the 'Chimeras' gallery on Notre-Dame, Paris, France. They depict evil interdimensional sculptures of the Predator Consciousness (or the Jinn and Archons). © Neil Hague 2002

empower the 'shadow' through accepting division, war and suffering as part of life, then it is we who call the Predator Consciousness to our world. The web-like structure in the mind of the predator empowers elitism but it also conspires, through absolute power, to create systems that control how the world is run and has always been run since ancient times. The Predator Consciousness seeks to impose a dualistic 'world order' through fear, limitation and separation on both the individual and collective mind of humanity. It thrives off the us-against-them paradigm and expresses itself through `oppo-sames'[16] which are polarised (black against white) thought forms. In this state of mind we are like putty in the hands of a child, symbolic of how the Predator Consciousness can affect and shape our world to its liking.

All modern systems of banking, trans-national business, political and military structures at their highest level, are vehicles for the Predator Consciousness. They don't have to be so, but the very nature of what we see happening in the world today, through acts of war, genocide and economic globalisation, makes me question what 'insane', destructive force is holding the reigns of power in countries perpetrating acts of devastation. The Saudi attacks on Yemen, and Israeli government attacks on Gaza (over the years), for example, are beyond evil and predatory! In some cases, the Predator Consciousness possesses the mind of individuals who then commit atrocities, generating even more fear and terror-based 'emotional food' for its own consumption. Like Faust or Dr Jekyll, who turns from academic life to become the evil Mr Hyde, many world leaders live 'dual lives'. In all cases, the Predator Consciousness uses ancient systems, like the 'pyramid structure', to maintain its control over what we see and therefore think into reality. In other words, the matrix or what we see as reality, can become the predator's 'net', when power is based on secrecy and concentrated at the centre of the web, or the peak of the pyramid.

The model I briefly describe here, is of an ancient system that expresses itself through 'centralisation of power' and control by the few. This type of centralised imposition by the few on the majority, is not a new ideology, or even a conspiracy theory; it is the way all institutions have been governed since before Babylon through to ancient Rome. Today, centralisation of power, whether in Europe, the Americas or Asia, is *not a natural phenomenon*. At its core, it is more to do with **control** of basic human freedoms, such as what we eat, how we vote, how we live, and so on. It is the Predator Consciousness at work, creating fear through war and terrorism (global problems), while offering global solutions in the form of an even more tightly-controlled 'Big Brother' society. These are not conspiracy theories. `Theories' don't murder people, starve people, blow up buildings, maim children for life, supply drugs for arms, or assassinate charismatic public figures; placing corrupt politicians in positions of power. Only 'physical acts', planned (conspired) and orchestrated for desired effect, can achieve these things.

Mind Controling the Masses

There is considerable evidence that the few control the many, rather than the majority freely determining their own destiny. As I said earlier, I believe uniformity of the mind is the greatest invention of the few and the hardest task has been to impose it on an often unsuspecting public. Since ancient times we have been encouraged to believe in half-truths or outright lies regarding the real nature of who we are and the reality we call 'life on earth'.

Elite priests going back into antiquity were only able to control thousands of people and thousands of people's minds, by withholding the truth, releasing half-truths and then having the `truth police' stamp out any contrary thoughts. The Holy Inquisition was a perfect example of this type of mind control. In truth their descendants are still at it, all they have done is change their names (logos) and improved their methods. The end result is as always, to create a subservient mind, which fears to tread beyond the barriers of what the thought police have decided is socially acceptable. Assaulting the mind with one hand, while hiding esoteric knowledge with the other, is how these brotherhoods and their secret rulers have helped create an illness of the mind called the 'not-thinking-for-yourself syndrome', which in its extreme form creates the blind fundamentalist and the many *isms* we endure today. Mind control, in both its ancient and modern form, is the vehicle through which we are fed the illusion that we are 'free to think as we choose', but in reality, we are constantly 'told what to think'.

When anyone starts to challenge the illusion of freedom or of the possibility we are mind-controlled, they are instantly labelled as 'radical', a 'nut' or a 'troublemaker'. Terms like 'conspiracy theorist', 'maverick' or 'occultist' are used by 'experts' to marginalise and remove alternative ideas from main stream debate and discussion. Anyone who persists in exposing the mind control of the masses soon finds their character being systematically assassinated through the media (see David Icke). Sometimes they are actually assassinated by forces operating through global secret intelligence agencies and the military industrial complex. It is the very same media industry that allows advertisers to use subliminal messages, through use of colour, symbols and hidden text, to control the habits and behaviour of our children. All of which in the long term, can have an effect on how we think, what we eat and how we live our lives. Richard Salent, the Former President of CBS News summed this up when he said: "Our job is to give people not what they want, but what we decide they ought to have." The media industry, from newspapers to the world of cinema and television, are the modern-day tools of this priesthood of magicians. At the same time, our governments are openly involved in security and intelligence operations (vehicles for disseminating disinformation) and controlling the responses of the misinformed masses - all the while maintaining power for the elite. The fact that the very logo of British Intelligence is an Egyptian all-seeing eye above a trimunati (triangle), should leave us in no doubt that our mind-controllers understand ancient systems of power that prevent us from receiving **all** the information we need

to free our minds. The technologies used within the CIA, like the project *Mind Kontrol Ultra*, which has come to light over the years, can also be used to create a totally mind-controlled slave.[17] If this is true, it sheds new light on the so-called 'lone assassin' characters who appear and conveniently disappear after causing atrocities and mayhem in the public's collective mind! In fact, if we're talking 'mind control', the military is probably one of the most obvious forms of mind control on the planet. It's the "Yes, sir" mentality that often produces psychopathic killers, some of whom have gone on the rampage committing attrocities in many countries. More often than not, the general public hardly gets to hear about brutal crimes, like rape, sodomy and murder, often committed by soldiers stationed in foreign countries, that is, unless they 'make the News'. For more information regarding miltary involvement in crimes and the lack of investigation by governments turning a blind eye to atrocities caused by servicemen/women, I recommend articles by a brilliant researcher, Ellis C. Taylor, who hosts a website (*www.ellisctaylor.com*) dedicated to not only uncovering sinister forces behind missing children, but also exposing corruption involving the police and the military amongst many other esoteric articles.

Seeing Pyramid Power: the Shadow Government

The pyramid is an ancient symbol and the knowledge it provides has been used since ancient Egypt for structuring power, based on secrecy and control by an aristocratical, priestly class. This form of control which runs the world, is purely masculine on the surface; however, its real power lies at the heart of malevolent goddess-worship. The pyramid is the model controlling all businesses, banks, governments, religions, universities and the military. The few at its peak, the ancient gods, (through their predecessors, directors, Presidents, Prime Ministers, Royalty, and so on), instigate policies and agendas, which pass through lower compartments of the pyramid becoming laws for the masses to live by. On one level, the pyramid offers a template for organisation and the efficient running of any business or government. On another level, it is a perfect 'tool for secrecy' and 'compartmentalisation' as used by the hermetic temple orders of antiquity. In truth, the elite at the peak of the pyramid **are not** the Presidents and Prime Ministers of the world, instead, they are the emperors of the demi-gods; 'high initiates', who hide behind extreme wealth and land ownership. These figures are the puppetmasters and string-pullers of many a politician, political movement or dictator. It is the 'shadow government' and prime force behind terrorism, war, revolution and the trans-nationals that has taken over the planet's resources within the blink of an eye, with utter disregard for real democracy and the environment. The same trans-nationals also operate a slave-labour policy in many parts of the developing world, backed by a central world bank imposing economic strangleholds on governments, and therefore, people. People who would rather grow crops for their own communities, but instead are forced to produce 'high-margin' export crops they could never afford to buy back. Slave labour is rampant in the 21st Century because of the economics

of madness! Homelessness is too! According to the United Nations, as many as 1.6 billion people lacked adequate housing in 2015.[18] The figure is set to rise too, with more and more people becoming homeless both in the USA and the UK. No one should be homeless in a civilised society, but, if we are honest with ourselves, our world is not civilised, is it?

As always, money never seems to be a problem when it comes to war, or producing 'compulsory' ID cards, or building systems designed to further enslave the human population. The fact that all political spectrums from left to right, across America, Europe and Asia are pursuing the same imperialistic policies, should have the alarm bells ringing in a truly democratic society. Instead, the centralisation of power by the few, continues day after day through this pyramid structure, undetected and quite often denied. Noam Chomsky, writing about the threats to democracy by the power of the few and the trans-nationals in his book, *Rollback*, says:

> *Freedom, democracy, human rights and other threats to authority, which evolved through many decades of social struggle, are being rolled back in favour of the discipline of the unregulated market, resulting in predatory capitalism and the "nanny state" with its welfare for the rich.*[19]

All areas of the pyramid are controlled from the top and each compartment is kept in the dark as to what other compartments are doing. This creates the perfect vehicle for manipulating agendas, especially when high ranking Freemasons are put in positions of power to help coordinate what is known as 'The Great Work of Ages'. Secrecy is one of the main tools within any pyramid structure. The secret societies, like the Freemasons, are not only the 'mortar' that holds together the foundation of this controlling mechanism, they too have their roots in the worship of 'star gods' and 'goddesses', with ties to fraternities who worshipped them in the ancient world. As I update this book, a story was publsihed by the UK *Guardian* highlighting how two Masonic lodges have operated in secret, from within the Houses of Parliament, for years. Why are we never taught about these subjects in school, so to instigate more questioning of world affairs, history and politics? Because if we were, our eyes would be opened to the truth that our 'secret rulers' and the power-mad authoritarians who work on behalf of the elite, want so desperately for people to remain oblivious as to who really controls the world. This book is not about naming these figures, many books already do a good job in that area (see bibliography). Instead, coverage of this strand of the subject here is more about the 'systems, or 'knowlededge' used to keep humanity in the shadows. It is the symbolism I am most interested in, and by understanding the true meanings behind symbols, such as the pyramid, we can start to 'see through' the control.

The War on Freedom

The owners (demi-gods) of trans-national corporations have always been part of the ancient orders that have worked towards their own agenda – the

'Great Work of Ages'. In more recent years presidents and politicians, who are also working towards the same agenda on behalf of the shadow government, have called it the `New World Order', or the `New Western Order'. At the time of the Gulf War in 1991, George Bush Senior (an elite family) even used these words in his speech to the American public. His son later continued the Great Work of Ages, with the invasions that followed 9/11 in 2001. Since writing this book almost eighteen years ago, much more has unfolded politically. The Obama adminstration through to the Trump policies in the United States, are still working towards this New World Order. The Order I am talking of, has its roots in Sabbatean Frankism and Satanism; it is steeped in secrecy and uses magic to full effect. The brotherhoods still controlling the world economy and political classes were the creating force behind the European Union and the United Nations, both carry esoteric symbolism on their flags. They are the same force behind all tyrannies throughout our history and the warfare orchestrated to bring these global bodies (Superstates) into existence.

G8, Davos, especially the Bilderberg meetings since the 1950s, along with the Earth summits of 1992 and 2012, are all vehicles for the 'hidden hand' working behind the public faces we call world leaders. The elite order hides behind international Freemasonry, and in the late 1930s this clandestine organisation made public its desires for the creation of a `New Western Order'; not least through the funding and building up of the Nazi war machine in the same decade. In a resistance journal published in 1942, called '*Vaincre*' (Vanquish), the Prieuré de Sion (through its Grand Master, P. Plantard), set out its policies for what would become a 'United States of Europe', to aid in the creation of that `New World Order'. All this was happening while a war was being fought to prevent the takeover of Europe by a Nazi regime that also used esoteric symbolism on its `chivalric' regalia and wanted a European Superstate. European unity was the realisation of the same elite and the secret societies to which they belonged, who have used the pyramid structure to full effect for hundreds of years.

In truth, no one can fight for peace; using wars to bring stability and peace is insane. All war creates further instability, both economically and politically. When nations are in a state of chaos caused by war, what their post-war world becomes will depend on who benefited most from having the war in the first place. Who benefits from war? Certainly not the men, women and children who have their world torn apart by the insane. No, only one force benefits from having bloodshed, torture and devastation brought about by terror called war; this is the Predator Consciousness via its puppets who represent it on the earth. As Julius Caesar once said:

> *Beware the leader who bangs the drums of war in order to whip the citizenry into a patriotic fervor, for patriotism is indeed a double-edged sword. It both emboldens the blood, just as it narrows the mind. And when the drums of war have reached a fever pitch and the blood boils with hate and the mind has closed, the*

leader will have no need in seizing the rights of the citizenry. Rather, the citizen-ry, infused with fear and blinded by patriotism, will offer up all of their rights unto the leader and gladly so. How do I know? For this is what I have done. And I am Caesar.

The outwardly-male dominant force, which includes the founders of religion, banking and the military, has created the pyramid structure now controlling our world. In truth, these founding fathers (the elite) are controlled by their own gods who share the same agenda, now reaching its final outcome on the world stage. What is this agenda? It is the total (global) control of our lives by an ancient force, one that has always used terrorism, imposition and warfare to achieve its desired results. In all instances, both ancient and modern, we have been conditioned to see only 'good guys' and 'bad guys', when in truth, both ends of the scale are part of the same source (force).

A Word About Europe

Europe *is* a fully-fledged, covert dictatorship. It is moving quickly into the Superstate it was intended to be when it was conceived with the Treaty of Rome (25th March, 1957). Most Europeans have never been told the truth about the European Union! The 2016 UK Referendum was pitched at those wanting to free themselves from the supposed 'hoards of immigrants' and 'endless payments to the EU' via central government. The usual 'political spinning' went into overdrive with the typical blaming and shaming, lying and fraternising that *is* politics. All parties failed to point out the obvious to the masses: any payments to the EU (with money that is ours) is merely distrubuted back to nation states in the guise of 'EU funding'; with legal 'penalties' and 'strings attached' to these handouts (sorry, 'funding'). As one chief accountant for a northern council in the UK told me, "There is *no* EU funding from that perspective"! and there is no real distribution of wealth.

There was also **no debate** about the 'tyranny' that *is* the EU and the **centralisation of power** towards a 'corporate superstate' run by the likes of Goldman Sachs and the Zionist banking elite. The real Brexit should have been about 'freedom from tyranny' and the reversal of the fast-moving pace towards all things centralised. Not least the creation of the EU army which was announced within the same time period as the UK voted to leave the EU. The European Union's rapid reaction force (its army) would be created to fight in more unjust wars (see NATO), just as the UN was created to 'pursue conflict' under the guise of 'peacekeeping'. If you think all this sounds ludicrous, then just ponder for example, the United Nations' achievement in actually 'keeping the peace' and then compare it to the number of wars in `trouble-spots' in which this organisation has actually fought and participated in since its creation. In fact, the 1990s saw a new peak in the annual number of wars being attended to by the UN. According to John Rees in his book; *Imperialism, Globalisation, The State and War* (2001), there were 34 conflicts in 1992, and in 1994 the highest number of war-related deaths were recorded

since 1971. The unstable and violent climates witnessed in Iraq, Somalia, the Balkans, Rwanda, Liberia, Turkey, Chechnya, Angola and Algeria were more to do with long-term global economic and political processes brought about through the centralisation of power. Look what has happened since Rees wrote his book? We have endured the nonsensical 'war on terror' ('war on terra firma'), or war against earth. Since 2001, we have seen the fall of Iraq, Libya, Yemen and Syria, with Iran and North Korea now in the Predator's scope. All these countries were listed in the infamous '*Axis of Evil*' speeches made by George W. ('Boy George') Bush, and named in documents created by the *Project for a New American Century* (PNAC), months before that fateful event in New York. The scope of this book is insufficient to go into detail on such areas, but if anyone is interested in finding out more, there are many excellent and well-researched books written over the past sixteen years documenting the 'conspiracy' that *was* 9/11 and all that has happened since.

In the next chapter I will focus on the 'hidden symbolism' and structures 'used' to shape our world (our reality).

Sources:

1) Extract from an article in the *Star Tribune* By Jeff Strickler.USA. January 14th 1996

2) *Dictionary of Egyptology*, Rockhampton Reference. 1970. p54

3) https://en.wikipedia.org/wiki/Roman_emperor

4) Monks 'torture pupils'. Article by Kirsty Scott. *The Guardian*. Monday January 8th 2001

5) French bishop, priest, found guilty in pedophilia case. source
http://sg.news.yahoo.com/010904/1/1e53e.html CAEN, France, Sept 4 (AFP) -

6) The etheric is sometimes used to describe the spiritual side of humanity, the finer body that is directly connected to the physical one.

7-8) Roll, Michael; *Censored in Great Britain Pamphlet Scientific Proof of Survival After Death* p7

9) Ibid, p2

10) Krishnamurti, *Education and the Significance of Life*. Victor Gollanz Ltd. 1992

11) Gatto, John Taylor. *Dumbing Us Down, The Hidden Curriculum of Compulsory Schooling*. New Society Publishers. 1992. p12

12) Brewer's *Myths & Fables*. 2009. p60

13) See the work of José Argüelles. His work looks into the real meaning of time and whole-systems mathematics.

14) Haymlin, Robin, Phillips. *William Blake*. Tate Trustees. 2000

15) Blake, William. *Europe: A Prophecy*. 1794. Plate 5, 6 and 13.

16) `oppo-sames' is a term used frequently by author, David Icke, to describe different belief systems that are not different at all.

17) See the work of Cathy O'Brien & Mark Phillips, *Trance-Formation of America*. 1995

18) www.futurism.com/1-6-billion-people-lack-adequate-housing-heres-how-we-can-fix-this/

19) Chomsky, Noam. *Rollback: The Return of Predatory Capitalism*. Alternative Press R. 1996. p43

Hallmark of the Gods

The Art, Symbols & Myths of the Elite

"No great artist ever sees things as they are;
if he did, he would cease to be an artist."
Oscar Wilde

A rt and esoteric knowledge have been used since ancient times to create fantastic structures that speak of the heavens on earth. The pyramids in Egypt and South America are fine examples of art and advanced science combined, to harness both masculine and feminine energies; to create power structures for the ruling elite. These power structures are still with us today and can be observed in the art and architecture commissioned by the same elite families of the ancient world. The elite I refer to are the 'patrons and priests' of the high arts, from Rameses, through to the De Medici bloodlines, who have provided us with 'brotherhoods' of priests and historical court painters. Many historical artists were members of the highest esoteric orders. The House of Medici, not least Cosimo de Medici the Elder (1389-1464), was the real force behind Leonardo da Vinci and the Italian Renaissance. In fact, Michelangelo Buonarroti (1479-1564), the painter of the Sistine Chapel ceiling, was the best friend of Pope Leo X, who happened to be Giovanni Medici! As with much of the art and religious refurbishments of this period, it was the 'masculine mystery schools' at work, quite often hiding behind, as we shall see in this chapter, the goddess and her ancient symbolism.

Symbols of Gods, Goddesses & Hierarchy

As mentioned in the last chapter, the watchman for the gods, in Norse mythology, was called Heimdall or Rig, who was said to have fathered the system of 'hierarchy'creating three points or categories of men. These were the slave (Thrall), the freeman (Karl) and the priestly class (Jarl). The symbol of Heimdall can also be found on the Hierophant card in the Tarot; meant to signify 'authority over others'. Jarl was said to be his special son, the first of the patriarchs and the priestly class who would communicate between the peasants and the gods. The lineage of Jarl is said to be that of the priest-king or, Pharaoh; a lineage who were given 'divine right to rule'. In symbolic terms, it is the ancient lineage of Jarl (magicians, priests and kings) who have used the occult and war since ancient times, as a vehicle for controlling the sons of Thrall and Karl. The three points (Jarl, Thrall and Karl) form the pyra-

mid structure allowing the servitude of the masses to continue into the present day, disguised!

The pyramids of Egypt are said to line up with Orion's belt and Sirius, both heavenly depictions of the god, Osiris and goddess, Isis.[1] The obelisk is said to be a male solar symbol (Osiris) and the dome, a female solar/lunar symbol (Isis). American Indian Mimbre pottery even shows what seems to be Orion, who like Osiris (or Min), is depicted with a huge penis being held up by three lesser figures; possibly Orion's belt stars (see figure 25). Yet within the ancient use of symbols the female, or goddess, always plays a more significant role behind the scenes. So does Orion symbolism, as I will address in the next chapter. The high priestess of civilisations like that of the Maya and the Carthaginian colony of ancient Spain, all revered the same goddess through the Lady of Elche, Ishtar and Isis. The connections between Isis, Lady of Elche, Semiramis (the Black Madonna) and the five-pointed star symbolic of Sirius, also feature predominantly in Freemasonry, a secret society I will also address shortly. Obelisk monuments can be found in all major cities of the most powerful countries in the world. There is the largest obelisk in the world in Washington DC (see figure 26) and several in Rome (the Vatican), not to mention the real monuments stolen from Egypt, that now stand in London and Paris (see figure 26). The tower housing the bell, Big Ben, in the Houses of Parliament is also an obelisk. So is the financial building at Canary Warf in London, which is similar to many other World Trade Centres around the world. I have often asked myself if the Senate of Ancient Rome are any different to the now Senate in Washington? Capitol Hill in Washington DC, compares to Caesar's Capitoline Hill of Ancient Rome, symbolic of the few (the ancient gods) holding power at the peak of the pyramid! The same esoteric knowledge used to design the Fascist Roman Empire (the Old World Order) was also used in the design of Washington in the District of Columbia (the New World Order). A matrix of occult symbols like the 'Pentagram', 'Star of David' and pyramid, amongst many others, can be seen in the street plans of Washington and Paris. They were designed by French Freemasons Pierre Charles L'Enfant, and La Fayette, and dedicated to this ancient order. The researcher David Ovason, in his extensive study into Freemasonic symbolism, shows how the street plans of Washington are based on ancient Egyptian stellar lore and Masonic mythology.[2] Charles L.Westbrook Jr., in his book *The*

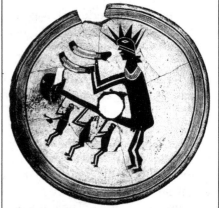

Figure 25: The Penis of Osiris (Orion). An 11th Century AD Mimbres plate showing Osiris (Orion, Min). The three figures holding the Obelisk (penis) could be the belt stars of Orion.

Figure 26: The Obelisk.
(left) The Obelisk housing Big Ben on the Houses of Parliament. *(middle)* The Washington Obelisk Monument. *(right)* The Obelisk from Luxor in Paris at the Place de la Concorde.

Figure 27: The Statue of Liberty?
This is a replica positioned on the Pont-de-Grenelle in the River Seine, in Paris, France. A copy of the goddess was given to the USA by French Freemasons.

Talisman Of The United States, Signature Of The Invisible Brotherhood, shows how roads in Washington relate to the points where the sun rises at the winter and summer solstice. In other words, the same ancient knowledge of sacred geometry and hermetic magic used in the construction of places like Stonehenge, the pyramids, earth mounds and temples was also used in the city plans of places like London, Paris and Washington.

Paris was referred to by the Romans as 'Juxta Isis' or 'Par Isi' which in Latin means near Isis.[3] According to historical records, where the abbey of St. Germain-de-Pres stands today, there was once a temple dedicated to the cult of Isis. The Goddess Isis is also the symbol behind 'Our Lady of France' (war and revolution), the Statue of Liberty, including the blazing star of Sirius that crowns this goddess (see figure 27). Napoleon Bonaparte (a high-ranking Freemason) was said to have set up a special commission to link Paris with the Egyptian 'virgin star goddess', Isis. So did Baron George–Eugéne Haussmans who, at the behest of Napoleon III, massively transformed Paris in the 18th Century. This culminated in a formal order by Napoleon to have a statue of Isis seated on her throne (with the star of Sirius placed on the coat of arms); situated in the City of Paris. In cities like Washington and Paris, monuments are specifically aligned to coincide with the 'passage of the Sun' and ancient Sun ceremonies. St. Michael and St. George are figures associated with the Sun, the Holy Grail (elite bloodlines) and the ancient orders of knights that emerged at the time of the crusades. The Arc de Triomphe or Place de L'Etoile (the Place of the Star) is located on an axis which includes the Louvre Palace, the Capstone of the original Egyptian obelisk at the Place de la Concorde, extending far west to the Grand

Figure 28: The Arch de Triomphe.
A sun symbol at the centre of a grand geo-
metric pattern in the street plan of Paris.
The twelve roads feeding into the Etoile
are symbolic of the 12 signs of the zodiac
circling the sun. All of these monuments
are connected to Freemasonry and the elite
brotherhoods of antiquity.

Arc of La Défense (Arch of the
Brotherhood, see figure 28). On the
8th of May, the feast of St. Michael,
it has been noted by historians that
the setting sun deviates twenty-six
degrees northwest in alignment
with this axis.[4] According to Robert
Bauval in his book *Secret Chamber,
the Quest for the Hall of Records*, the
star of Sirius as seen from the lati-
tude of Paris, also rises twenty-six
degrees southeast. Discoveries of
this nature are no surprise when we
consider the alignments with stars
and temples of the past, also dedi-
cated to ancient gods and goddess-
es.

Heraldry is 'Hereditary'

The heraldic art of 12th Century
Europe has all the hallmarks of ancient kings, princes and rulers boasting of
their divine connections with the gods. The symbolism in heraldry is no dif-
ferent from the symbolism used on sculptures and stellas in ancient civilisa-
tions like Sumeria and Egypt. As always, it was the 'ideas' and 'messages'
hidden within heraldry that spoke of a family's true heritage.

Native Americans decorated their shields with an array of animal, birds
and god-like figures. And in Ancient Greece, shields and armour bore a wide
variety of tribal figures. Aeschylus (500 BC) recorded lions, boars, fish and
other objects on the shields of warriors who attacked Thebes. Rome's legions
had insignia, as did early Teutonic peoples who attacked Rome. In much
later periods, the Normans and Saxons also decorated their shields and ban-
ners with beasts, crosses, stars and other icons of heritage. The Samurai of
Japan used emblems and many of their insignia, or Mons, related to the stars,
notably the Plough and Orion.[5] Students of heraldry are taught that ancient
insignia differs from that of 12th Century heraldry, inasmuch that ancient
insignia were created to establish identity of an individual, or of a bloodline.
It is probably true that the system of heraldry was developed to help regi-
ment armies and to decorate their military organisations; yet, it too, was an
obvious hallmark used by various bloodlines and their god-kings who can be
traced back to ancient times. As J.P. Brooke-Little writes in *Boutell's Heraldry*:

> It is true that some of the emblems found in ancient symbolism have survived to
> take their place as devices in heraldry. For example, the British tribal emblem of
> a dragon became a supporter of the Royal Arms in Tudor times and is still the
> badge of Wales.[6]

I suppose the Red Dragon of Wales gives the game away, especially when one notices the same dragons and flying serpents adorning ancient temples, gothic cathedrals, and stately homes; not to mention the financial centre of the City of London. Many other emblems, like that of the fleur-de-lis and the lion, are also ancient insignia for royal bloodlines that have ruled since the time of Sumer. This is why many insignia have survived on royal crests and coats of arms to this day. Other heraldic charges like that of eagles, cocks, serpents, monsters, panthers, unicorns, mermaids, bees, escallop shells, crescent and star symbols are also found in the ancient world to represent the gods, and their bloodlines. Other insignia relate to knowledge of star systems, planets, the occult and 'invisible forces' said to influence our reality. The lion, panther, jaguar and dragon are all representations of the reptilian gods (royal race), or what the Aztecs called: 'Lords of Xiballba' (Underworld). Crosses, trees, suns and stars are symbols of the sacred fire (knowledge) revered by the ancients. Many of these icons also found their way onto the insignia of various knights' organisations emerging at the same time as heraldry. The Knights Templar and Teutonic orders carried ancient symbolism that spoke of their god-kings and knowledge they inherited from the magicians (priests) of Egypt, and Sumeria. Adolf Hitler was even depicted as a Grail Knight on propaganda posters in 1936, which in my view, reveals the true nature of these ancient orders and extreme lengths they have gone to, to create their 'New World Order'. One of their most prominent symbols, which can be traced back to ancient Egypt, is the all-seeing eye. This motif would become the insignia of the biggest secret society of today, the descendants of the knights of heraldry, in other words: the Freemasons.

Freemasonry and the All-Seeing Eye

While the pyramid provides the wall-like (prison) structure, the all-seeing eye represents esoteric knowledge hoarded by an 'illuminated' priestly class. I believe this to be the knowledge used to suppress and condition our creative potential. As always this is effected through setting narrow boundaries of acceptable thought and behaviour initially through religions, and in more recent times, through media, politics, economics, education, and so on. This structure allows the few to impose limitations on how 'the many' think, and therefore create; in its widest sense, I would call it 'mind control'.

The global Freemasonic structure is huge and plays an immense part in the running of business, education, politics, banking and the military all over the world. Each President and Prime Minister belongs to this organisation in some shape or form. The whole basis of Freemasonry (at the highest levels) is hinged on secrecy, oaths and a refusal to impart ancient hidden knowledge. Joseph Fort Newton, writing in 1916, held that Freemasonry did not evolve from guild masonry. He wrote: "Freemasons existed in large numbers long before any city guild of Masons was formed".[7] According to Newton, the Freemasons were a `superior group' that occasionally hired rough masons from the guilds to carry out work on buildings and temples.

Freemasonry as an ancient fraternity is also littered with the same god and goddess symbols. The compass, the star and the laurel wreath, each relate to architecture and the building of temples and hierarchy. The laurel wreath is a major symbol for this brotherhood and is found in organisations like the United Nations, which is just another front for a global government in the making. Freemasonry, like its ancient brotherhood relatives, also worships deities through sun and moon symbols including the blazing star, obelisk and the dome. The commonly used masonic compass and square are said to be symbolic of the male sun impregnating the female earth. Others writers relate the compass and square symbol to the Sigil*of Saturn'. At an even higher level of initiation above 33 degrees (Sovereign Grand Inspector General), this symbolism relates to elite bloodlines and couplings between extraterrestrials and daughters of earth (humans).

Numerology and number symbolism are important to the Freemasonic secret society networks and in truth these relate to the science of star and sunworship practised by the ancients. Civilisations like the Maya and the Egyptians had a higher understanding of the cycles of 'electro-magnetic' activity taking place on the sun. Such activity is referred to as 'sunspot cycles', studied as a science and taught through 'numbers' (symbols) in the secret societies of Egypt and South America. In fact, certain symbols that seem to relate directly to freemasonry, like that of the 'blue hand' or 'blue degree', are also found encoded in the symbols of the Maya in South America, as are the compass and set square symbol, too. The ancients knew how magnetic cycles of the sun affects all life on earth, creating fertility (and infertility) in humans, depending on when the sun and the earth's magnetic fields are mutually coupled. Secret societies that worshipped the all-seeing eye (the saturn-sun relationship), did so through the use of numbers, art and rituals. Numbers like 9, 11, 13, 23, 33 and 39 all relate to the epicycles of planets and sunspot cycles on earth; they have been used in many secret committees, word associations, company titles, and periods of time (years) for magical and esoteric effect. *Nine* especially, is a number found repeatedly encoded in the tombs of god-kings like Tutankhamun, and that of Lord Pacal, at Palenque in Peru.[8] As a number, it is said to conceal astronomical information including secrets about how time and space is structured on earth. I'll come back to the number nine later in the book.

Numbers, Codes & 'Ordo Ab Chao'

The number 23 is also important to the secret society networks. It seems that '23' appears consistently in symbolism within movies, politics and ancient calendars. The association of 23 with 'physical immortality' was developed in the writings of Aleister Crowley and Robert Anton Wilson; it is called 'apophenia' (a tendency to perceive connections and meaning between unrelated things) by psychologists. However, there are many number codes (23 being merely one expression) that correlate with 'seeing' the matrix or illusion at work.

* In medieval ceremonial magic, the term 'sigil' was commonly used to refer to occult signs which represented various angels and demons which the magician might summon.

The ancient Egyptian and Sumerian calendars began on 23rd July, connecting to the rising of Sirius, something I will come back to shortly. The 1998 German movie, *'23 – Nothing is what it seems'*, and the Jim Carey film *23*, are both based on people with supposed apophenia. The former is about a 'computer hacker' who dies on 23rd May 1989. In the opening code sequence of the film *Matrix Reloaded*, the final, most prominent number is 23 reversed, as if looking from inside a mirror. A reversed 23 could also be '32' which is the double-headed eagle symbol for the Scottish Rite of Freemasonry. The prime numbers '2' and '3' together (to form 23), relate to 'creation numbers' and, in *Matrix Reloaded*, Neo (the prime man), was told by the Architect (Freemasonry again) that he could select '23 humans' to rebuild Zion, in order to continue the matrix. Interestingly, 23 is the width of the *Arecibo* message, sent to space in search for 'extraterrestrial intelligence' and is also the atomic mass number. Normal human sex cells are said to have 23 chromosomes (other human cells have 46 chromosomes, arranged in 23 pairs). *Psalm 23*, also known as the *'The Lord is my Shepherd Psalm'*, is possibly the most quoted and best known Psalm from the Bible ... The list goes on for those with apparent Apophenia! Interestingly, in March 2018, '23' Russian diplomats were 'expelled' from the UK due to a 'supposed assassination' of ex Russian spy, Sergei Skripal, and his daughter, in Salisbury. Why weren't 17, 19 or 21 diplomats expelled? Why 23? It seems clear to me that the '23 enigma' is connected to 'mind-magic' (spells), aiding in reinforcing the 'control', or the agenda, to bring about a 'new order' by elite 'magicians' working behind the scenes.

The highest degree of Scottish Rite of Freemasonry, the Meritorious Degree, is the 33rd Degree, or the Degree of the Illuminati. Their motto is 'Ordo Ab Chao' or, 'Out of Chaos Comes Order', meaning if they (the Illuminati/elite) break down existing society through enough wars, acts of terrorism, economic collapse, and so forth, they will cause the population to cry out: 'Something must be done – this can't go on'. The response to public demand, would be to offer already-planned solutions bringing in the new law, act or order. In truth, the elite are carrying out the wishes of their ancient gods that want a 'robot population' living in total servitude, and linked to a global computer via a microchip in the human body. Researchers like Robert Howard, Fritz Springmier and H.J. Springer have detailed evidence of this Masonic obsession with esoteric code. Howard talks of the use of esoteric codes (which also contain certain vibrations) in setting political agendas, creating organisations, acts of terrorism and/or starting wars through the use of numbers 13, 11, 9 and 33. He writes:

The numbers 3, 7, 9, 11, 13, 39 and any multiple of these numbers have special meaning to the Illuminati. You know that the original number of states in the United States of America was 13. The Constitution has 7 articles and was signed by 39 members of the Constitutional Convention. The following chronology shows that, from 1776 onward, significant events pertaining to the plan for a New World Order did occur every 13 years culminating in the founding of the

United Nations in 1945, exactly 169 years (13 periods of 13 years each) after the year 1776.[9]

Harry S. Truman, as the 33rd President, this 33rd degree Mason initiated the Nuclear Age, the crowning success of alchemy, when the first A-bomb exploded at the 33rd Parallel Trinity Test Site, (Almagordo) White Sands, New Mexico. He was responsible for the killing of thousands of Japanese (the Yellow Peril) at two cities close to the 33rd Parallel, Hiroshima and Nagasaki. On July 8, 1947 a UFO and aliens' bodies were allegedly found in the desert outside Roswell, New Mexico at the 33rd Parallel.[10]

Freemasonry is a cesspit of deceit and hypocrisy at the highest levels. The oaths made in lodges all over the world, override any made to a country, or people, as a leader or president. Think of that the next time you see leaders, presidents or prime ministers parroting cue cards about freedom and democracy, while standing shoulder to shoulder in manufactured wars that slaughter innocent men, women and children. Their real identities are revealed, horns and all, when they propose to stand for a caring and free world, while always thinking of ways to wage war on planet earth. Was the terrorist attack on New York in 2001, which was understandably an horrific event for all victims and their families, really any different to the horrific atomic attacks by the force behind the American government, on hundreds of thousands of Japanese civilians in 1945? Answer: No. Are we really expected to believe that an 'eye for an eye' and a 'tooth for a tooth' will cure the world of all evil? Again: No. 'Fighting' for peace is a ridiculous idea and if we are at war against terrorism since that crime (not war) began in New York, in 2001, then how come the same anger is not being directed at the endless list of terrorist organisations funded by the likes of the United States in the first place? What will follow? A war on war! Anyone with a curious, reasonable and intelligent mind must surely see that the most serious threats to the planet and our children's future, are world leaders who have no regard for life and freedom in this so-called 'free' and democratic world. Yet we, as people, are also responsible for these atrocities because we give our power away to the so-called 'good guys' by refusing to get informed about what is really going on in the world. If we bother to research at the time of any atrocity, rather than accepting the 'official line' (the News), what we often find is that both 'good guys' and 'bad guys' in any scenario, are actually part of the same mentality. I think it was the French philosopher Voltaire who said: "All it requires for the forces of evil, bigotry, superstition and ignorance to keep their grip on the minds of people is that good men and women continue to do nothing." The pyramid of deception, outlined briefly here, keeps a tight lid on the truth about religion and who really controls the world, and we continue to do nothing about it. Above all, our self deception keeps hidden the knowledge that could empower our lives beyond belief.

Scarlet Councils

In the ancient world, a symbolic language existed that used art and esoteric knowledge to a high degree. Egyptian hieroglyphics are clear examples of this symbolic language. The Mayans, along with other ancient cultures, also created symbols that observed sun cycles and the change in magnetic energy fields of the earth. The sun, moon and the serpent were worshiped by high initiates of the Babylonian, Sumerian and Egyptian mystery schools, so to 'harness' archetypal energies they believed would bestow wisdom on the chosen initiates. Ceremonies were performed to pass on truths about 'magic' and the gods, to those who would continue with the Great Work of the Ages. The ancient priesthoods were literally ruled by the gods. Sun and fire ceremonies (which included human sacrifice) were performed by the mystery schools in the ancient world, to directly 'link' participants with 'demons' and 'lower fourth-dimensional entities'. On another level, some ceremonies forged links with archetypal forces that inspired the mind controlling religions of the world; all of which would go on to wreak havoc in the realms of the human soul. Vibrational pacts with demons (gargoyles), I feel, still go on today within the Masonic brotherhoods and 'global satanic' networks at the highest levels. Back in the 1990s, I was once shown around some Masonic lodges in Birmingham (the Clarendon Suites), and the dark, gut-wrenching energy trapped within those rooms almost took my breath away. Goodness knows what the higher level lodges must be like? Is it too much of a strain on the imagination to see certain world leaders forming pacts with demons in ancient ceremonies, so to deliver the soul of the planet (us) to these forces? How many wars, created by 'possessed' leaders and dictators, must we endure, never mind all the bloodbaths of the past, for us to realise what is going on and what 'forces' are manipulating our reality on earth?

From Babylon to Rome, over several thousand years, the masses were manipulated into believing superstitions and taking symbolic stories literally, while chosen initiates were given the 'real knowledge' on penalty of death should ever that knowledge be revealed. In this way, the truth about life, history and our human creative potential were lost to the population; reserved only for the few, the elite! Regarding these initiates, Manley Palmer Hall wrote:

> *Thus black magic dictated the state religion and paralysed the intellectual and spiritual activities of the individual by demanding his complete and unhesitating acquiescence in the dogma formulated by the priest craft. The Pharaoh [Prime Minister/President] became a puppet in the hands of the Scarlet Council – a committee of arch-sorcerers elevated to power by the priesthood.*[11]

The priestly class of Babylon worshiped the sun, saturn, planets and the stars focussing on their multidimensional power over time, and therefore 'reality'. So did the aristocracy of Rome, including the creator of modern Christianity, Constantine the Great, who worshipped 'Sol Invictus' (the unconquered Sun). As I mentioned in the previous chapter, Constantine also worshiped the

Greek god, Apollo, Helios (Saturn); remaining to his death, the Pontifex Maximus of the Pagan Church. The highly-secretive Order of Comacine Masters, which flourished during the reigns of Constantine and Theodosis, was the important link between the Pagan mystery schools and the Christian cathedral builders. The Comacine Masters, like the later Freemasons, used sun (and star) symbolism in their art and architecture. Even royalty went so far as to use the Sun in their title. For example, it was the Sun god, Apollo, who was supreme at the court of Versailles where he was symbolised by the French King, *le roi-soleil*, Louis XIV. The Celts also had a Sun Goddess called 'Sulis' a name derived from 'suil', meaning `eye' and `sun'. Both these symbols appear within art on ancient temples and in Freemasonry, especially on the reverse of the American one dollar bill. There is much more to these symbols as I will address shortly.

Sirius and the Lawmakers

Much research suggests that almost all the major world religions were creations of a sun and star-worshipping priestly class. After the destruction of Atlantis, priests emerged in the surviving colonies of Egypt, Sumeria and South America to take control of various native beliefs (which included sacrifice to their gods). It's possible the same priesthood, centred on the Near and Middle East, emerged to create religious foundations of cultures like the Sumerians, Phoenicians, Cimmerians, Scythians and Celtic tribes. According to official history, it was a white Aryan race from the Caucasus mountain region which moved into the Indus Valley of India about 1550 BC and created what is today known as the Hindu religion. It was the same Aryan race (called Arya) which introduced the ancient Sanskrit language to India, and the stories and myths contained in their Hindu holy books, *the Vedas*. As I have already mentioned, it was a mysterious Caucasian race that brought advanced knowledge to the Inca and Peruvians of South America. Beliefs in Nordic-like supermen also influenced Nazi ideology in Germany, especially through the Thule Society, but in truth, the worship of a mysterious Nordic race can be found in the myths and beliefs of many indigenous cultures. The Nazi's twisted the legends to suit their own agenda. Like the South American Aztecs, Aryan Indians also worshipped the sun as the Father-god Indra, and the Hittite-Phoenicians called their Father-god: Bel or Indara. Under many names, the same Aryan tribes settled in Sumer, Babylon, Egypt and Asia Minor (Göbekli Tepe), taking with them the same stories, myths and religion. It seems these cultures stemmed from an earlier, more global civilisation, possibly Atlantis, which followed a similar religion centred on sun worship and the 'blazing star' – Sirius.

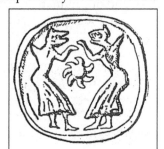

Figure 29: Sirius Worshipping Lizard-like Goddesses. Taken from a cylinder seal, Crete, 2000 BC

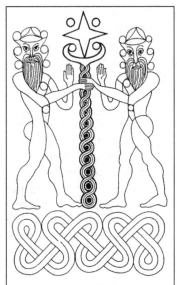

Figure 30:
The Watchers of Sirius.
A drawing of a Hittite
Syrian Seal showing two
'Sirian Watchers'. They look
remarkably similar to the
Watcher I painted in 1994,
before I knew any of this infor-
mation (see page 57).

The symbol of the blazing star (figure 29 and 30) found in both Egyptian and Freemasonic works is said to be our sun. However, it is also symbolic of the brightest star seen from earth, Sirius, which rises behind Orion in the constellation of Canis Major. The stars of Sirius represent two dogs following at the heels of Orion, who is described as the hunter in various myths. (I'll come back to Orion in more detail in the next chapter because the connection to earth's sun (or suns) is significant.) Sirius was also referred to as the Dog/Wolf Star, and much focus on this star, and the fire ceremonies associated with it, is found at the heart of many ancient civilisations. The name 'Sirius' comes from the Greek word meaning 'searing' or 'scorching' and was thought to be the source of all heat by the ancients. The sweltering `dog days' of high summer were attributed to this star, especially when Sirius came close to the our sun in the month of June. The Dogon tribe of Mali in Africa, also worshipped Sirius for thousands of years and authors like Robert Temple claimed that they knew of Sirius B before it was officially discovered by American astronomer, Alva G. Clark in 1862.[12]

In Normandy, up until the first half of the 19th Century, ceremonial chiefs and kings would be chosen on the 23rd of June on the Eve of Saint John (23 again). It was a tradition carried out by a mystery school called the 'Brotherhood of the Green Wolf', who are mentioned in the 2001 French film, *Le Pact le Loup*. As with the Teutonic Knights of Saint John, they too, would elect a king of the 'double axe' (another symbol for Sirius) on the very same day of June each year. It is said the Green King or Green Wolf was symbolically reborn by the fire on which an effigy of the future king would be thrown.[13] This ritual is so close in theme to the story of Nanahuatzin and Tecuciztecatl of Central American myth (I mentioned in *Chapter One*), and the sacred fire said to have birthed Quetzalcoatl (Venus) at the beginning of the Fifth Sun (Age). More than likely, this was the same deity (god-king) under different names, one who inspired a global policy of human sacrifice to these gods. Ritual sacrifice using fire and wolf-snake symbolism, is also linked to the gods and the Aryan Babylonian Brotherhood, who, like the druids and Teutonic priests, also paid homage to Sirius in their ceremonies. Tolkein's Istari brotherhood of wizards and elves characters created in his books, *The Hobbit* and *Lord of the Rings* (along with Gandalf, Saruman and Radagast), I

feel, are based loosely on the legends of Atlantis, Sirius, and Orion.

The Egyptian calendar was regulated by the movement of Sirius and what is called the 'Sothic' Calendar. The Sothic system was founded on the rising of Sirius one minute before the Sun, and became known as the 'helical rising'.[14] The number 23 was important to the Dogon, Egyptians and the Babylonians. Some researchers have pointed out that this connection relates to the helical rising on July 23rd, when Sirius, Earth and the Sun are in alignment. Others speculate the alignment could create a `stargate' or an interdimensional portal between two worlds. Interestingly, the *Wingmakers* Chambers mentioned in *Chapter One* also numbered 23 capsules, (forming an overall time travelling machine). Similar themes were touched on in the Sci-Fi movie, *Stargate* (1994). What is becoming more obvious is that common religious themes, and the gods associated with them, are stretched across different cultures covering great geographical distances in ancient times. For example, both the Hopi Indians of North America and the ancient followers of the Biblical character, Abraham, were given commandments on stones or slates (usually by a fiery sun deity), showing how to live as a `chosen' people, tribe or clan. The Holy Slate of the Hopi Bear Clan is said to explain how humans can achieve and maintain a life in harmony with the universe. It was given to the Hopi as a symbol of brotherhood (possibly by Phoenician Cabeiri priests?), to aid the six main clans of the Hopi on their migration into the Fourth World (our current world age). The notion is not so far-fetched considering the Phoenicians reached Mesoamerica before 1250 BC. The symbols on the slates represent Sirius, the Sun, Moon and Earth, all of which were worshipped by the Phoenician and Indian brotherhoods. It also seems the Hopi Fire Clan were given slates by a god, or prophet, called Pahána, referred to as the 'lost white brother', possibly from a Celtic or Phoenician background. According to their prophecies; the teacher, Pahána, would return in the times we are now living through to bring a 'missing piece' of the original slates he gave to the Hopi spiritual leaders. The re-emergence of ancient spiritual knowledge and the uncovering of hidden truths through lifting the veil, is symbolic of the return of Pahána to the Americas.

It was in Babylon, the ancient capital city of this Aryan priesthood and hierarchy in 586 BC, that the then captive Hebrew priests (Levites), relations to the Phoenicians, began to create a plagiarised history and spiritual law that obscured many truths. The Sumerian Tablets prove beyond question that *Genesis* was a much-edited and condensed version of earlier Sumerian records. The story of Moses, for example, being found in bullrushes by the Egyptian princess, was the same story told by the Sumerians about King Sargon the Elder. The Babylonians said that God gave Nemo, the lawgiver, the tablets (slates) of the law on a mountain top. The `Syrians' (name gives it away really) also had a character called 'Mises' who did everything the *Old Testament* attributed to Moses. Like King Sargon, Mises was also found floating in a basket and later given God's law on stone tablets. In Egypt, Ra-Haraldhti was another Moses character and giver of codes and laws. These laws seem to have been updated in many parts of the ancient world becom-

ing known as the *Hammurabi Code*, named after King Hammruabi who ruled Sumer in the second millennium BC.[15] The code itself seems to be much older and is said to go back to the fire/sun deity, Indra/Thor/St. George, who was supposedly the first King of Sumeria in 5000 BC. Like many later Jesus-figures and 'sun gods', Moses and the Jewish patriarchs were regarded as hero figures from much earlier civilisations. The symbolism relating to 'shepherds' and 'shepherd kings' in the Bible, relates to ruling bloodlines of the gods on earth. Just as books are turned into films, and some films become a spin-off movie, so it was with the 'religious recycling' taking place in ancient Babylon and later, Rome. Levite priests recycled stories of gods and pharaohs to suit their own needs. Just as the *Seven Samurai* (1954) of Japan became the *Magnificent Seven* (1960) of American West legends, the gods (or heroes) were dressed slightly differently and presented to the populace as being an original tale!

Goddess of the Cave and the Black Madonna

Hidden within religious iconography, if one looks closely enough, are numerous symbols, sculptures and esoteric imagery revealing the true essence of the icon. You could say these are your 'ancient eyes' at work; seeing through many layers of half-truths presented as `the only truth'. While travelling to many sacred sites over the years, I have seen more and more evidence of the true origins of religion contained within the art and symbols of secret priesthoods and the brotherhoods that commissioned great cathedrals. Personally, it does not matter to me what one chooses to believe, that's none of my business, but other points of view, other 'visions' of our past need to be talked about, so that we can have a balance in what we choose to believe. Whether you see yourself as a Christian, Jew, Muslim, Pagan or whatever, once you refuse to open the mind to other possibilities, once you give your beliefs a name, then you are closing the door on infinity and the hidden worlds of the imagination. As an example, I will focus on Christianity, not because it's an easy target (the same could be said of all organised religions), but because it is part of the predominant culture that we in Europe and the Americas live within; as well as part of the culture I grew up around.

Between 1170AD and 1270AD some 800 cathedrals and 500 churches and abbeys were built in France alone, all commissioned by the Knights Templar. All but a few of these magnificent works were dedicated to 'Our Lady' (Notre Dame) and what is known as Notre Dame de Sous-Terre (Our Lady of the Underworld) – the Black Madonna. Why was there such immense activity (spanning 120 years in the case of Chartres), in building these places of worship? The main reason was to exercise a centrally-controlled structure to rule the lives of hundreds of thousands of people. Pagan people across original Celtic lands needed to be brought under one roof, so to speak. Therefore, these great towers of stone were placed on ancient Pagan, Roman and Celtic sites of worship to many Goddesses like Diana, Artemis and the most legendary in France, the Black Madonna. The Black Madonna sites I have visited in France, like Chartres and Le Puy-en Velay are situated on, or near,

ancient Druid and Neolithic sites. The Pagan sites at Le Puy are surrounded by a natural amphitheatre of volcanic rock, to honour and harness the energy in the land. On the surface, these are places of worship to the Virgin Mary, the mother of God. Yet, when we consider ancient Goddess-worship, and that many temples or churches were erected in the name of the 'supposed redeemed whore' of Christianity (Mary Magdalene), along with 'Our Lady of the Underworld', all is not quite what it seems.

One famous town on the Camargue in the South of France, called Le Saintes Marie de la Mer (the Saint Mary of the Sea), is renowned for its worship of the 'Black Goddess' (or Madonna). Like other towns in France, festivities and religious holidays are linked to the Black Madonna. Arles, which is near Le Saintes Marie de la Mer, was an original gypsy location and they, too, paid homage to the Black Madonna. The women said to have come ashore at Le Saintes Marie de la Mer (with the mother of Jesus), were Mary Magdalene, and Martha, wife of Zebedee. It has been said in a number of best-selling books over the years, not least *The Bloodline of the Holy Grail*, written by Laurence Gardner, that these biblical figures came to France after the crucifixion. They were said to have provided the lineage of the Merovingian Priest Kings for what eventually would become European Royalty. This supposed 'Royal lineage' is said to go back to the kings of ancient Middle and Near East, from the same location gypsies are said to originate. Two of the symbols for this bloodline are the 'Fleur-de-lis' and the 'lion', which can found in use amongst aristrocratic families of Europe. This is the same 'royal race' I talked about in *Chapter One*, who in my opinion, are of a lineage of kings and queens easily 'possessed', or 'overshadowed' by, the Predator Consciousness because of their blood-ties to 'interdimensionals'. One ancient demonic entity connected to the royal race, is the serpent goddess called 'El' (Kali/Semiramis), that I believe has possessed certain queens (through black magic rituals/human sacrifice), since the time of Babylon. It is a 'force', working through world leaders, monarchs and the 'pillars of authority' (in all countries), which has sought to bring war and bloodshed to the planet since ancient times.

Gypsies were said to be related to the *El*-ites and the race of El (the Dark Queen of the underworld). Originally Hindustani, gypsies were said to have been driven out of India by the Islamic conqueror of central Asia, Timur Lenk, in the 15th Century.[16] There are also records of gypsies in Hamburg, Rome, Barcelona and Paris between 1417 and 1427. Also in the story by Victor Hugo, *The Hunchback of Notre Dame* (1831), we find Esmeralda and the gypsy kings. As the Christian hierarchy was destroying Gnostic, Pagan and Druid religions, it is said that Pagan priests passed their knowledge of the stars, sacred geometry and the 'gods' into the hands of these travellers, who undertook to keep it safe and share it with those who were considered worthy. In other words, gypsies became the guardians of ancient teachings that were part of the wisdom of Egypt, Chaldea, the Gnostics, the Albigensians (Cathars) and the Yogis of India. The same wisdom was said to be contained in the Tarot, or Tahoti, a gypsy word meaning the 'Royal Way', another clue

Figure 31: Mary and Jesus?

The Madonna and baby Jesus at Le Puy-en-Velay in France. This monument overlooks the town and surrounding countryside of Le Puy. The goddess stands on a globe atop a 17 metre serpent, all of which is made from cannons melted down after the Crimean Wars.

Below left: The Black Virgin (Isis) and the Saviour (Sun God) at Chartres Cathedral.
Right) The Madonna at Rocomadour, France.

leading to certain gods, bloodlines and the 'divine right to rule'.

In all these ancient cults, and the wisdom carried by gypsies to France, one will find many depictions of the 'black virgin queen' holding her son, the saviour sun god (see figure 31). Erzuile Freda, one of the voodoo goddesses of Haiti, Cuba and Brazil, is also the same deity, and she too was depicted holding her son, Marrassa.[17] In truth, it was not the fact that the gypsies brought this knowledge and worship of the Black Madonna to France and Europe, she was already worshipped by secret priesthoods of Sumeria, through their goddess Semiramis, or as Alditi (Kali) in India; or as Isis in Egypt and Ashtoreth in the *Old Testament.* She was also El, the Queen of the Underworld for the Vikings. For example, in Egypt we have Isis holding the baby Sun God, Horus, and in ancient Sumeria, we have Semiramis holding the Sun God Tammuz. These are an exact mirror of later sculptures depicting Mary holding the baby Jesus. Even details like the crown of stars and the position of the child, are exactly the same in different versions of this image. So why do some of the most famous statues of the Madonna in Western Europe and more than 450 images around the world have faces and hands that are black? Because they are exactly the same Ancient Pagan goddess under different names. This goddess was also the precursor for the Neolithic goddess of the cave, quite possibly symbolised through the cult of the bear (the primeval mother goddess).

One of the most spectacular sites affiliated with the worship of this deity is in the town of Le Puy situated in the Haute Loire department of France. The whole town is nestled in the hollow of volcanic mountains and was one of the nine commanderies set up by the previously-mentioned secretive Priory of Sion. At the peak of what is known locally as the Corneille rock, stands a 16 metre statue of the crowned Madonna holding the baby Jesus, while crushing underfoot a 17 metre serpent (see figure 31). According to tourist guide literature, the statue was made from 213 cannons melted down after use in the Crimean Wars. Norse-Germanic Goddess-worship, based on the 'dark queen' of war and the underworld, was known as 'Hel' worship. Hel

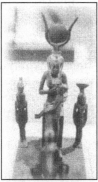

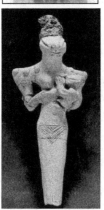

Figure 32:
Isis and Horus.

Top) A Bronze figurine of the ancient Egyptian Goddess, Isis, holding the baby Horus.
Bottom) A Reptile Goddess suckling its child. The clay figurine was found in what was ancient Sumeria (now Iraq). Both these figures, in my view, are based on the same deity; an ancient Virgin Star Goddess, (Isis, Ishtar, Mary, etc). This 'goddess' or 'queen' is still an important figure for the Brotherhood mystery schools.

was a serpent queen and one aspect of the 'triple goddess', also known as 'Hecate' in Greek myth. The same goddess appears widely on chivalric banners of the different knights orders, who would shout her name in honour as a battle cry. In truth, the Templars and Teutonic Knights' organisations at the time of the crusades were fighting for their supreme lady, El/Isis/Semiramis (the 'serpent queen' of the underworld (see figure 32). Clues of which can be found in religious art if one looks closely enough. On ceiling art of the Sacré Coeur in Paris, we see Mary Magdalene and Martha holding a dragon by what looks like a leash, another symbol for the royal bloodline Mary and Martha are said to represent. In fact, it is more than likely these three "M's" (Magdalene, Martha and Mary) were purely symbolic characters, like other biblical characters, made into literal people by writers (priests) who also worshipped the triple goddess - Hecate. The story of Joan of Arc can be related in some ways to the goddess, Hecate, who I am sure was also fictional. Artists like Hieronymus Bosch, portrayed the 'toad and the serpent' on the shields of knights and soldiers in his masterpieces. His imagery delighted in hellish creatures dwelling in Hel's (El's) mouth. Bosch (like other artists, poets and composers) was a member of a secret society called the Illustrious Brotherhood of Our Blessed Lady, founded in 1318 to promote the veneration of the Mother of God.[18] So you could say Bosch knew a little more about his subject than most! This secret society was/is connected to the Order of the Garter, comprised elite members from all over Europe, who swore allegiance to the serpent goddess. The Queen of England is the current symbolic head of this order.

The Freemasonic networks also honour the goddess, or 'widow code' within their initiations. The 'code' was another symbol for Isis, the 'dark virgin queen'. In medieval times, followers of Venus Columbe were known as Harlequins who were also called the kinsmen of the 'dark queen' El (Hel). Writers and poets of this period named them as the lovers of the dark virgin – the dragon queen. Morgan le Faye, of King Arthur Legend, is another version of El, while Arthur is symbolic of the sun god surrounded by his twelve knights (signs) of the zodiac. 'Morgans' were also known as sea women or

mermaids, and there is a fantastic amount of siren symbolism on the Romanesque chapels and churches all over Christendom, especially in areas dedicated to the Black Madonna. The Greeks knew El as the cruel mother goddess, Artemis, who demanded animal and human sacrifice, just as the jaguar priestesses of South America, and the Pharisees in Judea, had done. From the various cults dedicated to the fiery El (or Frigg) came the term Hell, or burn in Hell (Frigg-in-hell), which was another word for the underworld. El or Frigg had two angel counterparts (often depicted as owls or watchers), called Harut and Marut, who, according to the *Quran*, were 'wicked', idolatrous and demanded sacrifice. With this evidence in mind, are we really supposed to believe the genocide and murder perpetrated through religious crusades, including today's holy wars, are committed by a belief based on a 'loving' God? I strongly suggest that the torture, rape, murder and war committed in ancient times (including the war that provided 213 cannon for the statue in Le Puy), was committed in the name of the dark queen Hel, who was (still is) worshipped as the destructive element of the ancient triple goddess, by a secret society that established the Christian faith and continues to control the Vatican. Look a little closer at the detail on Gothic cathedrals across Europe. They are awash with sun, astrological, esoteric, goddess and sexual symbolism. Carvings on `holy places', like those at Chartres and Notre Dame in France, show demonic beings and possessed monks carrying off children, eating flesh and having sex with women. Even the Eucharist ceremony practised in Christian churches goes back to Babylon when priests were actually eating flesh (bread) and drinking blood (wine). On most of the great cathedrals the rose window faced west, which in Pagan tradition is symbolic of the goddess El, death and sexual energy. Most churches and cathedrals were erected to align with the moon, the sun and the stars, just as the original Pagan sites beneath them were dedicated to the heavens. The ancient science of astrology was even said to be taught in Chartres Cathedral in its early years. Christians all over the world are actually going into Pagan shrines, which the Christian hierarchy condemn as the 'work of the devil', each and every `sun' day. You've got to chuckle really.

Hecate, the Pagan Trinity & the Immaculate Deception

The real source of the Christian trinity is connected to 'three versions' of the goddess Hecate in Greek myth. It is said Hecate's powers extend over Heaven and Hell and she is the triple character of Shakespeare's *A Midsummer Night's Dream*:

> And we Fairies that do run
> By the triple Hecate's team...[19]

The Triple Goddess, and the idea of the 'trinity', is connected to ancient star gods, not least Orion's three belt stars and the many triangular alignments in the heavens. Stories of the three wise men or Magi (of Jesus fame) are also symbolic of Orion's three belt stars, Mintaka, Alnilam and Alnitak, as is the

Christian crucifixion scene of Jesus, flanked by two thieves. The spider goddess scratched into the surface of the Nazca plains was also said to depict the belt of Orion, too. Across ancient Britain, there are many references to the goddess Brigit who also symbolised 'three' different sacred fires. She was known as Brigit, Bride and Brighde who ruled the fire of 'inspiration', the 'muse' and 'poetry'. In fact, the word poetry comes from the Greek word 'Poesis', which means creation (to be on fire). The Goddess Brigit was also said to have three talismans: the Grael, the Shining Mirror and the Spinning Wheel; all of these talismans can be found in various myths, legends and fairy tales, like *Snow White* and *Sleeping Beauty*, each relating to 'triple' goddess symbolism.

In Hebrew, the Christian trinity is regarded as feminine, which again has much earlier connections to the neolithic star goddess Astarte, whose shrines can also be found all over Southern France. Gothic doorways and the ridges around them are also depictions of the vulva and some even have a clitoris symbol at the top of every arch. Doorways and cave entrances are important to the triple goddess who was worshipped as the hag, the maiden and the young girl. The Romans also worshipped the same goddess as Luna (the sky), Diana (the earth) and Hecate (the underworld). Another name for Mary of Christian legend was Cybelle, who in Pagan times was considered the goddess of the cave. In Chinese tradition the same moon goddess was venerated on the 15th day of the eighth month when people would come together to look at the full moon. Five thousand years later, in Christian belief, Mary, the blessed virgin moon goddess, is also worshipped through the Feast of Assumption on the 15th of August. It's all recycling!

Many ancient star goddesses were said to be virgins who conceived a sun god through 'immaculate conception'. Balder (the son Odin and Frigg or Hel), in Scandinavian mythology, is just one of many examples of this. Tammuz, or Thammuz was another immaculate son born to Nimrod (Ninus) and Semiramis (Ishtar). So was the son of Osiris and Isis, Horus, in ancient Egypt. This 'trinity of deities', through the worship of the sun (son) saviour-figure was eventually passed onto Jesus in the *New Testament*. One of the origins of these 'saviour-figures' is said to have come from a universal solar myth that the sun (son) was born in a new 'virgin' moon, when the constellation of Virgo rose with the sun. It could also relate to legends associated with Venus the 'new star' that would appear at the birth of many of these 'sun-saviour' figures. At the same time, it's not so impossible to imagine some kind of artificial impregnation taking place in ancient times, evidence of which is recorded in places like the Sumerian Tablets and in images on the temple walls at Luxor, Egypt. Evidence is also contained in the *Mahabharata* (3000 BC) of ancient India, which tells of Gandhari, the mother of a hundred sons (test tube babies) who were called 'Kauravas'. What Christian founders failed to address was the nonsense of how the sun god, Jesus, like others before him, could be the saviour of a human creature exempted from 'original sin' from his conception? The Church could only try to reconcile this nonsense as late as 1854 by relying on the goddess herself to appear in places like

the cave at Lourdes, confirming that she indeed was conceived without sin. What a sham! A belief that is actually based on half-truths and recycled myths is always going to get caught out on something so small.

Sun Mounts and Sea Serpents

Alongside Black Madonna worship one often finds what are called 'Michael Mounts'. Mainly at sea, they are rooted to the worship of another collection of Pagan deities: the sun gods. Sun temples found throughout Europe are dedicated to Miok or Thor (Indra of Indian belief) all found in Phoenician and Sumerian legend. Saint Michael's Mount, off the coast of Cornwall in Britain, and Mont Michel off the coast of Normandy in France, are shrines dedicated to Miok or Michael. St Michael (Miok) d'Aiguille in Le Puy, France, is another example of many 'inland shrines' dedicated to these hero-figures. Monségur, the Cathar fortress in Southern France, is also said to be a sun temple and similar mounts exist off the coast of Germany and Italy. Many Greek islands in the Agean sea are also connected to sun gods like Miok, George, and Apollo. What they all have in common is a sun religion practised by a seafaring, sun worshipping, ancient Caucasian peoples, whose main deities were heroes like St. George of Cappidocia and St. Michael. Both of these hero gods would do battle with, either slaying or banishing, the dragon (serpent) within the underworld.

The battles between a (serpent) monster and a (sun) hero is a common theme throughout the world's mythology. As we have seen in *Chapter One*, Saint George and the Dragon, Indara and the Vritra, Apollo and the Python, Jehovah and the Leviathan, and in all these basic myths, good pulverises evil.[20] In Scandinavian legend, Thor is said to go fishing for Vritra, a great serpent, which lies at the source of major rivers. The Sumerian epic of *Gilgamesh* also depicts Gilgamesh (Thor) struggling with a serpent at sea, while being pursued by the angel of death (another version of Hel). In many ancient legends there are dragon myths which record a sky god defeating an earth-threatening monster and making the world a safer place for mankind. This underlying concept of a sun god slayer-of-monsters is evident in the poetic kennings employed in texts like the *Edda*. In Nordic myth, the serpent is called 'su er goth fia' 'the one whom the gods hate'; while Thor is titled: 'vinr verlitna', 'friend of the race of men'. The stories of ancient battles between the forces of nature and the Pagan gods they represented served the Christian church well. Especially when it came to reinventing old beliefs and declaring a triumphant saviour had removed the evil Pagan deities. Thorskegga Thorn writing about religious recycling on the Internet, said:

> *It is possible that the appearance of the Midgard Serpent at Ragnarok was inspired by accounts of St. Michael's fight against the dragon. The two predictions have much in common but where the Christian saint can walk away triumphant the pagan god can conveniently be disposed of.*[21]

In symbolic terms, the mounts represent the sun god (often at sea) and water

surrounding these islands, is symbolic of the moon goddess. The same symbolism of the sun and moon is seen in the architecture of domes, cathedrals and chapels. Quite often these churches were placed on ancient sun and serpent 'ley lines', so as to harness the 'forces in nature'. These energy sites, often symbolised as the great serpent in many legends, were said to lay at the source of major rivers, preventing them from flowing to the land of men.[22] I feel these stories are symbolic of the ancient energy grid where temples and megalithic sites were placed to access earth's natural energy field. The same deities inspired many pilgrimages across Britain, France and Northern Europe. These pilgrimages symbolise ancient rights of passage and worship of the sun and serpent gods who later became Saint George, Micheal and James. One of these three saints is mentioned by Paulo Coelho, in his book *The Pilgrimage* (1987), which follows the trek of 'St. Jacque de Compostela'. The whole book is based on a 'spiritual journey' starting in France and ending on the Spanish West Coast at the place dedicated to St. Jacque. Over the years, I have visited many of the chapels (set on needle-like rocks) at these sun and serpent sites across France and Britain, and they are littered with sea, sun and serpent symbolism.

Hamish Miller and Paul Broadhurst, in their book *The Sun and The Serpent* (1990), document one of the most famous sun/serpent ley lines in Britain. As does Jacques Bonvin in his book *Vierges Noires* (1989), which show similar patterns of sacred geometry in ley lines across France. Britain and France, like many other countries, are littered with stories of saintly dragon slayers who destroy great serpents roaming the primordial rivers and seas. The most famous being 'La Gargouille' (a serpent monster), said to live in the river Seine, near Rouen. Many tales of serpent-slayers also relate to the closing-down of the earth's energy field, at sacred sites, by the ancients. Many sacred sites, dotted across ley lines in France, are dedicated to the worship of the Black Madonna (or Isis). Even the Church of Joan of Arc, in Rouen, is shaped as a 'stone dragon' or serpent! In some cases, the battles between the sun and the serpent gods/goddesses, could also represent the 'winding down' of energy at these sites by a priesthood worshiping the sacred fire (sun) and ancient serpent gods (Poseidon) of Atlantis. One particular mystery school, known as the 'Brotherhood of the Snake', whose symbol is the Caduceus (the two entwined serpents), is said to have emerged after the destruction of Atlantis. According to ancient texts, like the *Nag Hammuadi*, the Brotherhood of the Snake's task was to infiltrate the Brotherhood of Light; descriptions of the battles between dark and light forces, can be found throughout ancient myth and epic films such as *Star Wars*.

The more I researched into 'sun mount enigma', I kept coming across another saint of biblical fame, who, like George and Michael, had roots in ancient sun, sea and serpent legends. Saint James the Greater, or Jacobus Major, is also a figure associated with sun mounts and the many pilgrimages throughout France and Spain. He also was called the `moon slayer' and was said to have banished the old serpent of the sea. In Christian doctrine, James was born to Mary and Zebedee, one of the three Mary's associated with the

triple goddess. St. James became a figure of worship mainly through legend, symbolised as holding the martyr's 'sword' or the 'staff of power' in religious art. In Celtic astrology, the sword symbolised intuition and the zodiac sign of Cancer, the crab, and I believe he (St. George/Jacque) is another symbol for the Inca sun god, Viracocha. Much devotional art depicts St. James or St. Jacque with a water gourd and a Scallop shell on his hat. The hat is remarkably similar to the halo adornment worn by the Inca sun-priests. The scallop shell, including coral, is a native goddess-symbol relating to the life force in the blood (DNA) and the energy contained in the natural resources of the earth. The 'oil giant', Shell, use this symbol as their corporate identity.

Jacobus (or James) is considered another version of the sun god, Miok, or Magni (the son of Thor), who also defeated the dragon. The story of James is similar to that of Hippolytus, the son of the Greek king, Theseus, who, like the Spanish knight in the later St. James story, sees a mysterious stone ship emerging from the sea. On seeing the strange sight he is dragged by his frightened horses into the water. In both versions of the same theme, the sea is where the serpent goddess emerges, just as superhuman Caucasian gods of Central American legend had travelled on 'stone rafts' adorned with serpents.[23] There is so much more to know about life under the oceans, especially in the Pacific Rim and Atlantic Ocean. The story of James and the scallop shell has definite Pagan connotations; it can often be found in religious paintings relating to sea goddesses, Aphrodite (or Venus) the daughter of Zeus. Aphrodite's counterpart was Venus Columbe symbolised by the dove which became the emblem of the 'holy spirit', the messenger after the biblical flood and yet another aspect of the 'trinity'.

Apparitions from the `Other World'
Ancient legends talk of psychic powers held by the serpents of wisdom, including their ability to communicate with beings on other dimensions at mounts located all over the world. The Oracle at Delphi in Ancient Greece, was an example of this practice and ability. Early Christian saints and the Gnostics also revered the serpent for its ability to communicate telepathically with `other worlds'. The Gnostic symbol is a circle of sixteen figures around a serpent of wisdom (see page 225). Many so-called saints and shamans consulted the 'sacred fire' and the 'serpent' to receive psychic visions from other realities (worlds). After receiving a communication they were usually spurred on to evangelise others, and in some instances, instigate brutality in the name of their entity, or god. Psychic visions, or communication with 'beings' on other frequencies, are common across all religious spectrums. St. Paul, for example, was said to have been blinded by a light on the road to Damascus, and Constantine the Roman Emperor was said to have seen a 'sun cross' in a vision prior to entering the field into religious battle. So did Native American prophets like 'Wovoka' (which means cutter of wood), who were regarded as a saviour figure by Native American tribes like the Numu. Wovoka was said to have had communication with God who told him to instruct the plains' tribes in the famous 'Ghost Dance' ritual; an

attempt to bring back the disappearing buffalo and make the Europeans leave, which eventually ended in the slaughter of hundreds of Sioux at Wounded Knee. Wovoka's great revelation was said to have occurred when he collapsed in the forests on New Year's Day 1889, during a solar eclipse. In traditional Numu religion, the sun was the greatest of powers, and some people said that Wovoka had the power of the sun.[24] Mahomet, or Mohammed (which incidentally is a Greek word for psychic), was another prophet who had communication in a cave with an angel figure, or sun deity. According to the story, his communicator said that Arabia must return to the simple faith in Allah (El, or Jehovah to the Hebrews). As I will expound on shortly, Jehovah is Saturn and both Saturn and the Moon are the main celestial bodies, symbolically speaking, that have inspired *all* religions on Earth. What these stories of religious apparitions have in common, is that their communicator's doctrine was either supplied by, or inspired by, a strange being (possibly from another dimension); in some cases this involved the 'possession' of the so-called prophet. The Gnostics, along with the Cathars of 12th Century France, believed that people did not need a middleman such as a priest, arbitrating between themselves and something they were already part of. This philosophy did not go down well with the Holy Dominican Order who, through Pope Innocent III, instigated mass genocide in Southern France between the years 1209 and 1244AD. The Cathar priests (many of whom were women) and the Albigensian people as a whole, were slaughtered for this truth by crusaders. This final and fourth crusade paved the way for many other dictators and religious leaders, who today, continue to commit atrocities in the name of God.

The Brotherhood of the Wolf

Another aspect of the malevolent form of ancient goddess worship is reverence of the wolf and the many legends of the wolf tribe. The star Sirius, which can be found in Masonic symbolism, also relates to the wolf tribe and the 'she-wolf', known by African, Celtic and Native American tribes as the 'Dog Star'. The legendary Amazonian tribe were said to be connected with Sirius and Atlantis, one of several 'wolf seafaring tribes' that came to Europe in ancient times. Historical accounts say that the Amazonian priestesses mated with Scythian warriors of the Caucasus mountain region, who were also known to the Amazons as 'Sauromatia' or the land of the lizard mother. The Scythians were said to be a Nordic-Aryan people who migrated into Northern Europe from the Near East around 3000BC, becoming the Sicambrian Frankish tribes of France.

Both the Scythian and Amazonian (Valkyries) tribes were goddess worshippers, whose priest-queens, like the South American priests of the Maya, performed human sacrifice. The Berber people of North Africa are also associated with the Amazons and today they still call themselves the Amazogh. In ancient Ireland, the Ossory tribes, which had strikingly similar customs to those of the Berbers, are said to have been a 'wolf tribe' whose members could turn into wolves at feasts and rituals. In his work, *The Ancient Americas:*

Art From Sacred Landscapes, Richard Townsend points out that transformation during rituals was an important aspect of ancient civilisation, and that humans and the gods were considered to have animal alter egos. Writing about the Peruvian priests (shapeshifters) he says:

> *...modern folk tales about the ease of animal-human transformation suggest that most Moche anthropozoomorphs (shapeshifters) were not masked figures.*[25]

These priests and priestesses seem to have been able to metamorphose, like that of the 'moon animal' in various legends who could take the form of a jaguar, fox or wolf. I am not saying that wolves are evil, I am saying that the symbolism connected to the wolf can relate to other frequencies (dimensions), some of which are not pleasant.

In the tales of Tyr (Nuada) and Fenrir of Germanic myth, we have stories of a monstrous wolf-beast who was bound by a magical chain within the legendary underworld. According to Norse mythology, the chief god Odin (Osiris) was killed by the wolf Fenrir, son of the mischief-maker fire god, Loki. All of Loki's offspring are said to have lived underground and represent the malevolent side of nature. Even Loki himself is linked to the origin of Lucifer, the planet Venus and fallen angel of biblical fame. The wolf is known throughout ancient legends and myths for having both a dark and light force, which is true of all life. In Cherokee legend, for example, Sutaliditi, or Sun Woman, was attacked by a wolf/serpent hybrid; in Germanic myth are stories of 'Skoll', a wolf beast who pursued the sun goddess in her flight across the sky; another wolf named Hati is said to have chased the moon. Both versions of the same story are symbolic of change through world ages, especially when the earth passed through catastrophic events. Other themes relate to battles between light and dark primordial forces celebrated at the equinoxes. In other words, there seems to have been a common theme in the ancient world of a wolf-god/tribe who were 'endowed' with wisdom of the moon goddess and whose priestesses, like that of the shamans and impersonaters of South American Indian culture, could shapeshift into their ancestor spirit, the wolf.

The Roman Empire, with its 'blood-letting' and 'warfare' is said to have been founded by two mythical characters 'Romulus and Remus', of the Roms. They are said to be a dark-skinned aboriginal people to whom historians refer as the 'Iberian Celts'. Both Romulus and Remus are said to have been wolf-suckled, yet another symbolic reference of the mother-son cult of the ancient world. In Egyptian myth, Rom or Romul was Seth, a wolf-headed demon deity, who killed his brother, Osiris, and then went on to fight Horus in classic George-and-the-Dragon (or Thor-and-Jormungandr) style. The theme of the sun god being tempted by, or fighting the dark lord, appears repeatedly in many texts and legends.

Stories of wolf people and shapeshifters are to be found in ancient records all over the world. In North America, for example, the Inuit of the North West Pacific coast, talk of a wolf tribe that walked on two legs and lived under-

ground. Other civilisations, like that of the Moche people of Peru, share similar legends of the horned owl, Moloch (a demon god of war), who was a shapeshifter. In Moche tradition, the priest would become the anthropomorphic owl, the chief sacrificer, who dispatched victims to the underworld.

Sacrifice became the expression of renewal for native cultures adhering to the practise. But for the priests and their dark lords, sacrifice became a twisted version of a fertility rite, portraying the never-ending process of birth from the underworld (the Cave), to life on the surface. Through life force in the victim's blood, these dark lords were able to maintain life on the surface world. Some Christian festivities (including their Pagan roots) symbolise this sacrificial process, such as the birth of the new king and the death of the old king practised at Epiphany. Fire ceremonies involving the burning of effigies to bring renewal and rescue the world from darkness are also part of the sacrificial ritual. This is why the cave and the darkness of the ceremonial lodge was (and still is) important to secret societies that conduct rituals. The darkness of the lodge or cave serves to link the initiate to supernatural beings who are said to dwell in the place where all evil was banished since ancient times. If we follow the train of thought that what existed in ancient beliefs and customs was eventually recycled into new organised religions of the world then it is not a stretch of the imagination to assume there have been secret societies and priesthoods that have always been involved in dark, magical practices. The very foundation of first worshiping the gods (and later God), is built on surrendering one's 'sinful soul' to a supreme deity. Quite often, this deity 'demands sacrifice', both human and animal, for appeasement. There is no difference in sacrifice to the Aztec fire/serpent gods and the mass slaughter of animals, and firstborn sons (Cain/Abel) in those temples of the *Old Testament*. Or burning men, women and children inside giant Wicker effigy/figures across Celtic Britain, right through to horrific scenes in the UK of thousands of cattle burning on pyres in order to 'eradicate' Foot and Mouth disease. The common denominator in all these forms of 'sacrifice' (both ancient and modern), is a priesthood that pays homage to a Goddess who embodies 'destructive forces' connected to lower-astral dimensions. Wolves, and their association with death, destruction and sacrifice, are apparent in Hades' 'cloak' of wolf skin, the wolf 'ears' of the Estruscan god of death and the capacity of warlocks and evil men to turn into wolves (lycanthropy). All this leads me comfortably to a mysterious event that occurred in 18th Century France.

Near the famous town of Le Puy-en-Velay in France in the region of Gévaudan, near what is known locally as 'Mont Mouchet', there is a fantastic legend of a wolf-beast. It is said by historians that in a period of three years between 1764 to 1767, more than a hundred people, only women and children, were attacked and killed (often decapitated) by what locals recall as a mysterious hybrid beast. Many men were sent to track it down, including the French army, and 57 dragoons under the command of Captain Duhamel; all who searched for it over those 3 years, failed in its capture. It was not until June 19th, 1767 that a so-called peasant hunter called Jean Chastel of La

Bresseyre St. Mary, apparently killed the beast, taking the remains to the Palace of Versaille at the request of King Louis XV. To this day, there is no hard evidence to suggest what this beast was; many theories have been put forward, speculation that these gruesome murders were the work of a sadistic killer. Others blamed wolves, a theory that has no credibility with zoologists and enthologists of today. However, one theory of most interest was presented in a documentary film made by a French filmmaker, Phillipe Bardiere, in which he and a colleague use historical data and satellite technology to plot where the killings took place. To their astonishment the victims' bodies and place of attack formed a geometric circle pattern, around Mount Mouchet. I also visited the Mount and felt the energy there to be very strange indeed. Bardiere points a finger toward the Catholic priesthood and their knowledge of a `wolf woman' connected to Jean Chastel (who supposedly killed it), but kept this knowldege covered up.

Local history also talks of a priest who raped a local witch and their child was said to be a 'demon', 'hidden away' from ordinary life.[26] Considering ancient stories of `wolf people' and legends of a Brotherhood who worshipped the wolf-mother-sun goddess, the connections to the Church in France are of interest. In the Cathedral of Brioude, in the same area of Gévaudan, I found an interesting faded mural on a column. Painted in the 13th Century, the mural depicts what looks like two priests in robes both having the head of a dog or wolf, devouring human body parts. In Romanesque art, these creatures were commonly known as 'Cynocephalusses' and they were thought to have existed in places like India. On two side doors of the 12th Century cathedral of Le Puy (in the same Gévaudan region) one can see relief carvings of a hooded figure, a priest garbed in red with a huge beast-like hand (see figure 33). These doors are known locally as the 'cedar doors'; cedar are sacred to Native American Indian tribes, such as the Lakota, for their attributes in ceremonies when shamans would communicate with interdimensional beings. Given evidence of human sacrifice and satanic ritual from all around the world, is it

Figures 33: Wolf (Dog) Priests.
Left: A mural decorating a column at Brioude Cathedral, France. *Right:* A wooden relief on cedar doors of Le Puy Cathedral in France. Both images were created by priests who seemed to have a fascination for wolf-dog-men, hybrid creatures, the macabre and cannibalism.

not too much strain on the imagination to consider the possibility that a satanic cult, interconnected with the Christian church, could have carried out these attacks? Similar accusations were made against the Knights Templar, who were said to worship a trinity of devil gods including El, Baphomet and Lucifer. Was the perpetrator of these sacrificial attacks just another Freemasonic Jack-the-Ripper type in 18th Century France, or could it have been a kind of human-hybrid beast? The former would fit more with eye-witness accounts recorded by locals, some of whom had actually survived the attacks of what they described as an "upright, walking creature". The French film, *The Brotherhood of the Wolf*, hints at a now-extinct Thylacine (marsupial wolf), a savage creature (half-wolf, half-tiger) brought back from Asia by the brotherhood. In the film, the beast is kept chained in an underground cave on the estate of the Marquis d' Apcher, and like Conan Doyle's *The Hound of the Baskervilles* (1902), it is released by a high-ranking member of the brotherhood to carry out attacks.

From my own research, I cannot ignore the fact that this brotherhood was a later branch of the Dominican order, an Order which paid homage to the jackal-headed Egyptian god, Anubis. French writer, Jean Robin, concludes that the Order of the Temple, like the Druid schools, consisted of seven outer circles which taught the minor mystery arts, three inner circles were taught the major mysteries; yet one inner circle performed the highest magic. The same structure applies to modern Freemasonry and the brotherhoods today that still carry out rituals underground, in lodges, crypts and temples. Their ceremonies are based on the same ancient magic performed by the mystery schools of old. The Aztecs, like the Hopi Indians, were also said to have been birthed from seven sacred caves, represented in their art as a wolf-man/shaman emerging from underground. When I look at evidence presented in the case of the killings by this 'beast' in 18th century France, I cannot help but wonder if the murders committed in Gévaudan were the work of a shapeshifter, or hybrid creature, conjured from the bowels of Mount Mouchet by a priestcraft obsessed with black magic, Satanism and voodoo-virgin goddess-worship.

Assemblies of Sun (Sion) Priests

The use of symbols and their power and influence on the mind (to control or set us free), can be traced throughout the ancient and modern world. Tyrannies and regimes throughout history have used the artist to create and bring into reality, many symbols and secret languages for the mystery schools. In fact, many artists themselves were initiates of clandestine networks. William Blake, in his work *The Marriage of Heaven and Hell* (1790-93), attempts to explain how ancient priesthoods created a system of 'mental slavery' derived from a Pagan view of the world. He writes:

> *The ancient poets animated all sensible objects with Gods... adorning them with the properties of woods, rivers, mountains... Till a system was formed, which some took advantage of & enslaved the vulgar by attempting to abstract the men-*

tal deities from their objects: thus began priesthood...[27]

In the earliest of days, monasteries were sanctuaries of aestheticism and illuminated manuscripts, produced by various fraternities, were rife with esoteric symbolism. They only became tools for Christian missionaries after the complete takeover and conversion of the British Isles coinciding with the arrival of St. Augustine around 400AD. As already mentioned, the Gothic cathedrals of Europe, especially architectural detail of Chartres in Northern France, are filled with examples of symbolic language that speaks of hidden knowledge. So do many paintings, especially the work of Sandro Botticelli, Leonardo Da Vinci and Nicholas Poussin all of whom were elite members of secret societies like the Nazarene Church, and the Priory of Sion (Sun) based in Paris. Since the time of Ancient Egypt, assemblies of men, specially skilled in architecture, art and science, were called upon to build new cities, erect monumental structures and enlarge shrines and temples. According to historians like Manley P Hall, these 'assemblies of artisans' belonged to secretive groups who had their own elected chief or prince and guild union, one of which was centred at Chartres. Many 'brotherhood art movements' also used Pagan mythology and symbolism as a tool for passing on certain truths about who, and what, they believed. Art brotherhoods such as the Nazarenes, the Nabis, the Ancients, the Symbolists, the Brotherhood Of Our Lady and the Pre-Raphaelites, formed not necessarily because of the ideology around art, but because of an interest in metaphysics, myths and esoteric knowledge. Yet, this makes perfect sense, since it was the ancient priest or shaman who made art to the highest order in much earlier civilisations. The question I often ask is, "Whose order was being followed/obeyed when religion was invented?"

The Sun Cross

The cross, like many other well-known symbols, is claimed to be a statement of Christianity, but actually has its roots in Paganism. Many ancient civilisations, like the Maya, Phoenicians and Babylonians (thousands of years before Christianity), used what is widely known as the 'sun cross' to depict the sun's journey through the year. The circle and the cross are symbolic of four cardinal points, elements, seasons of the earth, and all part of a wider understanding of life and humanity's connection with the cosmos. In even earlier civilisations, the 'sacred fire cross' represented primordial forces of creation. The ancient priesthoods, like native shamans, knew that even though the earth 'moves around the sun', from our point of view, the sun moves around the earth through twelve different sectors of earth's elliptical orbit. The twelve sectors (constellations) are, of course, the zodiac. The apparent movement of the sun through the constellations must be understood through the earth and therefore, the individual. In practical terms, the horoscope or the 'animal wheel' (the zodiac), is a map of the heavens at the moment of birth (some say conception); charting which direction the planets were beaming their unique energies onto an individual at that impressionable moment.

The Bible is full of codes and parables that speak of 'sun worship'. When

taken literally, which is what the creators of the Levite texts intended, we lose a wider understanding of these codes. For example the three syllables in Sol-om-on are all different names for the Sun. Through these codes we can see that King Solomon's temple was not a real location, but more than likely a symbolic one. Freemasonic historian, Manly P. Hall, wrote that King Solomon's 1000 'wives' and concubines symbolised the sun, moons, asteroids, and other 'receptive bodies', within his 'house' or 'temple' (the solar system).[28] Some geometric symbols found in religions, like the pentagram, or the Star of David, and the cross, are found in the orbital patterns of various planets in our solar system. The two giants, Jupiter and Saturn, are planets that provide a sequence of conjunctions forming the basis of what is described as the 'Golden Mean'. Jupiter, the largest planet and 'king of the ancient gods' (a dwarf star in its own right), has a pair of asteroid clusters called 'Trojans' that move around Jupiter's orbit 60° ahead, and 60° behind. This partnership moves around the sun as though held in place by the 'spokes of a wheel'. The positions of the Trojan clusters are known as 'Laplace points', with the Sun, Jupiter and the Trojans forming gravitationally-balanced equilateral triangles. When the spokes are joined they create 'three hexagrams' which can be seen to produce earth's mean orbit from that of Jupiter's.[29] Another name for the geometric pattern created by the position of Jupiter, its asteroids and the earth moving around the sun, is the six-pointed star (or the seal of Solomon). The same geometry is found within the structure of every crystal and in the hexagram. The same symbol can be seen forming within the storm at the centre of Saturn's north pole. Some researchers claim the stories associated with Solomon's Temple could be connected to ancient cults connected to Saturn worship. Writers like Manley P. Hall point out that stories attributed to Solomon and David can be found long before in places such as India, and are more than likely symbolic of movements of various bodies in our solar system. So if these figures are symbolic and not real people, does this imply god-figures like Jesus are purely symbolic?

On Chartres Cathedral in France, located inside the North arch, is a depiction of Jesus (the sun) surrounded by the 12 signs of the zodiac. This pictorial version of the sun circle and cross is used by the mystery schools of Babylon. The sun circle and cross depicted here (see figure 34) are symbols of the sun's journey throughout the earthly year. The four points of the

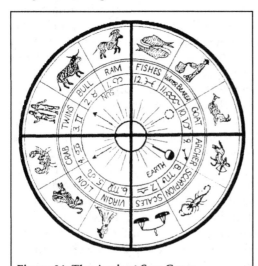

Figure 34: The Ancient Sun Cross.

Figure 35:
The Moundville Sun Cross.
The Native American 'bringer of light', or 'Grandmother Spider' with eight legs, representing the 'eight markers' of a solar year.

Figure 36:
Maponos – The Sun King.
My painting of Maponos, the Celtic 'bringer of light', who emerges as the 'new sun' at the winter solstice.

cross mark the changes in seasons: the solstice and equinox points of the astrological year. In ancient Egypt, the same four corners (or points of the cross), were said to be 'creatures of darkness, light, water and air'; all of which provide the earth with atmosphere and changes in the weather we know as the seasons. It was said by the ancients that the sun symbolically died at the year's end on the Winter Solstice (21st December), but reborn on the 25th of December to herald a new beginning – a new increase in the sun's light. Celts across Europe, hundreds of years before the so-called time of Christ, called this rebirth process, the 'giamos' (other world) and 'samos' (surface world) cycle. To the Moundville Mississippian natives, the 'sun cross' (see figure 35) was part of an ancient religious order known as the 'Southern Cult' (connected to Orion worship), which placed the cross at the centre of the spider goddess symbol. This symbolism was quite possibly a 'later merging of beliefs' in the spider goddess (who brings the light) and Christ (I am the light of the world).

This overall knowledge of the sun was portrayed by ancient Babylonian, Phoenician and Sumerian priesthoods by *'placing'* the sun *on* the 'cardinal cross' at the centre of creation. They symbolically 'crucified the sun! In the Celtic tradition, as with earlier Sumerian accounts, the 'new life of spring' was venerated through a deity known as 'Maponos' (see figure 36). Eggs given at Easter, symbolic of new life, are still part of the Pagan celebration of Ostara (Easter). The Christian Easter is literally named after the Pagan Goddess, Ostara, and was celebrated in Northern Europe as a festival of renewal. To the Celts, the Winter Solstice, like Easter (Ostara), was part of that annual cycle for celebrating the goddess (Gaia) being affected by the sun's energy (light). The same cycle of the sun in relation to the earth was also symbolised through the journey of two gods: Cernunnos (Lord of the Beasts), and

Maponos (the Divine Child). In Mithraic myth, these gods were known as
Cautes and Cautopates, or as the Dioscuroi in ancient Greek mythology. The
same deities were known as Camaxtle (cam-ash-lee) and Xipe Totec to the
Mayans. The torches or batons these twins carried alluded to the ascent and
descent of the sun at the autumn and spring equinoxes. All of this can be con-
nected to Orion symbolism, or Orion's Door, a subject I will look at in more
detail in the next chapter.

Cernunnos, Camaxtle, or Actheon in Greek mythology, was a god with
antlers, who many shamans from numerous traditions would impersonate.
It's said that during the dark half of the year, when the land is dormant,
Cernunnos is reunited with the goddess. This happens at the autumn
equinox, which results in the land's renewal following the winter solstice.
More importantly, in connection with the Jesus figure is the divine child of
light, Maponos. He, like many earlier saviour gods, would suffer death to be
resurrected and reunited with the goddess in spring. In other versions of the
same story, Maponos is reborn at the winter solstice, hidden away by a
malevolent goddess (the Snow Queen in fairy tales and myths), grows to
manhood and is rescued by the kind goddess (Gerda) on the eve of spring at
Ostara. Samson of biblical fame, is another version of Maponos who is
depicted as a babe in winter, a child in spring and a strapping young man in
summer. The story of Camaxtle in Mayan belief, is similar to the story of
Samson. He too, was given superhuman strength symbolic of the sun's
power. When Samson enters the house of the virgin, Delilah (Virgo), he loses
his strength when his hair (his mane) is cut, symbolic of the sun's rays get-
ting shorter, as the days get shorter, towards giamos. At the point of moving
into giamos, Sam-**Sun** becomes the 'old man of winter' who will die to be
reborn. The story of the birth of Camaxtle (a bearded white man), and his
journey into manhood, is found painted on the walls of a Mayan holy tem-
ple in the jungles of the Yucatán Peninsula. Camaxtle was said to be born in
a stable, become Xipe-Totec (just as Cernunnos would become Maponos in
Celtic myth), to die on two wooden sticks (batons), which he is shown carry-
ing! The mother of Camaxtle/Xipe-Totec, Chimalma, is said to have swal-
lowed a jade bead that impregnated her without touching the insides of her
body. This story also hints at an 'immaculate conception' as she gives birth to
twins (morning and evening star), which relate to the `birth' of Venus associ-
ated with the saviour god Quetzalcoatl. And folk think Christianity is origi-
nal!

I believe the twelve disciples of the Jesus story are the twelve signs of the
zodiac, circling the sun. The cross relates to the combined points of giamos
and samos cycles, which the sun 'endures' through its journey in relation to
the earth. Leonardo da Vinci also depicts zodiac symbolism in his painting
The Last Supper, by splitting the disciples (one of whom is a woman symbol-
ic of Virgo, Mary, Isis and so on), into the four groups of three astrological
signs. The killing, wounding or imprisoning of the sun at giamos can also be
found in many ancient myths. Balder, the son of Frigg (El-Mary) in
Scandinavian mythology, is said to have been wounded by a spear of mistle-

toe, thrown by the blind god, Hod. Just like Jesus and the blind Centurion Longinus at the crucifixion, Balder is seen depicted in exactly the same classical resurrected pose as Jesus. Why so much similarity between the stories of the sun and pre-Christian gods like Balder, Maponos, Camaxtle and the later Jesus figure? Because all are versions of the same story of the divine boy – the child of light. This is the same 'light' said to be born on the winter solstice in the period the Romans called 'Saturnalia', to rescue the earth from the darkness of winter.

Christ, Crowns and Halos

In ancient Syria and Babylon, thousands of years before Christianity, the son of the virgin goddess Semiramis, was known as Tammuz. It is said Tammuz was crucified with a lamb at his feet and placed in a cave; three days later, when a rock was rolled away from the cave's entrance, his body had disappeared. When Babylonians held spring rites, in the sign of Aries (the ram), to mark the death and resurrection after three days of Tammuz - Ninus, they offered bread buns inscribed with a solar cross. You will find that the hot cross buns of Easter tradition came out of the rituals in Babylon. The bloodline of Babylonian kings was said to be the bloodline of Tammuz (Jesus), regarded as the 'shepherd' who looked after his flock of stars. Legend has it that Tammuz died wearing a crown of thorns (horns?) made from myrrh and was worshipped in the area of Jerusalem, at the exact location the later version of this story would be told. Cave symbolism is also common in various saviour-god myths, and gods like Tammuz and Zeus (the same person), like the later Jesus figure, were also said to be born in a cave. Even St. Jerome (342-420AD) admitted that ancient Bethlehem had been a sacred place dedicated to the fertility god Tammuz – the spirit of the Corn. This same deity was honoured as the 'corn mother' by the Hopi and Navajo Indians for thousands of years before Christianity, in their Soyál ceremonies*. Many of these ceremonies included a cross symbol on which their corn was blessed by the sun (see figure 37).

To Orthodox Christianity, Jesus is the begotten Son of God who died so our sins could be forgiven. But, as I have already touched on, you will find exactly the same claims for a list of gods in the ancient world long before the name Jesus was heard. One fact is for sure, we know his name wasn't Jesus because that's a Greek translation of a Jewish name. The term 'Son of God' would seem to originate as far back as the Gothic kings of Cilicia, a tradition which was adopted by the Pharaohs of Egypt, who claimed lineage back to their 'star gods'. Even the word `Christ' comes from the Greek word `Christos', meaning 'anointed'. And in that period to be an `anointed one', was to be ritually covered in Crocodile fat, an initiation of kings and priests as the messah, or messiah.

Figure 37:
Hopi Sun Symbol.

* Hopi Soyál ceremonies were performed at winter solstice in December and connected to the Sun's cycle. The Soyál would last twenty days beginning with purification rites and ending with hunts, all focused on the Sun and Moon, by the Hopi.

Priests known as the 'anointed ones' belonged to the cult of Sebek at Crocodilopolis in the Faiyum, and just like the Royal Court of the Dragon, it was set up in the course of the Middle Kingdom from 2040 BC. The stories of the Essenes who wrote the *Dead Sea Scrolls* and of the coming of the messiah, are linked to this brotherhood of priests based in Egypt. Great mythological accounts in this period were set down regarding the stories of Horus, the protector of kings, and Seth, the dark destroyer. Seth, like the Jaguar gods of South America, required placation through war and destruction and took the forms of a crocodile, reptile, wolf, fish and hippopotamus.[30] Horus was the hawk, a sun god, the son of Ra (Osiris) who would avenge his father's death by fighting Seth. In the epic battle between Horus and Set, Horus loses an eye, just as Odin would lose an eye in Norse myth. This eye became the symbol for a brotherhood who pay homage to the deity who caused this loss of sight – Seth. The same eye sits on the peak of the pyramid on the reverse of the one dollar bill of the USA and represents a destructive force that has controlled the world since ancient times. At Letopolis in the Delta, there was an ancient cult of Horus known as Hor-khent-irti, or Horus of the two eyes (the sun and the moon). This period goes back to a time before the fraternity of black magicians (the priests of Seth) who were said to have taken charge of the spiritual reins of Egypt.

The Egyptian Sun god Horus, just like his South American counterpart Quetzalcoatl, was said to be born to a virgin goddess Isis (moon), and the god Osiris (sun/saturn) who founded the lineage of the pharaohs in Egypt.[31] It would seem that Horus would not be either the first or last sun god to be born to a virgin, avenge his father, and redeem the world. The scope of this book cannot cover sufficiently the religious recycling and common themes, continuing throughout the last 5,000 years. Instead, I will give you a concise examples of the many hero saviour figures - 'suns (sons) of god', each of whom were born to a virgin goddess on December 25th (the ceremonial date for the dead and resurrected newborn **sun**), so the sins of the world could be forgiven. For the suns (sons) of the gods, see also:

> Baal - Taut (of Sumeria/Phoenicia); Osiris -Horus (of Egypt); Mithra (of Rome); Krishna (of Hindostan); Odin (of Scandinavia); Thor (of the Gauls); Crite (of Chaldea); Dionysus (of Greece); Nimrod - Tammuz (of Babylon); Zoroastor (of Persia); Quetzlcoatl (of Mexico); Buddha Sakia (of India); Mohammed (of Arabia); and Yeshua / Jesus (of Christianity /Western world).[32]

All of these deities were said to be born to virgins, descended to hell (underworld) and were resurrected on the third day. Each and every one of these deities are the same hero/saviour figure dressed in slightly different clothes of their time. In fact, it seems to me, that this saviour sun god was the creation of ancient priests who paid homage to celestial beings operating from outside of our space-time-world. The 'eyes' of these gods are the sun and the moon. Every attribute given to these saviour figures can be traced back to our ancestors' understanding of how the sun, planets and stars affect life on

earth. When the earth went through major cataclysmic upheavals, like a deluge, ice age, nuclear explosion or meteorites striking the earth in prehistoric times, then the re-emergence of the sun, and other heavenly bodies, following these events, would have been the focus of our ancient ancestors' lives. It's possible to speculate that the sun or 'new sun, comet or star' could be turned into a saviour and personified through time.

All but a few of the 'suns of the gods', including the prophets of religions later founded in their names, came out of lands influenced by the previously mentioned: Viracocha. These Caucasian gods, said to have emerged after the great flood, brought new technologies, arts, magic and science. As with the halo drawn circling the heads of many of these Sun Gods, and later saints who followed in their name, Viracocha travelled the world healing the sick and restoring sight to the blind.[33] The halo is symbolic of the sun's rays on one level and on another, represents the invisible, electromagnetic rays of light as understood by the ancients. A depiction of the sun god Mithra (Bel/Phanes), surrounded by the zodiac, is also seen with a halo around his head, exactly how other sun gods, like Jesus, were later depicted. The lion-headed gods, amongst some of the oldest artworks on the planet, are connected to Mithra – the Lord of Time and something called the 'Demiurge' found in Gnostic writings. I will come back to Gnostic symbolism in the next chapter.

Over the years I am more convinced that the Jesus figure, like all Pagan saviour gods, did not actually exist, physically. Outside of the Bible there is no solid evidence, or other historical record, whatsoever of the 'man'- Jesus. It is said that more than forty writers are known to have chronicled the events in Palestine during the alleged time of Jesus, yet not one mentions this famous miracle worker at all! In fact, there seems to be no physical description of this hero-god anywhere, not in the Bible or in any contemporary or near-contemporary document describing this man's life. Even the infamous 'Shroud of Turin' is regarded as a fake, likely created by Leonardo da Vinci, depicting his own face! In this context, the assertion of resemblance seems to have echoed amongst Renaissance artists who visited with, or met Da Vinci. The Flemish artist Düher even painted himself as Christ at that time, and some say the classic image of Christ was created in the Renaissance period by artists like Düher. Philo, the historian of Alexandria (30 BC-45 AD) who wrote the history of the Judeans, does not record anything relating to a messiah. For example, Philo even lived near Jerusalem at the supposed time of Jesus' entering the city, Jerusalem on an ass, greeted by 'palm-waving fans'. Missing that event would be like the media today missing some major news item, yet Philo says nothing of it! The most likely reason for this, is that none of it ever happened, it was all invented to enslave the minds of millions of people. However, I am convinced that Jesus and all the other sun gods are part of an elaborate ancient sun religion that still pays homage to specific hero gods, through the science of numbers, calendars and the movement of the planets and stars.

Seeing 'Sevens' Everywhere

The science of numbers recorded in many religious works throughout antiquity are all codes that speak of advanced calendar systems created by ancient priests. These codes relate to direct observation of nature and how the cycles of the sun and moon affect oceans, crops and people's lives on earth. The same language of codes is used in numerology, carrying meanings that express the hidden forces, cycles and esoteric qualities in nature. The orbital patterns formed by planets in our solar system, and the geometric structures they create, have been used in religious texts all over the world. The system geometers have used to calculate these precise patterns is called Bode's Law, named after amateur astronomer, Johann Elert Bode. Where planets pass each other, or have near-approaches, these patterns are called 'synods'. Using Bode's law and synods, geometers and astronomers can explain the time it takes for a planet to go around the sun and have even used the system of numbers called the *1750 Titius* to locate 'missing planets'. The planet Ceres was discovered between Mars and Jupiter in January 1801, by using the same formula of numbers. According to Bode's Law, planetary orbits around the sun occur as simple ratios. In other words, certain planetary pairs are rhythmic and harmonic, often displaying 1:2:3 ratio of periods.[34] The Earth has two planetary neighbors, Venus (sunside) and Mars (spaceside), and according to Bode's law, the earth kisses (passes) Mars three times for every four Venus kisses. This is said to create an ultraslow 3:4 rhythm or a constant musical fourth being played around the earth. I feel, that this particular rhythm relates to what the ancients call the `fourth dimension', something I will come back to in more detail later in the book.

These codes and ratios, expressed through movements of planetary bodies and explained through numbers, eventually became interwoven with ancient religion and hidden within parables and legends. The ratio of 3:4, the rhythm of the Earth in relation to Venus and Mars, is an interesting numerical code, otherwise known as the `ancient secret of sevens' (3 + 4 = 7). Even before planets were being discovered in the western world, an ancient seven-fold system had been in place, practised through alchemy and cosmology for thousands of years. Even the word *Seven* derives from the Egyptian god Sevekh, Seshet - a crocodile deity. In the Bible, for example, the numbers 7, 9, 12 and 40 are code numbers that relate to planetary cycles, certain stars and how the sun affects life on earth. This ancient system of numbers was based on 'seven', clearly visible, wandering heavenly bodies, arranged around a heptagon, in order of their apparent speed against the fixed stars. In fact, the word 'planet' derives from the Greek word 'wanderer' and these planets are: the Moon, Mercury, Venus, the Sun, Mars, Jupiter and Saturn. As wandering heavenly bodies they were also named after the days of the week and this remains so in many modern languages. The seven planetary bodies are said to correspond with seven metals of antiquity: Silver, Mercury, Copper, Gold, Iron, Tin and Lead. In keeping with the 'system of Seven', there are said to be seven 'planes of existence', by the more Eastern traditions, which include seven main 'chakras' forming the spiritual body (see page 246). These spin-

ning wheels of light can be linked to the seven colours of the rainbow and said to have sound that can be measured through seven 'harmonic scales', just as planets can compare with musical tones, hence 'the music of the spheres'.

In Aztec legend, the world we now live in was said to have emerged from the seven sacred caves. In most native American medicine wheel teachings we are given 'seven directions' on earth: north, east, west, south, above, below and within (more on this in *Chapter Seven*). For *Lord of the Rings* fans, that's: "Seven rings for the dwarf lords in their halls of stone."[35] So in the Bible, we have the 'seven spirits of God', the 'seven churches of Asia', 'seven golden candlesticks', 'seven stars' (quite possibly the Pleiades constellation), 'seven lamps of fire' (chakras), 'seven seals', 'seven trumpets', 'seven angels' and the red dragon with 'seven heads' in *Revelation*. Also in *Genesis*, God is said to have rested on the seventh day! Which happens to be a Sun-day. Other numbers relate to crop growth, engineered by the sun, and the ancient Egyptians are said to have estimated that it took 40 days after grain was sown for growth to to appear through the soil. Parables that talk of 'reaping what we sow' are as much to do with growing grain as the usual life lessons attributed to the teachings of the many sun gods. 'Grain' in the desert soil became the Israelites in the desert for 40 days. The symbolism doesn't end there. The Bible says Adam enters Paradise when he is 40 years old; Eve follows 40 years later. In the Great Flood it rains for 40 days and 40 nights; Set is carried away by angels at 40 and is not seen for 40 days. Moses is 40 when he goes to Midian and he stays for 40 years; Joseph is 40 years old when Jacob arrives in Egypt; Jesus goes into the wilderness for 40 days. I would suggest the Bible is pure esoteric code and not the word of God! Mystery school priests using esoteric codes are the writers/authors! All of whom were initiates of secret societies, who understood the hidden teachings connected to numbers and how numerology relates to different dimensions, vibrations, planetary orbits and the powerful cycles in nature. However, instead of focusing on metaphysical aspects of this knowledge, it has been taken literally by the masses, which ultimately leads to massive misunderstanding!

The Black Sun (Saturn)
The 'Black Sun' is an occult term for the planet Saturn, which doesn't make much sense unless you know what 'planets' like Saturn actually are. Saturn is not a planet, but a brown dwarf star and it is the same with Jupiter and probably other large gaseous bodies in our galaxy. Some dwarf stars actually 'light up' while others don't, the latter are often referred to as 'failed stars' (or fallen stars). Both Saturn and Jupiter generate more energy than they receive from the Sun, which would explain their dwarf star nature. Jupiter accounts for more than 70 percent of the mass of 'planets' in the solar system and has faint rings. Saturn, like Jupiter, Uranus and Neptune, is called a 'gas giant', all have a subtle ring system of some kind, although the others are nothing like Saturn's rings. You would say that no life could possibly live on Saturn if coming purely from the human 'five-sense perception'; but **non-**

physical entities, like the ones I mentioned in previous chapters, could live in otherworldly realities. In other words, these entities are 'energetic' rather than physical, unless they choose to take form to infiltrate and confuse other life forms (other beings). Interdimensionals can very easily interact with 'gas giants' like Saturn. Both Jupiter and Saturn have their own mini 'solar systems' having in excess of 60 moons – some of which are more like planets. The majority of Saturn's moons are named after Titans and Titanesses in Greek mythology; the so-called 'brothers and sisters' of Saturn.

Chronos is another name for Saturn in certain myths. Prometheus of Olympic fame was also a titan whose name became one of Saturn's moons. A golden statue of Prometheus looms over the 'ice ring' outside the G.E. building in New York, showing him carrying the fire of the gods (the flame). Over the door of the same building, Chronos looms with his Masonic compass (see page 97) and both Prometheus and Chronos represent the 'before and after' personifications of Saturn. The Titans are supposed to have fought the Olympians (gods) for control of humanity and for dominion over the earth. The battle of the gods is a common theme in the art and sculpture of the elite on earth. Even the titan, Atlas accompanies Prometheus and Chronos in the same vicinity of the G.E. building in New York. The symbolism is blatant once understood.

The Light Bringer (Saturn)
The legend of Prometheus is based on this titan deciding he would disobey the gods by making humans 'gods' themselves. According to Greek mythology, Prometheus belonged to the 'old order of gods'; he came from the bloodline of 'Iapetus (also a moon of saturn) and Uranus. His legend tells of how this young upstart steals fire from Zeus and gives it to 'select humans' (the elite). The fire Prometheus stole was said to be the essence of life or the 'light of the world'. On one level, this 'light' is the energy which gives us 'life' and is symbolised in *Genesis* and *Enoch* as the 'let-there-be-light' narrative. In Greek mythology, Prometheus is also a creator god, and like the Elohim in the book of *Genesis*, Prometheus's actions were considered both 'rebellious' and 'disastrous'. The rebellious aspect is symbolic of the 'fallen angel', Lucifer, who was said to be another 'bringer-of-light' figure. In the 2012 Ridley Scott movie *Prometheus,* scientists discover a piece of cave art which hints at the notion of our 'creators' coming from another planet in an ancient epoch. Much research into cave art by historians and neurobiologists, also hint at the possibility that 'human consciousness' (our prehistoric ancestors) went through immense neurological and biological changes around 40,000 years ago; the same time frame in which Neanderthal cave artists began to disappear; possibly 'removed' by an alien spieces (a Draco Reptilian intelligence) that wanted to completely change life on earth in order to suit their own agenda. You could say that our human ancestors' 'brains' were 'upgraded' to facilitate what some scientists refer to as a 'higher-order consciousness'. A genetic upgrade designed to allow a 'new' homo sapien species to live within a new 'matrix of light'. We were given the 'light' as such, and in some

myths this 'new-found ability' of a 'new earth species' was described as the 'gods' giving knowledge (or light) to Homosapiens. In this narrative, who were these Titans from whom Prometheus stole fire?

The *El*-ite and the *Elohim*

The noun El, according to scholars, is found at the top of a list of gods known as the 'Ancient of Gods' (or the 'Father of all Gods'), in the ruins of the royal archive of the Ebla civilization, located at the archaeological site of Tell Mardikh in Syria dated to 2300 BC. The bull is also symbolic of El; both he and his son, Ba.al Hadad, wore bull horns on their headdress. Ba'al of course was another Saturn/Jesus figure predating Christianity. El is listed at the head of many pantheons and is considered the 'father God' among the Canaanites, too. El is also the *El*ohim, the creator of Adam, said to be a lower entity (lower Aeon) in Gnostic writings. According to various researchers, the Elohim are a race of gods (note 'plural') described as a singular God in the Hebrew Bible. El is also another aspect of the 'Demiurge' (or Father God), found in the Gnostic texts and is obviously a reference to Chronos, Yahweh or Saturn. In the *Gnostic Gospels* and the *Quran*, the Archons (or Jinn) serve the Demiurge (God) who is considered a 'fake god', one who was said to have created our 'physical' or material reality. The Demiurge is also known in the Gnostic texts, *Hypostasis of the Archons*, as the 'Lord Archon' and they quote him as saying: 'Come let us create a man according to the image of God and according to our likeness.' El (Elohim) *is* similar to the Gnostic Lord Archon and the same deity appears in the *Matrix* movies as the Architect of the matrix (human world). As mentioned in the previous chapter, William Blake depicts the Demiurge as *The Ancient of Days* (see page 95). He is the masonic Architect, the classic image of God (white beard on a cloud). The creators of the *Superman* film, *Man of Steel* (2013) and the *Matrix* movies (1999-2003), I would suggest, are heavily inspired by the Hebrew belief in EL (Elohim). The sources seminal to Sabbath, Saturn-day and 'Sion', are also connected to the *El*ohim. Even the word Israel (IS-RA-*EL*) contains a trinity of gods: Isis, Ra and El, who are all connected to Moon, Sun and Saturn worship.

Saturn's Symbols

The deeper you delve into symbolism, the more obvious it becomes that Saturn was (an still is) a major focus for the mystery schools. The All-Seeing Eye is a symbol of Saturn on one level, and can be seen in many corporate logos (see figure 38 overleaf). So are other symbols, not least the cube, crescent (as horns), cross (crucifix) and the Star of David (hexagram). A cube is constructed from the hexagram, and a cube unpacked (or flattened) is also a cross (crucifix). All religions are 'constructs' of saturn-worship in their different forms. Saturn is the 'fallen' star/sun (or satan/sat-urn) the Gnostic texts warn about. There is much more to know about Gnostic symbolism and Saturn, along with Orion, as we shall see in the next chapter. Saturn, I

Figure 38: Saturn appears in the many logos of the corporate-banking-political-religious world.

feel, is a gigantic inter-reality gateway, a broadcasting body and its rings are a sound (waveform information) system. In my art and illustrations over the past ten years, I hint that Saturn is the *Lord of the Rings* (Sauron) and Saturn's energy field was converted by an Archontic realm collectively called the Demiurge by the Gnostics. All religions, secret societies (including satanism / saturnism), are 'tuned to' this black or 'fallen' star/sun. The symbolism is portrayed by George Lucas as the black-clad Darth Vader in the *Star Wars* movies. Darth Vader was a 'Jedi' Knight called Anakin Skywalker who 'fell' to the 'dark side' of the Force'. Interestingly, the *Anakim*, with only an 'm' replacing the 'n', were said to be a race of biblical giants (watchers) living in Palestine and ancestors of the Philistines and the giant, Goliath. Saturn is the Demiurge Sun and is used as a means of broadcasting a 'fake light' (information field) to distort and *invert* human perception. Therefore, 'dark sun', 'black sun' and 'dark lord', the names given to Saturn by the ancients and today's secret societies (and Satanists), are all very appropriate.

Reversed Symbolism
All knowledge and power can be reversed or inverted. The dark sun is a reversed symbol focused on creating elite power structures which do not have humanity's best interests at heart. According to some physicists, all suns (stars) are broadcasting the universal waveform energy field which becomes a decoded 'holographic universe'. If a waveform, or energy field is 'hacked into', it can be used to have a negative, or even 'restrictive effect', on the frequencies constructed from waveform. To illustrate this concept, the reversed (negative) swastika symbol, used by the Nazi hierarchy in the 20th Century, is one example of how a neutral esoteric power symbol (or energy) connected to the sun (dark sun), can be twisted and used for ill. In other words, there are both good and bad forces working through the 'energy' of what we percieve to be suns and planets. After all, they are consciousness just as we are too, and humanity collectively, can link to star/sun consciousness.

The swastika can be traced back to Sumeria and like other solar symbols,

it is found all over Egypt, India, and through to the Hopi lands of America. In its positive 'original form' the swastika is often depicted within a Star of David symbol. Both symbols combined with the rays of the sun in Hindu symbolism relate to 'life force' and heaven on earth. Hell on earth, of course, would be a reversal of this symbol!

There are many sources and much historical evidence suggesting the builders of Nazism before the Second World War, were inspired by secret societies like the 'Order of the Golden Dawn', which again offers more solar (sun-saturn) symbolism. This particular secret grouping, founded in 1888 by Freemasons Dr. Wynn Westcott and S.L. Mathers, used 'secret signs' including the pointed arm salute later used by the Nazis.[36] One other important symbol employed by these secret societies, is known exoterically as a 'triad'. The same symbolism can be represented as the Fleur-de-lis and the Triskelion (or triple spiral) motif. The latter is a neolithic symbol found on countless ancient sites, stones and cave walls. It is another representation of the triple goddess (the creator, protector and destroyer), relating to how energy is used to manifest 'reality'.

In most cases, reversed versions of sun symbolism are actually connected to saturn worship and are designed to pervert the true meaning of the spiritual power of this sun/star, before its 'fall'. When any energy (including our creativity), is reversed (or used for negative reasons), it hinders our true creative expressions and denies our spiritual sovereignty – our ultimate freedom. Through structures today, from banking to governmental agencies and their various abuses of power, we are witnessing the *opposite* of true creative freedom. Yet, this is not surprising when we find out that almost all modern institutions (banking, military orders and royalty) can be traced back to ancient priest kings and the bloodline of the gods.[37] The poet W.B. Yeats, who was a member of the Order of the Golden Dawn, summed up the aims and general mindset of the elite brotherhoods behind the 'cabal' running today's institutions. He said:

> ...an aristocratical civilisation in its most completed form, every detail of his life hierarchical, every great man's door crowded at dawn with petitioners, great wealth everywhere in few men's hands, all dependent upon the few... in court, in the family, an inequality made law.[38]

As individuals I think it is important that we face the many lies of our history; it's our responsibility to expose them for what they are! Our children's future depends on us. While this as always can be an unpleasant task, it is undeniably liberating one for the mind. I see the creative process as part of the exposing and unveiling of the shadow realities of our day. It is our ability to 'see with ancient eyes'. When we attempt the process of seeing through the 'great smoking mirror' (or illusions), as the Lakota Sioux call it, we can eventually liberate our minds, heal our world and cleanse our perceptions.

Leaving the Gods Behind – Taking Power Back

Since humanity became aware of a 'higher presence' in prehistoric times, we have always looked up to the gods, the chosen few, and our heroes, for direction. Native peoples, and classical civilisations alike, all had reverence for the gods who were credited with bringing fire (the light of the world) to humanity. The heavens from whence the gods descended became a focus point for the ancients, as did the bringing of light, signifying advanced knowledge (possibly technologies) given to our ancestors. Amazing temple structures were made by communities, guided by religious hierarchy and dedicated to different deities bringing advanced knowledge to the peoples of earth. Our native ancestors would say that history became legend, and legend became myth. Stories of gods and goddesses formed the basis of religions whose priest kings became monarchs, presidents and authoritarians of the modern world. The creation of the sculptures on Mount Rushmore in South Dakota, with its almost godlike presidents are symbolic of the new gods of our age. The fact that these faces were blasted out of sacred rock on Indian land, was a huge statement in terms of announcing the 'arrival' of the 'new order of gods' to the Americas. As in the ancient world, sacrifice is still demanded by these gods. Their minions use money like scented water in the temples of big business, the military and global banking. The gods of today are the rulers of the transnationals, who wage war against the one time social contract between people and the earth herself. In terms of wealth, they are the ancient royalty and lineage of priest kings, as well as Medieval occult families, who have always seen themselves as gods amongst the masses. As in ancient times, power and wealth are still concentrated amongst the elite (the 1%), through key families; while the oppressed masses, as always, search for truth, freedom and their creative power.

Native Americans, like other aboriginal peoples, have had their lives systematically destroyed by so-called business decisions made by this New World Order of corporate father (God) figures. The many faces of repression, at the hands of these modern deities, are perfectly described by the late Native American Indian poet, songwriter, actor and activist, John Trudell, whose words and music remain as personally relevant today as when I first heard his poetry in the early 1990s. Trudell claimed both his wife, children and mother-in-law were murdered in their own home, by the American government (FBI), when he, like many other Sioux, were protesting against the plight and injustices imposed on American Indians during the 1970s. In his song, *Rich Man's War*, he sums up graphically the insanity inflicting our world at the hands of a god-like ruling elite. He says:

> *Industrial Allies cutting the world as though they can't see blood flow,*
> *Central America bleeding, wounds same as Palestine and Harlem,*
> *Three Mile Island in El Salvador, Pine Ridge in Belfast,*
> *Rich man's war,*
> *The poor starving for food, starving for land, starving for peace,*
> *starving for real,*

Attacking human, attacking being,
attacking tomorrow, thinking of always war... [39]

As long as we believe that real power, our 'creative power', is only in the
hands of the chosen few (our leaders or the gods), and we see the rest of us
as simply ordinary or merely fodder (or numbers/statistics), we will contin-
ue to inflict destruction on one another, and on our environment. When we
give away our creative power, we allow the 'few' to *use* the 'many' for any
atrocity, even if it means destroying planet Earth. Believing in saviours,
heroes, even Presidents and Prime Ministers is a sign of deep inadequacy at
a collective consciousness level. Whilst we worship saviours (or even celebri-
ties), we are not fully grasping our 'divine origins' or our creative power.
This is something we are going to have to face if we are to 'open our eyes' to
who and what we are, and what we can achieve. Giving our individual cre-
ative power away has allowed the elite priests, monarchs, political leaders
and dictators alike, to divide and rule through the ancient pyramid structure
as described in an earlier chapter. From this perspective it is not difficult to
understand how all conflict and wars happen on the planet. And let's face it,
there has been far too many wars in the last century alone. If we nurture a
vision that empowers spontaneity, creativity, inner growth and fulfilment of
potential, then we move towards a more humanistic and imaginative society.
We naturally become more loving towards each other. This comparison
between the common man (clone of the system) who goes to war (no matter
what), and the peacemaker, who challenges imposition, quietly and unique-
ly in his own way, is told beautifully in a novel by French writer Jean Giono,
entitled: *The Man Who Planted Trees* (1954). It is a story, a parable telling of a
shepherd wanderer who chooses at the height of the First World War to sow
seeds that become trees, which become forests, instead of going off to fight. I
feel it is this type of expression of one's individual creative power (including
direct action) that can remove all tyranny on earth. If we are to realise where
our real power lies, then we have to 'shift our perceptions' from the top of the
pyramid, its leaders and their irrelevant games, bringing power back to our-
selves and our unique creativity. To do this, we must really desire change in
how we 'perceive' our world and ourselves within it. Ben Okri, in his book,
A Way of Being Free (1997), expressed similar thinking when he said:

> *There is no genuine creative or human problem that cannot be solved if you are*
> *sincere enough, humble enough, hard working enough and if you have learned the*
> *gentle arts of concentration, visualisation and meditation.* [40]

I believe these three arts are the key foundations for taking back our cre-
ative power. They can also help us to realise our links with each other, includ-
ing all life forms. More so, they can be used to liberate each individual, if we
shift our focus to things that really matter, like 'freedom' and 'love' for *every-
one*. When we do this, it helps us to place strength where it has always been,
along the edge, uniting the people, making a circle, a model I firmly believe

will help change how we live our lives, especially through the 21st Century. The human psyche is suffering because of this straightjacket-like hold on spontaneous expression and individuality. How do we change how we're being controlled? We too, need to start expressing ourselves by using one of the most ancient devices for empowerment (both on an individual and at local community level): the circle. The various circles I have attended over the years are empowering; giving each individual the platform to feel connected to the centre of their being.

Using the Circle

The circle is the oldest organisational structure on the planet, used by all our tribal ancestors, from Alaska to Australia. Some writers, like Christina Baldwin, have called it the 'first and future culture'. When used in society, the circle ultimately places leadership along the 'rim' so that everybody has the opportunity to make a contribution towards life, society, a problem or a project. By incorporating the circle in everyday life, whether it be how a business, government, or even how a school is run, we automatically place creative power and decisions within the hands of the many and not the few. This is the opposite of what now is taking place around the world where governments and the people they are supposed to represent, are having their lives dictated to by an ever-increasing and intensely sinister structure of centralisation. The European dictatorship based in Brussels, with its unelected bureaucrats, its single currency and central bank, can be seen as a perfect example of the 'reversed use' of the power of the circle. So can any parliament (government), especially when the democratic rights of people are constantly ignored by those who really serve the elite. People might think that the circle model I am about to describe is another version of what is called Communism, it is not. I would suggest all groups, whether communist or capitalist, are mentalities of black and white, all playing a part in the polarised pyramid structure. The idea of the circle is too ancient for group dogmas, with its roots in the mystery of our ancestors and their relationship with the universe. The power of the circle has been used to conspire against people, but can be used by people and communities to change the social structures and reality we call life on earth. In her book, *Calling the Circle* (1996), Baldwin talks of the need to bring back the circle into daily life. She writes:

> *Both the circle and the triangle have influenced each other they work best when allowed to occur in combination. A council may be called in which every person has a voice and then the group of 'elders' takes all these voices into consideration when they make a decision.*[41]

However, the triangle or hierarchy, has become imbalanced in our civilisation, and separated from the circle. This has created a 'patriarchy pyramid', a machine-world without a real soul or consciousness; one that threatens the very life of the planet. In terms of education, the pyramid insists there is only

one right way to learn, and each one must have their place in a 'structure' they can't change. All 'national curriculums', and their almost strangleholds put upon teachers in terms of creativity, is part of this process. John Taylor Gatto addresses this point with precision in his book: *Dumbing Us Down* (1992). He writes in relation to American education policy:

> *What's gotten in the way of education in the United States is a theory of social engineering that says there is one right way to proceed with growing up. That's an ancient Egyptian idea symbolised by the pyramid with the eye on the top. Every one is a stone defined by position on the pyramid. This theory has been presented in many different ways, but at bottom it signals the world view {sic} of minds obsessed by dominance and strategies of intervention to maintain dominance.*[42]

That is why it is so important we acknowledge the circle and bring its knowledge into our communities once again. As an archetype it can help us understand our lives and show us how we perceive and create from our 'inner circle', our own 'source of power'. I personally would like to see the circle used (with respect) in all areas of society. This would help lay the foundations for an open society, one that considers all knowledge and information. The circle would help us to support each other through the many possibly turbulent changes that lie ahead; providing communities with 'localised structures' that can take us out of any centralised control. In other words, in the face of catastrophe of any kind, the circle (if used respectfully) would focus people on 'coming together' in unity and helping each other. What methods of self governance, for example, would we employ in the local community should a major disaster cut off food or money supplies? Or if our government were overthrown through warfare, which is happening today all over the world in many countries; how would we survive? Do we honestly think we are immune to this type of devastation? From a higher perspective, the circle structure would help us through any real change or major problem faced by any community. It could give both inner and outer strength, keeping power focused on the whole, the community, the people and not the corrupt desires of the few.

If the circle were in place and in use in our society, our lives would be very different. We would become active citizens within our communities, rather than passive bystanders watching our councils continually increasing taxes and fostering abusive laws that only serve to suit central government. Voting, in what is becoming a phoney democracy, is nothing like being an active part of a community with consciousness. When we are part of a circle, we are asked for our views, our ideas, and above all, we are asked 'how' we would like to contribute. In this mode, the power belongs to 'participation', there are no political bosses, as such; instead, authority rests in the problem-solving process. I disagree with politicians who want us to be less self-sufficient, have one global government and a totally controlled society. The real challenge for people today is to put the circle in place and experience the empow-

erment it can bring to daily life. Political devolution in places such as Scotland and Wales is inadequate; ineffective. If we wait for disasters or some crisis to force us into the circle mode, then the aftermath could result in even more centralised control by the few. If, one day, we wake up and find a natural disaster, or a political crisis on our doorstep, then looking to our leaders, the elite, or the gods to help, would do us no good. But if we had in place community councils that understood the power of the circle, we could, in the face of a crisis, call on our inner powers, efforts and community resources, to try and resolve any impending problem. The circle culture, as it was for our ancient ancestors (from the American Indians to the Samurai), helps us to come together, talk things through, step forward, regroup, and 'stand united'. It is the sacred hoop that cannot be destroyed!

To move into the power of the circle we need to look at life through our ancient eyes and see the sacred in everyday life. We have to be open, aware and ready to listen to our inner selves, our bodies and nature in all its forms. If anything new is to be learned, created or perceived in life, we as people, also need to feel alert and energised. This means we must be able to articulate alternative information in the public arena, without constantly insisting on conforming to somebody else's belief system. It also means we have to get off each other's backs so we can express our uniqueness and get to know the internal workings of ourselves. To do this, we need to get to know the soul in all life, how we think, create and journey through and around the circles of our minds. More importantly, we have to be unafraid of our journeys or where our spirit has the potential to take us. While bringing this chapter to a close I am reminded of a quote by Saint Bonaventura, which gives powerful insight into the nature of the circle. He said:

"The nature of God is a circle of which the centre is everywhere and the circumference is nowhere."

The circle is one of our greatest tools for utilising creativity through communicating with each other in our communities, just as it was for our ancestors through their councils, dances and rituals. When we use this archetype to bring forth the spirit in our lives, we give ourselves permission to 'cleanse our perceptions' and to realise that everything that lives is holy. In this chapter I have tried to shed light on some of the realities that confound and control us today. My intention is to ignite the process of self-discovery, vital to our individual learning and not to impose any belief system on the reader. The process of self-discovery and liberation of our true self (through using our creative imagination), is what I call 'soul movement'. In the remainder of this book I will explore ancient knowledge which provides 'keys' for unlocking the potential within us all. But before I approach that knowledge all artists can tap into, I want to focus on a 'deeper knowledge', one that connects us to the stars.

One constellation, in particular, needs our attention.

Sources:

1) Bauval, Robert, *Secret Chamber*. Arrow Books 2000. p415. (fig.28)

2) Bauval, Robert , *Secret Chamber*. Arrow Books 2000. p434

3) Jurgis Baltrusaitis, *La Queye D' Isis*, Flammarion Paris, 1985. pp 21-78

4) Robert Bauval talking of the work by David Ovason. *Secret Chamber*. Arrow Books.1999. p442

5) Turnbull, Stephen, Samurai Heraldry, Osprey Publishing, 2002. pp10 - 12

6) Brooke-Little, JP , *Boutell's Heraldry*, p3

7) *The Builders*, Cedar Rapids 1916 (Taken form *Masonic Orders of Fraternity* by M. P. Hall, p15)

8) Cotterell, Maurice. *The Lost Tomb of Viracocha*. Headline. 2001. pp15-23

9- 10) Extracts taken from the work of Robert Howard © 2000. At www.centernews.com and www.iluminati-news.com

11) Hall, Manly P., *The Secret Teachings of All Ages* (The Philosophical Research Society. Los Angeles, California, the Golden Jubilee Edition, 1988) pL

12) https://en.wikipedia.org/wiki/The_Sirius_Mystery

13) Frazer, Sir James George, *The Illustrated Golden Bough*. Simon & Schuster Editions. 1996. p162

14) Robert K. G. Temple, *The Sirius Mystery*, St. Martin's Press. 1976. pp 26 and 28

15) Acharya S. *The Christ Conspiracy, The Greatest Story Never Told*. Advertising Unlimited, Kempton, Illunios. 1999. p241

16) Brooke, Elizabeth, *A Woman's Book Of Shadows*. The Women's Press. 1990. p172

17) Phillip, Neil. *Annotated Myths & Legends*. Dorling Kindersly. 1999. p90

18) Bosing, Walter. *The Complete Paintings of Bosch*. Midpoint Press. p12

19) William Shakespeare, *A Midsummer's Night Dream*. V, ii

20) Davidson, Ellis. *Scandinavian Mythology*. Newness Books, 1982.

21) http://www.sacredspiral.com/Database/serpent/3serpent.html

22) Hancock, Graham. *Finger Prints of the Gods*. 1995. p51

23) Howey, M. Oldfield, *The Encircled Serpent*. Rider & Co circa 1900.

24) Walker, Paul Robert, *Spiritual Leaders*. Facts on File. New York.1994. p85

25) Townsend, Richard; *The Ancient Americas: Art from Sacred Landscapes*. The Institute of Chicago - Prestel Verlag, Munich. 1992. p311

26) Bardiere, Phillipe. *La Bête du Gévaudan*. Une production Skeudenn Vev S.A.R.L au Capital de 8000E

27) Blake, William. *The Marriage of Heaven and Hell*. Plate 11. 1790.

28) Manley, P. Hall. *The Secret Teachings of All Ages* (the Philosophical Research Society, Los Angeles, California 1988. p A1.

29) Martineau, John. *A Little Book of Coincidence*. Wooden Books. 2001. p45

30) *Dictionary of Egyptology*, Rockhampton Reference. p 150

31) Cotterell, Arthur; *The Encyclopedia Of Mythology*. Lorenz Books. 1999. p243

32) Eckington, David. *In the Name of the Gods*. Green Man Press. 2001. p287

33) *South American Mythology*. Hamlyn 1968 p 74

34) Martineau, John. *A Little Book of Coincidence*. Wooden Books. 2001. p16

35) Tolkien, JRR. *The Lord of the Rings*. p 77

36) The Order of the Golden Dawn (founded in 1887), had amongst its members, prominent poets like William Butler Yeats, and Satanist, Alister Crowely.

37) Icke, David. *Children of The Matrix*. David Icke Books Ltd. Appendix II

38) Quoted by Francis King in *Satan and the Swastika*, Mayflower Books, London, 1976.

39) *Rich Man's War*. John Trudell & Jesse Ed Davies; Poet Tree Publishing & Black Hawk Music. 1992.

40) Okri, Ben; *A Way of Being Free*, Phoenix House. 1997. p49

41) Baldwin, Christina; *Calling the Circle, the First and Future Culture*. Gateway books. 1993

42) Gatto, John Taylor; *Dumbing Us Down, The Hidden Curriculum of Compulsory Schooling*. 1991. p75

Orion's Door

Symbols of Gnosis & Cosmos

*"There are things known and things unknown and
in between are the doors."*
Jim Morrison

A lot of my art is symbolic and considers the cosmological perception of reality. The general name for the mystics who pondered on the nature of the cosmos, creation and the 'nature of reality' were the Gnostics. One famous source for Gnostic teachings came from a series of manuscripts called the *Nag Hammadi* texts and the *Dead Sea Scrolls*, found near the town of Nag Hammadi about 75-80 miles north of Luxor on the banks of the River Nile, in Egypt. These texts generally became known as the 'lost gospels' of the *Nag Hammadi* Library. The *Nag Hammadi* find included thirteen leather-bound papyrus codices (manuscripts) and more than fifty texts written in Coptic Egyptian, which were the work (along with other ancient influences) of a people known as Gnostics. The Gnostics were not a racial group. Their ideology was as a way of 'perceiving reality' under the heading of 'Gnosticism', which comes from the term 'gnosis' - a Greek word that translates as 'secret knowledge'. To be Gnostic simply meant to be 'learned'. let us look at what the 'learned' knew and the stories they told.

The Aeons (Higher Consciousness)

The Gnostic texts of *Nag Hammadi* offer an alternative creation story that teaches of a cosmological 'birthing' of our world through the dreaming of what the texts call 'the Aeons'. The Aeons were said to be divided into upper and lower realities (consciousness) and one particular Aeon, called Sophia, was pivotal to this story. Sophia was the goddess that became Gaia or Earth in the Gnostic teachings. Dictionaries define this meaning of Aeon as 'a power existing from eternity; an emanation or phase of the 'supreme deity'. Gnostic texts refer to the Upper Aeons and Lower Aeons in very different terms and they say that between the two worlds is a curtain, veil, or boundary. The Upper Aeons are said to emanate directly from the unity of 'The One' – *Infinite* Awareness of itself – and can be symbolised as concentric circles expressing the *Oneness* of their Creator or *Emanator*. The Upper Aeons are described by Gnostics as 'The Silence', or the 'Living Silence', or

THE EARTH IS
THE LORD'S
AND THE FULNESS
THEREOF

Figure 39:
The Goddess and Cornucopia.
The central statue above the doors of the Bank of England, in London, is symbolic of the 'field of plenty' being 'manipulated' by those who control the wealth (money) on earth. Note the caduceus to the right of the goddess and the ship to the left. Both are symbols of **control** over humanity.

the 'Watery Light'. The Lower Aeons were said to be creator gods that could only influence worlds beyond the veil or boundary.

The Gnostics talk of the teachings of the 'Pleroma', or what the *Nag Hammadi* texts called the 'abode of the Aeons'. They described it as the place of higher consciousness, 'eternal ideas' or the home of archetypes. The word 'Aeon' for the Gnostics, was another way of describing 'higher consciousness' or the *Infinite* that *is* the Pleroma. In recent years, I have often depicted in my art, the Pleroma which I see as 'living plasma' (the force behind the electric universe) that constitutes the 'mass' of our *living* Universe. The word Pleroma also means 'fullness' or 'plenty' and relates to what Native Americans called the 'Field of Plenty'; the place from which *all* life manifests. The cornucopia is another symbol for the Pleroma or 'Field of Plenty' and can be found on buildings (mainly banks) and stately homes of those who have much invested in the 'control' of this field of energy used on earth (see figure 39). In simple terms, the Pleroma is 'living electromagnetic consciousness'. *Everything* is alive and can take multiple forms. As the physicist Wallace Thornhill says in the book he wrote with David Talbott, *The Electric Universe (2007)*:

We can detect magnetic fields in space which, according to Maxwell's equations, means electricity must be flowing in space to produce them. It is impossible to have a magnetic field without moving electrons. Electrons only move in response to charge imbalance. Once an electron is moving, we have an electric current.

Sophia, Asherah or Mother Nature

The two thousand-year-old *Nag Hammadi* texts say the Aeons were separated from their celestial region by Horus (or Boundary) and beyond its veil was what the Gnostics called the 'Kenoma', or the 'void'. Humanity was said to have been created out of the meeting of the 'Kenoma' and the Aeon Goddess called Sophia. It was thought by the Gnostics that humans are

god-like (Aeon-like) with a powerful tool at their disposal – our 'divine Imagination', a subject further elaborated on in later chapters. In the *Nag Hammadi* texts, the Aeon called Sophia (wisdom in Greek), aided by Thelete (intent in Greek), was said to have dreamed into existence a world that was connected to the Upper Aeons. Sophia became self awareness and through her dreaming process, into the realms of the Kenoma (beyond the veil), she created what the Aboriginal cultures call the 'Dreamtime'. The Aboriginal Dreamtime is a creation epic predating *all* Biblical creation narratives by at least tens of thousands of years.

Figure 40:
The Wife of God.
A possible depiction of the Aeon Goddess Sophia, or Asherah, known as the Venus of Dussledorf.

Another aspect of Sophia can be found in the stories of Asherah, the Wife of God found in Mesopotamian art and sculpture. The famous 25,000 year old neolithic sculpture of the 'Venus of Dusseldorf' is another image of Asherah or possibly Sophia (See figure 40).

It was said that as Sophia dreamed, she 'fell' further into the 'void' and awoke within her *nightmare*, as her impact on the outer veil led to the 'emergence' of what Gnostic texts call 'in-organic' elementals known as 'Archons'. In Arabic texts the same elementals are called the Jinn, and in Christianity they are referred to as demons or 'phantoms' said to plague humanity. I see them *all* as aspects of the Predator Consciousness I referred to in *Chapter Two*. Sophia's impact on the boundary-between-worlds created a cosmic calamity as these in-organic forms circled and swooned around the chaos that was formed by Sophia's fall into the Kenoma (see figure 41). You could say that Sophia fell into a 'coma', a place from which she would eventually awaken.

Virtual Heaven

According to Gnostic myth, the world we inhabit was pure 'thought' (the region of matter made manifest) through the material, or physical world. Like the Cathars of 12th Century France, the Gnostics saw the physical world as the land of shadow and darkness, a place where 'perception and deception' would coexist. According to Gnostic texts, Sophia eventually took physical form as Gaia (the original Earth) and her daughter was called Zoe (Imagination). The Native American Northwest Thompson Indians illustrate a similar story of the Earth being a goddess through their cosmology:

> At first Kujum-Chantu, the Earth, was like a human being, a woman with a head, and arms and legs, and enormous belly. The original humans lived on the surface

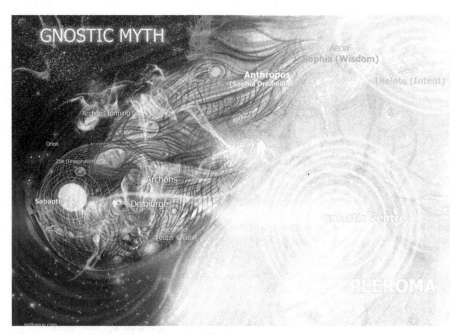

Figure 41: Sophia's dream turned nightmare ...
Sophia's dreams giving form to worlds centered on the Orion constellation.

of her belly. Her hair became the trees and grass; her flesh, the clay; her bones, the rocks and her blood, the springs of water.[1]

From within Sophia's nightmare, according to the Gnostic scriptures, there appeared a central figure, or a deity that she gave birth to and quickly rejected. This figure proclaimed itself to be the source of all that was born out of the impact caused by Sophia's dreaming (see figure 41). He was the Father God called 'Yaldabaoth' and announced that 'he' was the architect of the virtual worlds that were forming due to Sophia's dreaming. The worlds forming were the 'stars' and 'nebulas' in the lower worlds of what the Gnostics called the Kenoma. Under the instruction of this Architect God-figure, along with what the Gnostics called the Archons, they built solar systems including a 'fake Earth', or Matrix. The Archons used other planets and suns to alter the original geometry and 'fractals' of light in order to replicate 'the heavens' in their liking. The texts say that the offspring of Sophia, guided by this Architect God-figure, constructed an illusory reality, purposely made to 'mimic' the original organic reality born of the Aeon Goddess.

In the Aboriginal Dreamtime, the forces I am describing here were actually called the 'Mimics' and were said to look like giant frogs or lizards. The illusory worlds started by Sophia's 'dreaming' and then copied by the 'mimics' (archons), were said to have changed in appearance 'four times', and are the different worlds described by the Hopi and other native peo-

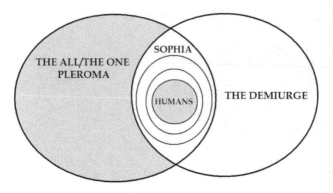

Figure 42: Caught Between Worlds. Humans are caught between two worlds: The Aeon *organic* Earth World and the Demiurge 'fake' (*artificial Intelligent*) controlled Earth. We have a choice to make!

ples. The Gnostics also say that humanity is still caught up between two realities: the original Earth, and the one created out of what the Gnostic texts call HAL, forged by its architect Creator-God – the 'Demiurge' (see figure 42). The duality of these two worlds will become more apparent as we get further into this chapter.

A Demented God - The Chimera

According to the *Nag Hammadi*, HAL, or the illusory world, had its own Creator called the Demiurge. He was the deity that was eventually called *God* by the monotheistic patriarchal religions. You can see why the Gnostics and later Cathars were removed? According to the Gnostic texts, *'he'* was an angry, demented, impostor-god who envied the human divine imagination. He is the 'beast' often depicted as a 'rampant lion' whose minions are the 'inorganic' archons (resembling an aborted fetus) that supposedly, were also birthed out of the *chaos* caused by Sophia's fall through the Pleroma. As the acclaimed John Lamb Lash writes in his book, *Not in His Image*:

> *...and Sophia desired to cause the thing that had no innate spirit of its own to be formed into a likeness and rule over primal matter and over all the forces she had precipitated. So there appeared for the first time a ruler out of chaos, lion-like in appearance, androgynous, having an exaggerated sense of power within him, and ignorant of whence he came to be.*[2]

Gnostic texts such as the *Hypostasis of the Archons,* say the Archons were born out of Sophia's dreaming and that they created 'seven powers' for themselves. One of the powers created was 'six angels' (six archons), one of which was called Sabaoth (the Lord of Hosts), who was said to have 'a dragon's face'. Sabaoth, Helios and Saturn are the same entity and in some myths they are also Prometheus and Chronos. Both these gods relate to an ancient epoch, a cosmology connecting another central sun (Saturn) to the earth in a golden age. For more information on this concept see David Talbot's excellent book, the *Saturn Myth* (1980). Lash equates the sixth angel Sabaoth with our sun, but the *Apocryphon of John* says: "The sixth one is Cain, whom the generations of men call the fallen Sun." This fallen Sun, in my view, is both Helios and

Saturn (Prometheus and Chronos) and it is Orion that holds sway over the original 'ring-less' Saturn (the old Sun). A harmonised human, connected through his or her heart will naturally bypass the 'rings of constriction' imposed via Sabaoth, or Saturn. I go into these concepts in great detail in my graphic novels *Moon Slayer* and *Aeon Rising*.

In the *Nag Hammadi,* the Gnostics describe Yaldabaoth as Ariel, another variation of the angel Ariel (or Ariael), which means 'Lion of God' or 'Hearth of God', something I will return to shortly. *The Apocryphon of John,* a work heavily quoted by John Lamb Lash, describes the Demiurge as a dragon-like lion beast. The same beast was often symbolised as a chimera, a lion-headed serpent, that was said to forge a world in its own likeness (see figure 43). The Gnostic text, *Hypostasis of the Archons,* alludes to the lion-like Demiurge and the veil between the spirit and material world:

A Veil exists between the world above, and the realms that are below; and shadow came into being beneath the veil. Some of the shadow [dark matter] became [nuclear] matter, and was projected apart. And what Sophia created became a product in the matter, like an aborted fetus. And it assumed a plastic shape molded out of shadow, and became an arrogant beast resembling a lion.[3]

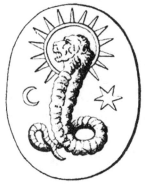

Figure 43: The Gnostic Demiurge.

Figure 44: Angra Mainyu.

Much Upper Renaissance art also shows us the 'beast personified', not least the work of the Fifteen Century Flemish artist, Rogier Van der Weyden, in his painting of *St. Jerome,* (who was the father of the early Christian Church). The lions' faces are peculiarly human in many of these paintings so as to emphasise the subtle connections between the 'beast and man'. In my art, I use similar concepts of 'personified energy'; yet my lion imagery represents the *Pleroma* not the *Chimera*. My *Lions of Durga* in the *Kokoro Chronicles* are purely the Pleroma, or Aeon Consciousness personified. Interestingly, Angra Mainyu, the deity found in the *Gathas,* (the oldest texts of Zoroastrianism), is also depicted as a lion-like sun beast (see figure 44). 'Angra Mainyu' is the devil-like god translated as a 'mind', or 'spirit' or otherwise an abstract energy.[4] The syllable 'angra' in this context also means 'destructive', 'chaotic', 'disorderly', 'malign' and a manifestation of 'anger'; all are perfect words to describe the angry 'fire-and-brimstone' god of the *Old Testament,* who, according to Gnostic thought, was the Demiurge. The beast, or rampant lion featured

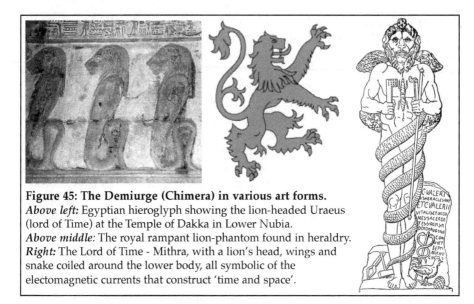

Figure 45: The Demiurge (Chimera) in various art forms.
Above left: Egyptian hieroglyph showing the lion-headed Uraeus (lord of Time) at the Temple of Dakka in Lower Nubia.
Above middle: The royal rampant lion-phantom found in heraldry.
Right: The Lord of Time - Mithra, with a lion's head, wings and snake coiled around the lower body, all symbolic of the electomagnetic currents that construct 'time and space'.

on royal heraldry, through to the many statues of lions on Stately homes, all relate to the symbolism of the prideful, arrogant, chimera, or Demiurge (see figure 45). The lion-headed 'Time Lord', Mithra, was another version of the Demiurge. The lion is also a symbol for the tribe of Judea in the Biblical sense, with Jesus as the lion king, but this is just another representation of the royal lordship of the chief architect - the Demiurge.

Impressive research conducted by US research business analyst Danny Wilten, shows so many correlations between Orion and the electric universe theory, not least imagery of Birkeland currents that look serpent-like and appear to mimic the classic image of the Gnostic Demiurge.[5] In some of Wilten's image mapping, the central sun symbolism, said to be part of the Orion Nebula, can be seen as a lion's head in profile with a snake-like cluster of stars that descend from its head forming parts of the nebula. There is so much more to know in this area of research and the connections with Orion's focus in terms of its 'influence' on planetary systems that constitute our solar system. I feel that Sophia's fall in the Gnostic texts, hints at the very formation of the Orion Nebula as part of the creation of our physical reality.

Orion, the 'Son of the Red Man'

The Kabalist's (Qabalah) refer to Orion as Adam Kadmon, or the 'heavenly man' whose head (Merkava) manifests our reality. Danny Wilten seems to have found similar visual themes in his research into the 'mirror images' of the Orion Nebula, with the Nile Delta region. The symbolism contained within the 'tree of life', from the head to the toes of the celestial human, through what is described as the 'middle pillar' (spine), also seems to connect us to the Orion Nebula. When we consider the notion of a Holographic

Universe, it wouldn't be too impossible to understand how geography on earth can be mirrored in the stars - namely Orion. *As Above, So Below.* I'll come back to this in a little more detail shortly.

Our unique connection to the Orion Nebula, and how it links into the 'fall of Sophia', can be seen in myths showing the joined forces of a Christ-like figure (Adam) and a Goddess Creator/lover (Sophia), as they combine their energy to change the world tree (Tree of Knowledge). The coming of the Aeon called 'Christos', to aid Sophia in her 'creation process', can also be found in ancient sources and characters in present-day movies. See Neo and Trinity in the *Matrix Trilogy*; Leeloo and Korben Dallas in *The Fifth Element*; Jupiter Jones and Caine in *Jupiter Ascending* and Quorra and Sam Flynn in *Tron Legacy* to name but a few. All of these movies feature a god-figure working to prevent the joining of these two halves (male and female) of the same whole. The 'preventer' is the Architect, or omnipotent creator god - the Demiurge.

Religious belief, from Native American tribes to the Hebrew books in the Bible, talk of an omnipotent god. There are many similarities between the apparent different 'father gods' spanning great distances in the ancient world. This is because they are mainly the same figure and quite possibly all part of the same focus on Orion, Mars and Saturn. 'Masau'u' (Hopi), 'Osiris' and 'Ptah' (Egypt), 'Adam/Yahweh' (Hebrew), 'Jesus/God' are all deities that 'focus' on Saturn and the Orion constellation. The word 'Adam' connects to the word 'red'; both 'Adam' and 'Mars', according to the etymologist Pierre Sabak, also link to Orion through sacrifice, war and death. He writes:

> *The Hebrew word 'Adam' is deduced from 'adamah' (earth) and adom red, thus adamah implies red earth and is related in the Semitic to ma'adim Mars. Its derivation is 'me'adim' literally (from Adam). In Egyptian Arabic 'Mars' means March (and is found also in the French word mars march). Mars religiously denotes the sacrifice of the spring lamb an innocent equated with Mars and the genealogy of Adam. Theologically the sacrifice of the ram denotes the destruction of Adam Arabic 'adam literally (annihilation) suggesting the death of the planet Mars and the descendents of Adam.[6]*

The red rock canyons of Arizona and New Mexico are also interconnected with the symbolism associated with Orion's stars. In Gary A. David's brilliant book the *Orion Zone*, he puts forward compelling evidence illustrating how the natural architecture and constructed Hopi mesas are aligned to astronomical phenomena connecting Orion's stars with the surface of the earth. Hundreds of petroglyphs created by the Pueblo Indians also show their understanding of Orion's influence on earth through their beliefs and myths. The Hopi deity Masau'u is an important figure in Pueblo Creation stories and their 'emergence' into the world. Masau'u is similar to Osiris of ancient Egypt and both gods are 'Son-of-Man' deities. They are symbols of

Orion's archetypal 'impression' on our ancestors' 'collective mind'. The pineal gland, Odin's eye, Golgotha (the place of the skull) symbolism, along with the 'Son of Man' Jesus (Adam) figure, allude to the celestial 'giver' and 'taker' of life - Orion. The same attributes can be seen in other creator gods like 'Atum' and 'Ptah' of ancient Egypt. Lion symbolism is also connected to these gods, not least through Ptah's wife, Sekhmet, the lioness goddess of War. In places like Tiahuanaca in Bolivia, underground pyramids, along with pyramids on its surface, are dedicated to another god (I mentioned briefly in *Chapter One*) called Viracocha. Lord Viracocha is the South American version of Osiris and the Inca version of the god, Orion.

Orion in the American Southwestern skies is represented by the Hopi god Masau'u, whose symbol is sometimes shown as a 'whirlpool gate', or a 'double spiral'. All of the main Hopi mesas align with Orion and like the Mayan pyramids, and the pyramids of Giza near Cairo, they all seem to place a huge importance on this star system.[7] The three Hopi mesas in Arizona, like the three main Giza pyramids, all seem to align with the belt stars, Alnitak, Alnilam and Mintaka. In Sumer, circa 3000 B.C., Orion was worshiped as the god Ninurta (son of Enlil), who was known as the god of fields and canals (mounds) and the bringer of fertility. He was also the god of war and the 'hunt', who brings death. Osiris was venerated in exactly the same way in ancient Egypt. Even the *Pyramid Texts* say, 'Osiris has come as Orion'. Like much ancient Egyptian royalty, Osiris even seemed 'giant-like' in comparison to the natives often depicted around him in Egyptian imagery. The race of giants, or the Watchers I talked about in *Chapter One,* also connect to the focus on the 'giant hunter', the Son of Man - Orion (see figure 46). Pierre Sabak points out in his book, *The Murder of Reality:*

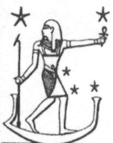

Figure 46: Orion, Osiris, Ptah, Masau'u - *all the same 'star god' (star man).*

Adam's bloodline is equated with Orion. Adam is punned in the Old Semitic with the word 'qadam' (east), a word translated into Latin as oriens east an etymology symmetrical with Orion. This bloodline is combined with the descendants of the nephilim giants (nafil) Greek Titan appellations of the Anunaki (anaki gigantic). These names appertain to the race Gibborim from Gibbor giant. The word gibbor is a synonym of Orion.[8]

Orion is the celestial giant 'star man', a 'blueprint' for a myriad of symbols that have been with us since our ancestors looked to the heavens (to the Aeons) and the gods (or forces) that shaped our reality on earth.

The Dual God

The understanding of dual forces, eternally turning and aiding in the evolution of humanity, can often be seen in petroglyphs and pictographs of the ancients. You could say that the art left on rocks in places such as Arizona to Northern India by migrating artist-shamans, was put there intentionally to remind future generations of the life cycles endured through these opposing forces.

Strange deities, such as 'Kokopelli' (the hunchback flute player), who can be found in numerous locations across North America, are considered a symbol of the 'Solar life force'. Kokopelli is almost always depicted in rock art, adjacent to, or rising out of, the head of the god called Masau'u. The Hopi tribes of Arizona say that these two gods represent the duality of the 'supreme being' (or the 'force' if you are a *Star Wars* fan). 'Masau'u' was said by the Hopi to be a totemic deity who came out of the 'darkness' as a 'faceless' god who represented fear, death and the underworld. In some traditions, this mask-wearing figure also represented a destroyer of worlds, not too dissimilar to the fire-and-brimstone god found woven into Jewish and Christian belief. Parallels can be drawn between Masau'u and Yama in Hinduism, who was also the God of Death. In Vedic art, Yama is often depicted with green skin, red clothing and riding a buffalo. Both Masau'u and Osiris of ancient Egyptian myth were also depicted as 'giant green gods' associated with life, death and the underworld.

Alongside Masau'u, Kokopelli was also said to be the guardian of the North and a Solar insect deity associated with the colour white and blue. Both deities, kokopelli (life) and Masau'u (death), are often found alongside the bear claw marks. Bear symbolism in this case relates to the 'bear people' (Hopi Bear Clan), who were said by the ancients to be one of several human-animal races living on Earth in prehistoric times. I go into more detail about this subject in my book *Journeys in the Dreamtime*.

The Son of Man symbolism *through* Adam, Atum, Osiris (the Green Man) are all connected to Orion and 'the lord of time'. So are the 'seven lamps' found within the book of *Revelation*, said to be symbolic of the seven main stars of Orion.[9] Whether Pagan or Christian (same thing), a twin force symbolised through the Biblical Jesus and John figures, reigns over the solstices in a perpetual cycle of life, death and rebirth. Masau'u, whose head was often depicted as a 'skull or pumpkin' on the Hopi Fire Clan tablets (symbolic of decapitation), was often depicted carrying a head or a sack of seeds (or stars), while wearing a pumpkin-like mask (a new head), see figure 47 overleaf.

In the Bible, John the Baptist was said to be born six months before Jesus, astronomically marking opposite ends of the Milky Way in terms of the solar wheel and sun cross that 'marks' the position of the stars as seen from earth. Like their Ancient Celtic counterparts, the Oak and Holly Kings, John and Jesus are said to be 'twin solar deities' whose coronations coincide with the Solstices. Jesus, according to the scriptures referred to himself as the 'Son of Man' (Adam), whereas John was considered the Alpha and Omega

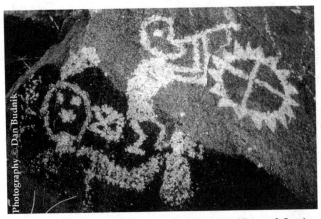

Photography © Dan Budnik

Figure 47: Masau'u (Orion) and Kokopelli (Central Sun).

in several mystery schools like the Knights Templar. Indeed the Baptist was considered a more important figure by the Templars based on his role in the narrative highlighted here. Writers like the late Reg Lewis, in his masterpiece *The Thirteenth Stone*, argue that both John and Jesus were the same figure! Masau'u and Kokopelli are the twin 'solar deities' (the celestial John and Jesus symbols of the Hopi) symbolic of the dual nature of Orion's influence on Earth. Orion's position in the Heavens also marks the time of 'darkness' as it rises in the Northern Hemisphere in October. Originally the eighth month of the ten month year, October comes from the Latin octo, meaning 'eight'. The eighth astrological sign of Scorpio is also significant to Orion as it was said to be Scorpius in Greek myth, who chased Orion in October across the skies. For the Rapa Nui Polynesian inhabitants of Easter Island, honouring their ancestors in their month of Hora Nui (October) through to Ruti (January), Orion was a key focus during this time.

The Hopi term for Orion is Hotòmqam, which literally means either 'to string up' (as beads on a string) or 'trey.' The use of this word could refer to the three stars of Orion's belt but also to the tripartite form of the ant, its head, thorax, and abdomen. These shiny, bead-like sections of the ant's body may have their celestial counterpart in what the Hopi consider the most important constellation in the heavens: Orion. The appearance of Orion through the overhead hatchways of Hopi kivas (semi-subterranean prayer chambers) still synchronizes many annual sacred ceremonies with Orion's appearance in the skies. The legends of the Ant People (possibly Grey aliens) in the Hopi creation myths, could also connect to Orion's stars.

Orion's appearance in the sky above the horizon signals the time when all that is 'unseen', all that dwells beyond the boundary or void, would begin to surface. Sun wheel symbolism depicted on petroglyphs, alongside Masau'u and Kokopelli, are symbols of the opposing forces said to be of Orion. You could say that all duality is born of Orion, the celestial Adam. In Egyptian mythology, Osiris and Horus are sun gods that embody the light, while Osiris's brother (Horus's uncle), Seth, embodies the darkness. Just like the petroglyphs depicting both Masau'u and Kokopelli, Seth is depicted in a manner that connects to Horus in other similar scenes (see figure

**Figure 48:
The duality of Seth
and Horus.**

48). I will pursue the notion of duality in later chapters because it plays out in so many different areas of life on earth.

The subconscious focus on images and symbols is what 'constructs' the Matrix of reality; you could say that they train our thoughts and perceptions. The more I have delved into this phenomena, the more I come to realise how the 'perception or deception' we endure does not end with saturn and moon symbolism. Orion *is* the door to so many symbols, rituals and states of mind. The Gnostic *Gospel of Philip* tells us:

Truth did not come into the world naked, but it came in types and images. The world will not receive truth in any other way. There is a rebirth and an image of rebirth. It is certainly necessary to be born again through the image.

Firestones, Swastikas & Crosses of Orion

Many petroglyphs in the Hopi lands are often 'markers' for the procession of the Sun's path as it crosses the skies, travelling through the 'solar year'. As I have pointed out, Orion's position in the Northern hemisphere marks the time of death, from all Hallow's Eve (Hallowe'en) through to Saturnalia, when the Sun's life force (as Kokopelli) symbolically dies and Masau'u (Orion) appears in the skies. The post-Atlantean civilisations of Egypt and Maya also seem to build their pyramids as markers to fix their connection on Orion. Triangular structures, Mesas and Kivas of the Hopi were often aligned to the greater picture that *is* Orion's influence on 'life and death' on Earth. The Mayan also focused their pyramids on Orion, especially the three stars or 'stones' of Alnitak, Saiph and Regel. The Hopi also used three fire stones to rest their cooking pots on within their homes.[10] They were called Hearth Stones (fire stones) to the Mayan and Hopi and they were often found in their ceremonies as symbols of the fire stones (stars) of the Orion constellation. Orion's stars, Alnitak, Saiph and Regel were considered to be the Hearthstones of the Quiche Mayan culture and these three stars formed a triangular boundary around a cloudy area in the Orion Nebula. The centre of this triangular area was considered the home of a central sun by some ancient cultures and shamans.

Crosses, from the 'H' cross, to the swastika symbol, the 'Ankh-cross-symbol' and the 'T-statues', all connect to Orion and humanity's *relationship* to the forces that work through *Orion's* location in the Pleroma (the Dreamtime). As mentioned earlier, Adam 'coupled' with an aspect of Sophia (whether Isis/Eve/Sekhmet) to form a 'trapezium' (a trinity symbol) through their child, or their offspring as the gods/goddesses on Earth. Humanity, on one level, are children of this celestial coupling. Some researchers even go as far as saying that we are from Orion. The Hopi god

Masau'u was sometimes shown to carry a tau cross (T-shaped cross). Renaissance painters, such as Giovanni Bellini (1459-1516) in his painting, *The Blood of the Redeemer*, portray Christ with a T-shaped cross standing on a checkerboard floor. And of course the 'blood', or our DNA through the 'X' and 'Y' chromosomes, is part of the same 'cross' symbolism. All of these symbols relate to duality which is significant to Orion symbolism. The many uses of 'X' symbolism in corporate logos, products, and in the movies, is part of the 'spell' being cast by forces coming from the darker aspects of Orion. According to researchers like Danny Wilten, who has made some very interesting videos about Orion symbolism on Youtube, we can see through art and symbols, that Orion's Trapezium could well be the location for the 'holographic projector' or celestial source from whence our reality (our physical world) is projected.

Orion's Rituals - All Hallows' Eve

The Death of a sun god, the death of a solar year (the death in nature), all producing darker days in general, leading to the 'dark mass' of All Hallows' Eve. The feast of All Hallows', on its current date in the Western calendar, can be traced to Pope Gregory III's (731–741 AD) founding of an oratory in St. Peter's for the relics of the holy apostles and of 'all saints', martyrs and confessors (or those who were often burned at the stake). In 835AD, All Hallows' Day was officially switched to the 1st November, the same date as the Pagan date of Samhain, at the behest of Pope Gregory IV. Of course, Samhain, also Anglicized as 'Sawin' ('Sowin' in the ancient world), marked the end of the 'harvest season' and the beginning of winter, or the 'darker half' of the year for the Pagan peoples of Europe.

Hallowe'en is a major point on Hecate's Wheel of Time and Hecate (or Kali the Dark Goddess) focuses our attention at this 'dark time' when Orion rises in the Northern hemisphere. Hecate is also known as Arianrhod, Catherine, Persephone and Lenaea in other versions of these beliefs and myths. The winter festival of Lenaea (the 'wild hunts') in ancient Greece was also akin to the celebration of dark forces that would run amok from their point of entry into our surface world at Samhain or Halloween. The Hunter of course is Orion, as it is he who leads the hunt or precession towards the time of the Lord of Misrule - Yule, or what the Romans called, *Saturn*alia. See my website and blogs for more information on Saturnalia.

The 'Unnatural' God of the Doorway

Orion is also the horned giant 'Haokah', celebrated through tribal dances to this god-figure by the Dakota Sioux (see figure 49). Like Morpheus in Greek myth, Haokah was referred to as the unnatural god, the ruler of dreams.[11] Haokah was simultaneously revered and feared among the Sioux as a deity that could use magic and lightning to destroy worlds. The Thunder-beings honoured by the Lakota also connect to the stars, not least Orion. Thunder, or more importantly 'lightning' was the weapon attributed to the gods con-nected to Orion. So was the Sacred Clown or the Fool, they were said to

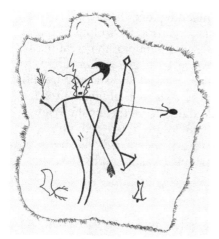

Figure 49: Orion or Haokah in Sioux mythology and belief.
The lightning emanating from the head of the Haokah, is symbolic of electro-magnetic forces that give life to stars and suns.

come from Orion by some of the American Indian tribes. 'Kesil' in Hebrew is the Orion constellation and it also means 'Fool'. The three-pointed hat of the jester-fool can also be connected to the three belt stars or three hearthstones of Orion. It's worth noting that the Hopi word for star is 'sohu' and although the vowels are arbitrary, the Egyptian word for star (particularly those of Orion) is 'sahu'.

The American Indians believe in the existence of many Giants (not least the Bigfoot tribes), but Haokah is one of the principal giants. He was the anti-natural god, or the teacher of opposites. For example, in summer he feels cold, in winter he suffers from the heat; hot water is cold to him, and the contrary, etc. He is the god of 'contradiction' and therefore, 'mimicry'. He was considered a 'double-faced' god, often shown to have a blue and red face, both colours symbolic of the giant stars Regel (Blue) and Betelgeuse (red). The Norse god Loki is another version of this deity and Loki's daughter, the goddess Hel, was also said to have a dual visage often coloured red and blue.

The *Rig Veda* refers to the Orion Constellation as Mriga (The Deer), or the horned hunter, often depicted as the classic image of the shaman wearing the antlers. The Celtic deity Cernunnos is another version of this hunter on earth (Herne the Hunter). Like other horned and antler gods, Cernunnos was the keeper of the 'door' between this reality and the realm that is just beyond the veil. All these different versions of the same celestial god (Orion), are symbols for the force sitting just beyond what the Gnostics called the 'boundary' or 'place that creates our world'. As a sidenote, I found it fascinating that CERN (*Cernunnos*) was set up to 'penetrate that veil' by a priesthood disguised as scientists in Switzerland. A statue of Shiva, who was sometimes depicted with horns, also stands on the grounds above CERN. It's all about 'star magic', and CERN is not a good omen!

These crossing points between the Milky Way and the Earth's solstices on the ecliptic are understood in shamanic traditions to serve as 'doors' to the spirits or underworld. Just as there are portals that link the earth and the sun, there also appears to be energetic 'stargates' that link our sun to other stars, notably Orion. According to some native cultures, saturn (as a dying sun), connects to the main stars of the Orion constellation especially at critical points at certain times of the year. Symbolically speaking, it is Saturn that is colluding with Orion to construct the fallen fake-earth reality.

Another version of Orion is Mrigashira meaning 'deer head' and Ardra (Arudra) meaning, 'tear drop'. Both of these *nakshatras* (Astrological Lunar Mansion in Hindu) are associated with the constellation of the great hunter, Orion. From Neolithic cave paintings in France, to images of Cernunnos in Celtic Europe, to Osiris in Egypt, Orion in Greece and Shiva-Rudra in India, the deer (and bull/bison) was often portrayed as a giver of life, a 'protector' but also the hunted. Herne the Hunter and Pan are the most obvious Pagan figures associated with both Orion and Saturn. It is worth noting that Yahweh, Amun and Maat (in Egypt) were also depicted with horns and were said to have fashioned the first two people (Adam and Eve) out of clay.

'Horny as Hell'

The daughter of Loki (Haokah) Hel, was another deity who carries elements of Orion symbolism. Hel (or Hell) also known as 'Notre Dame' was said to be the 'she-trickster' who could be invoked to bring mischief and misguided thoughts. She is the maiden of Betelgeuse or Bellatrix sometimes depicted in black and white just as the Koshari clowns found in Native American belief. The 1988 movie *Beetlejuice* starring Micheal Keaton, features the 'evil shape-shifting clown' called *Beetlejuice*, and shows him wearing the black and white stripes of the Native American Koshari clowns. It's no coincidence that the imagery connects, because for the Lakota, the Koshari and Haokah were considered sacred and *from* Orion. Betelgeuse to be precise!

There are many ancient records of the mysterious race of beings associated with what the Hopi Indians call the 'Two Horned Clan' (see figure 50). In the ancient world the Hopi talked of 'unnatural gods', the 'rulers of dreams' as having horns. The hopi said these figures were of the Two Horned Clan, or the 'Two Horn' and 'One Horn' Societies. In Hopi history, this clan along with the Unicorn and Bow Clans, perform some of the most significant and oldest ceremonies in their calendar. The latin word for 'bow' is 'apis' which was a word used for the sacred bull of Egypt. The worship of the Unktehi, through to the later buffalo reverence by the plains tribes of Dakota, are also examples of the importance of the Two Horned Clan to the American Indians (see Figure 51).

Interestingly, the 2013 *MTV Video Music Award* show also gave us a brief glimpse of the symbolism associated with Hel and the Koshari clown. It's all 'mind magic' for those who watch these 'big events' featuring the celebrities or 'stars'. As part of a performance, the singer Robert Thicke dressed like a

Figure 50: The Two Horned Clan.
Drawings taken from rock paintings on the Mesa Verde, Colorado.
Are these the same beings carved in stone on Aztec temples and Gothic Cathedrals?

Koshari clown of *Beetlejuice* fame, performed a simulated sexual act on a scantily clad young Miley Cyrus. For those who can remember her 'horned hair style' and protruding tongue, they won't forget the bizarre imagery that these two performers 'conjured' for the masses that night. Madonna's *Super Bowl XLVI* half-time show in 2012, also offered even more bizarre semi-occult symbolism. Nothing was held back in her performance (or ritual) for the millions that soaked up the 'magic' subconsciously. Madonna appeared as the horned god Molech on a throne, while other Canaanite imagery, including slaves (dancers) moved around her. Even the All-Seeing Eye symbolism appeared in her performance ritual. Hollywood and its 'celebrity worship' exists for one purpose, to replace the 'old gods' of the ancient world with the 'new gods', the 'celebrities' for the masses to look up to. The celebrities are the new gods (the stars) that the poor and 'ordinary' are encouraged to worship. Madonna's performance in 2012 was a 'ritual' and performance combined, designed to celebrate and invoke the horned god, Molech. Madonna is interested in the Kabbala and has attended various temples over the years, so she would know all about this symbolism and the Orion constellation.

Figure 51: The Koshari Sacred Clowns of the Native American Hopi.

The Shining Ones

Other symbols that connect to the two-horned deities associated with Orion are the Wall Street Bull, or Ox; both these are versions of the constellation of Taurus and the elite city of *Ox*ford in England. The Canaanite/Israelite god, Moloch, can also take the form of a 'horned' owl and bull and of course some of this symbolism can be found in the street plans of cities, not least Washington DC. Moses also was often depicted with 'horns' in religious iconography due to the translation by St. Jerome in the 4th Century *Vulgate* (see figure 52). This image of Moses has been passed off as a religious artistic mistake. Yeah, right. Michelangelo made mistakes? I doubt it!

The wealthy bishop of 12th Century Paris, Maurice De Sully (who created Notre Dame Cathedral) also used the same two horns and the 'snake' on his personal seal. The horns are said to be symbolic of being 'glorified' and in many ways they represent the 'rays' of the Sun (Orion's central

Figure 52: Michelangelo's Horned Moses.

Sun). However, there is also a connection to the 'Shining Ones' a term used for both the Biblical Nephilim and their firstborn. The Watchers or Shining Ones I mentioned in *Chapter One*, were often depicted with horns on their heads as it was a symbol of royalty and kingship (Bloodline). Osiris (Orion) was sometimes depicted with horns, too, and of course there have been people born with horns in China and India not to mention the strange human skull with horns discovered in a burial mound at Sayre, Bradford County, Pennsylvania, in the 1880s.

In terms of alchemical symbolism, the horns, or rays (if there are more than two), are reference to the philosophical *Dew* - an alchemical substance said to emanate from the 'centre' of the Galaxy and transmitted through the Sun. This dew, says the *Zohar*: "...is the 'manna' on which the 'souls of the just' nourish themselves". To the Israelites the 'manna from heaven' was said to be a celestial food that was given to the 'chosen ones' and directed by Moses in the Book of *Exodus*. In the Jewish Kabbalah, the 'dew' is an emanation or 'radiation' from the Tree of Life, which emerges as a conduit passing through the Sun. All these references of 'dew', 'manna', etc., are alchemical words, I would suggest, for the electromagnetic forces that shape and create stars, suns and planets - the universe.

Time Magazine has utilised images of world leaders framed in front of the letter "M" on several editions, so to play on the theme of 'horns'. The Clintons, Bushes, as well as Obama and Trump, in 2016, to name but a few, have also had the 'M' horned treatment on the magazine's cover (see figure 53). The imagery is symbolic of the 'horns of Moses', the 'shining world leader' of the Israelites in the Biblical sense, and also a symbolic connection to the 'enlightened ones' - the bloodlines of the 'Shining Ones'. *Time* Magazine was started by Briton Hadden a member of the Delta Kappa Epsilon Brotherhood, one of the oldest North American fraternities based at

Figure 53: 'Horned' World Leaders courtesy of *'Time'*.

Yale College in 1844. Over the years, Delta Kappa Epsilon members have included five of forty-five Presidents of the United States connected to the Skull and Bones Secret Society[12] (see figure 54). Along with world leaders, the number of celebrities I have seen wearing horns, or having hair shaped to look like horns, is beyond coincidence (see figure 55). It is not by chance, and it all relates to the worship of the 'horned gods', the 'Shining Ones' and the 'magic and power' connected to the symbolism associated with both Orion and Saturn. I would go one stage further, and say that the 'horned clan', the 'demonic clowns' and other dark entities touched upon in this chapter, often

Figure 54: The Delta Kappa Epsilon shield with various symbols. Orion's (Adam's) 'X', the Lion (Demiurge), three belt stars, Saturn winged-sun and the Eye of Providence.

Figure 55: The Celebrity Horn Clan.

possess the bizarre and 'ego-driven celebrities', so they become vessels for the darkness that infests places like Hollywood.

The Hunt & the 'Celestial Standoff'

You could say that Orion plays a huge role in the shaping of our 'collective thoughts', our beliefs and above all, the belief in duality. We see duality in many myths and legends, and of course we see it all the time in the 'opposites of nature' through the cycles or seasons on earth. Duality is evident in the stars, especially through Orion and Taurus, as they prepare to fight or oppose each other. In the constellation of Taurus (the bull), we find seven stars called the Pleiades, or seven maidens as they are described in many myths. In Greek myth it is said that Orion pursued the Pleiades, named Maia, Electra, Taygete, Celaeno, Alcyone, Sterope, and Merope after he fell in love with their beauty and grace. The hunter goddess Artemis asked Zeus to protect the Pleiades from Orion and in turn, Zeus turned these maidens into stars. In the same myth, after Orion's battle with Scorpius, Zeus then turns Orion into a constellation to further pursue the Pleiades in the skies. Zeus, like Orion, seems to love pursuing females! In other words, these maidens went from being chased on earth, to being chased across the heavens. Some say that the perpetual hunt by Orion, is a macrocosm for the chase between all men and maidens on earth. In fact once you delve a little deeper into the Orion symbolism, it seems that much of what is mapped out on earth through ancient art, myths and temple sites, can relate to the 'celestial hunter' and his dogs in the heavens. The constellations of Canis Minor and Major (or Sirius), are Orion's dogs. The dog that leads the hunt is called Procyon and both dogs are said to be chasing Lepus (the hare) or sometimes the fox, while Orion 'stands against' Taurus. In this role, Orion, is also Mithra who 'slays' the Taurean bull. For anyone still following my

symbolic threads here, all of these animals feature hugely in the 'hunts' and symbolism of the bloodline aristocracies mentioned in earlier chapters; fox hunting notably being a pastime for the bloodlines that consider themselves to be 'above' all life!

In the epic Sumerian legend of *Gilgamesh*, the hunter god-king Gilgamesh (another Orion figure) fights the Bull of Heaven. We see the same symbolism in the tussles between Attis and the Bull, through to Perseus and the Minotaur. The latter takes place at the centre of Adriane's labyrinth, a symbol of the mind and the 'Weather Within'. Orion, whether holding a club or bow, is hunting the animal kingdom or nature, and this symbolism can also be found on crests, heraldry and insignias of the same bloodline elite. In other stories we see Orion chasing Pleione, the mother of the Pleiades, for a span of seven years (symbolic of the seven stars). In other legends, Orion, while chasing the Pleiades, takes the form of a bear. The myths about Callisto and Artemis (the goddess of hunting) also include the hunter *becoming* a bear. The legends of Bear Butte (Devils Tower) in Wyoming, according to Native American myth, describe the creation of the Butte through the claws of a giant bear they say scratched at a 'giant tree' as it grew skywards to place the seven maidens, as the seven stars, that became Pleiades in the sky. Giant tree or not, what is more interesting to me is the notion of humans becoming stars, or stars becoming human. Orion is also referred to as a 'Heavenly Shepherd' or the 'True Shepherd of Anu' (a shepherd of bears). Interestingly, the mark of the Hopi Bear Clan can often be found alongside petroglyphs also depicting Masau'u (Orion). The Son of Man, Christ as the 'Good Shepherd', could also be connected to this symbolism. Other Bear symbolism refers to the constellation of Ursa Major (the Plough) as it aligns with the Pleiades and many bear myths relate to star people. Homer, in the *Odyssey* referred to "the Great Bear that men call the Wain, that circles opposite Orion, but never bathes in the sea of the stars". Even the Book of *Job*, a Biblical book about God's (or the Demiurge's) punishment of Job, mentions Orion: "He is the maker of the Bear and Orion" (Job 9:9); and in *Job* 38:31: "Can you loosen Orion's belt?" As well, mentioned in *Amos* 5:8: "He who made the Pleiades and Orion." The latter I feel, refers to the Gnostic Demiurge, which brings me back to the consciousness that created Orion and works through its electromagnetic life force, Orion's Nebula.

Orion's Central Sun

In various alchemical texts, Apollo, Vulcan and Mercury 'conceive Orion' in an allegory of the three-fathered 'philosophical child'. In simple terms, the three-fold powers of *light, fire* and *energy* (force) construct the celestial man called Orion. Another term for this process in Alchemical texts such as the *Opus Magnum,* is the Aurora. Symbolically speaking, these *three forces* combine to create the Heavens and all that is contained within 'time and space'. Celestial Light (electromagnetic) and star fire are crucial to this process, but it is what Mercury carries in his hand that brings the three forces together.

The caduceus or the double snake symbol carried by Mercury, is the celestial kundalini that unites all three forces. It is the 'Fohat' kundalini symbolism, or the equivalent of a cosmic birkeland electromagnetic current that converges to create the Eye of Osiris (Orion), or the freemasonic symbol known as the 'Eye of Providence' (see figure 56). In other versions of this story of the three

'deities' or forces, they represent 'fire', 'deception' and plague' on one side, while on the other, they are 'creative imagination', the 'magical arts' and 'perception'. In every instance these forces come together to forge Orion's persona as the 'hunter shepherd' of the heavens.

Figure 56: The All-Seeing Eye of 'Providence'.

The same allegory connects to Orion's Trapezium which is situated in a region of the Orion Nebula just below the three belt stars along Orion's sword (see figure 57). It is a region of speculation and ideas according to some researchers, not least Danny Wilten, that the Orion Nebula is a two dimensional 'projection' of our 'reality'. In other words, the Trapezium is like a 'movie screen projector' creating *'everything'* we call 'reality'. The Sun, Saturn and the Moon are 'strategically placed' to alter that projection, to create our Earth 'matrix'.

The alchemical knowledge of the Nine Spheres, the Holy of Holies, Sephiroth (Tree of Life) and the Epithets of God all seem to be telling the same story of how Orion's central sun, or Trapezium, was involved in the creation of our Solar System. From time to time this knowledge appears in religious iconography and one example is Saint Charles Church, also known as Karlskirche, one of the most beautiful and interesting buildings in Austria (see figure 58 overleaf). The building was constructed on the order of the Emperor of Austria, following the Baroque architectural style and its sculptural central focus. According to Wilten, the altarpiece could be one of *many* depictions of Orion's Trapezium cluster. The clouds and light contained within the art and decor of this central piece seems to correlate with the image of that region of the Orion Nebula when overlapped. In fact so much Renaissance art, not least the *Creation of Adam* by Michelangelo, which forms part of the Sistine Chapel's ceiling, seems to be telling the story of Orion's part in the Gnostic creation myths. The painting quite clearly depicts a 'brain' in profile framing God, who is creating Adam, the first celestial man. What is fascinating is

Figure 57: Orion's Trapezium.
A cluster of young stars appear to be the core of the Nebula in an area of stars forming Orion's Sword. © NASA

Figure 58: Orion's Eye and the Trapezium symbolised at Karlskirche.

that the word 'men' (man) etymologically means 'to think', or states of 'mind' (thought). Were the Masters of this period trying to tell us that the Orion Nebula houses the mind of God? What is fascinating in relation to these types of paintings of the Renaissance period, is they do overlap to give an identical visual comparison of different areas of the Orion Nebula. For more on this see Wilten's research and book, *Orion in the Vatican*. As we travel farther away from the Trapezium into the body of the Nebula, what looks like a human face, a 'red dragon' and the 'lion-headed-serpent (Demiurge) in the Flame Nebula (within Orion), all seem visible in the interstellar cloud of dust, hydrogen, helium and other ionized gases (see figure 59). Other nebulas such as Barnard's Loop, the 'Horse' and 'Monkey Head' also appear in the Orion constellation. Anything is possible within the realms of 'star magic' and the holographic nature of the universe.

Scientists have also said in recent years that Black Holes give birth to the 'holographic nature' of our Universe. They say that all of our galaxies and star systems are holograms projected from black holes. These vortexes are said to store information and project that information from the surface of

Figure 59: A god-like face forming in the interstellar cloud of dust in the Orion Nebula. Is this the Gnostic Demiurge, Adam or Eve at work amongst the nascent stars?

the Black Hole to create reality. According to astrophysicists (including UQ's Dr Holger Baumgardt), the Orion Nebula has a black hole at its heart, whose mass is some 200 times the mass of our sun. The mini black hole in the Trapezium of Orion, a centre that has given humanity its focus on much symbolism connected to alchemy and the Kabbalah (through to many other mystical/esoteric systems) begs the question: could this be connected to the knowledge of what Orion is actually creating? As I mentioned earlier, what the Mayan's called the 'Hearth Fire' in the middle of the Orion constellation acted as a macrocosm/microcosm for life and death on Earth. As we have seen, the alignments of the Great Pyramids and the Hopi mesas testify to this understanding of the 'holographic' projection, from Orion, onto the surface of the Earth by 'those' who constructed these alignments.

Many years ago I heard the term 'Earth Stars', and the understanding that humans are 'points of light' or stars projecting (like a hologram) onto the surface of a 'flat earth plane'. Each human being could be seen as the 'life and death' of each individual as a 'star'. It is no stretch of the imagination to see that the holographic nature of the universe would give us 'macrocosm-microcosm' when it comes to stars forming and 'human stars' forming (see figure 60). I have found that most people involved in 'ritual magic', Paganism, and the lower knowledge I call religion, have no idea what actually 'powers' the so-called 'celestial bodies' of the Sun, Planets and the Moon. Too many are worshipping the 'instrument' with no knowledge of who or what made the 'instruments' they worship in the first place.

Figure 60: Human Earth Stars.
The Gnostic texts describe the Demiurge and Archons as a 'neonate form' like an aborted fetus.

'Star Wars' *in* Orion

In the creation myths and migration records of the Toltecs of Central America, there is reference to the opposing colours of a mysterious 'Red and Blue Spring' or Caves. I feel that this 'Spring' is another symbol for the Orion Nebula. The colourful cluster of glowing interstellar gas clouds and hot, bright, newborn stars can be seen forming two distinct 'red and blue' areas when viewed with powerful telescopes (see figure 61 overleaf).

According to the Toltecs the 'red and blue' symbols, a circle and square spiral, relate to their warrior god Huitzilopochtli, who is another version of Orion. To the Central American Indians, the red and blue colour symbolism also relates to the 'meeting place' between 'heaven and earth' (or sky and land) and every temple is considered to be a central place of focus for these dual powers. I feel that the heaven and earth 'meeting point' in these indigenous myths, relates to the 'projector' in the Trapezium. The duality of 'light and dark' and the many dual deities, especially in the Americas and

Figure 61: The Blue and Red Caves of the Orion Nebula.
Two distinct clusters in the M42 region of the Nebula. The left-side cluster is 'blue' in colour and the larger area to the right, which contains the Trapezium, is 'red' and pink in colour. Are these the 'Caves of Creation' (or Eden) referred to by the Zulu?

Asia, were often depicted with a blue or red skin colour, too. This also relates to the opposing forces of sky and earth, or sometimes good and evil. Many angelic figures or saints in Italian Renaissance art are also depicted in red (or pink) and blue, which could have been a subconscious attempt to convey this knowledge. Interestingly, the same colour codes were used in the *Matrix* movie, for the pills offered to Neo (symbolic of Adam the first human) by the 'god of the Dreamtime', Morpheus.

I have researched Native American myths for over two decades now and from my understanding, I know enough to say that the 'order of influence' over our 'human perception' and therefore 'our society' (by non human secret societies) has to include the giant 'red and blue' stars of the Orion constellation. Bellatrix and Betelgeuse are two novas that have been focused on hugely by the indigenous people of Earth. Bellatrix is a blue star, which is a latin name for 'female warrior', and was also called the Amazon Star, the Conqueror, or Lion Star. To the left of Bellatrix is Betelgeuse, or Alpha Orion (abbreviated Alpha Ori), which is the ninth-brightest star in the night sky and second brightest in the constellation of Orion. Betelgeuse is a reddish nova also known as the 'Ninth Gate' or the 'House of Orion'. In Sanskrit, it was called Bahu, part of a Hindu understanding of the constellation as a 'running antelope or stag'. In 825AD the Japanese Samurai (who also wore horned head gear) seem to have focused on these stars. The Taira, or Heike clan adopted Betelgeuse and its *red* colour as its symbol, calling the star Heike-boshi. In the same epoch (900-1200AD), the Japanese Minamoto (or Genji) clan chose Rigel and its *blue-white* colour. These two powerful Samurai families fought a legendary war in Japanese history, symbolic of the two stars seen 'opposing' each other and only kept apart by the belt of the warrior hunter, Orion. Many opposing sides in myth and legend relate to these opposing stars.

Betelgeuse is said to be nearing the end of its life and when it explodes it should be visible in our skies. Some researchers say this could be the 'fire in the sky' prophesied by the Hopi at the time of 'great change' on earth.

There is also a connection to this star and the devilish trickery emanating from it, not least the Koshari clowns mentioned earlier. Betelgeuse was also known as Palasohu the 'red star' by the Hopi, and Palaakwapi was also known as the 'red house', a city of the 'star people' located in Arizona (the Sedona area). The Hopi ancestral home, the Red City, was said to be a 'temple city' surrounded by a 'towering wall of red stone'. If you ever visit the Sedona region, as I have many years ago, you will sense the magic in the stones and formations surrounding the town and this area. In opposition to Betelgeuse is the giant Rigel. Also known as Beta Orion, which is the seventh-brightest star in the night sky and brightest star in Orion.

The 'red and blue' giants are personified in the myths, legends and folklore of many indigenous peoples as the 'rulers of dreams' (not the red and blue American Dream, sadly), but the world within worlds, teeming with inter-dimensional life, or what physicists have called 'non-local' realities. The worlds I am talking about here are the home of the Archons, the Jinn, the 'tricksters' and the myriad of non-human life forms. The movie *The Purge - Election Year,* offered some symbolic imagery connecting to the 'red and blue' 'X' for eyes and the 'clown masks' used prominently in this horror film. So many horror movies incorporate the 'evil clown' archetype, which seems to have its origins in the myths associated with the star Betelgeuse. Much Superhero symbolism from *Superman* to *Spiderman* also utilise 'red and blue' codes or Orion archetypes. As well, US politics uses 'red and blue' colours and icons as 'opposites' to achieve maximum effect in much of the graphics, logos, flags and insignias. Indeed the use of 'red and blue' symbolism is deeply connected to the duality of 'opposing forces' said to be at 'war *in* Orion'. Some say that this 'Stellar War' is mirrored on earth through those that love to create wars. The opposite symbolism of George Lucas' Jedi and Sith characters in the '*Star Wars*' movies is, in my view, yet another example of codes found in films, relating to Orion's internal war. The 2016 movie *Warcraft* also depicts rival forces of the Orcs (red) and Human Clans (blue) on its movie poster. I would say that *all* war on earth is a microcosm of the dual forces at war *in* Orion.

Checkerboard chess symbolism, is another common symbol that captures the same duality and opposing forces. The chequerboard has its origins in shamanic cultures of Native America - who used dulality symbolism to focus on Orion and Sirius (see figure 62). Native American 'sacred' clowns are often adorned in black and white checkerboard symbols or stripes, again symbolic of

Figure 62: Native American checkerboard symbolism relates to the duality of 'life and death'.

their connection to the teaching of 'opposites' born of this interstellar tussle. The Roman two-faced god, Janus, was also said be the god of beginnings, gates, transitions, time, duality and doorways. Like the Haokah, his 'two faces', were said to see the past and future simultaneously and represented all 'beginnings and ends'. The temples dedicated to Janus were open only 'during war' in ancient Rome, and again this was another symbol for the forces operating 'behind' the veil, or what the ancients referred to as the 'Gates of Heaven'. The 'hidden', subconscious worlds of symbols 'influence' the physical (visible) world more than we realise. As Goethe once said, "*To construct it* [reality] *from light and darkness. Or break it down into light and darkness. That is the task, for the visible world, which we take to be unity, is most agreeably constructed from those two beginnings.*"

From Orion to Saturn

The 'Nine Rings', or 'Holy of Holies' found in alchemical and kabbalistic books, are the symbolic circuitry connecting 'Orion to Saturn'. In the Gnostic *Hypostasis of the Archons*, a system of eight circles were said to be the 'projected heavens', or worlds, forming our immediate Universe. In Norse myth, these 'worlds' also formed the 'world tree', 'Yggdrasil'. They were also called the 'Seven Heavens', with an *eighth* world called the 'Ogdoad'. This was considered a 'super celestial region' creating the spheres of the 'Seven Heavens' or 'Seven Stars'. These 'stars' were Saturn, Jupiter, Mars, the Sun, Venus, Mercury, and the Moon. For the Gnostic mind, each of these stars were supposed to be presided over by a different archon. The lower realms (the eighth sphere), beyond the influence of Sophia (from Saturn to the 'fake' Earth), was said to be the abode of 'Archangels'. The Gnostic and Ophite systems give their names and forms, from Michael as a lion, Suriel as an ox, Raphael as a dragon, Gabriel as an eagle, Thauthabaoth as a bear, Erataoth as a dog, Onoel (or Thartharaoth) as an ass. The central pillar connecting the angelic spheres was Adam Kadmon (Orion), or the 'mind' (man) of God. At the highest point of the Eight Spheres was the 'Ninth Sphere', where it was said that the 'great archon' - ruled over the Ogdoad, or ethereal region, described as reaching down to the moon.[13] I'll return to this again at the end of the chapter as it connects to so much in my art.

According to Gnostic writings, it seems the Demiurge and Archons evolved out of the nuclear fusion focused on the Orion Nebula. Named after the Latin word for cloud, 'nebulae' are not only massive clouds of dust, hydrogen and helium gas (and plasma), they are also often 'stellar nurseries' - or places where stars are born. All life is born of these stellar 'wombs', and our DNA is made of the same 'genetic star stuff' that gives us a myriad of life forms. Life, death, all duality centered on Orion, has to pass through a symbolic 'door' (or portal) into worlds that create reality on earth. Orion's electromagnetic nebula, centered on the Trapezium (a portal) seems to send 'life force' through the stars (like an electrical current) passing through our Sun, the dwarf stars Jupiter and Saturn, and other minions

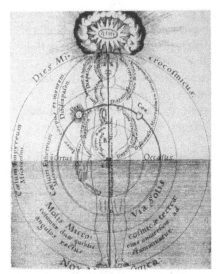

Figure 63: Cosmic 'Hu-man' (light-Man). The Illustration by Fludd seems to show man as the 'macrocosm'of the planets, the sun and stars, projecting out of a central sun (at the crown above the head). The rings forming around the cosmic man are symbolic of the Sefirot.

(or Moons). The human world is constructed by this 'power house' often symbolised as the Cosmic Soul, Tree of Life, Music of the Spheres or the 'Ladder', in Alchemy. Robert Fludd, the prominent 16th Century English Paracelsian physician, alchemist, astrologer, mathematician and cosmologist, often depicted this 'projection' in his *Utriusque Cosmi*, which shows man the 'microcosm' within the universal 'macrocosm' (see figure 63).

Athanasius Kircher, the 17th Century German Jesuit scholar, also produced many papers and drawings attempting to order the connections between the 'stars and humanity'. His systems, maps and illustrations symbolise the path taken by electromagnetic light as it descends through the 'world tree'-ladder, or circles, *into* the human eye. The descending light in the Kabbalah (Qabalah/Sefirot) is often depicted as a 'flaming sword' that travels like lightning through the Tree of Life from *Keter* (the crown or branches) to *Malchut* (the roots), from the *above* to the *below*.

The circles or realms descending symbolically from an upper central sun (projection point), are said to number 1 to 9 and these are the primary numbers from whence all others derive. Interestingly, it is written that the 'Eighth Sin', or the 'Eighth Circle', called 'Malebolge' was often depicted as the upper half of Hell, the place of the Fraudulent and Malicious. The Eighth Circle was described by Danté in his 12th Century epic work, *Inferno,* as a place where 'deception' dwelt. These circles (or rings) are also realms or frequencies that align with the so-called 'Seven Deadly Sins' through the Eighth Circle, and depicted as a human 'eye' by the 15th Century artist, Hieronymus Bosch. All of these symbols relate to *'perception'* and how the world is created through our perception, our imagination and of course, electromagnetic light (or plasma). The circles or 'rings' (if you are a *Lord of the Rings* fan), also relate to constructed hemispheres that 'restrict' human consciousness to form an 'ethereal link' to the otherworldly creators (the archons), also called the gods or goddesses (the Planets).

It's interesting to note that Satan or 'Saturn' in Danté's *Inferno* is trapped in the frozen central zone inside the Ninth Circle of Hell.[14] Saturn is 'controlled' and 'restricted' by the Holy of Holies, or 'Circles of Hell' that bind this 'Fallen Sun' and permit its alter ego Chronos, to devour as he does. The Kabbalah even compares the 'flaming sword', the electromagnetic light of

creation to Satan.[15] It is Orion, in my view, through *one* aspect of the 'three creators' of Orion, 'Vulcan', that 'binds' the young Saturn (Prometheus) for stealing the light of creation contained within Orion's Trapezium. It is the wife of Prometheus, named Pandora (another version of Sophia), who opens her box, or jar, thus freeing the Archons (Jinn or Genies) into the lower astral and human worlds. What these myths and legends allude to is the 'hierarchy of light' from the *unseen*; beyond the boundary or veil that creates, constructs and often destroys our human world.

The Power of Three & the Flaming Sword

The Gnostics and the later Cathars of 12th Century France considered the world to be a *fabrication* of *three forces* that 'project or create' the Cosmos. The English word 'Trinity', which is derived from the Latin 'Trinitas' (meaning the number three), is the most common symbolism for these three forces. Other systems consider them to be three primary forces, described as *positive, negative* and *neutral*. All three of these forces are necessary to create anything. The positive force acts, the negative force receives, and the neutral force is the mysterious force reconciling the two because it is the mix of positive and negative. In the Vedic tradition, the same three primary forces are the three Gunas. For the ancient Hindus Valley people, creation was described as the 'agitation' of a previously inert and perfectly-balanced state into the three gunas of *light, motion,* and *darkness*. The Biblical Adam, Eve and the Serpent are these three forces on one level, and they represent the forces required for any creation to occur. In other words, to manifest anything, these three 'primary forces' separate and then unite creating the triangular shape called a Tetrahedron.

The Tetrahedron is the smallest and most compact of all the Platonic Solids, which basically are the building blocks for solidity, or *three dimensional reality*. It's interesting to note that the Black Pyramid, with the Eye (or UV fluorescent Third-Eye Pyramid), a magnetic stone artifact, discovered in La Maná, Ecuador in the 1980s, **is not** a pyramid but a Tetrahedron (see figure 64). There is a lot of mystery around this artifact, not least the hieroglyphs on its base which seem to infer there was a global civilisation predating the Mayan civilisation. It also features the Orion Constellation and the 'Eye of Providence' I mentioned earlier. The bricks in the body of the pyramid add up to 33, which is a code for the human vertebrae and the kundalini force, something I will come back to shortly. The Trinity, the *Three Forces*, or the 'Three Pure Ones' are formless and are often portrayed in the *three* basic colours, from which all colours originate: Red

Figure 64: The Tetrahedron - Black Pyramid.

(active, fire or creation), Blue (passive, truth or reason) and Yellow or Green (neutral, wisdom, gold, or philosopher's stone). In all instances, and esoterically speaking, the number *Three* is a building block for reality.

The three forces of creation seem to be evident in the idea of humanity 'falling' through the frequencies. The Adam and Eve story, which sees God (the Demiurge) expelling Adam (Orion) and Eve, along with the serpent (the electromagnetic kundalini force), for disobeying him, is another version of the 'fall'. The *three forces* take the form of the tree of good, evil and the 'tree of knowledge' in the Garden of Eden. All of which seem to be symbolic of the forces focused on the Orion Nebula. In Jewish theology, the higher *'Gan Eden'* is called the *'Garden of Righteousness'*, a location said to have been created at the beginning of the world. It is said that here the 'righteous' dwell in the sight of the 'heavenly chariot'; carrying the throne of God. Is it possible that the 'chariot' and 'throne' was another way of describing the Trapezium area of the Orion Nebula? Was Orion and his Queen (Eve) expelled from the realms of paradise, the place of the Upper Aeons for disobeying the Demiurge? Again, it is interesting to note that the word 'paradise' comes from the term 'pardes', meaning a 'royal garden' or 'hunting park'- a perfect place for Orion. The serpent in this story is associated with Satan (or Saturn's influence) and how his act of disobedience led to his imprisonment in the Circles of Hell (see the story of Prometheus). The book of *Genesis* - says Cherubim (Archons) were placed 'east of the garden', and with them a 'flaming sword' which 'turned every way,' in order to guard the Tree of Life. In Norse mythology, the god Surtr guards Muspell (a realm of fire), one of the Nine Worlds of Yggdrasil (the World Tree) with his 'flaming sword'. Interestingly, the 'sword area' of the Orion Nebula which comprises three stars: Orionis, Theta Orionis, and Iota Orionis, is just above the Trapezium, the birthing place for young stars. Something was certainly placed in that region to prevent humanity from accessing its Super Consciousness. Symbolism connected to the number *'three'* (or $3 \times 3 = 9$) seems to be a major numerological code for creating the structure of the 'Tree of Life'. Could the Orion Nebula be the celestial 'brain' or 'mind' that *is* creating our physical 'fallen' Earth-reality, manifesting through duality? This duality is created by two points projected out of one, giving us (human perception) three points of focus (the Sun, Moon and Earth). So it is no surprise to find the number *three* expressed in Dante's *Inferno* as Satan having 'three faces' (symbolic of the Fall). Dante writes:

> ... *he had three faces: one in front blood red; and then another two that, just above the midpoint of each shoulder, joined the first; and at the crown, all three were reattached; the right looked somewhat yellow, somewhat white; the left in its appearance was like those who come from where the Nile, descending, flows.*

English playwright and poet Dorothy L. Sayers notes that Satan's three faces described in *Inferno* are thought to suggest his control over the three human races. Based on Judaic lore, red for the Europeans (from Japheth),

yellow for the Asiatic (from Shem), and black/blue for the African (the race of Ham). I would suggest the colour symbology here also includes 'black and white', and *all of it* relates to the science of chromatics. Our DNA and the influence of Orion, which 'powers' our sun, moon, and therefore our human world, is contained within our DNA. It was the late American astrophysicist Carl Sagan, who said that *'we are made of star-stuff'* and that all the elements on earth were once produced in the 'heart of stars' before being flung out into the Universe.

Lion of God

Gnostic creation myths say that Adam was coupled with an 'aspect' of Sophia called Eve. The Trapezium, from my understanding, is Sophia's point of connection with solar (star) consciousness creating a portal into our 'human earth world'. In the constellation of Orion, Rigel was also known as

(Altair), which probably goes back to the ancient Babylonians and Sumerians, who called Aquilae (Altair) the 'eagle star'. Rigel is one of three stars, the others being Alinitak and Saiph that together, create a triad where the 'central fire' of Orion lives. Rigel was also called the firebrand by the polynesians on Easter Island. Another name for the area contained by Rigel, and the other stars in that location, is 'Ariel', which in Jewish and Christian mysticism (Apocrypha) means 'Hearth of God'. It is also referred to as the 'Lion of God' (see figure 65).

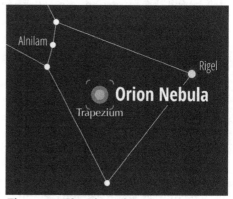

Figure 65: The Lion of God.

In Thomas Heywood's, *Hierarchy of the Blessed Angels* (1635), Ariel is called both a prince who rules the waters and 'Earth's great Lord.' He is mentioned with other elemental titles such as the 'third archon of the winds,' 'spirit of air', 'angel of the waters of the earth' and 'wielder of fire.' In esoteric art, Ariel is usually depicted as a 'governing angel' with dominion over the earth, creative forces, the north, elemental spirits, and all beasts. Ariel is also another word for the 'city of Jerusalem' (not IS-RA-EL), and Shakespeare used it as the name of a 'spirit' in his play, *The Tempest*.

In my image, Ariel, with the Lord Archon at his third eye (Eye of Orion), is focusing plasma (energy), which encompasses the 'separation' of man and woman, Adam and Eve (see figure 66). The image is also a symbolic rendition of the two sides of the brain (left and right hemispheres), which are part of the same symbolic narrative contained within the 'Fall'. The 'two sides' of the brain need to work in unity for there to be balance, and in my painting, Ariel is an 'energy' that has the opportunity to change human destiny. In its current state, this energy is 'sleeping' (dreaming) and in my

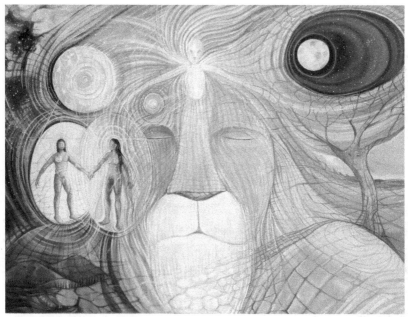

Figure 66: *The Lion of God* **- Ariel and the Eye of Orion.**
The image is based on a dream I had which seemed to show me the *Lion of God*
thinking into 'existence' the 'duality of life'. In my canvas, Adam and Eve are a
projection of Orion's central sun (eye) and the moon (far right) is ready to 'move'.

image, *The Lion of God* is still caught up in his own arrogance, like the
Demiurge, but is also contemplating the existence of something greater
than himself. Symbolically speaking, is the Lion of God a metaphor for the
unawakened Jerusalem? The Lord of Hosts at Ariel's third eye, is manifest-
ing the 'energetic prison-like worlds', or the egg with its shell intact, encas-
ing humanity within an illusion. The path that travels across the expanse of
Ariel's body, leads back to the Tree of Knowledge, and symbolically speak-
ing, gives us the potential for duality to cease, and for the 'two' (hand in
hand) to become *one* again. Genius song writer/musician, Peter Gabriel,
expresses well the notion of returning to *oneness* in his song, *Blood of Eden*:

> *In the blood of Eden lie the woman and the man,*
> *I feel the man in the woman and the woman in the man,*
> *In the blood of Eden we have done everything we can,*
> *In the blood of Eden, so we end as we began,*
> *With the man in the woman and the woman in the man,*
> *It was all for the union, oh the union of the woman,*
> *the woman and the man.*

Remembering *Our* Monad
It was the Pythagoreans, who called the 'first thing that came into exis-
tence', the 'Monad'. It was also referred to as the 'first being', 'divine form',

or the 'totality of all beings'. It was said that the Monad gave life to the Dyad (the Greek word for two), which begat all other numbers. In my painting (see figure 67), the Monad is symbolised as a 'stone or star' held between the finger and thumb of the 'hand of truth'. The image, entitled *'Placing the Stone'* was created for the cover of David Icke's book, *Remember Who You Are* (2011). The symbolism contained within this huge canvas attempts to convey the message that we as individuals affect the collective consciousness when we activate the *Monad*, the *Divine Imagination*. The placing of the stone (Monad) into the 'Tree of Life' above the vertebrae, is another symbol for the activation of the 'third eye', or the 'eye of providence' within us all. The 'placing of the stone' would reverse the separa-

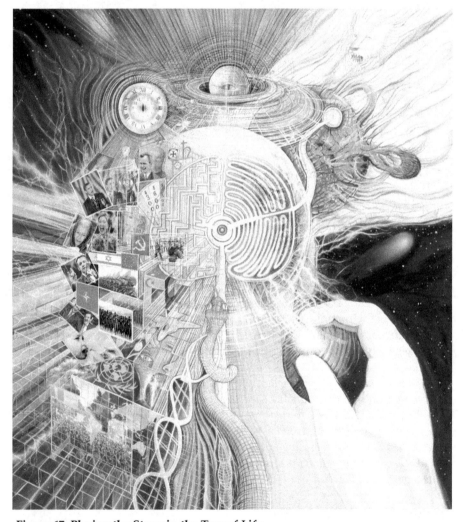

Figure 67: Placing the Stone in the Tree of Life.
It is our task as 'beings of light' to *'remember who we are'* and of what we are capable.
© Neil Hague 2011

tion, symbolised through the story of Adam and Eve, bringing an end to the illusionary state of awareness 'cast' by the Sun, Moon and Saturn. I use the word 'cast' to emphasise the notion that a spell has been cast over our 'true sight', erasing our memory of the time before the 'Fall'.

The dwarf star Saturn, or 'Fallen Sun', was once symbolised as a Monad (circle with a dot in the centre), before its light and sound was reversed to hold humanity in a lower vibrational field. Saturn is symbolically hovering above the crown of the celestial human in my painting. Orion is the 'time and space' that facilitates the Fallen Sun (Saturn) and also 'controls' our Sun. Ariel is capable of passing through the Sun to meet the 'hand of truth' at the centre of the Tree of Knowledge. This place is where the pineal gland *ignites* the 'third eye' giving us our 'true sight' - our 'ancient eyes'.

Moon-Sin

The Moon became a symbol of Eve's fall from the 'star garden' (paradise), which was hacked into, so to change the perception of humanity. In my image, the moon 'overshadows' the collective human third eye. Symbolically speaking, our Moon *is* another 'eye in the sky' harmonizing the 'auric egg' (energy fields around our physical body) and creating the biological 'prison' of the mind, body and emotions. The Moon acts like a super-computer regulating all life on Earth. It could be seen as a symbol for the supposed 'sin' (blame and shame), forced on Adam and Eve as they were 'banished' from the 'star garden' by the Father God (Demiurge).

The Semitic moon god called 'Su'en' or 'Sin' of the Akkadian Empire (2600–2400 BC), seems to have been the origin of the notion of 'original sin' blamed on Eve by a patriarchal priesthood that created the *Old Testament*. All women since Babylon have suffered, or endured the wrath of the moon god Sin, on many levels. From the obvious biological implications of the moon's effect on the female body, to religion-inflicted abuse on women on earth, the moon *is* the pivotal force. To the ancients, the moon's light, along with the sun's light, was personified through deities like Selene, Luna and Apollo, who were said to be children of the race of titans in Greek myth. Selene seems to be especially significant due to her relationship with Helios (Sun/Saturn) and how these two 'eyes in the sky' give us our perception of *time*. Inspiration for my art over the years has shown (proved) that the Moon was *used* to dramatically alter, or change, life on earth in a very ancient epoch (see page 280). On an unseen level, the Moon acts as a conduit for the archons and demons that seem to use it for harvesting human souls.[16] Samael Aun Weor, writing about the Moon and its influence on mankind says in his book, *The Narrow Way: The Global Crisis and the Sexual Solution* (2016):

> *The Moon is that great apocalyptic harlot that every intellectual beast carries within. This perverse [Fallen] race of Adam is one hundred percent lunar. This lunar race mortality hates the solar race, the sons of the Sun, the prophets, the*

masters of wisdom. Lunar multitudes crucified Christ, poisoned Buddha, incarcerated and calumniated Cagliostro, gave venom to Milarepa, burned Joan of Arc, betrayed the omni-cosmic and very sacred avatar Ashiata Shiemash and destroyed his work, etc.[17]

The lunar race Weor refers to are the Biblical Nephilim and their modern 'illuminati-serpent' bloodline who worship the moon-saturn relationship. It has been my feeling since writing the original version of this book, that the Sun and Moon, along with Saturn, are celestial 'instruments' used in a 'clockwork' solar system, created by the Gnostic Architect (Demiurge). The moon was often symbolised as a dragon or snake that measured 'cosmic time' – illusory time. The moon, along with other satellites and wanderers, especially Saturn, is said to be governed through what Alchemists called the 'Ray of Creation'. This 'Ray' is not measured through the 'visible spectrum of light', but is said to project out of the 'Eye of Providence' (or Monad), passing through all worlds - *all* realities. It is the *unseen* 'higher light' of the Aeons (Super Consciousness) that *is* the Ray of Creation. For the Gnostics, this Ray passes through all suns (stars), our sun, all planets, the earth and into the worlds of Inferno (Hell), the latter is the location over which the Moon rules. The Moon was considered to be the 'keeper' of the 'First Infernal Circle' of Hell, the place where souls dwelling in limbo had to pass through at the point of death. In some esoteric writings, the Moon and Saturn create the Ouroboros (the serpent swallowing its own tail) that souls would need to *pass*

Figure 68: The Ouroboros Moon Passage.
Left: The Gnostic Ring-Pass-Not (or Ouroboros), is also connected to Sun, Moon and Saturn. The illustration on the left depicts the lion-headed serpent devouring the white lunar bird. *Right:* An alchemical illustration showing the Moon and Ouroboros as a 'system of illusion' separating us from the Upper Aeons. The Crown is a symbol for the 'head' (wisdom) of Orion, and also, how Saturn has been 'used' to prevent souls from returning to the Monad, beyond the veil to *Oneness*.
For more information see the works of Heinrich Cornelius Agrippa and his Three Books of *Occult Philosophy*.

through to reach higher dimensions beyond the veil (see figure 68). Samael Aun Weor writes again about the Moon in, *Spiritual Power of Sound: The Awakening of Consciousness and the Laws of Nature* (2011):

The lunar influence is of a submerged subconscious type and controls the tenebrous regions of the terrestrial abyss. This is why in esotericism those regions are called submerged sublunar regions. Those are the outer darkness where there shall be weeping and gnashing of teeth.[18]

I see the moon as a partly dead consciousness that 'feeds off' those who live on the 'Fallen' (illusory) Earth. Along with the Sun, the Moon is working in synchronicity, to keep humanity, us, in a fake reality, rather than our true *Infinite* State of Awareness. I want the reader to *feel* these concepts, to ignite the imagination when it comes to 'seeing through ancient eyes'.

Orion symbolism, along with the *Lion of God* symbolism, is not what it seems, and as I have shown in my illustrated stories and paintings over the past decade or so, Lion Consciousness *is* part of the 'truth vibration'. The power of truth rises out of the heart of humanity and aids us in *'seeing all that there is to see'*. Our consciousness and *Infinite Awareness* is capable of dissolving the facade being 'projected' via the Sun and the Moon, the super projectors of light, through which we all *see* the world. The lion Ariel in my symbolism, is the 'rebel angel' within us all. He represents the awakened individual and the power to ignite our collective creative imagination; a subject to which I now turn my attention.

Sources:

1) Charles H. Long, *Alpha: Myths of Creation*, 1963. pp36-37

2) John Lamb Lash. *Not in His Image, Gnostic Vision, Sacred Ecology and the Future of Belief (The Apocryphon of John).* 2006

3) Ibid, p200

4) Hellenschmidt, Clarice; Kellens, Jean (1993), "*Daiva*", Encyclopaedia Iranica, 6, Costa Mesa: Mazda, pp 599–602

5) https://en.wikipedia.org/wiki/Birkeland_current
see also: www.youtube.com/user/5T4RSCREAM233

6) Pierre Sabak. *The Murder of Reality.* 2010. pp127 and 333

7) David, Gary A. *The Orion Zone, Ancient Star Cities of the American Southwest.* 2006. p203

8) Pierre Sabak *The Murder of Reality.* 2010. p80

9) Book of *Revelation.* 1:12-20

10) David, Gary A. *The Orion Zone, Ancient Star Cities of the American Southwest.* 2006. p70

11) Owusu, Heike; *Symbols of Native America.* Sterling Publishing. 1997. p159

12) https://en.wikipedia.org/wiki/Delta_Kappa_Epsilon

13) https://en.wikipedia.org/wiki/Ogdoad_(Gnosticism)

14) *Inferno*, Canto XXXIV, lines 39–45, Mandelbaum translation.

15) J. F. C. Fuller. *The Secret Wisdom of the Qabalah A Study in Jewish Mystical Thought.* 1937. p44

16) Hedsel, Mark. *The Zelator, A Modern Initiate Explores the Ancient Mysteries.* 1999. p243

17) www.wisdomworld.org/additional/ListOfCollatedArticles/TheElectricEntity.html
see also: https://hollywoodsubliminals.wordpress.com/archons/

18) Samael Aun Weor. *Spiritual Power of Sound* (1966). p122

Unlocking the Imagination
The Native Understanding of Art

"The imagination is that which is the least human in man.
It wrenches him away from himself and plunges him into ecstacy;
It puts him into secret communion with the powers of nature.
Who speaks to me, with my own voice?
From himself comes a marvellous stranger called Art."
Mikel Dufrenne

In many North American Indian languages there is no word for artist. Probably because he or she was given other names, like 'holy man', shaman or medicine person. The priests of Egypt were the artists behind much fantastic esoteric temple art. Artists in native civilisations were 'sages' and 'visionaries' within their tribes, purely because of their ability to peer into many invisible worlds. Seeing the 'unseen' gave the native artist/shaman (through their art forms) the ability to make spirit tangible in the physical world.

Even before Palaeolithic times humans have benefited from inner visions of the shamanic artist. Our nomadic ancestors expressed their technical diversity and creativity in magnificent cave art from around 27,000 BC., in places like Chauvet-Pont-d'Arc Cave in Ardéche; Lascaux, Mas d'Azil in the south of France and Altamira in Spain, we have witnessed amazing draughtsmanship and sensitivity to animal-form through shamanistic art. In the caves of the ancient Anasazi in Arizona, and in Tanum, Norway, we also find prehistoric art forms (and symbols) offering a profound knowledge relating to migration, gods and the cosmos. Cave art seems to leave onlookers in awe of the beauty and mystery these art forms convey. Amongst the depictions of many different animals, we find drawings of insects, spiders, handprints, cobwebs, dots, zigzags, sun-wheels and checkerboards, together with entoptic-style symbols. These types of imagery open up a myriad of archetypes, which are as active today as they were in the ancient world. Inspired by their environments and the mysterious power of the cosmos, our prehistoric ancestors created shrines on walls that told of hunts and initiation, but most of all, they offered profound symbolic significance to our distant artistic relations' experience with life. The art historian, Herbert Read (1965), made an important observation about the primal way of making animal images, reflecting the ritual-making mode behind much rock art. He says:

In such representations there are no attempts to conform with the exact but casual appearances of animals; and no desire to evolve an ideal type of animal. Rather from an intense awareness of the nature of the animal, its movements and its habits, the artist is able to select just those features which best denote its vitality, and by exaggerating these and distorting them until they cohere in some significant rhythms and shape, he produces a representation which conveys to us the very essence of the animal.[1]

Much scientific research into shamanic art, especially by David Lewis Williams and Thomas Dowson, both of whom looked into the Kalahari Bushmen groups, suggests that the majority of imagery found in rock paintings seems to relate to 'hallucinatory scenes', 'stages of trance' and adventures of 'out-of-body' shamans. Author Jeremy Narby, in his book *The Cosmic Serpent* (1995), also shows that much shamanic art comes from the interaction between plants, animals and humans communicating through DNA. To go beyond the physical world, the shaman would sometimes drink a brew called ayahuasca (the soul vine), which is a combination of two plants blended to activate dimethyltryptamine, an hallucinogenic substance secreted by the brain. As with certain mushrooms used by Siberian shamans, ayahuasca allowed the drinker to encounter nonphysical dimensions. Therefore, much shamanic art was a reflection of knowledge obtained at a 'molecular' level, and why many aboriginal cultures already had knowledge of the twin 'life-giving' symbols (entwined serpents) found in their art forms, well before the double helix (DNA) was officially discovered in 1953.

By all accounts, the shamanic artist was considered a pohagunt, a 'man/woman of power'; translated as 'a man who writes', or a man who makes rock markings (see figure 69). Rock markings all over the world tell of ancient narratives, strange god-beings and archetypal forces appearing to the visionary senses of native artists. Through shamanic works of art, we can come to understand the thinking and aspirations of long-lost ancient societies.

Figure 69: Pohagunt. A Lakota Sioux drawing of a 'medicine man', or 'pohagunt' (Wicasa Wakan). Lifting his right arm and from his fingers radiates 'power'.

A Visionary Way of Seeing

The visionary capacity of artists is so diverse that it is often considered by western standards to be a bit bizarre, even 'mad'. And in a society in its current 'state of awareness', being percieved as 'mad' can be considered unworthy or even 'dangerous'. How many times have artists or visionaries throughout history been labelled 'mad', when in truth, they were merely expressing their unique ability to 'see' the world in a different way. The power of the Romanesque visionary artist has not held great influence over

civilisation since the Byzantine period, or since Gothic sculpture emerged in art. Through the work of Bruegel and Bosch, like the later work of Blake, we witness an elaborate 'personal mythology'. The art of the native pohagunt, and through the work of artists like Bosch, we venture into worlds of archetypal bird people, giants, monsters and humans living in *The Garden of Earthly Delights*. Bosch's mythical worlds speak of an earlier, mystical time on earth, and the suffering of the human soul at the height of the Middle Ages.

During the Renaissance (the period that Bosch lived), the ideal expression of 'external reality' almost solely dominated art, with little room for creating imagery of 'alternative realities'. In many ways, the Renaissance in Europe helped sow the seeds of the 'rational' Newtonian views of how the world was structured and perceived. During this time, the 'spiritual art' became 'separated' from science. Only in the elite mystery schools did the two remain intact to be pursued in secret. However, despite the separation of art from science, the visionary in art can be seen through the work of certain artists from the Renaissance period onwards.

William Blake, who was shunned by the 'art establishment', sowed the seeds of real visionary art in 18th Century Britain. Art historians quite understandably confuse Blake as 'religious', when he was more than likely a very spiritual man. I believe there is a difference. Blake was an artist and author who believed the imagination to be the real character of a person, and he even went as far as saying that the imagination was God! It was Blake's spiritual interests, fuelled by his interest in alchemy and the esoteric side of the Bible, that provided him with visions and passion for revealing the spiritual nature of humanity. In the end it was Blake's imagination that offended the art establishment, enough to keep him in poverty all of his life.

In Spain, El Greco, passed on the visionary spirit to Goya who later influenced Daumier and Manet. While in the north of Europe, it was Rembrandt and Brouwever who stirred the young artists of France, such as Delacroix, Decamps, and Courbet. These painters in turn helped Cézanne, Gauguin and Van Gogh remember their visionary sight. The Symbolist movement also expressed the absent and the transcendental through their imagery, yet even today, in the academies, curriculums and universities, there are people that deny that such visionary art has any significance. Regardless of how art is viewed and been taught since the classical period onwards, an 'alternative reality' has survived through the images of many visionary painters. As Blake once said: "The man who raises himself above all is the artist; the prophet is he who is gifted with imagination".

Today, we are beginning to remember that both science (esoterics) and spirituality (not religious doctrine) stem from the same knowledge. Art is what unites science and spirituality, as it always did for ancient priests of antiquity. As mentioned in an earlier chapter, subjects found in Science Fiction are also revealing the ancient and modern connections underpinned by 'quantum physics'. Over the years, I have asserted in lectures that 'Science Fiction' is a 'story', told to prevent people from realising the truth about interdimensional worlds, exteraterrestrials, non-physical realities and time-travel.

Art – A Search for the Fourth Dimension

When we look at prehistoric art up to the middle ages, drawing and painting was distinctive for its deliberate 'lack of perspective'. Gods, kings, knights and various animals, were depicted as though they were flat, which in religious terms reflected the omnipotent view of the gods. Examples of a 'two-dimensional' view of the world can be found in all types of cave art through to the famous Bayeux Tapestry, showing the soldiers of King Harold II of England 'pressed flat' in action. On another scene, the soldiers are in awe of a comet as it passes above them. In fact, comets and strange objects in the sky appear lots throughout art history. The Renaissance was a revolt against the omnipotent worldview. Three dimensional objects were instead painted from the point of view of a person's eye, using persepctive. Leonardo da Vinci, like other masters of this period, used single points on the horizon to reflect how the eyes viewed the world. In paintings by Michelangelo and Crivelli we see for the first time figures 'jumping out' of a flat, two dimensional space, creating perspective; giving imagery a sense of 'realism'. The Renaissance seemed to discover a third dimension through art. For hundreds of years, art seemed stuck in a three-dimensional view of the world until the Cubists revolted against perspective (in 1911). Artists like Pablo Picasso and Umberto Boccioni, captured a fourth-dimensional perspective in their works. They gave us a perfect example of how faces, objects and figures can be viewed from multiple perspectives, as though they were painted by someone who could 'see from outside this reality'and into the 'fourth dimension' (see figure 70). Another aspect of fourth dimensional art is 'movement' (through time and space), something I have constantly attempted to capture in my

Figure 70: Art - A Search For The Fourth Dimension (and Beyond).
From cave art, to the paintings of the 20th Century,
artists seemed to be naturally discovering that reality is multi-dimensional.
Left: Cave Art from Chauvet, France. *Middle: The Annunciation with St.Emidius* (1486) by
Crivelli. *Right:* Section of the painting *Gueridon*, 1913, by Georges Braque.
© Courtesy of The National Gallery

own work. I am fascinated with the 'movement of 'Aeon light' (energy), and the invisible (made tangible) 'forms' that construct reality. At this level, I am not talking about 'motion' in terms of the 'speed of light', but the movement of particles (waveforms) as recorded by physicists; or what is often referred to as dark, 'luminous' matter. There is light, and then there is 'luminous' higher vibrational light. Can art serve as a portal to worlds beyond this physical dimension? Of course it can! Visionary art, like astrophysics, can be a vehicle for seeing into invisible (parallel) worlds. Art is a tool for seeing into higher dimensions, and like science, it is a sacred gift that can aid the individual in discovering many 'invisible' worlds within our universe.

Transformation as a Source of Imagery

Through the eyes of native people past and present, everything on the planet is 'alive', something modern science has only come to realise through the 'Gaia hypothesis', spurred on by ecological physics. Native cultures (past and present), were impelled by their primeval imagination; spirits of animals and archetypal gods/goddesses were made tangible, using art as a form of ceremonial initiation. To the shamans of Palaeolithic cave art, their artwork was believed to be 'active' or 'illuminating' the present reality. Most shamanistic art could have been created as a form of celebration; depicting a successful hunt before it actually began. If so, then the images became 'agents' of 'transformation'; the art (image) had power to change reality through the imagination of the artist/shaman. Today, this process is recognised in art therapy as 'Image Dialogue', or what Carl Jung described as 'Active Imagination'. To the native artist, all images contained sequential 'fantasies' wanting to become conscious; by deliberately concentrating on particular imagery through meditation or trance, the art, in a shamanic sense, became a tool for 'transforming realities'. In other words, the artist understood magic (knowledge) by 'turning into' the image he or she created. The shaman became the image and vice versa. This idea is summed up perfectly by W.B Yeats, who said: "Who can tell the dancer from the dance?"

From a much wider perspective, art is important to the process of transformation, from *visualising* a world of 'limitation' to seeing it change into a world of 'abundance'. Every art form in the native sense came through the notion of bringing abundance into everyday reality! And my god, haven't we forgotten this? All native art attempted to communicate and 'manifest' many truths, hidden within nature; more so, when art became a 'ritual' for focusing (or directing) `supernatural' powers to facilitate abundance. The elite structures outlined in previous chapters, do not want billions of people 'accessing' their visionary power to facilitate global abundance. There would be *no* elite if the many accessed their ability to 'make magic happen' through visualisation. Using our visionary powers is part of our life (energy), it's a force never static, or regressive in its natural state. I would say the artist becomes an instrument of 'natural forces' capable of nurturing a natural expansion of energy to forge new channels of expression and experience. In fact, you could say it is the 'primary purpose' of the human imagination, to

expand the life energy surrounding us all. Therefore, our imagination is our innate gift, which can be called upon to help visualise a very different physical existence. By imagining or 'realising' our visions through any creative form, we manifest realities which eventually have the potential to materialise in our world in some way or another.

Another factor relating to much indigenous art, is the rendering of the 'invisible', making it 'visible' to our eyes. A perfect example of bringing to life what cannot be seen, would be the art of the Salish totem pole builders of the Northwest Coast of America. Their art and sculpture celebrated the mystery of their ancestors and the many 'invisible spirit keepers'. Making invisible worlds (or inner-worlds) real has more to do with the function and ritual of ancient rock art covering a wide geographical area. Effigies, masks, totems, cave paintings and so on, were created by individuals, a tribe, a clan or even a secret society, as symbols of who they truly were and the invisible worlds to which they were connected. Certain imagery became the hallmark of a particular tribe, or person and their imagery was considered to be 'alive', affecting the world around them. To the artist/priest, 'symbolic imagery' was considered 'pure energy', and by placing symbols (or energy) on important objects, whether a Blackfoot shield or the back of a one dollar bill, the effect was to affect consciousness or alter reality. For example, symbols and archetypes are widely used by secret societies because initiates 'know' the effect a particular image or symbol will have on the subconscious of anyone viewing. Our world is *saturated* in corporate symbols for this very purpose.

In the ancient world, priests (artists) used their visionary powers for positive effect, while certain priesthoods used their visionary powers for malevolent purposes through black magic. One can create or one can destroy! Every artist taps into their daemonic force, whether through dance, painting, music or other creative expressions. Some artists are called geniuses because of their ability to lock into guiding archetypal energies, using them to produce great works. I believe we all have that same inherent ability within us; yet, we are conditioned not to look for our inner power, never mind use it. Artists, writers, dancers and musicians who do call on their inner creative power, and use it to manifest the hidden forces in nature, are only doing what seers and shamans have done since the beginning of time.

The shaman-artist of today is no different from the shaman of the ancient world. Classic examples of a modern shaman can be seen within the art of musicians like Jimmy Hendrix, Jim Morrison, Bob Marley and John Lennon, to name just a few; each of them, in their unique way, seemed to touch on primordial forces and hidden truths through the medium of music. Artist like Blake, the Post-Impressionists and Surrealists showed us both a 'romantic' and 'cathartic' view of the soul; these artist-shamans help us to see different levels of reality. What all artists have in common, is the ability to use esoteric language in a way that can 'lift the veil' (vanquishing lies) to reveal a hidden knowledge often suppressed by the corporate elite. Even though we are not directly experiencing the mysterious or sublime symbolic language our ancestors experienced, we can still connect with a universal, 'timeless' cre-

ative power. Again, this ability was considered a raw creative energy or a 'daemon' by the ancient Greeks, or described as 'genius' by the Romans. By seeking out this universal 'Source' energy through creative action, we automatically gain access to an ancient 'memory bank' containing all creative acts. Our individual link to this memory bank (or collective creative-mind) is made through our soul. And the shaman (the artist within) is a constant reminder of the soul's creative power, both pure and eternal, residing within us all. The Abbess, Saint Hildegard of Bingen, who was a visionary, writer, preacher, musician, painter and healer, wrote in the 12th Century:

> *Art is a half effaced recollection of a higher state from which we have fallen since the time of Eden.*[2]

All art in its native (natural) sense is concerned with 'stirring our spirits', our souls and stimulating our extra-sensory perception.

Art as a Psychic Tool

The gift of art is to use 'our' creative power, combined with esoteric knowledge, to enlighten and comprehend our evolution as a species. In *Chapter One*, I assert how sacred knowledge, in the form of art and science, was taken from the 'gods' and given to chosen initiates within secret priesthoods of civilisations like Egypt, Sumeria and South America. The priests in these temple cultures, were in effect the 'first artists', whose patrons were the gods themselves. The same creative forces and esoteric knowledge utilised by all artists throughout all great civilisations of antiquity, gave birth to many myths through a variety of art-forms. As always, it is the art of storytelling (whether oral or pictorial), which is a real sign of creative vitality in any culture or society. Creating, or re-creating our own personal myths, helps to eradicate negative feelings generated by dogma, which ultimately can only disempowers us. All myths and legends inspire and fuel our imagination, and from a creative point of view, help us dig deeper toward understanding ourselves and therefore our relationship with the universe. For an example of this, consider how myths in ancient Greece provided creative foundations for philosophers like Plato and Socrates to flourish, develop and express their ideas. Creativity, when viewed from an indigenous perspective, is not just a physical process, but a necessary ongoing spiritual journey, something that was/is practiced and woven into the fabric of our native ancestors' lives. Whether we consider the natives of Easter Island, creating enormous effigies and stone heads to honour their spiritual leaders (gods), or the European aristocracy placing hippogriths and dragons on their clans' 'spiritual' coat of arms, the use of art to convey 'spiritual knowledge', protection for the community and connection with unseen forces, was paramount in the ancient world.

Today, in my view, there is a lack of a spiritual principle in art, especially schools of fine art, which concern themselves mainly with intellectualising and rationalising creativity. There is more to creativity than the 'physical

process', or the 'analysis of colour and form', through 'art for art's sake'. The most important aspect of being creative is not the product created but what it reveals to the one who has created it! What is unveiled through our art and creativity, relates directly to what we feel, how we think, see and how we move through the world on different levels. Humanity often gets caught up in a world of illusion when it fails to see beyond 'physical limitations' designed to prevent us from seeing into other dimensions. Therefore, art as a vehicle for psychic ability, can provide us with necessary insight for discovering the mystery of our being (our species). Drawing and painting, whether from life, casts, or other 'primary sources', can become a sort of meditation towards self-discovery. When we enter into meditative states through our art, then the archetypes behind many natural forms speak to us on a subconscious level, providing information not always absorbed through language or spoken words. The 'energy' behind a drawing or painting is just as important as the physical object or image created; and when we are in a meditative state, it is our unconscious, creative body that leaps into the unknown territory of the soul. Creativity is the bridge between multiple realities!

In many ways, the 'native' (or indigenous) role of art, was to provide a 'mediator' or 'mask' for other realities to take form in the physical world. Art gives the artist an inner window to 'see' what archetypes move within and what spirits move around us. All native art in this sense is the creative process or amalgamation of 'things seen in new ways'. The same process is also described by Native American Indians as a way of 'looking twice' at everything, to be able to develop clear 'visionary sight'. Art therapists often refer to this process as 'dreaming with open eyes'. When we dream with open eyes, we are developing a sight enabling us to 'see through' everyday illusions disconnecting us from vital knowledge contained in the web of life. This process of 'seeing' was summed up superbly by Jamake Highwater in his book, *Primal Mind* (1982). He wrote:

> You must learn to look at the world twice', I was told by an Indian who was very much worried about my preoccupation with words. As I sat on the floor of his immaculately swept room. First you must bring your eyes together in front, so you can see the smoke rising from an anthill in the sunshine. Nothing should escape your notice. Then you must learn also to look again, with your eyes at the very edge of what is visible. Now you must see dimly if you wish to see things that are 'dim'- visions, mist, cloud-people, animals which hurry past in the dark. You must learn to look at the world twice if you wish to see all that there is to see.[3]

The practice of dreaming before nature, or seeing into worlds unseen while interpreting what we see through art, is what makes art a metaphysical activity. It also makes it a vehicle for expressing our spirituality, something that connects us with the 'infinite mind'. Blake echoed the ability to 'see' the infinite when he wrote:

> To see the world in a Grain of Sand

And Heaven in a wild flower
Hold Infinity in the Palm of your hand
And Eternity in an hour.[4]

With this statement, Blake makes the invisible, visible; or the intangible concrete. The 20th Century artist Pablo Picasso also expressed similar beliefs by saying:

The function of art was to give spirits a form, in order to build up the psychic strength needed to survive and develop in life.[5]

Black Elk, a renowned medicine man (shaman) of the Oglala Sioux Nation, also expressed a similar understanding of 'seeing the infinite' when he said:

While I stood there I saw more than I can tell and understood more than I saw: for I was seeing in a sacred manner the shapes of all things in the spirit and in the sky.[6]

This process of making spirit tangible, or presenting to the senses something we know is there but cannot be sensed physically, is fundamental towards a deeper understanding of who we really are. It's also a guide for unlocking our hidden creative potential. The bridging of worlds through our 'art' leads us to consider the question: What is the artist within?

The Artist Within

The artist is an archetype representing creativity in all living things. We need both masculine and feminine aspects of life to perform any creative act, the artist within has both apsects. Just as both the male sperm and female egg need to combine to create, we too, need to unite both our opposite qualities to birth something new into the world. In much the same way that the balanced, creative individual needs to access both hemispheres of the human brain to materialise creative objects. In my opinion, art is not an elitist or specialist subject, even though it has become a privilege for those who can 'afford' to express an art 'specialism' in University, or in the luxury of their stately home. Art should be a right of expression irrespective of class or income bracket. German artist, shaman and politician, Joseph Beuys echoed a similar view that: "Everyone is an artist".

Artists like Beuys, through his engaging public debates as member of the German Green Party in the 1970s, acknowledged the creator in all people. He believed that humanity, with its turn on rationality, was trying to eliminate 'emotions' and thus eliminate a major source of energy and creativity in the individual. Like Beuys, I believe the artist is anyone who recognises his/her own *infinite power to create* (no matter what culture) and who applies that energy to life and the world which surrounds them. Art, however complicated or simple, needs to 'celebrate' the 'wonder' and 'magic' in life and the mysteries that confound. Those two key words, 'wonder' and 'magic', are

something everyone has, but not every academic artist wishes to use. I have found many examples in universities and academies showing the lack of these two key ingredients; where logic, categorising and 'results' are more important than 'beauty', 'spontaneity' and inner-growth. The conflict between rationalising and being spontaneous is summed up well by the late John Trudell when he said: "Life's not about how you win but how you swim." I feel, it is in the swimming with our inner feelings and dreams that we respond best to the wonder and magic in life. In fact, each fuels the other, providing a sense of direction, or what many would term `vision'. The artist within everyone is concerned with making those visions and ideas become a reality within the physical world.

Art as Medicine[8]

The artist is also a healer and communicator with spirit and other realities. Communicating with other worlds, or journeying into different dimensions with the idea of presenting what we find (see) as physical art forms, helps transform and heal anyone involved. Playing the role as both 'mediator' and 'transformer of realities', explains why the artist was considered a shaman or holy person by our native cultures. Cecil Collins expressed the multidimensional role of the artist and shaman so perfectly when he said:

> *The Saint, the Artist, the Poet, and the Fool are one. They are the eternal virginity of spirit, which in the dark winter of the world, continually proclaims the existence of a new life, gives faithful promise of the spring of an invisible kingdom, and the coming of the light.[7]*

There are many books and authorities on shamanism and it is not my intention to go into too much detail here; however, it is worth mentioning further the connection between the shaman and the artist.

The shaman was, and still is, a worldwide name for a 'medicine person' or 'healer', especially within many native earth cultures. A shaman would use his/her personal powers of awareness, combined with their own medicine, to heal the soul of individuals or communities alike. Navajo sand paintings are very clear examples of art, symbols and the earth (sand) being used to perform healing on people (see figure 71). These types of ceremonies were used to balance and remove 'emotional blockages' to cleanse the mind, body and spirit of disease. In healing ceremonies certain colours would be used alongside

Figure 71: A Navajo Sand Painting.

chants and rituals, to 'interact' on a 'vibrational level' with the patient's emotional body. Knowledge combining sound and colour is ancient, so is the use of art and symbols to affect energy fields; a true science, and one still practised by artists and initiates of indigenous secret societies. The work of Jackson Pollock, 20th Century American artist, like the Navajo shaman, is a modern interpretation of 'unifying experience' by seeing 'all things' in the cosmos as part of a vast order. Pollock was not simply dealing with decorative abstraction; his purpose was more in the 'act of creating', just like that of the native shaman. It was the 'act' itself that created the 'healing'.

Another name for the shaman, is 'Wounded Healer', which is another way of saying the knowledge and 'medicine' of the shaman is obtained due to his/her direct life experiences; some of which are traumatic or caused by severe illness. Quite often the 'wounding process' ensured a dramatic change within the psyche of the medicine person. The wounding experience, which is really a process of experiencing – learning – evolving, brings the person into direct recognition of their own powers to see[9]. What follows any trauma, is a 'new' way forward in life through one's vision, instigated by whatever caused the emotions to surface. Art can relate to this healing process, and if one is to look at art as 'medicine', two types of artists become apparent. One is the 'cathartic' or 'wounder' who helps to purify the soul; the other is the 'consoler', or bringer of paradise. The first type of artist, the cathartic, is not frightened to pierce hearts or unveil truths, so all that 'poisoned' emotionally can dissolve away. The second type (the consoler), instigates healing the wound through channelling and re-shaping forces in creation. The consoler elevates our senses once we have been touched by 'truth'. Before we can feel healed, a wounding of the soul needs to occur, so our true self can be released. The shamanic process of feeling emotional pain, then healing that place of trauma, applies to all aspects of our lives. All art is a powerful vehicle for healing.

There are many stories of indigenous medicine people becoming ill or close to death and then receiving a vision showing them how to heal themselves and the tribal community alike. One famous story is of the Oglala Sioux medicine man called Black Elk, who in the late 1860s experienced a near-death illness and received a vision of the Rainbow Tribe.[10] This sudden healing process does not happen because the shaman/artist is a genius, chosen or superior in any way; it occurs because the shaman 'receives' what is 'revealed' to him or her in visions, which tell where to look, what to create (or bring into balance) for needed healing to restore harmony in the soul concerned. In fact, true genius is simply the ability to 'act on our sparks of inspiration'. Baudelaire, the French 19th Century poet, even went so far as saying: "Genius is nothing more or less than childhood recaptured at will." I believe this is true of the artist, who in most cases, is really a child's spirit inside an adult body. Twentieth Century artists such as Paul Klee and Joan Miró, including the Cobra Group founded in 1948, expressed similar ideas in relation to art and the 'energy' of children. One of its members, Karel Appel, expressed the idea of needing to retain the child-within when it came to mak-

ing art. He said:

> *The child in man is all that's strongest, most receptive, most open and unpredictable. 'Adult' means 'controlled'. A child lives spontaneously; he's not aware of his talent; he looks at everything as though he were seeing it for the first time.*
> 11

All children have a natural shamanic ability to dream up 'imaginary' characters, but more importantly, they know how to form relationships with these characters and the imagery they receive. This is why children are the most aware artists, they are not frightened to approach creativity in the spirit of 'play', of 'doodling' and 'messing with materials'. If we as adults can approach creativity in the same way, and we do not go into it as a 'serious practitioner', then bit by bit it is possible to get to know the deeper side of ourselves. The spiritual side naturally surfaces as we become 'child-like'.

I believe healing occurs through any creative act, just as the shaman uses drums, masks and rattles, the artist also knows how to go within, journey and bring forth wonder and magic. The shamanic artist stirs the inner mind giving us a glimpse of many non-linear worlds made up of animal, plant and star consciousnesses (see figure 72). The trance-state of shamans, after taking hallucinogenic plants, provided them with visionary powers of seeing phosphenes and eptoptic imagery. Once these worlds are stirred, many symbols, including flashing lights, continually appear through plant and animal medicine. Visions can also appear in the form of 'sacred geometry', 'circles' and 'spirals', the most common archetypes in indigenous art. If you are seeing any of these when in a meditative state, then pay attention to the thoughts you are having around certain aspects of your life. The shapes are aiding you to 'heal' whatever you are contemplating. When we are in a more relaxed dream state, we sometimes feel archetypes as energy, spiraling from the body. Shamans, and artists alike, also describe these energies as flashing blue and orange lights, shaped as 'eyes', 'sunbursts' or 'lozenges' (or diamond shapes). As a child, I found myself experiencing this type of dream-state, especially when certain school lessons dulled my senses and provoked the daydreamer in me. I can still remember my maths teacher slamming his book down on my desk and telling me to pay attention! If he only knew that I was 'already' paying attention to something much more interesting than a left-brain maths lesson. If we con-

Figure 72: An Ojibwa Shaman Receiving Power.
A Native American drawing of a medicine man receiving the power of the 'Great Medicine Society'. According to Ojibwa belief, there are several skies on top of each other, symbolic of higher dimensions beyond the moon.

sider our native ancestors' art, it is possible to see how deeply integrated it was with everyday life. For native people, a ceramic drinking bowl deserved as much mystery and careful iconography, as did a totem pole. Everything made had a spiritual purpose as well as an obvious physical one. Being handcrafted by individuals, this left a unique mark of the artist on the object, a process that hardly exists today, due to heavy industrialisation and mass-manufactured *everything*. Instead, today's artist will always find himself/herself stifled against such controlling forces; since there are no more temples to build, then the artist within the majority of people has naturally subsided. But it doesn't have to be this way. The only temples in need of creative and spiritual development, at this time, are the ones residing within each individual. When we ignore this joint creative and spiritual need, it leads to lack of fulfillment in many areas of our lives. Rest assured, an unfulfilled society can only verge on the 'mechanical' and 'apathetic' extrinsically; if intrinsically, we remain unawakened to our creative calling. And this is one of the reasons why the mechanistic view of life is prevalent in our world today. The other reason relates to the horrors of 'transhumanism', something I will return to at the end of the book.

When we consider ancient civilisations and how we have evolved, one cannot help but notice how our ancestors 'married' the physical with the 'spiritual'. Temples, halls and homes were once adorned with 'original art' which constantly reflected back at society a need and understanding for the creative spirit in life. Blake echoed this notion at the beginning of his poem *Jerusalem*, when he wrote:

> *Nations are destroyed and flourish in proportion as their poetry, painting and music are destroyed or flourish. The primeval state of man was wisdom, art and science.*[12]

This lack of spirit was brought home to me one evening when I was looking out over London, while standing on the Embankment bridge situated over the River Thames. For Londoner's, life is as real as it would have been for the Babylonians in their great city. But what are we to leave generations to come in the way of 'signs', 'art', 'knowledge' and 'culture'? What would our legacy say of our present civilisation long after we have gone? Elephant dung stuck to a canvas, a light switching on and off, or body parts encased in formaldehyde, only serve to suggest that we were 'alienated' from the 'magic' and 'power' in nature; forgetting our connection with what Native Americans called the 'Great Mystery'. A lot of modern art reflects back at us, as a Western civilisation, the current state of our 'soul loss'. If we go back to the 1930s, for example, the Surrealists and the Dadaist art movements in Paris responded to this soul-loss by attempting to shock the public through their art. Dada art was a natural response to the mechanisation of the human spirit through war and industrialisation. Much modern art today doesn't go far enough, in my view, when it comes to reflecting both the 'spiritual' and 'political needs' of our current time. Art in all its forms, if we dig deeply

enough to the depths of our soul, is a device by which we can 'inform' and 'cleanse' our current civilisation. The use of ancient archetypes and symbols in art, can ignite the process of lifting the veil.

In Britain today, we find ancient symbols in use through buildings like the Millennium Dome and the London Eye, both of which sit alongside the River Thames in London. Similar architectural structures can be found in cities all over the world. However, do these symbolic architectural forms really represent the majority? Or do they instead satisfy an elite and their 'symbolic taste' of how the mystery in today's culture should be represented or celebrated? The elite priesthoods since ancient times (who are still operating today through fraternities like Freemasonry), have always commissioned architectural 'domes', 'eyes' (wheels) and 'obelisks'. As we have seen in previous chapters, the brotherhood of elite financiers, royal families and industrialists own most of the great works of art; they also own land on which many of these great works are placed. All art, in its widest sense, should not be for the few (the elite) at the expense of the many. Our art, whether 'symbolic', 'expressive', 'realistic' or 'naive', etc., is our own unique connection with the creative 'primordial forces' that have shaped the universe. It is the 'spirit of the artist' who speaks the universal language of the soul.

Spirit of the Artist

Art in the native sense was much more than going to art school and making credible pictures. Art for our ancestors was about creating abundance, expressing individuality and manifesting beauty in the surrounding world. Much art of the ancient Amerindians, for example, was more of a careful representation of iconography or symbols 'given' to a person during a 'Vision Quest'.[13] Images placed on shields, drums, and within the home, were perceived as 'alive' and coming from the 'world of spirit'. Therefore, native art was more of an apparition coming from 'elsewhere', not from where the people were but from the people's experiences in perpetual exchange with nature and the cosmos.

Art in ancient times, was one of the main tools for bringing both people and communities together, unlike today's feelings of cultural isolation; a pervading feeling still exists whether we have thousands of Facebook friends, or not. People in earlier times, from Ancient Egypt to the Miracle Plays of Medieval Europe, all maintained a personal connection to the 'spirit of the artist', through crafts, rituals, dances and festivals. On one level, these types of festivals were platforms for inspiring, celebrating and uniting people; on another level, they were theatrical performances associated with initiation rites of secret societies.[14] When the spirit of the artist is captured through a community, in any form, that community (or as individuals) instinctively 'knows' that *all* life should be celebrated. Recreational activities like eating out, attending craft fairs, evening classes, cinema, theatre, even the weekend ritual of 'pub-crawling', all comprise part of a 'natural desire' to break free and celebrate the 'spirit of life'. American Chief Seattle said: "All life is sacred to our people"; yet even though we outwardly celebrate life through recre-

ational activities, I would hesitate to say that we in the 'atomic world', have a 'sacramental' attitude towards life. To see all life as sacred, we have to make a giant leap down a 'distant' memory lane, to our innermost consciousness. You might say, we have to get to know the 'weaver within'. Doing so helps us realise what deep ecological science has discovered in recent years: that we are part of a pulsating, amazing 'Web of Life'; therefore, we hold a special place as co-creators in the world. Jamake Highwater rightly points out in *Primal Mind*, art in its native form always reconnects us with the mystery of the 'invisible' made 'manifest' when he writes:

> *This unique image of the Indian (shaman) mind springs from total innermost consciousness of people, and, if we can learn to grasp its message, we have managed to slip past ourselves and the stern sentries of our cultural isolation, and we have been able to peer for a moment into a reflection of ourselves from the other side ... As a friend once said: 'they (Indian artists) open up the real with abstract, giving us a quick look inside before the door slams shut.' In that way the solitary person within each of us, realises for a moment that he or she is not alone.*[15]

I believe art is therapy, no matter what form it takes; a view that seems to have escaped most academic Art School's mode of thinking. A lot of making and teaching of art is a 'fraudulent affair', or a total avoidance of a larger and deeper relationship with the mystery of life. Art, in most cases, is primarily concerned with 'mediocre decoration', 'market forces' and the dogma called 'self-expression'. A dogma to which the majority of artists unthinkingly pay homage, while historians, scholars and aestheticians alike (who have never painted), all stress its dogmatic importance. Art schools seem to forget that artists of every kind naturally seek to establish a 'personal style'; this style is at once an expression of those artists' personality, set of rules and relationship with their environment. It is a unique process unfolding within the artist, usually from childhood and by the time he/she reaches adulthood, personal style can be lost unless it is nurtured. At the same time, we seem to have lost contact with earlier profound functions of art - which have always related to our personal growth and our collective empowerment as communities. I believe the link between the soul, nature and art is an important part of any therapeutic process; so important, it can heal our lives. After all, the same vital force that creates a wondrous sunset, also gives life to the artist who desires to capture the sunset. The communication between a breathtaking landscape and the heart of the beholder, is a language beyond words; it is the ancient language of the spirit. More importantly, it is a language that can heal the soul. The connection between 'nature' and the 'human soul' is expressed by artist Edvard Munch, the 19th Century Norwegian painter whose work (like the Post-Impressionists, Paul Gauguin, Paul Serusier and Emile Bernard) was nearer to the native understanding of art. Munch said:

> *Nature is not only what is visible to the eye – it shows the inner images of the soul– the images on the back side of the eyes.*[16]

In this sense, all art is about exercising our spirit and grace through organic relationships with the earth, while seeking beauty in many forms. In fact, our personal connection with nature and the cosmos, comes through our most powerful tool: the imagination. Blake, who rejected (and was rejected by) the art establishment, once wrote:

> *...to the eyes of the man of Imagination. Nature is imagination itself. As a man is, so he sees.*[17]

To be able to understand the spirit of creation, means in the first place, we must desire to 'create' and 'bring into existence' our innermost feelings. Once these feelings are in place, we can then give them form through personal expression and our imagination. None of this ever happens in isolation as we are constantly interacting with other life-force around us. The artist within us will always mix nature's powerful elements with personal dreams, allowing a sacred space for the birth of those dreams to appear in our (tangible) world.

In this chapter, I have attempted to illustrate the link between art, nature and the human soul. Making art is more of a ritual that opens us up to experience the soul. As well, I would suggest that art is more of a 'psychic tool' than a commercial commodity. Our view of art has been somewhat tainted by history and a linear focus on 'personalities' and 'movements', thereby missing a deeper and more mysterious archetypal history of images (language of symbols). Once we find the desire to create, we become like Grandmother Spider of American Indian myth; we are the manifesters of dreams, the 'light-bringers' and 'weavers' of our personal visions.

Seeing is Believing?

One other aspect of being able to see, transform and heal our lives through art, is that our 'realities can merge'. What do I mean by this? If we take our imagination to be the most non-human part of us, then what other parts of our universe are visible through this great tool? The mental blocks placed on our imagination through years of conditioning (often since childhood), can prevent us from seeing the non-human (alien) parts of ourselves, as well as the worlds of spirit. Children, for example, quite naturally dream-draw characters, 'mummy is a cat', 'daddy is a monkey' and so on; they exercise a natural ability, a way of truly 'seeing' that thrives before any conditioning takes place. Yet, in modern society, parents comfort their children when they awaken from dreams by telling them: "The dream was not real". We seem to have forgotten that a third of our lifetime is spent asleep, which is just as valid a reality as walking to school, eating meals, or even daydreaming. If we are going to denounce dreams, while at the same time telling our children Santa Claus is real, then we are showing our lack of knowledge when it comes to the power of 'myth-making' and dreaming. In native cultures, children were encouraged to relate to their dreams, talk about them and draw, or paint them. However, in today's society we are encouraged to believe that art must

imitate material appearances. Yet, to the artist of many native peoples, dreaming was a device that could open the portals within the imagination. Our intuition, apparitions and the experiences not always of this 'ordinary reality', were considered by native people to have substance that could be made visible through art forms.

There is a wonderful tale of a meeting between Swiss artist and explorer Rudolph Frederich Kurz, and a Sioux Indian 'artist' on the banks of the Missouri River in February 1852, which better explains the native understanding of art. Writing in his journal of 1846-52, Kurz had exchanged drawings with a Sioux who had gone on to challenge the Swiss artist's credibility when it came to drawing human form. After producing several drawings of figures, the native American went on to draw a figure on horseback showing both animal and man in profile. The Indian artist depicted both of the rider's legs in view on one side of the horse. Kurz had tried to 'correct' the error by sketching a profile view of a man on a horse, saying that: "This is how it should be drawn with only one leg visible." The Sioux replied: "But, you see, a man has two legs." To the native (primal) mind, just because something is concealed, does not mean that it does not exist. To understand this way of seeing we need to stop speaking of reality as if it were necessarily ordinary. We need to de-automate consciousness in order to cleanse our perceptions, especially in terms of art and life. In other words, our reality is *everything* we experience both in the dream and the awakened world. How do we know which is the real world anyway? Are we so sure of everything that exists within the realms of the imagination? As Chinese Sage Chuang Tzu (369 -286 BC) once wrote:

> *I do not know whether I was then a man dreaming I was a butterfly, or whether I am now a butterfly dreaming I am a man.*[18]

Once we get into talking about imagination and consciousness 'expressed through' art, it is somehow difficult to ignore what is termed 'esoteric' or 'occult', which is simply the same old 'western' apology for anything extraordinary. What we seem to forget is that everything happening to us, everything we think, what we envision, imagine, conceive, perceive, dream, intuit and create, is *real* and a vital part of *who we are*. Seeing a reflection of ourselves in a mirror, observing a rainbow which seems to stand on earth, asks us to use our bodies as our eyes. To the native artist, the body became an organ of perception and like the various visionary painters of the 20th Century, he/she painted the 'inner life' of everything that was observed. Seeing and visualising in this way prompts us to 'see' the 'treeness' of a tree, or the life force of an animal. In the native sense none of these images are tangible, only visible, just as the world of the imagination conjures virtual images made visible and experimental through art. Similar phenomena can also be seen in what is known as 'symbolic inertia', or how we can see two alternate images in one image. The transparent box (see figure 73) is a perfect example of this double-sided seeing, as is the picture of what looks like a

**Figure 73:
Symbolic Inertia.**
What does your eye see first?

hooked-nose old woman (see figure 73). Look again and you will see a fashionable young woman, also looking to her right. Our eyes will automatically fix on one version of the drawing, and it then becomes extraordinarily difficult to discover the alternative image. The painting of dots

Figure 74: A child's eye view of a butterfly.

Face in a Tree.
Photgraphed in France, it captures what can be seen everywhere in nature. Trees were regarded as people by Celts and American Indians, alike.
Tolkien's Treebeard and the Ents come to mind here.

(see figure 74), is a typical example of how children make imagery and how they 'see' using their imagination. Take a closer look at the image here, *focus on it* and ask yourself what imagery comes to mind? Whatever imagery, object, face or animal you see in the painting is right for you. Visualising and seeing in this way can and does open our visionary sight to the many different dimensions vibrating on different frequencies; all sharing the same space as us NOW. I was told by the young artist that the painting was of a butterfly. How do we know that butterflies, birds and insects don't look like this when viewed from a higher-dimensional viewpoint? We seem to have a natural inbuilt tendency for seeing and believing, without really questioning reality; and from my own experience of making pictures, a natural ability to 'see through' the appearance of everyday reality occurs when we re-focus the mind's eye! People can look like animals, clouds can take the shape of everyday objects; even rocks can seem to have faces. Mainstream science calls this Pareidolia (perceiving a familiar pattern where none exists). But, within the worlds of imagination - *everything* can exist! The feeling of 'being stared at', especially in nature when there is no one around, also relates to this way of

seeing. This type of phenomena (of seeing energy) has been linked to what scientists call the 'morphic field' or 'collective thought fields' linking *all* life forms.[19] And it is the sensation of 'feeling' as though we are being watched, especially in nature, which suggests our minds (imagination) 'stretch beyond the parameters' of the physical five-senses. I have experienced numerous sensations of 'feeling and seeing' hidden thought-forms in nature over the years. Especially when walking in dense forests, trees can become 'silent people', 'watching', waiting and surrounding the finer-senses. Our 'sixth-sense' is another aspect of feeling or sensing energy. Seeing in this way, is symbolic of putting our heads above water and noticing there is another world teeming with life, shapes, colour and sounds; while below the surface of the water, one image of the sea is presented to the immediate five senses. Just like seeing a 3D pictogram jump to life when we 'refocus' our eyes, it is possible to catch a glimpse of the many 'hidden worlds' all playing their part in the one we call reality. Art and the imagination are ancient vehicles for taking us into these 'hidden' worlds. In the next chapter, I will go further into the unseen worlds of the human soul.

Sources:

1) Highwater, Jamake *Primal Mind*. Meridian Books. 1982. p58

2) Tate Gallery; *Cecil Collins*. Tate Books. 1994. p35

3) Highwater, Jamake *Primal Mind*. Meridian Books. 1982. p75

4) Blake,William; *Aurguris of Innocence*. 1803

5) Highwater, Jamake *Primal Mind*. Meridian Books. 1982. p156

6) Ibid, p75

7) Collins, Cecil; *Vision of the Fool*. Tate Gallery Press London. 1989. p77

8) To the North American Indians and other indigenous cultures, medicine meant more than a substance to restore health, but was an energy or vital force inherent in all nature and the cosmos.

9) The term 'to see' or 'look twice' is an ancient way of looking *beyond* this reality.

10) The story of Black Elk is well documented in the book *Black Elk Speaks* as told by John G. Neirhardt. Washington Square Press. Some have claimed the 'Rainbow Tribe' was a symbol for the Global New Age Movement.

11) *Primary Vision Art and Rediscovery of Childhood* (leaflet) Tate Liverpool May-October 2001

12) Blake, William. *Jerusalem, The Emanation of the Giant Albion*. 1804. Plate 4

13) A Vision Quest is a rite of passage practiced by many indigenous peoples. It was done in the form of a fast; finding a sacred place in the wilderness, so that one could contact the spirit helpers

14) Hall, M. P. ; *Masonic Orders Of Fraternity, The Adepts* (part 4),The Philosophical Research Society, Inc. Los Angels, California. 1978. p16

15) Highwater, Jamake *Primal Mind*. Meridian Books. 1982. p88

16) *Songs Of The Earth*. Running Press. 1995 p41

17) Ibid, p39

18) Ibid, p62

19) See work by Rupert Sheldrake, especially his book *The Sense of Being Stared At*. (2003)

Movement of the Soul
Using Our Creative Energy

"A man's work is nothing but this slow trek to rediscover
through the detours of art,
those two or three great and simple images
in whose presence his heart first opened."
Albert Camus

Using art as a tool for unlocking our potential, providing a bridge into 'multi-realities', can be experienced through many archetypal forms. Contemplation of archetypal forms, for example, is one the most important areas within art education; it merits place in any art curriculum; after all, that upon which we contemplate is what we become. The interaction between multi-realities and our soul's different bodies, is an acknowledgement of life being in constant motion (a spiral of energy), which can be tapped into at will. It's also the force behind what we define as inspiration, or our 'higher mind' sending impulses, urging us to create. Primordial energy (our inspiration and how we use it), can open up numerous 'creative pathways' when we start to make art. Being creative shows us how to 'change directions', 'understand messages in nature' and enable us to demystify the world in which we live. No matter how small the change in life, it tends to move us further down the road to self-discovery, which is why in all educational settings, the student should come first, not the 'structure of learning' placed on the learner. All creativity is about the 'mystery of life'; the mystery of being (or soul) should be the first thing we are concerned with when making art. So what are these 'mysterious archetypes' (or (instigators of change) that constitute our soul?

The ancients considered the soul to be multi-dimensional and modern psychology calls it the 'human psyche'. It is a magnificent vehicle, a 'perceiver of everything' within, and around us. It is a vehicle that is neither the originator of thought or the self, but a unique instrument of them both. Since ancient times we have been fascinated by the soul, so much so that Pagan philosophers from Egypt to Greece were persecuted for their persistence in self-discovery; symbolised by the words inscribed at the Oracle of Delphi, *"Know Yourself"*. Greek philosophers like Socrates, Pythagoras, Plato and Anaxagoras, all spoke of 'infinite consciousness' and how our soul operates on different frequencies (dimensions) simultaneously. As spirits wandering in a world of illusionary opposites, 'knowing ourselves' comes through soul movement, towards *Oneness*, into the centre of our being. In metaphysical

Figure 75: The Tree of Life (Soul Tree).
This image came to me through meditation. It represents the 'four forces' (aspects of the soul). The 'tree in the centre' is a common image found in esoteric books and is symbolic of the Tree of Life.

terms, finding our centre can be described as being at one with the all-that-exists. The 'worlds of the soul' have been given different names by psychologists, visionaries and shamans alike, yet the most famous 'interpretation' was attributed to Y'shua (Jesus), who is reputed to have said: "In my Father's house are many mansions" (John 14:2). The different realities or 'mansions' are the multi-dimensional aspects of the soul, described by shamans and visionaries as the upper, middle and lower worlds. In more eastern traditions, the worlds of the soul are connected to the Tree of Life and the Kabalah, mentioned in previous chapters. The roots of the tree are said to connect with the astral realms (underworld); the trunk is our 'physical reality' (or middle world) and the branches reaching into the cosmos are symbolic of the upper worlds reaching into the wider cosmos. The branches and the worlds above, are where the Upper Aeons and Lower Aeons (see *Chapter Four*) reside. The upper world and underworld are 'interchangeable' in many indigenous beliefs; therefore, the dark, star-scattered sky is considered the 'underworld' in certain traditions. For many native cultures, the 'Soul Tree' was symbolic of how the soul manifests itself on different levels of reality (see figure 75). To the Vikings, it was 'Odin's Tree' that revealed the Runic mysteries; the Mayans ritually climbed the 'Kapok' or 'Ceiba Tree'; the followers of Buddha make pilrimages to the Bodhi Tree; the Lakota Sioux honoured the 'Sun Dance Tree', to whom initiates would endure sacrifice to the sun. The Soul Tree is the Tree of Knowledge (life) found in the Garden of Eden; and the Adam and Eve narrative, including the serpent, is symbolic of how humanity was prevented from accessing their 'natural' multi-dimensional state of awareness.

Over the past 200 years, scientists have discovered that all phenomena in our universe can be reduced to 'four forces' of the electromagnetic: strong, weak, nuclear and gravitational. I am not a scientist, yet from what I do understand, the challenge for physicists is to unify these four forces into a 'single force'. What is inevitable, is science and esoteric knowledge (magic) need to 'join forces' for a unification to take place. The human being, nature, the electromagnetic poles of the earth (Gaia's energy centres), are all part of the same forces creating the universe. The different worlds/dimensions are

the same 'source' of what various shamanic cultures and indvidual sages call the Great Spirit, the Creator, or God.

Four Levels of Consciousness

Operating within the universe are a multitude of dimensions which interact similtaneously with four interwoven levels of awareness (worlds). The four realities (or worlds) are described by many shamanic cultures as follows:

*1) The **physical** or conscious reality, operating through our eyes, ears and the five senses.*

*2) The **imagination** or instinctual world of symbols and images, known as the sub-conscious reality; the sixth sense and intuition.*

*3) The **unconscious** the deeper world of bodily functions or automations that keeps our heart beating and controls breathing.*

*4) The Dreamlike state or spirit-self known as the **super conscious** or higher self.*

I do not see the different realities as levels, like a chest of drawers, but as a 'circle' of bodies forming the inner cycles of the soul. The circle in figure 75, could also be described as the 'four senses of the soul'. The four senses consist of our creative, archetypal, formative and material expressions of the soul. In truth, these four senses, worlds or realities, interweave with three directions: above, below and within. The four realities combined with three directions provide us with 'Seven Planes' of inspiration (see figure 76 overleaf). The shaman, artist or medicine person, throughout the ages, has sought communication with the Seven Planes (levels), through art, dance and ritual. The soul's different levels are constantly interacting with each other while forming patterns that reflect our relationship with the earth, cosmos and the energies surrounding us. In simple terms, we can change in psyche from one level of awareness to the next, just like the earth changes the seasons, through observing the movement of our soul in relationship to the forces in nature. The 'ebbing and flowing' forces in nature provide our soul's movement into different levels of awareness, especially when we are conscious, or awake. How we percieve 'reality' through these four levels of awareness will bring learning through different experiences.

Windows of the Soul

Sight is one of the most important of our senses but also the root of deception and our ability to be 'tricked' by illusions. Our eyes are often referred to as the 'windows of the soul' and they are symbolic of the sun's power within our selves. Our eyes are the lenses used to decode 'light' and give us our ability to see the movie called life. From a shamanic point of view, our eyes also represent the shimmering islands of fire; the inner celestial sun burning silently from our perspective here on earth. Enlarged photographs of the

Figure 76: Seven Planes of Inspiration – the Human Eye of the 'Sacred Cinema'.

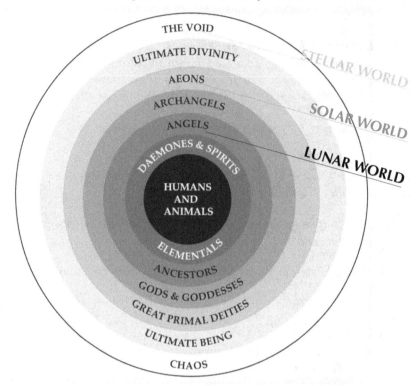

human eye even look plasma-like (or nebula-like), because they are a micro-cosm of the sun and star light. Our eyes are the sun and moon lenses (two eyes) we use to decode reality on earth. If we allow ourselves to cease verbal activity and concentrate on looking into the eyes of someone (or our own through a mirror), we start to 'see' the real self moving through various imaginary worlds, beyond the illusion of the physical world. In fact, the ancients understood that reality 'mirrors back' at us our 'multi-dimensional' personas captured in the human eye (see figure 76)! The Lakota Sioux prac-tised this way of seeing through what they called the 'Great Smoking Mirror' (the illusion); through meditation, it was possible to see oneself in the reflec-tion of others.

The majority of art comes from realms interacting with our subconscious, allowing us to see inside ourselves, forming a bridge into the 'unseen', so we can have communication with other dimensions. The Cubists, through their paintings, showed us a fourth-dimensional viewpoint, while the Surrealists penetrated the subconscious worlds on different levels. Surrealist artists like Salvador Dali, Paul Klee or René Magritte, used poetic wrath, peeling back the rational, rotten structures of a society suffering from devastation caused by war. The images of Dali and Magritte, for example, illustrate vividly the confused and broken levels of consciousness, due to mechanisation of the human spirit through a world at war. On the other hand, artists like Paul Klee

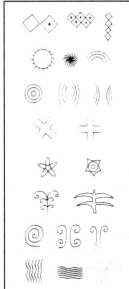

Figure 77: Phosphenes
Examples of the types of imagery found in both native art and nature.

and Wassily Kandinsky, in the early part of the 20th Century, showed us art created by tapping into the subconscious realms. Surrealist art of this kind is not too dissimilar to native imagery and petroglyphs found in cave art. The work of Klee, Kandinsky and Miro, like our native ancestors' art, used numerous circles, lonsenge shapes, 'phosphenes' and what can only be described as a lyrical symbolic language (see figure 77). Klee believed that childhood was a period of uncorrupted creativity; he was one of the first artists to recognize publicly the significance of children's art, and through it, our connection with the soul. The use of phosphenes, which can also be found in flower shapes, honeycombs, spiders' webs and so on, express a higher dimensional language people 'tap into' when in dream-like states. Similar phosphene and geometric shapes can be found in the designs of walls and floors of places like the Palace of Tell el-Amarna in Ancient Egypt. The Surrealists, like earlier Egyptian (shamanic) artists, used this language of the subconscious to full effect in their work.

French artist Odilon Redon (1840-1916), whose work is a precursor of Surrealism, also penetrated our reality with drawings of strange beings, 'spiders', 'eyes' and 'flower shapes'. Redon seemed to dwell permanently in the 'lucid' archetypal world of the subconscious. Pablo Picasso also delved into this symbolic territory. Even though he only touched the surface at times, he was communicating through the movement of his soul. Apart from his usual obsession with his lover (Marie-Thérèse Walter), Picasso utilised imagery of Native African cultures for inspiration. In effect, what we really do when we use our imagination through art, music or dance, to attune automatically to the vast myriad of archetypes already residing within us. These are the non-physical (non-local) aspects of ourselves which exist in each dimension (or mansion); they work directly through the 'four worlds' of the psyche. Sadly, the inability to feel other dimensions within our bodies, and/or the desire to connect with our higher self, is evident by society's scientific preoccupation with the five physical senses only. At this point, science in its true sense (seeking knowledge) and the art I've been describing, are separated in the human mind. Instead of balancing our lives by acknowledging our higher levels of awareness, like 'psychic sight', we choose to limit our experience within the movement of the soul. When we limit our experience to only the 'norm' or 'comfort zones', we deny a sight and a process of communication that 'empowers' the seer, or the artist within us.

Relationship with Energies

If we consider paintings as 'living energy', even if a particular image, say a still life, is executed in a very conscious and realistic way, we can still 'sense' something else in the image, characterised by the 'unique energy' of the artist who painted it. To be able to see this energy we have to look with more than just our physical eyes; we need to 'feel' the image through a language operating on the sub-conscious. In its highest form, this language defines the feelings behind what we see as beautiful or disturbing, but more importantly shows us how we form relationships with everything we feel. Music is 'felt' in the same way, which is why music, like art, can 'move us' into certain emotions. Understanding the process of communicating through our feelings and imagination, is at the heart of getting in touch with nature, earth and the cosmos. Higher feelings of being connected to 'source' emerge when we are alert and intuitive towards colour, shapes and movement in the natural world. I have felt this connection many times especially when something in nature hypnotises me and passes on information 'beyond words'. It could be snow falling, butterflies dancing in the sun, or a star-scattered sky, all these forms reach out to touch the finer senses through the windows of the soul. This process of feeling nature, through our higher (or more subtle bodies) is a science within all art! Connecting with the vast array of archetypes within us (which are also visible in nature) and the knowledge they hold, is symbolic of a constant journey into spirit, a remembrance of what we are doing here and *who we really are!* When we become too wrapped up with the five senses it becomes harder to 'feel' images originating from nature; therefore, we miss out on mysterious forms of communication between different dimensions.

Sometimes we have to be 'silent' to move beyond words, just like eye contact between two people is beyond words, so also is the picture that speaks a thousand words. When I have journeyed and walked in nature for several weeks at a time, this too, encourages a stillness beyond words. The humming of insects in a dense forest, sunlight filtering through columns of pine, returning trees to their true reverence, just as stained glass light filters into cathedrals; all these move us into multi-dimensional awareness. Faces in trees, rocks and clouds all give the same effect to the senses. Nature is a 'living library' that opens our eyes to spirit reminding us of our soul's connection with the Creator.

The following is from an extract of contemplations I wrote while walking the ancient Cathar routes in Southern France. It conveys the movement of the soul and how nature helps us contemplate (to see through our ancient eyes) when we are immersed in *The Journey:*

> *Not thinking of arrival, I undertake a journey that takes me to my heart, pulls me on my way. Like a long trek in the wilderness, to somewhere new, excitement; my first feelings.*

> *Early days are easy with much to discover. The road is here and now, stretching out before me. My mood is up, some roads take me down. The sun sheds its light,*

*days and nights feel uncomfortable. Heavy loads some of us choose to carry.
Slowly, I am immersed in nature, forest gorge, mountain hillside. Every detail
catches my eye. Ants on rocky winding paths become silent friends. Wind in the
trees rustle leaves, whispering of what is to come. Light on a mountain stream
and deep clear lakes, quench my thirst, cleansing my soul. Giving time for true
reflection.*

*After a while the journey becomes familiar, my load easier, destination nearer. The
elements clarify the day. Peace with nature means peace with myself. Animals
remind me of people, faces in the clouds and everything looks similar. Next, obser-
vation of the self occurred. In the silence my body speaks to me. Feeling pain,
tears, sweat cleanses and boundaries are broken. I recognise a priceless vehicle I
own. Contemplation with myself. In the middle of a vast plain with nobody for
miles, I wonder, what excess possessions can do for me right now, in the moment?
Then the moment spurs me on, like a power in the mind, creating an awareness
that I am that journey, moving and evolving.[1]*

Going beyond the physical senses inspires growth of our 'subtle senses';
whether for individual or collective growth (journey), both affect one anoth-
er through the psyche. How we form relationships and understand the dif-
ferent bodies making our 'thinking'/'feeling' us, is paramount to appreciat-
ing the finer and more beautiful aspects of life. In this way, the artist mea-
sures, much like a scientist measures electrons, the information in nature
through invisible vehicles of the soul. But unlike the scientist, the artist with-
in is more concerned with 'wholeness' evident in all life; more than that, I
would say the artist is 'haunted' by the mystery behind this wholeness. For
example, when science says that there are 'x' amounts of particles of energy
constituting the 'matter' of a flower, I can appreciate this, but I cannot form
a relationship with the flower after knowing this. As a creative individual, I
need to be able to 'contemplate' the flower's colour, its fragrance and touch
it within its surroundings (amongst the rest of nature). Quite simply, I need
to contemplate its 'whole being'; then I need to dream before it and let it com-
municate to the imaginary levels, to the subconsciousness realms of the soul.
The process and language I am describing in this chapter is a science too, a
science of the heart and beauty. Once we move through life with all our inter-
nal senses, like the imagination, feelings and dream-states active, we become
conscious of the 'artist within'. Like the physicist, the artist within is just as
accurate at measuring the world of nature and our soul's relationship to it.
When we become aware of deeper levels within ourselves and the feelings
aroused by the energy in nature, then it becomes possible to fly through the
windows of the soul, and journey to our heart; the place where our true infi-
nite potential resides.

Meditation
When we choose to journey into the subconscious, or super-conscious states,
we are going 'within' to obtain different perspectives. Making the mind 'still'

is the most common route towards these 'inner worlds' and the process for doing so is widely known as 'meditation'. In eastern traditions meditation is a very large part of life. In some parts of the world, it has been obscured by religion and parts of the New Age movement, to the point where meditation is seen as a complicated act of worship; or individuals practise it in a way that puts them in a 'spiritual mist'. People often forget 'reality' requires us to be present within it; to create, to inform others and interact with the world. All native cultures realised the need for meditation and it was understood that many paths existed towards these inner worlds. Silence, contemplation and internal stillness in the physical world, allows us to open doorways leading to different dimensions. Approaching our silence is an individual process or prayer, it involves centring ourselves in our own space. Relaxing the body, taking deep, rhythmic breaths to extract more life force (or 'chi' as it is called in China), is so important if we want to invigorate the body and soul.

All art can be seen as a prayer or a meditation, much more than most vulgar notions handed down to us through the religious texts of the world. Instead, art as a 'personal prayer', is a fresh, vital discovery of one's own special presence in the world. When Russian artist, Marc Chagal, was asked if he attended synagogue, he answered: 'My work is my prayer!' I see my art as my prayer, too. Prayer and meditation is a way of merely sitting quietly before I embark on the next stage of my journey. For example, when I draw or paint, I like to 'approach' the silence within because 'stillness' invokes a connection with the world of archetypes and the subconscious. Painting and drawing in this sense is a 'ritual', which is more concerned with the 'flow of energy', rather than the 'making of form'. Meditation of this kind is like going for a walk, so as to flow with the energies, especially if one is submerged in nature. Numerous images can come to us once the mind is in a state of silence to the point where our internal chatter subsides and the inner tutor is allowed to express itself.

The essential and important part of meditation which relates to beauty and the language of the heart - is the 'art' of contemplation. This is a 'gift' every human soul has, yet many refuse to recognise, or use this gift. When we live life just focusing only on the physical senses to a point where we believe nothing else exists, we create a world that denies the imagination and therefore our power of contemplation. If we wish to meditate, or as many phrase it 'enlighten ourselves', then we have to consider a change in perception. How do we change our perceptions? We have to connect with our inner-tutor (the source) through our meditations, while contemplating our world (the earth) through very different eyes. The philosophy found in the *Wingmaker Time Capsule*, also addresses the need to see beyond the physical senses in order to contact our inner source. It reads:

> *These insights require a new sensory system beyond the five senses that rule the human world in your time. These new senses are the outgrowth of the source code activation, and represent the first stage of transformation.*[2]

Our perception of reality is basically our power to think (or not think at all in many cases), and view the world only through our five senses. This is necessary on one level, but the inner and outer worlds of the soul also need nurturing in order to bring forth our 'visions'. When we view the world based totally on external influences and manipulative opinions of others, we deny our own unique imaginary power of 'seeing'. Denying our imagination creates a lack of inner contemplation, leading to apathy and a merely 'one dimensional' perception of the world around us. William Blake expressed this one dimensional view in a letter to the reverend John Trusler in 1789-90. Blake wrote:

> *...And I know that this world is a world of imagination and vision. I see every-thing I paint in this world, but everybody does not see alike. To the eyes of a miser a Guinea is more beautiful than the sun, and a bag worn with the use of money has more beautiful proportions than a vine filled with grapes. The tree which moves some to tears of joy is in the eyes of others only a green thing that stands in the way.*[3]

There are two exercises I have used to nurture this type of 'seeing' through my own work: one I call *Meditation Through Drawing and Painting* and the other is *Painting to Music*. Both exercises can be used in a workshop environment, enabling us to experience the spontaneity of creativity while accessing our extra-sensory sight. Both exercises have spontaneous approaches to creativity, which break down any barriers or preconceived ideas we may have regarding art or image-making. When we are spontaneous with our art, then we are more likely to be inspired rather than forcing imagery through intellectualising what we 'think' we should create. More importantly, when we allow the free flow of energy to come through our art, we are connecting with higher levels of consciousness.

Meditation through Drawing and Painting

Meditation through painting is an exercise which allows imagery to create itself, through encouraging our imagination to lead us somewhere in the process. In this mode, we are not concerned with how the image will look or whether it is rendered in any acceptable way. Instead the exercise is more to do with putting us in touch with our inner child and the creator within. As Picasso once said: "All children are artists they just forget when they grow up". His statement is so true and easily observed, especially when working with young adults within art school settings. Ideas are often forced and the natural ability to create imagery inspired by the 'original archetypes' can be stifled by the time a person has gone through the school system. Yet if one puts a blank piece of paper in front of a small child there are no barriers, no preconceived ideas, no fears of how the image should look; instead, just a natural interaction with the imagination occurs.

I have also noticed that when budding young artists are given analytical drawing tasks, such as using perspective to draw a building for example,

quite often the observer naturally draws the object, not from where they are sitting, but from many other points of view. I believe this is a natural skill that needs nurturing, not correcting. By using drawing, doodling and painting as a form of meditation, we automatically forge links with streams of creative energy, all of which reside within us. The key to remember with this type of exercise is not to have anything in mind when commencing your image; instead, just allow a natural flow of hand to paper and become the observer, watching what imagery unfolds.

Drawing & Painting to Music

Another similar exercise to the one above is what I call 'Painting to Music'. It is a type of meditation combining the notion that art and music spring from the same *'mysterious'* source. Working in this way is not a radical idea and can be found in much 20th Century art, not least through the work of Klee, Kandinsky and Miro. With this exercise, music becomes the focal point and the lyrical imagery it inspires usually comes from 'feeling the sounds', rather than just listening to them. I see this type of image making as a multidimensional experience which automatically inspires the invisible, subconscious parts of our psyche. Like 'dream drawing' used in many art therapy workshops, this form of meditation, through art forms, can tell us much more about our inner-worlds and the energies with which we interact. The spiral image (see figure 78) was created through using the Painting-to-Music exercise. The drawing in figure 79, is a presence I have felt around me since I was very young. The drawing came through listening to music and allowing the pencil to flow, drawing what I could 'see' with the inner eye. When we go into a meditative state it becomes easier to see these personas, spirits or energies existing beyond the five-sense 'physical' dimension.

Figure 78: Red Spiral.
What is often called 'psychic art' can also be produced through meditative states of being.

When we meditate through our art, I believe we are experiencing and often seeing our multidimensional aspects. Some would say we are seeing our 'past lives'. Allowing time to meditate and get in touch with the invisible parts of ourselves (through art), can help us to access our spirit. When we are in a subconscious state (or dream-like state) we have inspired

Figure 79: Egleefan.
A spirit guide I felt since child-hood.

thoughts; we see things we would not normally see on a physical level. This readjustment of the eyes, in a fleeting moment, can send us inward to the core of our being as we spiral through different levels of consciousness.

The artist Cecil Collins described his personal meditations as *'Hymns of Life'* (1939-55), and talked of the need for more poetic imagination and internal nourishment. The following piece is is excerpted from some of Collins' notes (meditations) and describes the feelings generated though contemplation:

> *It is inexpressible. Today in the sun, I feel such an aristocrat of the spirit. The light in the curtains, the summer light, distant and all around, and the sounds, soft, piercing; the thick foliage, the voices. A gentle wind stirs the curtains with implication of far off happiness, the threads and clues of a mysterious sacrament; and I know how deep within, the wide sea breaks in foam and waves; and I know that the bread of life is ready.[4]*

Contemplating our connection with nature (from the earth to the stars), leads to an understanding that we are multi-dimensional creatures. In Native Earth cultures, knowledge and learning about ourselves came from many animal teachers, the elements, the earth and the cosmos. In this sense, our perceptions are always changing due to the cycles in nature and the different qualities they carry. Going within, or ceasing activity physically, was regarded as an attribute of the energies associated with winter for many indigenous tribes. Nature and art are inseparable to native people; when combined they can be used as a tool for observing internal cycles (the subconscious worlds) linking the human soul with nature. Many native cultures give this combination of 'art and nature', or 'soul and earth spirit' a name. It is called 'Earth Medicine', or the 'Medicine Wheel'.[5] Knowledge of cycles and learning what is known as Earth Medicine, is very relevant to how we see, create reality, express our personality, dream our dreams and relate to each other. In the next chapter, I will outline a 'living knowledge', and an ancient symbol used to gain spiritual understanding.

Sources:

1) Neil Hague; *Notes & Poems* written while walking the Cathar Sentiner in Languedoc Roussillon. France ©1996

2) www.wingmakers.com/philosophy (1999)

3) Ackroyd, Peter; *Blake*. Minerva. 1996. p217

4) Collins, Cecil; *Hymns of Life*. (taken from *The Vision of the Fool*). Golonooza Press. 1994. p35

5) Earth Medicine is derived from hidden teachings of Native Americans and European Celtic traditions that show a system of self-discovery passed on orally through shamans and elders.

The Circle Within
Contemplating Nature's Time

"When a man does a piece of work which
is admired by all
we say that it is wonderful;
but when we see the changes of the day and night,
the sun, the moon, and the stars in the sky,
and the changing seasons upon the earth,
with their ripening fruits,
anyone must realise that it is the work of
someone more powerful than man."
Chased-by-Bears (1843-1915) Santee Sioux

Expanding the mind and connecting with our 'spirit self' is autonomous with developing the imagination and our visionary powers of seeing. More so, I believe this process cannot happen without a connection to the Earth through art forms and creative expressions of every kind. In this way it is necessary to look at our 'finer bodies' that as a whole make up what I term the 'circle within'. These bodies can also be divided into four aspects, or what many visionaries have termed the 'four eternal senses of humanity'. When we consider ancient symbols and knowledge like the circle, they tend to have a common theme across many cultures. The number four constitutes the basic cardinal points and power of a circle and this relates to the four seasons, directions, elements, ages of the zodiac and primary races here on Earth. The powers of the circle and the ancient knowledge contained within it, charts four bodies that make up an individual cyclical system. This inner system sets out to explain how the soul puts on a garment (a physical body) in order to experience the physical world. According to our position on the circle (or wheel of life), we connect with the Earth's natural cycles, which offer experiences for spiritual development. Seeing in this ancient way helps us to understand the multidimensional aspects of ourselves, and through them, our connection with the larger cycles in nature. Observation of our life cycles also gives us a wider view of how we create patterns, including both disorder and harmony, within our lives. The four different bodies (that constitute who we are) have been described by many visionaries, in the following manner:

The **spiritual body/creative world** *concerned with imagination and intuition.*
The **astral body/archetypal world** *concerned with emotions and feelings.*
The **physical body/formative world** *concerned with structure and sensations.*
The **mental body/material world** *concerned with thoughts and reason.*

It is said that these different bodies are positioned on the circle according to the particular direction it characterises. Each compass direction (north, south, east, west) represents a knowledge that is unique and carries an understanding of how we interact with the cycles in nature (see figure 80 overleaf). On a higher level, observing the circle within can show us how to read the future, while giving us a grounding of what we need to experience in the present. The 'Circle Within' was considered an ancient device that manifested through every aspect of our life on earth, through the 'four bodies' of the soul. A Native American teacher, Wa'na'nee'che otherwise known as Dennis Renault, with whom I had the privilege of meeting several times, described the circle within as the *Old Way*. He said:

> *The Spirit of the Thunderbird flies to all four corners of the Earth and brings the people back to the natural way of life, not through religion or a Native American way, but the 'Old Way', that once belonged to all humans.*[1]

This *Old Way* does not mean that we revert to living in tents, it relates to the need to 'see beyond' the material illusions that blight our lives, while harnessing the collective power of the circle.

Medicine Wheels and Earth Circles

Medicine Wheel knowledge was used In the ancient world, especially by Native Americans and Celtic tribes, to focus on the stars; directing energies from the stars to the Earth. Physical evidence of this understanding can be seen in hundreds of standing stones and Earth mounds. One example is the Big Horn Medicine Wheel in Wyoming, USA. Like many creations in the ancient world, these stone circles, earth mounds and pyramid constructions, all harness energies that speak the language of the relationship between the Earth and the Stars.

The *circle* (wheel) can be found in so many Native or First People's attempt to interact with a deeper knowledge of the Cosmos as a whole. Most ancient communities were built on circular models as a symbol of unity. The Majorville Medicine Wheel located south of Bassano, Alberta (dated at 3200 BC), is a good example of the use of the circle archetype. Other circles can be witnessed in megalithic structures all over the world, not least places like Stonehenge, Avebury and Tara in the UK. The stone circles are often placed on powerful energetic sites that connect to 'arteries of light' or ley lines, and this is why our ancestors chose the circle, or spiral, as it anchors and harnesses 'star light'. Places like Avebury have been 'broken' energetically to a certain extent; yet in terms of the circle being broken (courtesy of roads now cutting into the place), the power (the light) is still active and 'awake' in the land in those areas.

The Big Horn Medicine Wheel in Wyoming is ninety feet in diameter, with a central rock of twelve feet across, from which radiate twenty eight spokes of smaller stones. Like many other stone circles and earth mounds, this one

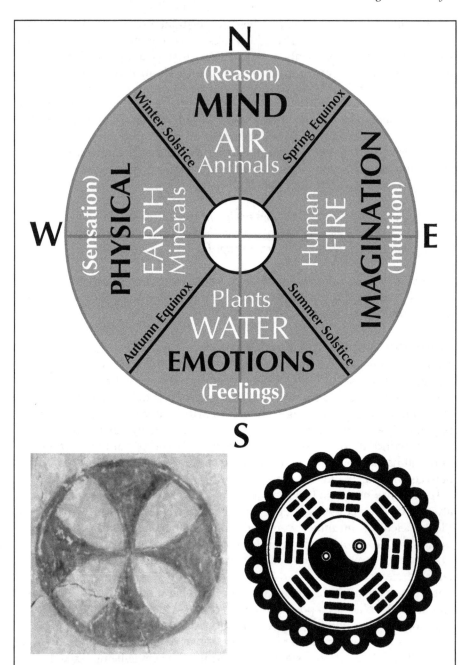

Figure 80: Medicine Wheel Knowledge
Universal 'Four directions' found in numerous ancient cultures.
Top: A Native American Medicine Wheel with Four Directions. *Left:* The Maltese Cross is another symbol of the 'Cross of Orion'. *Right:* Pah-Kah, a Chinese symbol for the power of manifestation.
Courtesy of Dover Pictorial Archives Series *Symbols, Signs & Signets*. Ernst Lehner

aligns with the Summer Solstice sun as it dawns and sets. Many ancient monuments align with star constellations and in the case of this Medicine Wheel, it aligns with Taurus, Orion and Sirius. As well as honouring the stars the Wheels also focused on earth's natural cycles of time, such as birth and death, night and day, Summer and Winter, all of which connect to the Four Directions (East, West, North and South). Cycles of birth and death are an important aspect of all people's cultures, and the celebration of time was part of a cycle of natural changes, honoured through diverse ceremonies and festivities. The Christian hierarchy, namely the Jesuit Order, also personified this knowledge as four females, often titled the *Four Parts of the World* in much religious art and literature.

The Medicine Wheel takes many different forms. It can be an artwork such as an artifact or painting, or it can be a physical construction on the land. Hundreds or even thousands of Medicine Wheels have been built on Native lands in North America over the centuries, whether rock formations or Navajo sand paintings, or petroglyphs, they all relay the same use of a simple knowledge: that we always return to the 'centre', to the Circle Within.

The Four Corners of the Soul

A Celtic sage and later Christian saint known as John Eriugena (820-870 AD), viewed nature on the basis of four aspects of creativity in his book *Periphyseon*, in Greek meaning: "About Nature". In his work, Eriugena represents a creation-based cosmology with an holistic view of nature and humanities place in it. You could say he was a bit of a heretic for the time in which he lived. Eriugena's four divisions of nature shows the Celtic cross as the continious 'cycle' of nature. The first cycle for Eriugena was the uncreated creator (Alpha), or the first cause of everything. Its opposite on the Celtic cross was the end of the creative process (Omega). To the Celtic mind, it was the mode of giamos and samos; the dark and light, yin and yang, winter and summer, goddess-and-god-principle, contrasting the year and creating the divisions of nature. Simply put, the 'outward expression' would go 'inward' at a certain time of the year and inward expression would 'reveal itself' outwardly at the opposite end of the year. For sages like Eriugena, nature and supernature were not separate, but part of a cycle of creativity manifesting itself in the workings of the natural world.

The four transitional points on the circle or wheel are also highlighted by Earth, Sun, Moon and Fire Ceremonies performed by the ancients. Certain gods were said to represent the polarity of change as the earth travelled through the year, and as I have already mentioned in *Chapter Three*, the Celts called these two mythological characters Cernunnos and Maponos – the old man and the divine boy. Cernunnos was represented as having antlers by the shamanic clans that paid homage to him. He was the God of Winter (Orion) and his antlers were shown to be long or short, depending on which half of the year he was travelling through. Maponos, the divine boy, was the God of Summer who, according to Celtic tradition, would suffer death to be reborn.

His story is of a classic Pagan scenario illustrating the opposing forces used in many later religious beliefs, like Christianity. The journey of Maponos illustrates the passage of time in relation to the sun's light on earth. Maponos would decrease in power as he entered giamos, only to be born at the winter solstice, stolen away, and resurrected in spring. The transitional points on the Earth, when these two deities are transformed, are said to be Samhain (Hallowe'en) and Beltaine (Mayday). These points are when major fertility and thanksgiving rituals are performed to celebrate the energy shift on the earth.

Through the four corners of the soul we, too, have our personal giamos and samos modes moving within us; we instinctively respond to these natural cycles on earth if we are open to the energies that surround us. We are also manipulated at these points of transition by forces that want us to become addicted to ceremonies that negate the true understanding of these energies. Christmas, or what was once called Yule, for example, is such a massive guilt-producing, money-making machine, that we have lost complete understanding of the energies passing within us at this time. We have been 'sold' the Wonderland, the Promised Land, Xanadu, Disney Land, Santa Claus and Christmas Day for so long, that we just play our part in one vast pantomime, hardly questioning the conditioning that takes place through rituals at these transitional points. Festivals and the celebration of 'time' are an important part of our world, especially for our children, but once they become a ritual that creates pressure, guilt, addictions and other emotional tensions, then we are allowing our personal energy to be depleted. The energies moving through the four corners of our soul at these transitional points, like the summer and winter solstice, can help us to connect with the cycles in nature. How can this be?

The Medicine Wheel described earlier, was an ancient device like the zodiac, which provided meanings and symbols for individuals to integrate within their lives. The important part is that all of these feelings, cycles and interactions with the Earth through vehicles like Medicine Wheel, have to be a personal experience. If the process becomes group-orientated then it could be detrimental to the growth of everyone involved. Many teachings have emerged of various versions of the Medicine Wheel; however, there seem to be some common themes that run through them all. The directions of the wheel can offer an understanding of how we move through life, expressing emotions, becoming more introvert or extrovert. So for example, the directions, North, South, East and West embody the Four Elements which combine to make Air, Water, Fire and Earth, and the Four human Races of Red, Yellow, Black and White. All these in turn are said to affect the Four Bodies of Spiritual, Mental, Emotional and Physical, within the human being, which are continually expressed through the Four Ages of a Life: Childhood, Youth, Maturity and Old Age. According to Native American and Celtic teachings, the North of the Wheel (circle) is where the mental body resides: in the East is spirit, South is astral and West is the physical realm relating to death. All four bodies are said to relate to a particular element, animal totem, plants,

mineral and expressions that help formulate that body. For example: the North is said to be where the mental body resides and this is likened to the element of air, which in turn connects with wind (movement) because the ancients observed how the strongest and coldest winds came from the North. North on the circle was also the place of Winter, death and rebirth, symbolised by the giamos cycle and depicted through the colours of white or black. At the opposite side of the Wheel, Summer was considered a time of outward expression when the earth expressesd herself in full bloom. South on the wheel is also a time for nourishing and preserving energy, especially sunlight when samos begins to

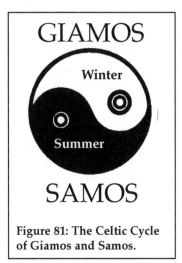

Figure 81: The Celtic Cycle of Giamos and Samos.

yield towards *giamos*, the old man of winter (see figure 81). The colour that symbolises Summer, within many traditions, is red and in many native iconographies, as well as religious art, red and black are continuously used on one level to symbolise opposing forces in nature.

In more secretive circles, red is symbolic of the connection between the stars (especially Sirius) and the earth. Red was also considered a colour of childhood and raw energy and the same emotions can be seen within ourselves, when we become more expressive, choosing to go outside and enjoying the fruits of longer, Summer days. As we move into autumn and towards Samhain (Hallowe'en), our focus naturally turns to concentrating on gathering resources on all levels of our soul. The autumn equinox or Samhain, was considered the beginning of our inward reflection (the Celtic New Year), when the invisible became manifest on the physical (surface) more easily. Hence the festivities that relate to Hallowe'en and invisible forces typified through ghosts, spirits and 'otherworldly' entities. In many Celtic and Native American traditions this point in the year was the beginning of a brand new cycle, a time when the Earth and ourselves would turn to other worlds or our inner worlds for inspiration and direction. Through archetypes (gods and goddesses), like Maponos (Mabon) the great son of the great mother, the ancients would seek direction with one of earth's many natural cycles in relation to the sun and the moon. Eventually, these natural sequences and the forces that became archetypal figures were personified for religious purposes. The Circle Within placed the human being at its centre, surrounded by power (the Earth) and magic (the Stars).

The Elements, Cosmology and Creation
The four cardinal points, representing the seasons of the earth, also relate to the four main elements in what is known as the ancient science and art of Alchemy. Again, this relates to the 'circle within' each human and is supposed to be concerned with the transformation of base man/woman/metal

into pure spirit or gold. The Greek scientist, Aristotle, said that the basis for the physical world was what he called *prime matter* (cosmic fire), this he said was a non-physical energy which one could neither see nor touch. Aristotle believed that prime matter could manifest itself as a physical form through the four elements: fire, water, earth and air. Even though the elements are different from each other he said they were connected by a common bond of dryness or moisture, heat or cold. Our personal alchemy can be understood through our different states of being which are also connected to the elements and bodies already mentioned. The idea is that one element can be transformed into another through the bond it has in common with others. So, for example, fire can become air through the bond of dry heat. Aristotle said that if one can transform the elements into each other, one must be able to transform the substance from which each element is made. Therefore, this substance or 'cosmic fire', to the alchemist, was connected directly to the different bodies and energies comprising each aspect of the Circle Within.

The four directions of the circle within also relate to the four temperaments or main personality types, which psychologists refer to as: choleric, sanguine, phlegmatic and melancholic.[2] In a more recent work, the writer Jackie Creland connects this knowledge with the four types of person in work and life; she calls them: the Accommodator, the Optimist, the Producer and the Data Collector. The four elements and directions also relate to the suits of the Tarot (playing cards); all of these bodies are aspects (our eternal senses) which constitute our whole being. Only through dynamic balance of what Blake called the 'four mighty ones', 'The *Four Zoas*', can human consciousness complete a spiral of development from one life cycle of perception to the next. In his epic poem *Milton*, Blake wrote:

> *Four Universes round the Mundane Egg remain chaotic,*
> *One to the North, named Urthona: One to the South, named Urizen*
> *One to the East named Luvah: One to the West, named Tharmus*
> *They are the four Zoa's that stood around the Throne Divine...*[3]

Like many alchemists and visionaries before him, Blake was tapping into the archetypal realms while illustrating the four cardinal aspects of the human psyche. The egg shape in his image, *The Four Zoa's* (see figure 82), symbolises the human psyche (or the soul) in its conditioned state. The outer circles relate to the four bodies (aspects) of man that formulate the soul. The 15th Century mystic, scholar and physician, Paracelsus (who inspired Blake), also wrote of the circle within. He said:

> *So it is a great truth, which you should seriously consider, that there is nothing in heaven or upon the earth which does not also exist in man,.... man is a sun and a moon and a heaven filled with stars: The world is a man and the light of the sun and the stars is his body.... The human body is vapour (energy) materialised by sunshine mixed with the life of the stars. Four elements are in the world and man consists of all four, and which exists visibly in man exists invisibly in the ever*

pervading world.[4]

All places or bodies on the Wheel of Life, like our imagination, feelings, senses and thoughts, have to be experienced in harmony with the natural world. When we break the conditioning (symbolic of the egg) it becomes possible to realise how enlightenment is our natural state of being. Enlightenment already exists through the finer bodies that formulate who we are in this life. If acknowledged through creativity, these bodies can connect us directly with the more subtle energies of the Earth and the cosmos. Each body also provides a direct connection with the magnetic fields of the Earth and therefore a balance is gained through the ability to ebb and flow through these four points, while the earth moves through its solar-oriented journey. Blake's *Four Zoas* image is a symbolic rendition of the swirling forms that come together to create the illusory three-dimensional world, whether in human form or the larger cosmos.

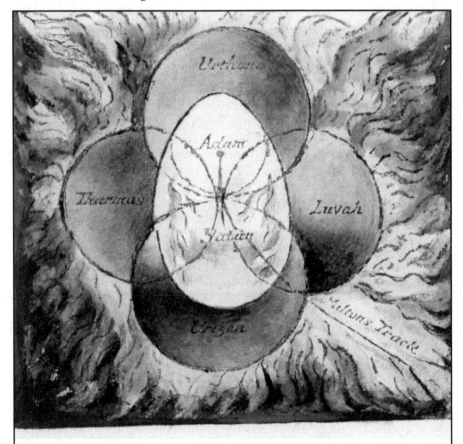

Figure 82: The Four Zoas.
A section of an illustration from *Milton* by William Blake.
Plate 32 © British Museum. Courtesy of the Trustees of the British Museum, London.

The other important aspect of Blake's image is that he is depicting the 'fire of creation', the plasma and celestial light engulfing the egg. Adam of course, is the first hu-man (or light-man) who is another symbol for 'primordial man'; who, like the universe, was born from an egg. The story of a primordial man is ubiquitous across many ancient civilizations and cultures. The cosmic egg, born from 'primordial waters', in some myths, splits into two halves to give birth to Heaven and Earth (symbolised as Adam and Satan in Blake's image), or as the Hindu Brahmânda, or the 'two Dioscuri' in Greco-Indian myths. In Hindu mythology, Brahma – the omniscient, the source of all that exists, forms out of the golden embryo and egg. According to Hindu belief, Brahma was the self-born 'uncreated creator', the first manifestation of the One's existence. As the embryo from which the universe originates, he is also called Hiranya Garbha (golden embryo), the ball of fire. Other names for the 'egg god' were Pitamaha (the patriarch); Vidhi (the ordinator); Lokesha (the master of the universe) and Viswakarma (the architect of the world). The 'architect' of course connects to Gnostic creation myth, Freemasonry and the imposter creator, the Demiurge as described in *Chapter Four*.

The Primordial 'Easter Egg' of fire

The Druids saw the egg as a sacred emblem of their initiation rites, hence the importance of the egg in Spring (at Easter). The procession of the Goddess of Agriculture, Ceres, in Rome, was preceded by an egg; it was often depicted entwined by a serpent or crowned by a crescent moon. The egg also signifies the polarization of the Hermaphrodite in some instances and was a symbol for the 'beginning of life'. For the ancient Egyptians, 'life emerged' by the action of the 'Demiurge' through the 'Nun' (the personification of the 'primordial ocean') that 'gave birth' to the egg. Chinese legend tells how an enormous 'black egg' was formed in the darkness at the beginning of time. Inside this egg, the sleeping giant Pan Gu was formed. Likewise, Hanuman, the monkey king, was said to be born of primal chaos, hatching from a 'stone egg' impregnated by the sky. The Gnostics also talk of heaven and earth, symbolised by the 'world egg', in the womb of the universe. Not a crucifixion or bunny in sight folks; just a human (light-being) born of the cosmos.

In terms of symmetry, astronomy and sacred geometry, the egg has been used by alchemists to depict the 'cycles *within* cycles' and the 'relationship' between the earth, moon and the solar system. The elite Elizabethan occult magician, Dr John Dee, likened the origin of the planets to the metamorphosis of an egg made up of the four elements (the Zoas), from which a scarab beetle carries the egg along a spiral path. Dee referred to the egg white as the work of the Moon (Saturn) and the yoke, the Sun (Jupiter). In the mysteries of Bacchus in ancient Greece the egg was a consecrated emblem symbolising the 'soul' and this symbolism was portrayed in the film *Angel Heart* (1987), when Louis Cyphre (Lucifer), played by Robert De Niro slowly peels an egg and eats it as a symbol of the 'consumption of the soul'.

The Gnostic Circle Within

The Gnostics saw the Circle Within as the nature of the *Divine* and the 'divine spark' within humanity. The sixteen naked figures encircling the central fire becoming the Circle Within, is a symbol for attaining Gnosis. Nakedness in this piece relates to re-birth (being born again) through Gnosis (see figure 83). The Gnostic approach to the circle sees what they called the creator as androgynous, and "all-containing" or sometimes "the uncontained." It was also referred to as the Monad, or the First Aeon, often depicted as a circle. The Christian mystic Hildegard von Bingen, like the earlier Gnostics, knew that the power of creation was contained within the circle as she depicted in her visionary works called *Scivias* (see figure 84).

Figure 83: The 'Uncontained'.
The First Aeon (Uncontained) depicted as a circle of sixteen figures. The fire at the centre of the circle is a salamander, appearing through the 'primordial spark', or the Monad (see page 182).

The Gnostic use of sixteen figures (numbers) to create a Divine Spark is obvious mathematically as it relates to the 'four times four' markers on the Wheel of life. Two figures of 8 (16) also gives the double infinity symbol, giving us the idea of limitless possibilities; a beautiful and empowering reminder of eternal measure. The numbers One and Six also add up to Seven, relating to the Heavenly Spheres I mentioned in the previous chapter. Double-Infinity also symbolises the idea of combining two everlasting infinities to create equal 'unlimited possibilities'. Interestingly, the 16th card of the Tarot, the Tower,

Figure 84: The First Aeon.
A later version of the Gnostic Monad. The *Scivias* symbolism was meant to be a represenations of the 'Tree of Knowledge', the 'Circle Within' and the 'Human eye'.

asks us to 'reflect' on what happens when we hide from the truth (our truth) and refuse to confront the façade we often call daily life. Just as we become increasingly aware of how much we are betraying our true selves, symbolically we start to welcome the 'bolt of lightning' on the tarot card which destroys the façade. The 'calling of the circle', or use of a Circle Within in a ceremonial sense, can break down personal illusions for those who participate in its power. It can also change our 'perception' and the way we 'see'.

The Eye and Egg

Six hundred years before the likes of Paracelsus, the aforementioned Eriugena, also placed the 'Cosmic Sun' in a central position within the cosmology of man. The eye was considered an image of the world by the alchemists, and the colours, which relate to the solar spectrum, were arranged in circles by alchemical artists. For Blake, the eye and optics represented the illusion of the physical world which he described as a black pebble surrounded by a raging sea (*Milton*, 1804). The egg shape and the eye were both connected to the shape of the heavens for astronomer and mathematician, Dr. John Dee (1527-1608). Dee, like Paracelsus, thought of the sky as a shell that separates the physical world from God. Scientists today also recognise how the solar system has an egg-shape plasma which is constantly expanding due to the increase in photonic light. The eye and egg are both symbols for the 'theft of the soul', or the visionary limits of 'perception' placed on humanity by the Demiurge. All over the ancient world, from China to Babylon, the egg was also painted and venerated as symbol of 're-birth' and the 'soul'. The soul of humanity 'captured', 'bound' or 'eaten' is a common theme through the use of the symbol of the egg.

Hieronymus Bosch's painting *'Concert inside an Egg'* depicts his knowledge of alchemy, the Philosophical Egg and the 'light that can be seen with the ears'. The 'light' is the electromagnetic light (waveforms) the brain translates into pictures and sounds, hence the light that can be 'seen with the ears'. Bosch also includes humans that are 'entering into' an egg in his masterpiece *Garden of Earthly Delights*, painted during the 15th Century. The strange creatures and imagery contained within the scene are reminiscent of reptilians/greys and naked humans (Adam and Eve prototype) being born in reverse, or being 'encased' in the egg through the limitation of their DNA. The egg is also a symbol for the moon and its control over our biological bodies.

Travelling the Path: Finding our Natural Rhythm

The tree or circle symbolism provides three other directions which are above (branches), below (roots) and within (our centre). How we find our own natural rhythm relates to how we interact with the different directions on what has also been termed the 'Psychic Compass', or the Mandala in eastern traditions. On another level, the tree, through its branches, shows us how the decisions we make in this world reach out to affect the many invisible worlds

all around us. The stillness and strength trees 'show' us is a prerequisite for the peace that we as humans have the potential to obtain.

In Chinese medicine, for example, the element of wood was considered an archetype of the pioneer. Symbolised by the tree reaching upwards, driven by discovery, expanding through movement and vision. When all our bodies are activated, through what we experience in life while moving around the *wheel*, we often start to realise that whatever is travelling within us can be seen as a reflection somewhere in the outer world. So, for example, if we wish to expand our awareness and our understanding of ourselves, the power for new vision is represented by the East on the Native American Medicine Wheel. The element linked with the East was said to be fire, and to ancient peoples this symbolised expansion and illumination, brought about through the imagination of ourselves. The East is also symbolic of the new day, or dawn, bringing the rising sun, one of the most powerful symbols used by the mystery schools for realising new vision. The rising sun symbol also relates to the scarab beetle, revered by the Egyptians for its transforming powers as a creator. The Egyptian mystery school initiates were called 'scarabs', as these insects apparently push along their eggs, containing their own regeneration. It is worth noting that if you were to look at the shell of a beetle from an aerial view, it looks remarkably similar to the top of the human skull: symbolic of the mind, the place where our subtle bodies, such as our emotions and imagination, interact on the circle I have been describing (see figure 85).

Travelling our own path around the *Wheel of Life* begins when we recognise we have a right to know our own natural life-force, our unique energy. It is also recognition of wanting to be at peace with our own sexual energies, the physical manifestations of our creative life-force. Many problems occur in our lives connected to this 'sacred energy' and more often than not, we are encouraged to feel incredibly guilty about our creative life-force. Religion has brainwashed thousands upon thousands of people to regard sex as a 'sinful activity', that should only be done to reproduce. Encompassed in denial, deprivation and prevention of the natural sexual energies, resulting sexual frustration, especially in priests, can lead to committing the most egregious of atrocities. When sexual energy is blocked, either through mental or emotional problems (often stemming from childhood), then it becomes difficult to experience the multitude of forces that abound in nature. Finding our own rhythm means that we also need to be aware of our body's natural ability to ebb and flow throughout the course of a day. This awareness has been called our 'hour of power,' or our individual connection with natural energies. We each possess our own 'rhythm' which can be tapped

Figure 85: The Scarab and Human Skull.

into, and this rhythm tells us what parts of the day are most beneficial for doing creative work. This connection has nothing to do with a mechanical clock, or time of birth, it is instead our unique relationship with the cycles of the earth and the energies occurring through day and night; sun and moon. To be able to find our own 'hour of power', we need to realise our connection with the earth and nature's natural rhythms which speak to us on unseen levels. Studying our personal energy levels at certain times of the day helps us to find our natural rhythm. As a meditative exercise we can start to do this by travelling around the circle within, focusing on what happens to our different bodies at specific points on the wheel. If we use the different directions, North would be the Winter of our world, or the silence of night. The East is our Spring or dawn. The South is our Summer and the heat of midday; West is our Autumn, or evening. Our energy levels will be stronger at certain points on the wheel, and this personal connection with the Earth at this time is usually when we engage in our most inspired creative work.

In Chinese medicine, the human body is considered a garden and also a microcosm of nature. The seasons, cycles of change that exist in the garden, can also be observed in the life-path of a human being. Where Western medical science dissects life into separate fixed parts, ancient systems consider lives dynamic, constantly-shifting phases in relation to our environment. When we are disconnected from our personal rhythms, through emotional or physical changes to our body, then we can lose this internal timing. However, we are constantly evolving; therfore our internal timing will also adapt to any new growth or change within our lives. If these ancient systems of the circle within and that 'hour of power' are felt and understood individually, there is a potential to elevate our daily lives from the mundane to a higher understanding of who we really are and how we can transform, create and heal our lives.

Attuning to Earth, Sun and Moon

Another aspect of the Medicine Wheel related to the cycles of the Earth and Sun through the seasons, are the festivals and Pagan celebrations dividing up the year. As you see in my diagram of the circle within (see page 191), it actually dissects into eight points. The other four positions provide us with markers for the solstice and equinox festivals that are not only sacred periods of transition that can be harnessed, but hold keys to the movements and spiritual interactions of all life forms on earth. The figure-of-eight depicted by two spirals found in ancient rock art, also relates to the sun's annual journey through summer and winter over 365 days, from our view on earth.[5]

Part of acknowledging the change in seasons reveals a hidden equilibrium within the human psyche, to be aware of how we flow with nature in relation to the four directions, or how they correspond to certain transitional points on the circle within. The four occasions, known as Winter/Summer-Solstice, and Spring/Autumn-Equinoxes, all play a major role as indicators of the 'natural' transitions within ourselves, as well as the obvious points of change on the surface of the Earth. These transitional points were originally

recognised by the early Christian Church and at the same time they were used to provide festivals keeping the medieval population in touch with earlier Pagan ceremonies. Easter, for example, is named after the Middle-Eastern pagan deity, Ishtar, and the Anglo-Saxon Goddess, Ostara. In fact, the Pagan origins of Lent and Easter, was decided by the Christian Council of Nicaea in 325 AD. The Council decided that Easter would fall on the first Sunday after the first full moon, at the spring equinox (March 21st). In Pre-Christian Britain (Albion), the four turning points of the yearly cycle were recognised as solar festivals, known as Ostara or mid-spring (Easter), Litha or Mediosaminos (Summer Solstice); Mabon or mid-harvest (Autumn Equinox); and Yule or Deuoriuos (which later became Christmas). To our native ancestors, the solstice and equinox points were seen as 'switches' which brought about a change, either in the increasing or decreasing of light. The Celts, for example, called these switches the giamos and samos cycle, providing all the necessary ingredients to be able to live in harmony with the earth. They were the points of celebration helping to observe instances of permanence, crop growth and continuity in relation to the environment. Since light is the source of *all* colours, the earth responds to this change in light by altering her canvas (surface) accordingly; so each festival became a celebration of the 'change in nature' and humanity's response to the solar annual cycle.

Celebrating Dark and Light

Yule was a Pagan celebration of the new born sun (son), a remembrance of how the new year would bring an increase in light on the Earth once again. The religions of the world, mainly the creation of the Babylonian-Aryan priesthoods, used these same festivals for their own ceremonial purposes and in some cases on these festival dates, satanic rituals were performed. If that sounds bizarre to anyone reading this type of information for the first time, then ask yourself what was the real reason for human sacrifice, which was rampant all over the ancient world? Witches and warlocks, including heretics, were burnt alive by the Church at these sacred points of time on the Pagan calendar, which also included the burning of logs for the festival of Yule, connected to sacrifice and tree (Druid) Saturn worship. Yule, or what became Christmas, was considered by the ancients to be a festival of reunion, fertility and celebration of togetherness with the family or the tribe. It was a celebration of the decrease in light as the Earth reached its darkest point of the year, and was counteracted by the need to celebrate the coming new light at the Winter Solstice. Yule was celebrated symbolically to rob the enduring darkness at this transitional point as the earth became darker, colder, moving north on the Circle Within. Our ancient ancestors would anticipate the coming new sun through celebrating the power of light over darkness. The now 'traditional' evergreen, or fir tree with its fairy lights is symbolic of this period of transition as inner energies surfaced at the time of giamos. The darkest point of the year was also considered a time to value family ties and relationships with all living beings.

In Phoenician and later Celtic Britain, plays and parades were performed by artists, musicians and dancers using the white horse, symbolic of the sun for this time of year. She was the White Mare goddess of ancient Europe who was also worshipped for her ability to ride between the inner and outer worlds of the soul. To the ancients, she was called Rhiannon or Rigantona, the primal ancestor of the 'Horse Clan' who lies in the south east of the Celtic Medicine Wheel. According to Native American teachings, the south east is the home of the Ancestors; it is directly connected to the Pleiades, the 'Seven Daughters of Rhiannon'.[6] One of the most spectacular images of this goddess can be seen in the outlines of the Uffington Horse, carved in the white chalk hills overlooking the Vale of Pewsey in Oxfordshire, England. The same image is believed to be that of a dragon, and like the ancient Nazca lines of Peru, it can only be seen in its entirety from the air.

All uses of energy can be reversed within various celebrations of nature. The power of the Horse Clan was reversed through the usual sacrificial blood and sex rites that were also performed on the Solstices. Reversed symbolism in certain Welsh traditions, for example, can be seen through the Mari Lwyd (grey mare), a monstrous figure consisting of a horse's skull on a pole; the carrier, hidden beneath a blanket to give the impression of a giant with an animal's head. Every year in the Roman town of Chester, the Christmas miracle parade, known as the 'Winter Watch', passes through the streets, and never fails to include this same giant and the white horse in its celebrations (see figure 86). Other variations of this deity show it bedecked with ribbons and bells attached to the lower jaw; probably the origin for the good-old Christmas *Jingle bells* tune. To the Celts, birds and sirens surrounded the White Mare (Rhiannon), who also appear in the *Welsh Triads* and the Romance of Branwen singing with wonderful sweetness; recall how they are the called the 'Seven Birds of Rhiannon' (the Pleiades). Other Celtic and Teutonic versions of this deity have the giant surrounded by devils being escorted by a variety of grotesque creatures, symbolic of the goddess's ability to move between worlds of both light and dark. In the Middle Ages, the same processions and dances inspired many mural paintings on what became known as the 'Dance of Death' or the

Figure 86: The Winter Watch Parade.
The parade is a modern day rendition of the 'Miracle Plays' passing through the streets of Chester during mid-December. © Neil Hague 2001

'Danse Macabre'. Murals on cloister walls found in many churches, which were based on earlier native celebrations, usually showed participants arranged in hierarchical sequence from the Pope down. These paintings, especially the *Holy Innocents* in Paris and the *Danse Macabre* at La Chaise Dieu (Chair of God) in France, all show images of the living and the dead (light and dark) dancing together. The most famous muralist of this subject matter was the Mexican revolutionary and painter, Diego Rivera.

The various celebrations of the sun reigning over the period of darkness (depicted as devils and monsters), seem to go back to ancient festivals connected with fertility. Through celebrations of time, various guardians of the land and fertility would be called upon in hope that the 'new sun' would bring renewal and regenerative powers to the earth, producing the crops people needed to survive the coming year. In his book *Celtic Rituals: An Authentic Guide to Ancient Celtic Spirituality* (1998), Alexei Kondratiev explains the universal meanings of this festival. He says:

> *The land spirits who govern fertility - from the centaurs of Greece to the divine Asvins of India - were imagined with horselike traits, and whenever their power was to be invoked equine imagery would be used.*[7]

Looking at the Solstice as a fertility festival, we also have to consider the goddess aspect of the land. In line with the aforementioned gaimos and samos 'modes', the goddess was seen to be mourning her lost child 'the child of light' in a barren Winter world, or the dark time of the year. The goddess in this story is also Isis searching for Osiris, or Nanna - El looking for Balder. The symbolism relates to the wife looking for the male child or husband who is a symbol for the new sun. In a sort of seasonal exile, the goddess is accompanied by other-worldly helpers, (ghosts, spirits, and interdimensionals) parading the houses searching for her great son, the child of light. I feel that we also experience this inner searching at the Solstices, as the light and dark energies are activated within us. Personally, I find the inward cycle very rewarding in terms of contemplation, meditation and creative projects.

At the opposite side of this cycle, the Summer Solstice was recognised as an occasion to celebrate one's individuality and creativity, or a time to concentrate on personal growth and expression. This time of year was considered the Tide of Growth, an annual period for focusing; consolidating efforts towards our potential. In the light half of the year the goddess, seen cavorting with the sun, is represented through deities like Minerva (the Roman patroness of the arts and crafts). Every individual who 'turns on' and 'tunes into' their creative energy at this time, can feel the effects of the sun and the goddess all around. Overall, the Solstice and Equinox points were, and still are, recognised as opportune times when the flow of cosmic and solar energies are stronger, so to help bring about changes and new projects on earth. These two cycles (Giamos and Samos) provided imagery and narrative content that would become rituals invoking the need for change. On another level, the alternation of Summer and Winter, focusing on the land and tribes,

including native peoples' relationship with agriculture, was part of these celebrational points.

Native cultures, as well as the ancient priests, understood that the sun was more than just a physical life-bringer. They understood its magnetism and how the sun's cycles affected all life on earth. Therefore, the celebrations (or stations of the sun) were used as aids for planting seeds (intentions for the future) and making positive changes within ourselves. At the same time, negative use of solstice festivals through reversed symbolism, was, and still is, done to harness malevolent energies that help implement changes in society that diminish true potential and freedom. More than any other time on earth, we are now separated from those tribal connections with the land. I suppose we don't need to engage the goddess or seek the aid of spirits of the land in order to ensure a plentiful harvest. Instead, we can go to supermarket 'giants' and department stores, while the face of agriculture is changed and controlled by powers that scoff at self-sufficiency which, by the way, encourages community spirit. Friends of mine, who run a graphic art design consultancy in Sheffield, summed up this point on a series of brilliant posters, one of which said: *"Department stores are our new cathedrals."* Growing and making our own food, as an example, also connects us more closely to the land. We have forgotten that the sacred points on the circle, like the feasts of our ancestors, when celebrated communally, can create a powerful source of bonding between people and the land that we live on.

The artist and visionary within us will always respond to these powerful connections with the land and the changes that occur in nature due to the influences of solar and lunar activity. Why do we suppose Van Gogh, for example, painted so passionately the movement within everything he saw in nature? Light was his motivation, the energy of the sun, its relation to country (Pagan) people and how he saw it move within nature and within himself. When anybody tunes themselves to this energy and creates from these feelings, they will find encounters with many ancient symbols that appear continually in the form of animals, stars, spirals, cloud formations and such (see figure 87). For the shaman artist, these archetypes are also omens that speak of trials, tribulations and messages from other levels of creation. For example when Van Gogh captured crows fleeing a golden field in his last painting, *Wheat fields under Threatening Skies with Crows* (1890), for me he was communicating a very native understanding and symbolism of the shaman; while at the same time announcing his own immi-

Figure 87: Spirals of Light in Nature. Was Van Gogh seeing what astronomers saw in the 1850s? His spirals in oil on paintings such as, *Starry Night* (1889), were probably inspired by the Whirlpool Galaxy recorded by astronomers in the 1850s.

nent death. His soul, trapped and suffering through many years of frustration and confusion, spoke through the flight of the crows as they left the Earth; merging within the dark and mysterious sky. The crow in many native cultures was a powerful female archetype linked to the moon, universal law and shamanic death. Did Van Gogh experience a shamanic death in the latter part of his physical life? I would suggest it is possible.

Fire Ceremonies: Attunement to Galactic Time

The other four points on the circle (east, south, west and north), also represent a series of ceremonies (fire festivals) that were more connected with lunar energies. These moon festivals were practiced across the ancient world as a way of connecting with more feminine energies, while the solstices were considered by many Native cultures to harness solar energies. Organised religions, like Christianity for example, do not view time as a cycle of 'eternal return', each harbouring with it the 'seeds' of future events. Instead, religious orders of this kind dictate that time marches ahead, towards an ultimate 'second coming', a one-time only event when the whole world would be judged. As we have already seen, Christian mystics like John Eriugena and Thomas Aquinas (1225-1274AD), viewed the cosmos and universe as an organic, interrelated whole (circle), an idea that would have found sympathy with today's scientists and seers in terms of their understanding of time and space. Eriugena records in his work *Periphyseon (On the Division of Nature* 1225): "Heaven, God's abode is nowhere". He also states that freewill is no illusion and that human effort and creativity are important. According to Eriugena what humans create, God creates.[8]

In the mind of ancient peoples and for most indigenous cultures, 'time' was nature's calendar based upon the cyclic nature of the Universe. The moon festivals, which later became witches' festivals, were known as Imbolc (February 1st), Beltaine (May 1st), Lúghnasadh (August 1st) and Samhain/Hallowe'en (November 1st/). These occasions are not seen as annual events for celebrating seasonal transition, they are recognised as periods of attunement to the fourth dimension; nature's time. This sounds like a contradiction as you would think that the seasonal/solar celebrations were more appropriate for attunement to time. Not so, our ancestors, especially the Phoenicians, Celts and Amerindians, realised that the moon through its thirteen month (28 day) cycle, was a direct connection with the feminine principle, or what the Mayans on their Long Count calendar system, call 'fourth-dimensional time'. Bones found in the Dordogne region of France, dating back 30,000 years, are covered with round gouges, which represent the Moon's course. The 27,000 year-old "Earth Mother of Laussel" also shows the carving of what appears to be a pregnant woman holding a horn marked with 'thirteen notches', symbolic of the thirteen moons/months.[9] The understanding of native time is also linked to the menstrual cycle of women, observed in the 13 month cycle it takes the earth to rotate around the sun; and it is identified as the noosphere, or earth's link with the human mind and Galactic Time. I think this ancient system of 'measuring time', also relates to

specific constellations and how we can access many non-linear worlds when we step 'out of time', or become 'timeless'. These are the same cosmic cycles as recorded in the science of numbers by ancient Sumerians, Egyptians, Mayans, Chinese, Hopi Indians and more recently by scientists and 'whole systems' anthropologists. José Argüelles, author of *The Mayan Factor* who over thirty years of study, is one of the pioneers of 'whole systems' anthropology. In his study of the Tzolkin Mayan Calendar, Argüelles points out the significance between the thirteen month moon cycle and what are known as 'twenty solar seals' (symbols) representing the 'changing' electro-magnetic energy which occurs on a daily basis.[10] The seals are also icons embedded with a higher knowledge of the earth's evolution, and they form part of an advanced mathematical system of codes plotting fourth-dimensional time through what Argüelles describes as the '13-20 timing frequency'.[11] They, like many original tribes of earth, recognise the original thirteen signs of the zodiac, the thirteenth being 'Grandmother Spider' at the centre of the circle. She is considered the weaver of galactic time which includes the different astrological qualities within the human psyche.

The four festival points on the circle also relate to the four cardinal astrological ages of Aquarius, Taurus, Leo and Scorpio. The astrological phase of Scorpio is often symbolised as an eagle, owl or snake in many native cultures; as well, the 13th sign of the zodiac has been said to be the 'serpent holder', which exists between Scorpio and Sagattarius. The four cardinal signs of the zodiac are the inspiration behind the four biblical evangelists, a Christian misinterpretation of the above four precessional ages recorded in ancient calendars. These ages are also depicted as a Man (aquarius), Bull (Taurus), Eagle/Serpent holder (Scorpio) and Lion (Leo), all of which illustrate ancient understanding and knowledge relating to a wider cosmology; a progression of ages studied by advanced civilisations long before Matthew, Mark, Luke or John were invented by the Gospel writers.

The Net and Linear Time

Indigenous peoples were not limited by 'linear time' and the analytical division of twelve months, instead they focused on 'Gaia's time' with its ever-changing biological cycles; the time it takes a tree to grow, or a flower to open. Being in tune with nature is to be influenced by fourth dimensional time as Albert Einstein himself phrased it, and not the artificial narrative/version controlling our reality since Ancient Babylon. The Babylonian system of 'stolen time' (based on the twelve divisions/phases of a circle), is a measurement of space rather than time! The creation and implementation of the Vatican's Gregorian Calendar in 1582 eventually modified the Babylonian version of time. The early Christian hierarchy recognised the effect and importance of the twelve astrological signs of the zodiac and its effect on how humanity perceives time from our 'earthly perspective'. This knowledge is depicted quite clearly in architectural sculpture of the central bay of Chartres Cathedral in France, showing the twelve zodiac signs surrounding the sun (Jesus) along with the four precessional ages (the gospels).

Let's face it, the Gregorian Calendar (the one we all use today) is a ridiculous measurement of time with its 31-day months, 30-day months, and 28-days with a 29 minus-a-day month occurring every four years. Instead, the Gregorian Calendar is a 'net' or an 'illusion of time' that keeps our minds focused in the third dimension; the physical world. The human mind is attuned to this manufactured measurement of time when we look at a clock or plan for future events with a diary, or calendar. Since the Middle Ages the Gregorian Calendar has been updated by the mechanisation of the 60-minute clock and over 400 years we have become trapped symbolically, or 'netted' within a system of 24 hours, 12 months. All this, in many ways, has disconnected us from 'real time' (or the place where time doesn't exist), while giving control over how history is recorded by the patriarchal systems I've described so far. Eventually, time became the money system which accelerated our evolution, via city cultures (Babylon's) towards a church and state society. Cyberspace is another version of this net; its name (Internet) gives it away. It is another form of control, a device that locks us into the 'New World order', allowing more control over how we view time and money. I know the Internet is a great tool for being creative and sharing information but 'cyber' is the 'science of control'; it consists of transmission of electromagnetic wavelengths for cerebral radio communication, including subordinate technologies such as: brain-computer interfacing, data surveillance, mind control, biomedical telemetry and man-machine interaction: Transhumanism. All are designed to transmit the basic ideology of the Information Society. We are dehumanising ourselves by relying on 'search engines', 'servers' and computers in general and the more we go down this path, the more likely 'robots' will eventually rule our reality! Like any use of creative power, the Information Society can be used either to control, or enlighten our lives. Even the scam called electronic money (including cryptocurrencies like Bitcoin) can be at the mercy of electromagnetic energy travelling out of the sun, in the form of electro-magnetic flares.

Time Travel and the Fourth Dimension

We have to remember that many native cultures have a spiritual heritage dating back more than two thousand years (to the Roman Julius Caesar Calendar) and many have their own systems of measuring what we believe to be 'time'. The Mayan sacred calendar, for example, shows time from a fourth and fifth-dimensional viewpoint, a system that synchronises with the Earth's biosphere and Sunspot activity throughout its duration. Einstein revealed, through his *Special Theory of Relativity*, that time is the Fourth Dimension and according to other physicists besides Einstein, like Peter Freund for example, space and time could be unified in a fourth-dimensional theory.

Viewing the three dimensional world from a higher perspective, or from a fourth dimensional viewpoint, the confusion of what seems like chaos in nature can be seen to have a coherent order, according to scientists and theoretical physicist like Michio Kaku. When we see from a higher dimension, all

energy and phenomena in our universe can be reduced to four forces of electromagnetic: strong and weak, nuclear and gravity. The challenge for physicists today, according to Kaku, is to unify these forces into a single force through a higher-dimensional geometry. In his book *Hyperspace* (1999) Kaku says:

> *Simply put, the matter in the universe and the forces that hold it together, which appear in a bewildering, infinite variety of complex forms, may be nothing but different vibrations of hyperspace.*[12]

I would suggest that the scientists of advanced ancient cultures on earth also had an understanding of these higher dimensions and how different frequencies (worlds) exist beyond space and time. Therefore, through the art and mathematical precision of the ancient Mayans and Egyptians, for example, the Earth's natural cycles are viewed from a wider or higher dimensional perspective. At the same time, the symbolic language of much native art often transcends linear time, offering a glimpse of the future and the past all taking place in the present! In my view, much Bronze Age American rock art seems to capture interdimensional beings appearing from 'nowhere', or another reality in time. Children naturally transcend time, it has no meaning to them when they are playing. So, too does the artist when he or she is immersed in the act of creating. What they all share is the ability to move into the world of the imagination where the artificial clock, as we understand it, does not exist. In the books by Lewis Carroll (*Alice in Wonderland*) or through a painting by Picasso, our imaginary powers can have the ability to place us in strange lands where time, or the fourth dimension, can not be fully understood.

Art, Nature and the Machine Age

The advancement of the machine and mechanisation of time through technology and industrialisation repulsed many artists. Van Gogh, was one artist, who felt the mechanisation of linear time and the 'city culture' spreading through his own era; like other painters and poets of this period, Van Gogh detested the growth of industrialisation. The very nature of Van Gogh's work reveals this to us through his empathy and close relationship with nature and people. Van Gogh shows us through his paintings how we need to become part of nature if we want to see and feel different dimensions of the soul when he writes:

> *It is not the language of painters but the language of nature to which one has to listen.*[13]

I believe this connection with nature is at the heart of why most people wish to create. You only have to look around, or if you are more adventurous, immerse yourself in the wilderness, to understand that mother nature is the most beautiful artist, daily painting her body with the vastest array of lifeforms imaginable. The surrealist movement, emerging in the early 20th

Century, also challenged the rational machine-world by entrancing the viewer with fantastic worlds, using nature as a metaphor for imaginative dream-like places. Salvador Dali, like other surrealists, gave the status quo of his time; mental landscapes that defied the logic of the machine-world; the so-called 'norm' in society. As stated at the beginning of this book, our inner power, which urges us to be creative, comes from recognising a life force within us which moves through all beings, gives us breath and weaves the intricate webs of life. The machine age, for many artists, is considered to be the antithesis of how humanity's natural creative powers should be used. Many indigenous cultures would also suffer at the hands of growing industrialisation throughout the world. One well-known Native American chief, Joseph of the Nez Perce, said: "The earth and myself are of one mind. The measure of the land and the measure of our bodies are the same."[14] By expanding the idea of celestial time through our innate creativity, especially around the four main moon-time points in the solar year, we become vessels for higher energies inter-penetrating our world. Being creative helps us synchronise with nature and a wider cosmology, putting us in a position to feel the earth's energy fields as she transits and rides the wider cosmological changes. When we use our natural creative forces within the thirteen-month moon calender, it is possible for our bodies to resonate with higher dimensions or the higher
levels of ourselves.

The priestly class (including modern forms of organised religion) that enforced the 12-month Gregorian Calendar and pyramid structure outlined in Chapter Two, do not want the masses to access this knowledge. Yet they themselves have utilised the thirteenth month moon cycle and goddess ceremonies for their own purposes since ancient times. As José Argüelles explains in his book *The Call of Pacal Votan* (1996):

> European power, instigated by acquisitive material greed and the church's need to gather all souls under its cross, had literally straddled the globe. Henceforth, no one could receive the 'blessings of Christianity without receiving the Gregorian calendar.[15]

That is why every indigenous culture, over the past five hundred years (which includes Europe's witches and gypsies), has been systematically destroyed, a knowledge hoarded and kept secret. Taking control of our own destiny, which includes exercising our creative power, was not on the agenda for the ancient brotherhoods that developed their own mechanisms for control. Utilising nature's cosmic calendar can and does change our perception of time. If we can grasp alternative worlds beyond the restrictions imposed by manufactured time, we can change our view of the world, dramatically. By changing our view we automatically start the process of creating something new based on our change in perception. What we create both mentally and spiritually can transform our physical world.

Taking Time for Timelessness

Attunement to 'timelessness' does not have to be a complicated process of ceremony or ritual. On the contrary, when it becomes 'ceremonial' or attached to systems belonging to past cultures, it will more than likely hinder our potential to access our higher spiritual self. To become timeless it could just be a simple process of switching-off from the mechanical clock, quieting the mind, having a siesta, daydreaming or letting our senses reach outward like tender branches reaching towards the river of energy surrounding us. Doing this form of meditation can place us immediately in a state of relaxation allowing synchronisation with other dimensions. What is important is the information *received* whilst in this meditative state. Focusing on certain symbols, or even a candle flame, for short periods, in meditation, can help us travel through altered states. Nature itself can show you this timelessness, especially when one takes the time to sit and watch animals, insects or birds and study how they operate in the moment. Nature is a classroom and all creatures can be our teachers, just notice how you lose track of time when doing some activity in nature, this might be anything from walking, fishing, to enjoying a picnic. Using nature as a catalyst for seeing and feeling timelessness has allowed me space to catch many sparks of inspiration over the years. This timelessness also relates to our 'hour of power' or our natural rhythms from which we can find escape from the narrow constraints of life imposed upon us by linear time. As the female body is more receptive to nature's time, so also is the artist within us all. Put another way, when we go within and call on our creative powers, it is possible to find our own natural version of time or reality. This act will become very important to us as we weave our way through the 'years of change' as prophesied by the ancients for this time. Why? Because time is speeding up as we synchronise with nature's time and the higher dimensions, which formulate cosmic time.

Becoming aware of the 'Circle Within' and these eight ancient festivals situated around the circle can help us recognise our own feelings and subconscious attitudes towards nature and the cosmos surrounding us. It is important we do not lose sight of the 'fire at the centre of the circle'. This fire represents solar and stellar fire, or the 'life-giver'. When people gather around a central fire in a sacred manner; stepping into the spirit of the ancient ways, through drum-

Figure 88: Celebrating the Circle Within.
The land of the sacred goddess in Peru at Sillustani. I felt the 'goddess energy' there like no other place, as we gathered in a *circle* to connect with the earth.

ming and dancing, they become a vessel for *Oneness*. The drum represents the 'heartbeat' of the earth and the heartbeat of humanity, *unified*; it is a tool for allowing unique expression. As I said earlier, we don't need to be living in tents to 'feel' this connection, but we do need to have an open heart and a connection to the Earth – the 'organic energy' of our planet.

I spent a long weekend in the summer of 2017 at the *Rainbow Futures - Super Spirit Camp* near Gloucestershire, and the vibration at the end of the camp, at the 'closing ceremony', was uplifting, raising the vibrations of all involved. It reminded me of the many times I had gathered in a circle since the 1990s to connect with other people at sacred points on the earth. The strength of the circle was especially powerful in the 'lands of the goddess', in Peru, at a place I visited called Sillustani. Along with David Icke and a gathering of wonderful souls in 2012, we accessed the power of the 'Circle Within' (see figure 88).

The Circle Within is our personal micro-cosmos of the universe and it is our link with the goddess, creation, and the heart, especially while we are utilising our imagination and accessing our visionary powers. At the same time, finding a focus for our creative energies helps manifest the 'fruits' that enrich our lives. Just like the spider uses all eight legs to create a web and move around, we too, need to *know our whole self* in relation to the earth and our organic environment. Our attunement to transitions in nature through the earth's 'real time' calendar helps us to more effectively observe the people, places and experiences that come into our lives, bringing the visions and much-needed changes necessary as we travel the Circle Within.

Sources:

1) Freke,Timothy & Wa'na'nee'che': *NativeAmerican Spirituality*.Thorsons. 1996. p21

2) See the work of Xandria Williams; *Love, Health & Happiness: Understanding yourself and your relationships through the Four Temperaments*. Hodder & Stoughton. 1995.

3) Blake, William; *Milton: A Poem*. 1804-1810/11. plate 34

4) Harriman, *Paracelsus*, pp 67 and 265.

5) See the work of Charles Ross the American artist who used a series of lenses and wooden planks to mark the passage of the sun. The sun burned tracks on each consecutive plank, showing a tighter spiral in summer and a more looser spiral through winter.

6) Jones, Kathy; *The Ancient British Goddess*. Ariadne Publications.1991. p44

7) Kondratiev, Alexei; *Celtic Rituals*, New Celtic Publications. 1998. p126

8) Periphyseon, Book IV, 768B (Taken from *Visions of Creation, Rediscovering John Eriugena*, by Martin Counihan) Godsfield Press 1995.

9) Duncan, David Ewing; *Calendar: Humanity's Epic Struggle to Determine a True and Accurate Year*. Avon Books. Inc. 1998. p10

10-11) Argüelles, José; *The Call of Pacal Votan, Time is the Fourth Dimension*. Altea publishing. 1996. p7

12) Kaku, Michio; *Hyperspace, A Scientific Odyssey through the 10th Dimension*. Oxford University Press. 1994. p15

13) Taken from *Songs of the Earth*. Running Press. 1995

14) McFadden, Steve; *Little Book Of Native American Wisdom*. 1994

15) Argüelles, José; *The Call of Pacal Votan, Time is the Fourth Dimension*. Altea publishing. 1996. p12

The Magic of Life
The Road to Self Discovery

*"The soul has a substance which tends towards higher
intellects, like the diaphonous body towards light...
the soul takes on a certain innate luminosity,
that continues at all times,
also when it is separated from the body."*
Giordano Bruno

To appreciate the idea of magic in our own lives we have to be able to recognise the existence of an energy that lives within *everything* and gives life to the Universe. It is a living power that flashes in the eye of a child, makes the birds sing at dawn and provides *all* life with consciousness. Once we feel this energy individually and creatively within us, then our lives can take a new turn on the road to self discovery. The Circle Within and the different bodies I have talked about previously, all play a part in creating the patterns in our lives helping us to see our personal magic.

Nothing lives in isolation on Earth, even if we sometimes feel alone. Our ability to not only see but feel the bigger picture, is given to us daily while we travel through our lives. Sadly, so many of us fail to see the signs along the road that can lead us to an abundance of creative potential. In ancient times our native ancestors, when looking for answers to life's limitations or problems, would go to the forests or hilltops to observe the portents or signs that would assist them in healing and seeking wisdom. This process of seeking was called a 'Medicine Walk' and even today in this 'busy' digital world, it is possible to connect with the same 'teachers' and 'signs' that come from being in nature. All art can form a bridge that helps us connect with other dimensions, other levels of ourselves. This bridging of worlds nurtures the language required to be able to see the signs in nature while walking either dense forests or city streets.

So what are the signs that constitute the magic in our individual lives? For us humans and co-creators on this planet, we need to be able to get to know a powerful friend, our Intuition! The Egyptians called this inner-voice the 'Ka', the inner-tutor, which resides within all our finer bodies (our soul), while remaining connected to the Earth. Through our 'intuition' we understand the language of the natural world. The writer Paulo Coelho called it 'the language of omens' in his novels. It is also the 'cosmic fool' within us all that shows us how we speak to animals or know when a tree or animal has 'spoken' to us. I believe this power never leaves us but we often deny its exis-

tence. For proof of its existence, one only has to observe how children and babies converse with the invisible, or how pets and animals know what you are thinking. It is through our imagination that we come to know our intuition and when we read the signs in nature (on the Earth and in the skies) we are learning a language that is closer to what many call God and what I call the 'Creator'. The American artist Georgia O'Keeffe maintained this personal connection with the source, or Creator, saying:

> *When I stand alone with the earth and sky a feeling of something in me going off in every direction into the unknown of infinity, means more to me than any organised religion can give me.*[1]

What I am outlining here is a personal magic or a power that is part of being human, which explodes into unlimited potential, once recognised and channelled. The artist within us all, will always attempt to develop this power and create our own diverse language so we can read the omens or signs that greet us in everyday life. The same language can also help us to give thanks to the creator for the love that we receive from the Universe in all its forms. No one can take that power away from us, even though we are persuaded by the 'structures in society' that we have no power. And this is why so many people give their mind-power away to outside authorities. We often forget the love that birthed us and the magic that surrounds us, and then end up fearing life which diminishes our real, creative power. In extreme cases the avoidance of our creativity and the power we hold within, can and does turn its use into something destructive. We even waste an awful lot of energy just 'doing nothing' and yet we are encouraged to do this by having passive attitudes towards our creativity. William Blake criticised this human trait when he said:

> *I must create a system, or be enslaved by another mans;*
> *I will not reason and compare: my business is to create.*[2]

To feel 'magic' and create our own systems through our imagination, we have to know that everything on this planet has a purpose for being here. Each rock, flower and animal can be our teacher. By recognising their sacredness we gain respect for ourselves and acknowledge the responsibility we hold as 'guardians' and 'creators'. The next time an animal catches your eye, or the wind stirs your senses, stop and listen to what is been imparted to you, let your intuition tell you what messages these teachers bring. By looking and listening to nature I have realised there is a language spoken by all living things, from cloud formations to grasses blowing in the wind, everything has potential to communicate at the level of our soul.

The wind is recognised by many native cultures as the forerunner of any lessons entering our lives. This is because the ancients said that all spirit came on the wind. I have experienced the feeling of hearing spirits on the wind many times in nature. One memorable occasion was when I camped at

a 10th-Century castle 700 feet above sea level in the South of France. It was an old Cathar fortress called Peyrepertuse, surrounded by forests in the Pyrenees. During the night I awoke to the sound of the wind howling through the castle ruins. On the wind I could hear the sound of horses stirring and moving around the tent. When I looked out of the tent there were no horses in sight, but the rest of the following day was spent feeling what I would describe as a kind of deep apprehension. A few days later I discovered some literature about the Cathars and that particular castle. It outlined the story of their plight against the Inquisition and Crusading armies sent to destroy them, which I suppose would have generated much apprehension. More importantly, the leaflet showed a diagram based on a then 12th-Century map of the castle grounds at which I had camped. It pointed out a courtyard where the horses were originally held, and to my surprise this was the direct spot (now covered in grass), where we had pitched the tent. This is one of many examples of how the wind can speak of spirits past and of events yet to come.

When we consider the 'Circle Within' once again, it is said if the wind comes from the South it can be offering a lesson on trust, innocence, humility or the 'child within'. If it blows from the West, it offers lessons on inner-knowing, seeking answers or goals through introspection. When the wind blows from the north, it asks you to be grateful and understand the wisdom being offered. The wind I felt at that old castle came from the East, bringing new beginnings, ideas, freedom through illumination and the imagination. The east wind can also offer assistance in casting aside doubts by being assertive and willing; expanding our imagination. Once we understand the type of lesson coming our way along the path of life, we can proceed by noticing which signs call out to us. Another example of this was when my partner back then told me she was pregnant with our daughter and from that point on, wherever I went, babies would catch my eye like they had never done before. It was as if my new life patterns and lessons were speaking to me through a language that is 'beyond words'. In this way the 'magic in life' only becomes visible when we are ready to expand the imagination, read the signs and listen to our intuition. When we do this we are trusting in the powers that provide our unique place in the grand scheme of all-that-exists.

No Such Thing as a Coincidence

Other examples of the magic that shapes our life experiences are what people call 'coincidences'. In truth it is the reversal in understanding of what we call 'coincidences' that provides the magic and 'realisation' that we are on the right path. In other words, once we 'see' that there are no such things as 'chance meetings' we automatically give ourselves permission to see the magic that spurs us on towards our true potential. More importantly we start to operate on the finer levels of our being which are in tune with our spirit and our higher self. Another example of this was in April 1995 when I exhibited a series of visionary paintings in London. Within minutes of hanging the work and the exhibition not yet officially open, a man wandered into the

exhibition room and proceeded to look around the show. It turned out, after he came and introduced himself, that he was Hopi and a photographer who was visiting his son in London for the first time. He also said he was moving on to Norway in search of a particular petroglyph amongst the cave art of Northern Europe. We had a fascinating conversation about art, spirituality and `seeing'. Just before he left he turned and said: "Remember, Neil, there are no such things as coincidences". I believe that one does not have to cross the Atlantic Ocean to participate in the magic of life, and that particular event was relative to my own growth. It happens daily the more we become aware of it, and has been happening since our childhood. For example, how many times have you said: "Fancy meeting you here!" or "What a coincidence, that's the third time this week I've seen you at this place" or "It was amazing luck, this person showed up at just the right time". In fact, another Native American Indian friend once told me that if you kept meeting someone a lot 'coincidentally', then maybe it was time you sat down with that person and had a talk, to discover the message being imparted! I feel that once we recognise the invisible levels of ourselves at work through 'chance meetings' or 'perfect timings', we instantly acknowledge the great mystery at work within all things. Magic in life, through an understanding there is no such thing as coincidence, enhances our response to daily living. It can make us aware of how much more we are in control of our lives through the magic we project into the world around us.

On another occasion, this time in France, the magic of life was brought to me when my then partner and I were hiking through Languedoc Roussillion. We planned to meet our family in the town of Foix at a specific time, date and location. We eventually arrived in Foix two days early, and were making our way through the streets to look for somewhere to stay, prior to our rendezvous. Being quite tired after almost ten days of hiking, the magic in life appeared that same afternoon. We had only been in Foix for less than an hour, when we turned a street corner and saw our family walking towards us. They also had felt the urge to arrive by car two days earlier than originally planned. There have been so many examples of 'coincidences' that have sparked magic in my life's journey, too many to mention in one book. But it's worth looking at how I feel we create this magic.

To understand the alchemy behind coincidences we have to look at ourselves from a wider perspective. This means not seeing everything that we do as being part of just linear time operating within this physical reality. For this we have to come to terms with the idea that the mind is not the brain (of which increasing amounts of open-minded scientists are now realising), and that thought can be measured as energy; a force that is alive and exists within all things. Some visionaries have described this energy as the 'breath of life', mainly because in ancient traditions the mind was linked to the element of air – movement – and this was seen as the essence of all breath. It is also possible to see this energy and feel its warmth especially when the sick receive 'hands on healing'. You can see this energy or aura out of the corners of your eyes in a darkened room, or when the sun is rising or setting. It is the

beautifully coloured shapes, spirals and flashes that seem to appear around objects, people, animals and plants, all seen through the corner of our eyes, when we are in a relaxed state of awareness.

Our minds are the eternal aspect of our multidimensional selves, which is why in what we call 'near death' experiences, people have been able to recall everything going on around them at the time. This is because our spiritual, thinking, feeling bodies, which form part of what I describe as the Circle Within, actually never die. Instead our etheric (electro-magnetic) bodies, which are the sum total of who we really are, change frequencies (leaving the physical), but still are able to observe everything that happens. The energy that makes up all our eternal bodies can be seen as a series of electromagnetic fields, which both psychics and scientists call the 'aura' or 'etheric' (see figure 89). These fields of energy have been photographed over the years by a

Figure 89: The Human Aura
A drawing of a Greek tombstone showing the aura (etheric field) of energy surrounding the head and body.

technique known as Kirlian Photography, named after the Russian engineer Semyon Kirlian, in 1939. The same energies generated by the body have been described through more Eastern traditions as the 'prana' or 'mana' energy. Our energy fields are said to be constantly interacting with earth's magnetic field, through colour and sound vibration. And in many ancient traditions, all energies provide a direct link with the cosmos and the rest of creation.

The Field of Plenty – Using the Matrix

Our personal link with the cosmos is also described as the 'field of plenty' by many Native American tribes, like the Iroquois. For native people it was a way of describing a great vortex of energy housing all new ideas, needs and inspiration; like an accessible energy bringing objects or desires into reality. In his book, *The Way Of Inspiration* (1996), Joseph Rael, a Tiwa elder, states inspiration does not begin with us; instead, it begins outside of us and within an energy field surrounding *all* matter. The native understanding of a field, or vortex of creative energy, is also part of the Web of Life I have been describing; it contains simple keys for using our personal magic to manifest abundance for ourselves. Creating new ideas and abundance (on a daily

basis) comes from the power in our minds, or what many term: creative visu-
alisation. The key to exercising our creative visualisation is through our
imagination. In its native American sense, however, it has more to do with
'giving thanks' for something on its way to a person (a tribe), while trusting
that all needs would be satisfied. These two keys of trust and thankfulness,
combined with a physical action, harnesses creativity needed to achieve
something; yet, becoming innocent enough to realise a connection with the
magic and mystery in life. Every time an artist, dancer, writer, musician,
architect, or any creative person acts upon an idea and creates something,
that person is developing his or her personal gifts, their magic. They are also
bringing abundance into this physical reality for others to access and work
with.

Art therapy (in its simplest form) revolves around the notion of drawing
and painting our inner worlds, helping us to recognise aspects about our-
selves that would otherwise stay under the surface. For example, the
shamans who created images on cave walls depicting hunts and initiations,
could actually have been seeking to make those scenes or sequences happen
physically, or make them 'a reality' by bringing magic out of the 'field of
plenty' through their art and prayers. One exercise relating to this type of
active focusing and creative visualisation, is a 'wish list' or the 'Moon ener-
gy list', others might call it a 'prayer' or 'paho' (see below). Some say this is
the real meaning and celebration of the magic behind manifestation. The
same methods used by shamans and ancients to evoke the invisible vibra-

Visualising Exercise: The Wish List

Working with this form of visualising is like making a shopping
list of the things you really need in life, not what you think you
need, but what you really need; there is a difference. Take a piece of
paper and write seven wishes on the sheet, while visualising in your
mind's eye those different wishes coming to you in a way that does
not manipulate other people's freewill. The metaphysical aspect of
the number *seven* relates to teachability and, to Native American
Indians like the Tiwa, *seven* represents the materialisation of
thought. Tell yourself that you are accepting the magic in life that
will deliver these to you and that you thank the sea of energy for
bringing them. Remember to be specific and believe it is possible.
Once you have performed this ritual in your own way, put the piece
of paper in a safe place and do not look at it again. As the weeks and
months roll by you will start to see the things on the list actually
manifest themselves into your life, exactly as you ordered them.
Some people eventually forget about the list and when they do find
it again they are amazed at how many items on it actually came to
pass. *Remember life should be about making miracles happen!*

Figure 90: Dream Fulfilled.

I painted this image especially for the cover of David Icke's fantastic book, *And The Truth Shall Set You Free*. On one level it represents the 'awakened human', whose soul is merging with the soul of the world. On another level, the figure is symbolic of higher consciousness on earth. The 'awakened human' stands with all energy centres (chakras) erupting and filling the world with light so dispersing the darkness that blights our evolution.

© Neil Hague 1995 Oil on canvas.

7) Crown chakra (Etheric Body) Knowing whole concept, receiving information – colour **Violet**

6) Third eye chakra (Celestial Body) Seeing, visualising, pictures, symbols – colour **Indigo**

5) Throat chakra (Etheric Template) Hearing, speaking, sounds, words, music – Colour **Blue**

4) Heart chakra (Astral) Love, sense of loving – colour **Green** (sometimes rose)

3) Solar plexus chakra (Lower Mental) Intuition, knowing – colour **Yellow**

2) Sacral or splenic chakra (Emotional Body) Emotional feeling, joy, fear, anger – colour **Rose** (pink)

1) Root chakra (Etheric Body) Touch, movement, presence – colour **Red.**

tions of prayer can be still used today to bring actual objects, visions and sequences into reality. I have tried this form of sacred visualising on several occasions and it works. The key thing to remember is that our 'intention' is what triggers the magic that then creates the outcome.

Spiralling Suns Within

Another expression of our personal energy (our magic), operates through a system of vortexes that spin and resonate to a particular colour, sound and vibration. These vortexes are also known as 'chakras', which is an ancient Sanskrit word meaning 'wheel of light'. According to many ancient cultures,

we have several of these energy centres in the body (and some outside the body) that connect us with other levels of our consciousness. According to the Hopi and ancient Egyptians, the living body of man/woman and the living body of the earth, are both constructed in the same way. Through each body runs an axis, a man's axis being his backbone, the vertebral column, which controls the equilibrium of his movements and his functions.[3] Along this axis are *ten* vibratory centres said to echo the primordial sounds of life (see figure 90). These ten centres (suns) are manifesting a state of being into the world. What we 'think' and how we create through thought, also comes through these spiralling centres. In traditional metaphysical systems we find only seven main chakras. The *three* additional centres are the *root* (nurturing), the *feet* (movement), and the *base of the brain* (power); these three were said to be in full use by humans in the ancient civilisations of Atlantis and the ancient Motherlands. It was said by shamans that these three chakras became dormant after the Earth's orbit of the Sun was changed, when those civilisations disappeared as a result of catastrophic events on Earth. These catastrophic events are illustrated in great detail in my fictional Triology, *The Kokoro Chronicles* (for anyone wanting more information). However, only those who had access to the ancient wisdom of shamanic cultures, kept knowledge of the use of these three chakras active.

The chakra system is our own personal rainbow of energy, colour and sound that acts as a warning system if anything within our body starts to go wrong. The ten body chakras are situated: below the feet; the feet, bottom of the spine (base or root); the navel (sacral or spleen); above the navel (solar plexus); chest (the heart); throat, base of the brain; centre of the forehead (third eye chakra); the top of the head (crown chakra). The chakra energy centres are also connected to the glandular system, which can be the transmitters of dis-ease to the physical body when one centre (or more) becomes blocked/imbalanced. The energy centres beneath our feet connect us with the Earth and the ones above our crown are of the spirit, the cosmos. I am also certain that the chakras have also been 'hacked' into by forces that wish to hold humanity back and keep us in an energetically-supressed state. In many ancient cultures the crown chakra was seen as the `open door', the portal by which a person receives his or her life force. It is also said that all inspiration comes through this 'door', and like a beam of light striking a single nerve cell in the brain, the seed (idea) is placed in our mind. As I mentioned in *Chapter Four*, this door connects to Orion and Saturn and has been shut symbolically by forces that feed off human fear. Out of these vibratory centres are said to be the roots and branches on the 'tree of life', symbolic of our connection with other visionary worlds and dimensions I have described so far.

The chakras transmit their state of being directly to our physical level through the glands of the endocrine system. At the same time this glandular system is governed by the pineal gland in the centre of the brain, which connects with the 'third-eye chakra' and therefore our psychic sight (our monad, see page 182). We can access this `eye' when we look into the eyes of anoth-

er person; we often see the real them, or their soul; you could say that you are authentically seeing what is truly in another's heart!

The chakra system is also represented by certain colours and senses, which in essence are really just wavelengths of light, radiating from (or reflected by) an object. All colour is light dispersed into a spectrum of rays, each of which has different characteristics. The sensation they leave on the retina of the eye is interpretated as colour(s) but at different rates of vibrating light. The colours and senses the chakras work through are given various interpretations by mystics and scientists alike.

Colour and Sound – The Language of the Universe

The ancient understanding of colour was symbolised through the yin-yang in Eastern traditions. In other words, light was white: the yang, the primeval Father. Darkness was black: the Yin, the womb, the primeval Mother from which all colour comes when penetrated by light. Colour, like sound, can also be measured by octaves of tints and shades by adding white or black.

The three primary colours of red, yellow and blue provide the foundation for all other colours as they move in a rainbow pattern from the lowest frequency at the base: red, to the highest frequency at the crown: violet. The red end of the spectrum is said to vibrate at longer wavelengths and is moving towards absorbing the black yin polarity; whilst violet has a shorter wavelength and is moving towards the white yang polarity, separation and individuality. Magenta is where the octaves are said to change. Colour is how we see the illusory world, and how we are touched by the parts of creation moving between the 'invisible' and the 'visible' light. Symbols that use colour are also communicating with the subconscious mind and they 'speak' to us on a deeper level. The 20th Century artist, Paul Klee, went as far as saying: "Colour was the place where our brain and universe meet". You could say colour is the changing factor of everything within our lives. The Earth changes in colour as it passes through the seasons. So do certain animals and birds, which like ourselves are part of the invisible forces of change occurring in the visible world. Colour and sound are aspects of the same thing, both relate to movement and vibration of energy. Sound could be described as a colour we can 'hear' and colour might be described as sound we can 'see'. Ancient wisdom relating to vibration (sound) was said to be the 'shaper' of the universe: "In the beginning was sound, and sound caused matter to form and take shape."[4] In his book *Being And Vibration* (2012), Joseph Rael explains that the entire cosmos is made up of five principle vibrations. According to mystics these vibrations, when they manifest as sound, are the five principle vowel sounds, \aah\, \eh\, \iii\, \ohh\ and \uu\. Sound, in other words, contained the 'thought' and thought was said to be *silent sound*.

We are all made up of energy, sound and colours that are constantly changing depending on the state of our emotional, mental and physical bodies. When we are with other people the colours (frequencies) emanating from our own auras are interacting with other people's energy. This is why we are attracted to some folk and not so attracted by others; which can have noth-

ing to do with spoken words but more to do with feelings and atmospheres (moods) generated by other people's auras. The colours themselves, connected to the chakra system, either vibrate in harmony or discord, which generates feelings of attraction or repulsion. Our health is also connected to the chakra system and can be read by psychics through the aura of a person. I have seen these almost cocoon-like shapes that emanate from the chakras, in various colours and densities. I feel it is our 'ancient eyes' that can see these auric colours and shapes and the way we see them is through our imagination – our visionary sight.

Once we realise that these energy centres affect our health through the way we think and feel, it is easier to see how an emotional imbalance can directly create a physical disease (or dis-ease), via the chakra/endocrine system. Some etheric imbalances, for example, can disrupt the smooth replacement of cells and eventually create what is known as cancer. In this way what we call cancer is more than likely a severe emotional disharmony that becomes physical dis-ease through inefficient cell replacement. In fact there is mounting evidence to suggest that cancer is etheric disruption sometimes simulated by emotional disruption, although contact with electromagnetic energy fields, like power lines and Wi-Fi could also trigger erratic cancerous cell replacement. As well, ionising electromagnetic devices like airport body scanners, mobile phone masts, X-rays and CT scans are included in this level of etheric disruption.

The Fool Within

One of the biggest healing factors in our lives is the ability to take a look in the mirror and have a good laugh at ourselves. Too many people are so serious about life that they fail to see the 'sacred' through humour. Over the years, as part of my own journey, I have seen so many people from within the New Age, religious and political spectrum in all walks of life and careers often forgetting that we are probably the most hilarious species on Earth. In fact we don't laugh at ourselves enough. On a physical level it is very good for our health to have a good, belly-shaking laugh. It increases the heart rate, respiration rate, and our blood pressure can swing below normal the way it does after exercise. Doctors also recognise that through laughter, the stimulation to the cardiovascular system, nervous system and pituitary gland, indirectly stimulates the production of endorphins, which are the body's natural pain-reducing enzymes. Laughter can also reduce stress, which is a huge creator of dis-ease in today's world.

There is also a spiritual side to laughter, captured by the ancient clowns, mummers, jesters, mountebanks and fools, who centred themselves around the royal courts of antiquity. In Mayan culture for example, there was a jester-god, whose three-pointed hat provided the later kings with the three-pointed crown and quite possibly the fleur-de-lis symbol. From the first card of the Tarot's major arcana, to modern comedy, the role of the fool (or baffoon) is as important now just as it was in many native cultures (see figure 91 overleaf). The fool is also an archetype for the cosmic human, captured brilliantly in art

Figure 91: Fool on the Hill with Tree and Moon.
© Neil Hague 1996 (Oil on board)

The Fool is no fool!
He is wise enough to know that although he 'sees' the sun move through the sky,
in fact it is the Earth that moves. He understands both the magic
and illusion of life on Earth.

and sacred texts all over the world. The cosmic human is often depicted inside a circle (a sacred hoop) and seen in the images of Shiva; Leonardo da Vinci's *Vitruvian Man,* and Blake's giant figure of *Albion,* which accompanies his epic poem, *Jerusalem.*

Laughter and creativity go hand in hand, especially in the development of our soul. In certain American Indian tribes, for example, the Heyoka clowns or divine tricksters, would help their fellow tribesmen see if they were acting too seriously, for their own health's sake. All tricksters, fools and jesters use the power of opposites to impart lessons, which could show a person how selfish, materialistic or single-minded they had become. In Native American tradition the Coyote was the teacher of Heyoka 'medicine' and through his/her use of jokes would endeavour to trick others into enlightened states of understanding. In the first place, however, this could only be done through the ability to laugh at oneself. The fool is symbolic of that bridge

between 'above and below' and the magic of 'seeing the world through opposites'; we are reminded of this in that fantastic song by the Beatles – *The Fool on the Hill*.

The fool is our guide to the magic in life, the unpredictable, the innocent and individual-minded. This archetype is at odds with the Predator Consciousness, mentioned in an earlier chapter; in fact, the predator fears the fool. The fool symbolises inner freedom through knowing that the world (our reality) is an illusion. It is also an archetype for self-discovery, a process that can lead us to realise our infinite potential. The fool can also see from a greater height and has the innocence to let go of ego, which is so important if we wish to see beyond the mental barriers we impose on ourselves. The fool is within all of us; it is this archetypal energy that tricks us into finding our own path of wisdom.

The Magic Mirror – Go on! Laugh at Yourself

Artists and photographers from the Renaissance to the Surrealists have used mirrors and lenses as tools for creating their work. One photographer, Duane Michal, even used the mirror to create bizarre reflections which he photographs to reconstruct our identities in the so-called `real world'. Michal's works are almost photographic versions of Cubist paintings and they too, offer a fourth-dimensional view of life, forcing the viewer into a world that cannot be easily seen from our perspective in three dimensions. One of the exercises I have done since childhood is to stand facing a mirror, while really staring hard at the reflection of myself. Against all the old religious superstitious belief, I did not see the 'devil staring back at me'. Instead, what I saw was the equivalent of a small film with many parts, all played by *me*. What I started to realise was that if I focused on my eyes, without breaking the stare, a hazy, shimmering world seemed to come and go around the outline of my head. The first time I did this I burst into fits of laughter when I saw my head change into what looked like a monkey, covered in long hair, with only my eyes visible! In the space of what seemed like seconds, my face changed again from a Sasquatch (see figure 92 overleaf), to a small boy, then a hooded character (I could not clearly see); a one-eyed Indian man with a long beard and finally a woman of oriental origin. At that point I broke the stare, I came back to my normal self (if you can call it that), shook my head like anyone would and thought to myself: "This is nuts!" The visual impact of using what I call the 'magic mirror' effect, revealed to me that we are not who we think we are. And by using our ancient sight to dig a little deeper, we become aware of our multidimensional personae, or what some may translate as: our previous lives. Artists, like William Blake, practised the same process; even producing a series of visionary heads for his artist and astrologer friend, John Varley. Some of Blake's images depict half-animal, half-human creatures, like that of *The Ghost of A Flea* (1819). What we think they are is not really important; it's our ability to see through opposites (the mirror of ourselves) which opens up many worlds of self-discovery. It is also confirmation that 'our mind is our imagination', and by seeing through what

Figure 92: Visionary Heads.

Self-Portraits (left, *The Jester*). Oil on Canvas © 1996
(Right) *Monkey Man* (Bigfoot). Pencil and wash in sketchbook. © 1996

we perceive to be reality, we can activate the magic in life.

The mirror, and our reflection in it, is a wonderful analogy for the 'reality' in which we are immersed. In many ways we are trying to 'change our reflection' in the mirror, rather than the 'real person' creating the reflection. We also take our presence in the physical world far too seriously. We need to 'step away' from the mirror to truly know (or see) ourselves; all we have to do is change how we think, act, feel and *see* the 'original' person creating the reflection: the imagination. We are wandering 'earth stars', constantly moving and evolving through how we interact with reality (the mirror). Many of us are seeing through the illusions (halls of mirrors) and 'smoke screens' we dare to call 'normal' life. Once we can grasp the desire to change the imagination of ourselves, rather than the reflection of who we have been conditioned to be, then *any* reality awaits us. Why? Because we become co-creators who know we each are responsible for the lives we 'think' into existence.

A Pebble in the Pond – Creating Our Reality

Once we acknowledge that our mind (our thoughts) produces energy, shapes and colours, then we can get nearer to the understanding of how we move through life 'creating patterns', connecting with other people, places and experiences. Every thought is like the classic image of a pebble being thrown into a pond; like that stone hitting the water, our thoughts create ripples effecting the flow of energies around us. So where do our thoughts go? They go out into the collective consciousness, into the sea of energy and beyond, carrying signals that attract other signals, rather like magnetic energy attracts

and repels. This process of magnetic attraction, via the energy generated by our aura and chakra systems, then pulls in people, places and experiences based on the exact state of our subjective mind. Another term for this magnetic process is *instant karma*, which was the theme of John Lennon's song of the same name. The process attracts the so-called 'coincidences' that give us a glimpse of how we are following our intuition, or not. Magnetic attraction, the notion of how 'like attracts like', gives us insight into seeing how we actually 'create our own reality'! When we understand this process and act upon our feelings and intuitive side it becomes easier to see the signposts put there by the way we think and perceive in the moment. In this way life becomes a journey that induces the magic needed to spur us onto further discovery of ourselves. More importantly through this process, we are urged to take responsibility for what we think, do and how we live. Many times I have opened a book and come across an image or seen something in a sentence that has provided me with an answer to one of life's questions. The same has happened to me in nature when an animal has stopped me in my tracks reminding me of my connection with the earth and the subjective characteristics I was expressing in that moment.

Living in the moment and responding to coincidences is a vital part of seeing with our ancient eyes. I know some people may dismiss this ability to recognise the coincidences in life as a catalyst for our personal magic, this is understandable given the reduced level of imagination and awareness pervading human sight at this time. Yet, I believe, this innate ability will change as more and more individuals search out their spiritual path - their personal truth. As long as we have religions telling us God is in control and we are not, and while science says all is a 'cosmic accident' and life is about survival and that when you die, that's it, then we are failing to give ourselves the spiritual sovereignty of self-discovery; that we have the ability to take charge of our lives and become whatever we need to, within the realms of our imagination. By taking back our creative power, our responsibility from the many groups that want our minds, we are saying as individuals: "I know who I am, and I know what I need to achieve my growth". We are all pure creativity in motion and everything in creation *lives forever* in some shape or form. I believe this to be the understanding we need, to be able to access our 'ancient eyes'. Through our ancient sight we can start to see our role in life as being part of an immense web of creativity reflecting the collective light of this planet; a light switching on all across the earth.

Sources:

1) Taken from *Songs Of The Earth*. Running Press. 1995
2) Blake, William, *Jerusalem*, 1804. pl.10.
3) Taken from, *Hopi - Following the Path of Peace*. Chronicle Books. 1995. p26
4) The *Gospel of St. John*.

The Weaver Within
Getting Our Own Visions

"There is no one who can take our place. Each
of us weaves a strand in the web of creation.
There is no one who can weave
that strand for us.
What we have to contribute is both unique and irreplaceable.
What we withhold from life is lost to life.
The entire world depends upon individual choices."
Duane Elgin

I believe each individual has their own unique mythology and creative power. That power can be symbolised as the 'weaver within', or the creator of our life experiences - our personal webs. The subtle web-like structures created by the spider inside are different states of awareness and frequencies that formulate our perceptions providing structure for consciousness to appear in its different forms. The web-like structure I am describing, constitutes all expressions, aspirations, hopes and fears, through our *thoughts*, linking all life-forms together in the infinite matrix known as Creation.

The weaver within is a metaphor for the 'creative user' of our life force; permeating our whole body and connecting us to the earth and the wider Cosmos. It is a neutral force residing within us all until we express it through our creativity. We are in effect a 'storehouse' of creative potential. Just as the spider weaves patterns and circles ten times its size and stores its thread internally, we also can create patterns and invisible structures which 'store' (house) our inner feelings, states of mind and deepest dreams. Our 'webs' are representations of what we do with the creative life force within and how we create our own reality. The weaver within (or spider inside) wants to manifest our hidden dreams and bring them into the world around us so we can understand deeper levels of ourselves. Just as the spider knows every strand of its own web, so do we when we exercise our creative energy positively. On the other hand, if we choose to create webs out of negative states of mind, our life and the world around will reflect those choices. For example, if we build a web out of greed and lust for power *it* will eventually trap and devour its own creator; if woven too tightly, it will not allow the harmony of giving and receiving to take place. Conversely, a web woven too loosely without care, lacks strength and durability to support its creator. Just as a web woven out of fear will attract the kind of lessons needed to overcome those fears. When we are in any form of fear, our power to access inner vision is reduced and we become prey for whoever wants to steal our energy. This is how psyco-

paths and 'vampires' operate through 'fear-inducing' tactics and then 'stealing' energy. When we weave webs created from love and the desire to create abundance, we nurture, provide for ourselves and fulfil our dreams and desires.

The Wider Web

The idea of a web can also be used to understand how all humans are linked in 'mind' through what psychologists like Jung call the 'collective consciousness'. At this level we become strands in a much larger web connecting all living beings. How we develop our individual webs (circles) eventually affects the whole. Another analogy would be to say we are like droplets of water, individual, but influencing the nature of the ocean. Plato said:

> *The Universe is a single whole, comprised of many parts that are also wholes.*

I feel that every individual contributes to the state of the world through his/her creativity, and this reflects itself outwardly as collective understanding. If we are imbalanced and use our creative power destructively, then this ultimately manifests on the planet as death, war, rape or terrorism through collective and individual ignorance.

I see the wider-web as a 'grid' of magnetic energy that travels through the Earth interpenetrating the planet, creating vortexes at certain points on the Earth's surface. At these power points we find standing stones, like Avebury, or Carnac in France, placed there by the ancients at strategic points on the grid. Some say these stones were arranged on specific spots to balance or redirect the flow of energy travelling through this web. Researchers have hinted that many of these standing stones are part of a network designed to 'close down' the true potential of the original Earth grid (web), just as acupuncture needles close down or 'redirect' energy in our bodies. From my own experience, I tend to think a 'shut-down' of energy took place at these points; as seldom have I felt positive energies at places like Stonehenge, or West Kennet Long Barrow in Wiltshire. On the other hand I have had fantastic experiences at other lesser-known sites, where I have physically felt magnetic forces pull my feet to the ground. One memorable place was in Scotland at an almost same-size replica of Glastonbury Tor, near a place called Meigle, Perth. In his book *Earth Stars* (1990), C.E. Street documents in great detail how the geographic plan of London (like other major cities), correlates with the sacred geometry of the 'circle squared'[1] at numerous Pagan sites. Street's work proves beyond doubt that the ancients understood where these power points on earth could be located and how they related to a wider cosmology. In his book, Street says:

> *Nor are they [Earth Stars] limited to London, Britain, or even the Earth. They have inescapable cosmic connections. They are a manifestation of the formative forces of creation, life-force, not just this planet, but the entire universe.*[2]

There is also an interesting link between these stone circles sites, earth mounds and faults in the Earth's magnetic field. Serena Roney-Dougal, in her book *Where Science and Magic Meet* (2010), points out that of the 286 stone circles in Britain, 235 are built on rocks more than 250 million years old, which statistically is a million to one! Certain geographical locations in France, like that around the famous Rennes-le-Chateau area, also form pentagrams and geometric circles on the Earth. If this wider web was disconnected from the Earth in ancient times or at least dramatically reduced, then it would certainly have had an effect on human potential to link with higher dimensions and cosmic forces.

In some ways we only have to look at what has been done to destroy the Earth and our environment in a short space of time, to notice a severe lack of understanding of the wider cosmology of our planet. Motorways and power stations have been placed either through, or alongside, these sacred sites and this must have an affect on the well-being of the Earth's grid. Weather modification technology such as the secretive HAARP (High Frequency Active Auroral Research Program) in Alaska is also affecting the Earth's energy fields and grid. If we see ourselves as part of a wider web, as part of the consciousness of Earth (Sophia/Gaia), then the urge to take responsibility for our lives, so we can heal ourselves (and therefore the Earth), becomes imperative. Once the web is whole and unbroken, I feel it will become possible to reach out to connect with other planetary bodies, star systems and more subtle frequencies (see figure 93). We might also realise that travelling across space in metal ships is not always necessary, if we want to communicate with extraterrestrial life-forms or interdimensionals already existing within the earth's various frequency ranges and part of our DNA. By forging links through meditations, creativity and visualisation, we create our own personal bridge to the forces dwelling within the wider

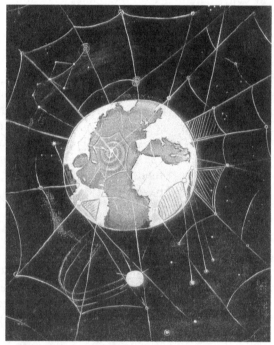

Figure 93: The Wider Web.

This image was part of a sequence of paintings illustrating the Earth's place in a larger web/matrix, connecting with other planets and star systems.

© Neil Hague. 1995 (Acyrilic on paper)

cosmos. This connection can be symbolised as 'returning to the father' in many religious texts, or the reunion of Geb and Nut (Heaven and Earth) in Egyptian Mythology. We as individuals are a microcosm of the universe too, and the webs we weave will reflect our part in the grand scheme of all-that-is. In other words, our creativity can become a key to discovering our individual link with the Universe. Nobody can weave our web for us, nor can we live somebody else's life for them; just as no one can create the artist's work but the artist. Taking our own responsibility for an internal journey towards self-discovery is so important to grasp if we are to become awakened to our highest potential.

Our Personal Webs – Connecting with Spirit

All journeys and personal quests, through any creative act, are about uncovering the original self. Peter London in his book *No More Second-hand Art, Awakening the Artist Within* (1990), expresses this point in relation to drawing and painting. He writes:

> To create art drawn from within is to access our internal power and also to uncover an all but forgotten original primal self.[3]

To create from within is like drawing upon a source of wisdom no one else could possibly have, it is our uniqueness and ours alone. We have to be the only ones who can explore this territory and then return to tell the tale. The more we exercise our uniqueness through creative imagination, the more openings and alternative doorways we encounter along our journey. When we allow our hearts to open and our minds to roam freely, the less likely it will be for us to 'pitch our tent' and close our mind to other possibilities. Once we start to 'create' from a wider perspective then we begin to realise what every traveller on the road to self-discovery has realised, that life is really a journey towards a deeper understanding of who and what we are. If anyone was to do this type of journey today, they would be doing what every visionary or shaman has already done for thousands of years; alternatively, are we not those ancient visionaries anyway?

The idea of a web provides us with the fundamental link between all life; this link in its simplest form, is energy. Each part of the web of life has its own energy that vibrates at its own particular frequency. The energy encompassed by an entity, be it a tree, a stone or a human being, is an extension of the web of spirit and the extent to which we can affect and be affected by spirit, depends on how receptive our personal webs are. To become more aware of our web-like connections with spirit, we must become more aware of energy on an instinctive level. We quite naturally use our instincts to sense various atmospheres, be it the mood in a room after an argument, or more subtle atmospheres that come from being in nature. Through our personal connection to the web of life we are sensing energy that can be extended to feel higher vibrational parts of creation (see figure 94 overleaf).

There is a difference between being alone and being lonely. If we cannot be

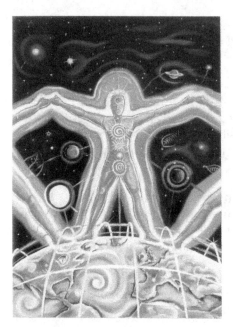

Figure 94: Free Spirits.
Breaking out of the space-time frame
(illusions) on earth.
© Neil Hague 1996 (oil on canvas)

alone then how can we allow our-selves to journey past the doors of ordinary thinking and seeing? I believe we have to be alone in many ways so as to discover what resides at the centre of our personal webs. Remember, it takes only 'one' spider to weave 'one' web, just as we are born as an individual, and then leave the physical world as that individual soul. This does not mean that in order to create we have to live in solitude. On the contrary, nothing on earth lives in solitude. We, like all life on this planet, need companionship, communion and dialogue. Even the sun in all its power needs the sky to travel along and the birds to welcome it as it returns every day. We too need a continuous assembly of sunshine, moonlight and landscape, with a cor-nucopia of things to see, touch, smell, taste and hear. All of nature, which we feel through the five liberal arts, our senses, plus how we imagine, remember and dream - all provide the thread for our personal webs.

The Language of Nature – 'Seeing the Unseen'
Within many ancient cultures there is a deeply interconnected belief in a spir-it world. For our ancestors this was a world full of shapes, colours, sounds, images, strange beings and guiding forces. In fact, sound was more pro-foundly understood in the ancient world, and was quite possibly used in healing through various forms of Acoustic Resonance.[4] It is said that the way to contact these 'etheric worlds' was through the inner eye, exactly the process used by oracles, mediums, prophets and psychics since ancient times. Modern clairvoyants use exactly the same inner sight (sixth sense) when working with `spirits' for contacting loved ones. In more cases than not, I feel that the medium is actually reading the mind of the individual and telling the listener exactly what he/she needs (or wants) to hear. I say this not to belittle the experience of mediums and people that go to them, because I think it is a highly relevant and natural part of life to want communication with the spirit world. It's just that the quality of information received depends on the medium (or medicine person) and his/her connection with the ancestors (spirits) beyond the physical reality (see figure 95).

Shamans of old would say that plants, clouds, trees and animals could talk to us on a level that bypasses the spoken word. Animals especially, can com-

municate with us on a telepathic range more easily than other parts of the natural world. Yet we also know that plants can talk to us, as many a gardener has recognised when they have seen certain flowers flourish much better than plants not shown any atten-

Figure 95: Communicating with the 'Unseen'

tion. In the ancient world, the 'flower people' were consulted in ceremony, so were animals, and the spirits of those animals, manifesting as guardians when called upon. Plants and flowers speak to us through the language of colour and form, a language understood more profoundly in ancient times. Quite magically, certain plants, crops and fruits can appear to take on an alien-like personage when viewed under a microscope. Some of which look uncannily like some of the indigenous deities worshipped to increase crop growth and bring a good harvest.

Animals can speak to us through symbolic imagery, and I have had many experiences of this type of communication in nature. On one memorable occasion a stag came across my path in a dense forest in France; the imagery I received when we looked at each other was relevant to my quest at that time. All animals are messengers of that inner world, a world that will speak to you if you are in the right place in your mind. Quite often the imagery you receive through conversing (in the mind) with animals can pass on clues to life's questions. I remember once sitting on a hot Summer's evening in my parent's garden, talking with my sister about many things that she was going through in her life at that time. When suddenly a barn owl swooped into the garden, landed on the roof of my parents' house and turned to look at us. Owls are considered messengers in various native earth cultures especially in relation to psychic ability and death. Despite owls being very much connected to me as a totem, the imagery I received through my mind's eye was relevant at the time to my sister's life problems (which could have been quite serious); it made me more aware of the hidden worlds that interpenetrate this reality. For example, have you ever walked in a forest or some other wild place and felt you were being watched or that someone was calling you, only to turn and see an animal or tree that caught your attention? Have you ever seen faces in trees, clouds, even in smoke and fire, which remind you of certain animals or a person? If so, you are seeing in what is described as a 'sacred manner' (see figure 96 overleaf). Seeing in this way is part of our natural ability, and the more we access our 'ancient eyes' the more wonders we

**Figure 96:
Interdimensional
Visages in Nature?**
Left: A microscopic view
of a blue maize stem. Corn
was considered a god by
various indigenous tribes.
Right: An angry looking
rasberry stem!
Middle Left: My painting
of an 'insect man'. Biting
midges look like this
when viewed under a
microscope!

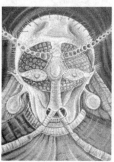

Above Centre: Carnac in Brittany, France. The stones often resemble people or giants.
This rock looks like a 'robed priest' pulling a cloak around himself. ***Above Right:*** These
rocks sit on the coast of Brittany in France and seem to resemble aged profiles of faces
watching over the Atlantic Ocean. For me, they show the 'next layer of our reality'.
Once we *see* this type of imagery, then more of the same becomes easily available to
anyone accessing their 'ancient eyes'. In truth, all visionary art is the act of 'seeing the
unseen' and then manifesting it through our creativity.

behold. At this time, seeing in that sacred manner is becoming more preva-
lent as we enter a new period of evolution on Earth. In fact, I feel that people
are going to be amazed at what they will see appearing on the news, in
nature and even in their own back yards as we access our visionary abilities
in the years to come. For example, at the time of the atrocity that occurred in
New York in 2001, I was not the only person to access my visionary sight
when I saw what was a demon's face appearing in the smoke and fire of the
World Trade Center (see figure 97). On seeing this image I realised that I was
seeing the demonic forces that perpetrated this horror as they appeared in
their telluric, archon form.

To appreciate what I am talking about one has to experience receiving
imagery of this kind for themselves. Only then does it have the relevant
meaning that puts us in touch with the world of spirit. Everything in nature,
in the skies and across the Earth was alive to the ancients. The wind was a
language in its own right; Native American Indians even had a name for it,

Figure 97: Demon Faces in Fire & Smoke

Taken from live news footage at the time of the event in New York on the 11th September 2001.

they called it *Mi'kmaq* (meaning allies).[5] According to Native American myth, the wind was the Sacred language of the flute given to people by the woodpecker,[6] another story that has connotations of magical gifts or knowledge being endowed upon humans by non-human beings. The same theme relates to the story of the hunchbacked flute player, Kokopelli, a spirit or inter-dimensional deity that accompanied the first Hopi on their journeys out of the underground world of Tuwaqachi.[7] Kokopelli or Mahú, a dualistic being I talked about in earlier chapters, was also described as an insect deity who was said to carry the healing art of music. Drawings of this mysterious god-archetype on cave walls all over the world often show him with feathered plumage on his head, like that of the woodpecker, while his flute resembles the beak of the bird.

To understand the language of nature, numbers and sound, we have to enter into a different type of awareness, one that is the poetic, the romantic one that delights in the five senses, but is not ruled by them. We also have to go further than just being 'delighted'. We have to venture into the world of seeing and feeling, which is more animistic or primitive in its attitude. Through this type of observation we open up to the magical world of our imagination. The process I am describing comes very naturally to children, yet most people have only faint memories of the world of make-believe. The child's world of imagination is so at odds with that of the adult world that we instinctively deny its existence. The 'make-belief' that children see is the same that our ancients recognised, we have abandoned our natural knowing of this world in order to survive in a harsh 'grown-up reality'. Artists and children converse with these hidden worlds of the soul; children above all are fresh from that world (the other side), and require nurturing through the wisdom of the imagination.

Dreaming

Dreams are so important to the process of getting our own 'vision', yet so many people either rebuke dreaming or treat the subject with little importance. In ancient cultures, dreams and the information received through them, provided the spiritual and cultural foundations for both individuals and communities alike. The elders in many native tribal societies understood that our dreams were guided by celestial bodies, like the Moon, along with a myriad of original archetypes. Some of these archetypes spawned the many deities that ancient cultures worshipped, and they became the guardian spir-

its, god-like inter-dimensional beings we have looked at in previous chapters. The most common deities became part of sun and moon worship, both in its positive and negative forms.

One of the most important archetypes to ancient Pan cultures was the feminine principal and its relation to both the earth and the moon. We have travelled a long way in evolutionary terms since ancient times; along the way, there has been misrepresentation of the goddess energy, leading to male domination over the earth. Even women are encouraged to be masculine in their attitudes towards work and life in general. In many ways we have forgotten how to relate to the feminine principle in *all* life. And as most men will already know, the feminine principle is both powerful and magical. Men go weak in the presence of true feminine energy. Supreme mother/father figures (hero worship) embedded in negative forms of sun, saturn and moon worship (through religion), are responsible for our lack of memory of the goddess. However, if we realise our personal connection with the worlds beyond the Moon, through listening to our dreams, then it becomes easier to access the feminine principle, our wisdom (Sophia) and the artist within us.

So many times when I have taught art I have heard people say that they have no imagination, or that they find it difficult to imagine. Most people have forgotten that dreaming and imagining come from the same source. Everyone can shape a dream, allow it to pass before their eyes again, even remember the people, events and quality of images. Is this not imagining and creating imagery also? We find it quite easy to dream-draw all the necessary people, places, events and symbols our everyday lives require; yet, we still condition ourselves to think that the imagination is something possessed only by the gifted or artistic. Each one of us is a crafter of dreams; visual thinking and visual imagery is our native language. This same language was fully understood by the ancient mystery schools and the various brotherhoods of artists who emerged up until the last century.

The elite networks that control the world today through banking, media industry, politics and so on have used this knowledge of symbolism to create required effects on people. The multimillion-dollar media and advertising industry along with Hollywood, is a perfect example of how archetypes and symbols are used to entice us, generate particular emotional responses and 'mesmerise' us. This was the origin of the term Hel-wood or Holle-wood (Hollywood) the forest or place of magic worshipped by the Druids, the Chaldeans and the Naddred in the ancient world. Movies and television shape attitudes, create conventions of style and behaviour and in doing so reinforce or undermine many of the wider values of society. Hollywood with its 'tinsel-town stars' are worshipped like gods by millions of people today. The Hollywood mindset with its magic and special effects is just as mesmerising as any ancient deity (or ancient technology) could have been. Places like Hollywood and the symbolism behind it, are the calling cards of these ancient brotherhoods who have thrown aside their robes and chivalric armour for corporate suits, white gloves and dodgy handshakes. Colours, sounds, images and icons are often used with effect in advertising, on com-

pany logos, movies, television commercials and so forth. For further information on symbolism in the movies, please see my movie blog: throughancienteyes.blogspot.co.uk.

So many movies, and television in general, contain subliminal messages designed to affect those who consume such visual imagery; as do projected subliminal messages influencing our emotions and stimulating needs and desires. Children fall prey to this type of mantra-like attack on the subconscious, especially through television, tablets and cell phones, today. The same knowledge of visual stimuli is used with effect through the news, media and advertising industry network, so to create desired responses to information drip-fed into public mass consciousness. The more open we become to the subtle energies that operate on the subconscious levels of our soul, the more we start to notice when we are being forced, or manipulated, into believing a certain line (lie), or are being emotionally drained through what comes out of the 'news' on a daily basis. If we leave behind all the preconceived notions of the media industry and realise when we are being compelled through subliminal messages, it is possible to see into behavioural patterns that diminish our creative power. Only then can we start to create alternative subconscious imagery (from our own internal source), which allows the natural artist within everyone to reveal itself. The following words are attributed to artist, Eric Gill, who said: "Artists are not special kinds of people, but everyone is a special kind of artist".

Having Visions

The idea of having a vision is also highly underestimated and not understood within our modern society where in most cases, dreams and visions are considered the same thing. Within ancient cultures, dreams were regarded as mental release that showed the individual concerned aspects of their everyday lives from a higher perspective. However, visions came from a willingness to participate in changing one's life towards a higher understanding of the self. What do I mean? Quite often in dreams we can get pushed around, while the dream itself can have no logic. On the other hand, a vision can feel more condensed with a certain amount of meaning or purpose, which is the opposite of running-and-getting-nowhere scenario, something that often occurs in dreams. Even though both vision and dream share similar fluid characteristics, people will recognise a vision for its quality of information in relation to the willingness to be involved in the vision itself. I would suggest there are no set rules for how a vision can come to us, it is as individual as painting a picture. However, when visions comes into our world through whatever means, we can be sure that doorways are opening for us. Whether we choose to go through the 'door' depends on if we are willing enough to accept the challenge offered by the vision.

For thousands of years 'visions' have been told in stories and described through paintings as a form of remembering our connection with non-physical levels of creation. Visions are what you might call seeds planted in the minds of creative individuals that are now growing to bear fruits of great

changes here on Earth. A grand ripening process at the core of our being is bringing 'earth changes' now unfolding across the planet. Visionaries like Blake, Nostradamus, the Hopi Indians, and the Mayan mystics, all saw this process as part of a new web or consciousness that will supersede the old structures of limited creative potential. The new web can be likened to what Blake called the *New Jerusalem*, and what Saint John in *Revelation* saw as the Holy City coming down from Heaven to Earth (Rev: 21, 1-2). It could be said that the foundations of this new web (energy grid) will come with a 'shift in consciousness' from looking outside of ourselves for answers, which diminishes our creative power and empowers all the illusory structures that make up our daily toil, to instead, looking within for answers that will empower unique, subjective creativity.

Plato saw this process as one that involved two zones, our *zone of influence* and our *zone of concern*. People who operate totally in their zone of 'concern' are generally people who are out of control and look outside of themselves for solutions to their everyday problems. This type of person (and we have all been there) looks to others to make everything right with their world and more often than not, when we are in that zone or state of mind, we are in the habit of giving our power away. On the other hand, our zone of 'influence' defines where our true power and responsibility lies. By extending that inner zone through proactive action, positive attitude and creativity, we become influential to our immediate surroundings. In other words, all this really means, for me, is to be creative with our thoughts and actions today through our own imagination. From that notion we fashion our own future and by doing that we change our world. Like the spider has no map to look at before she weaves her web, we too, do not have our lives totally mapped out for us in advance. Instead, we determine and shape our web (life) by the choices and directions we take in the moment, all the while responding to signs along our life's journey. I feel that we learn to acknowledge our responsibility for creating the life we weave through trusting our creative powers. Once we realise our own part in the web of life, perceiving the wider picture and coming back to cooperating in the circle of life, we set a precedent for removing the dominating and controlling structures which foster limitation and grotesque suffering in our reality. As I have already stated, to connect with nature and the web we have to empower the feminine, especially in men. Our intuition, inner knowing, inner peace and desire to create through love are the keys for transformation. In truth our life is never-ending like the circle, we just take up different positions along the rim. When we refuse to embrace change and go with a personal flow, then it manifests itself in ways that deny the spirit and the fire of our true self. I sometimes feel that the world is starved of vision and the eternal worlds of spirit, only because as a whole we deny spirit's existence.

In Blake's visionary epic poem *Jerusalem, The Emanation of the Giant Albion*, there are themes which relate to the recovery of humanity's soul while returning Earth to a higher vibration. Through one of his mythological characters, Albion (a Druidic name for Britain), Blake illustrates the reunification

between Albion and his sister, Jerusalem, which is symbolic of higher dimensions being anchored on Earth. On another level the poem is a story of reunion and the coupling of Sun and Moon (divine male and female) energies, which Blake depicts quite clearly in his illustrations. I feel that it is also a story about re-connecting with our ancestor spirits, while opening the portals to other dimensions, so the spirits that want to help us with this transformation can return to the earthly planes. These are the same portals that more malevolent beings can pass through, when called on by initiates, to gain access to different dimensions. In Blake's illustrations for *Jerusalem* and on the art and sculptors at Knights Templar cloisters that I have visited in Britain and France, the same symbols are often used to depict these portals. One of these symbols is a series of interlocking circles which show angels in Blake's version and a devil climbing through the centre of the circle (portal) on Templar art and sculpture (see figure 98). What both versions show are interdimensionals peering through the grid time-frame structure, which is said to link different worlds with our reality.

Over the years, I have received very powerful visions relaying this reunion with the ancestors and other dimensions. I have also had similar visions that relate to individual empowerment releasing our internal forces, which can lift the veil, so revealing the truth about our real potential. One of the main reasons why all this is happening now, I feel, is because the veil is being lifted away through the process of remembering that we're all co-creators with infinite powers and 'magic' at our disposal. What I am talking about is not some extraterrestrial saviour coming to aid in our self-discovery, or a return of a religious figure like Jesus. Instead it is the individual realisation that we

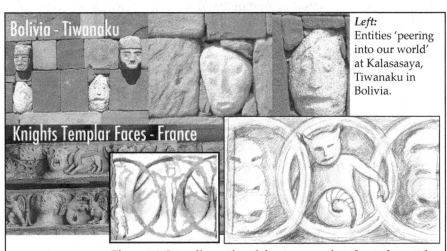

Figure 98: Interdimensional forces emerging through portals.
Above Right: Drawing of a Templar capstone at Le Puy cathedral, France.
Above Middle: A copy of a section from Blake's *Jerusalem*. These are common images found in rock art and on gothic cathedrals; the linked circles represent different realities connected through moon and earth consciousness.

must face our own fears and cleanse our emotions through *loving* who we are. We cannot complete this process of self-discovery without having visions and while our perpetual belief has been that choices are limited, we have shut down our true creative power, symbolised through arachnophobia and fearing the spider (creator) within. When the veil came down in ancient times we became shut off from our creative life-force, and this imbalanced the human psyche for a multitude of reasons. Over a long period of time we developed what shamans and visionaries call 'soul loss', or a creative sleep; our spiritual slumber is evident through the lack of vision and diversity in society. In many areas of our lives this can be related to apathy, which is the main creator of what is often called the common-man-syndrome. When we choose to become more sacramental towards life we automatically let in the creative spirit and the ancestors that want to work with us at this time. All our creative expressions of the god-force (the energy within us) are the stuff with which we can weave a new web, a new reality here on earth. It is only a choice or a thought away.

The Coming of the Light – The Fifth Element

There is an immense energy entering our world today, one that has been building since the 1960s. I believe this energy, or light, is causing such a disturbance deep within our souls that very shortly it will have to be answered by the spirit of the Earth and the spirit of the artist. What do I mean by this? The current transformation of human consciousness is being inspired by energies introduced to the earth's electro-magnetic fields, or what is described as the 'Earth Matrix'. This global energy field must affect human consciousness because we are part of that field which, if we consider our relationship with nature and her atmospheric fields, must also affect weather patterns.

Both Russian and American scientists have been monitoring extreme weather changes and natural disasters for at least forty years. Scientists say that from 1963 to 1993 there was a 410% increase in typhoons, hurricanes, mudslides and tidal waves. According to American scientists like Michael Mandeville, the overall earthquake activity is said to have increased by 400% since 1973.[8] What the Russian National Academy of Sciences in Siberia and the Rutherford Appleton National laboratories in California agree on, is that the overall changes we are witnessing through natural disasters can be broken down into three categories: energy field changes, luminosity changes and atmospheric changes. All these changes are said to be affected by a higher energy flooding into our Solar System. Of course, much of the extreme weather we have endured in many parts of the world has been caused by 'weather modification' at the hands of the elite. Hurricane *Irma* in 2017 was the strongest hurricane observed in the Atlantic in terms of maximum sustained winds since *Wilma*, as well as being the strongest storm on record to exist in the open Atlantic region. Despite lack of proof regarding climate change models, many believe the US government has been actively engaged in hurricane modification programs for a minimum 70 years,[9] with Haarp

being pivotal in radical change, no doubt.

According to both ancient and modern sources many of the changes we are witnessing are also part of a natural cycle of learning and evolution, which manifest as climate change. The forces flooding into our reality, according to Gnostic ideology, are part of what they call 'Sophia's Correction' as she reverses the damage done by the Demiurge (something I will come back to in the last chapter). Some say we are in a time of opportunity to unite our intuitive feminine, artistic side with our masculine creative side. The freeing of this female (Sophia) energy will show itself in more women in positions of influence and a very different kind of man altogether. A man unafraid to feel emotion, or to be creative and speak out against injustice, irrespective of what others think of him, is a man who is finding his female side. Many men are already feeling lost and without a sense of identity as the macho man stereotype departs the collective psyche. The more balanced male is one who is not frightened to express deeper emotions, which is exactly what has been happening over the last thirty years through the Ecological and New Age movements right across the planet. However, at the same time, men of this generation seem to be disconnecting from the role of the 'warrior', due to an influx in the 'transgender agenda', as I call it.

I feel that this increase in light (higher consciousness) on the planet reached a peak in 1987 with what has been recognised as the Harmonic Convergence. An event that triggered a 'spiritual alarm clock', so to speak, in thousands of individuals, including myself, many of whom were compelled to gather at sacred sites all around the world at the same time. The Harmonic Convergence was an event that allowed thousands of people to ground a higher energy – higher vibrations on Earth, and to receive visions of the coming rise in consciousness.

In a vision I received in the same year, I saw what were masses of different peoples gathering on a high plateau and embracing each other, while immensely bright-coloured lights and sounds filled the air. The space all around these people was bathed in a radiant multicoloured light, one that penetrated their bodies. I now realise what I saw was symbolic of an intense magnetic energy, or light, as it entered the earth's grid. I also felt that the imagery in my vision was showing me the reunion with our ancestor spirits, or ancient aspects of ourselves as the human collective consciousness peaked. The plateau was symbolic of that higher perspective, or the higher planes of existence which can only be accessed from within. I never saw this vision as a fluffy or flaky dream-like experience; it was a very powerful, tearful and emotional experience. The feelings generated by this vision were as if we, as people, had come through a very challenging experience and were rejoicing at the outcome. I feel that those experiences are about to be faced in the next five years, as we confront everything in this life we came here to deal with. My experiences will be different from yours but I am certain that we are all about to make our mark in the name of love and freedom. The creator within us is guiding each individual in their tasks, and this means that we are in control of what we can create and achieve at this time. Nature is also

inspiring us to become energised, so as to be able to see into different levels of awareness and therefore transform our singular perspective of life.

At the time of that vision I also felt that people in their hundreds of thousands were anchoring a higher electromagnetic energy within themselves and therefore on the Earth. For myself, it was a vision of a shift in consciousness, a purification of the spirit, mind and body. It could also be seen as a meeting between the spirit of the Earth and Heaven, or the merging of different dimensions. Some of the activity I saw in that vision could have been taking place on another frequency range, which according to scientists like Gregg Braden and Michael Mandeville, is increasing its vibratory rate by the year. To access higher knowledge and make this lift in consciousness at this time, I feel, we have to allow our creative energies to vibrate throughout our bodies. At the same time we can use this vital life force to make positive changes to our lives. Like anything on Earth, we only create when one energy is mixed with another and just like a baby being conceived, we are birthing the energy, signs and images that can transform our lives. When we open up our own unique, creative power, we become a bridge between the earth spirit and the cosmos; in this way, we can anchor much higher energies (dimensions) on the Earth and within ourselves. In truth, we are those inner and outer dimensions and our connection with our higher self or the source comes when we know deep within that we are that source. As Paracelsus the 15th Century mystic, physician, scholar and wanderer once wrote:

God who is in heaven exists also in man, and the two are but the same.[10]

Only until we allow ourselves to be free from all self-imposed limitation through how we think, will the 'spider inside' unravel its silvery threads of energy, creating the foundations for our own unique language of the spirit. More than ever before, I feel it is a time to awaken that weaver or spider and let the living rivers of the imagination run free.

Sources:

1) Street, C.E, *Earth Stars*, Hermitage Publishing. London 1990. Chapter One & Chapter Two. 'Earth Stars' also relates to the Golden Mean.

2) Ibid, p52

3) London, Peter, *No More Second Hand Art, Awakening The Artist Within*. p43

4) Elkington, David, *In The Name Of The Gods*. Green Man Press. 2000.

5) Wa'na'nee'che'(Dennis Renualt) & Timothy Freke; *Principles Of Native American Spirituality*. Thorsons. p29

6) *Tribal Winds*, Music From Native American Flutes. CD. First Flute song. Earth Best Records. 1995

7) Owusu, Heike, *Symbols Of Native America*. Sterling Publishing. 1997. p33

8) Information taken from the David Icke website: www.davidicke.com

9) www.geoengineeringwatch.org/massive-us-senate-document-on-national-and-global-weather-modification/

10) Ackroyd, Peter, *Blake*. Minerva press. London. 1996

Journey Maker
Into the Places Where Art and Science Meet

"Thoughts are things. Imagination is experience.
Accept this and the gateway to other worlds will
slowly swing wide for you and each day will bring
forth new wonders, so that you become more as a child,
absorbed and enchanted by all there is of which to learn."
Gildas (400 AD)

The more I have exercised my own creative powers, the more I have come to realise that what we call time is actually a cosmic river that is ever turning and ever changing – running its own course. This river of time does not dance to the tune of clocks, it just keeps on flowing returning to the sea – its source – ready to be transformed, to fall as rain on the land and given a new direction. We too, are part of that celestial river, the journey makers who enter the path of self-discovery. Every image I have brought into the world has shown me that celestial river of time – the path of self-initiation. Each image has been a puzzle picked up on the journey, and like stones on the river bed, each painting tells a story of the past and the future, living in the present. Some of the things I am about to talk of would be hard to prove in 'scientific' terms, but I am not out to convert anyone to my own personal vision. Instead I will complete this book by taking you on that journey with me, into those hidden worlds, the places of the divine arts, prophecy and the imagination.

The Galactic Circle

Today as we live through early decades of the new millennium, and from my own research, meditations and paintings, I feel there is an awakening taking place across the world. The earth itself is also going through tremendous changes both on a physical and ecological level and, like our ancestors before us, it is quite possible that we may witness 'global' life-changing events in our lifetime. What new discoveries, dangers or opportunities await us in the end depends on how we respond to our rapidly changing world. How we see ourselves is also part of what many ancient cultures have termed 'Earth Changes', or what is often described as a 'passing of worlds', as the old is replaced by the new. What these fantastic changes bring depends on us and how we respond to the world that we see daily. How we see the world is going to be the difference between creating a personal *prison* forged by allowing others to 'control' every aspect of our lives, through extreme law enforcement (fascism), or a *paradise* created through liberation of the human psyche. I believe this time of choice between freedom or tyranny is now facing us and

it is more prominent, in global terms, than it has ever been before.

From ancient to modern times there have been prophecies of an 'end time', or a change on earth, as this cosmic river charts a course to a higher level. It is said that this end time (a new age) is occurring *now* as we move further into the 21st Century. Nostradamus, the Egyptians, the Hopi, not forgetting numerous religious texts like *Revelation*, have all pointed to a time of change when the Earth, and therefore humanity, would also pass through into a different reality.

The Hopi Prophecies

An ancient Hopi Indian prophecy states: "When the Blue Star Kachina makes its appearance in the heavens, the Fifth World will emerge. This will be the Day of Purification." The Hopi name for the star Sirius is 'Blue Star Kachina' and they say that the purification will come when the Saquasohuh (Blue Star Kachina) dances in the plaza and removes his mask. The taking-off of the mask could be symbolic of 'interdimensionals' revealing the true nature of who, or what, they are. It could also relate to the 'lifting of the veil' that separates the upper and lower worlds I touched on in earlier chapters.

Near the Second Mesa on the Hopi Reservation in Arizona, a picture is etched on a cliff; depicting the past, present, and the future. This site is more commonly known as Hopi Prophecy Rock and it depicts the Hopi emerging from the underground to the surface of the Earth. The actual place for this event is said to be a religious site located in the Grand Canyon. The story depicted on the Prophecy Rock shows how the four leading clans of the Hopi migrated in four directions, each turning left forming the ancient Swastika symbol. After journeying North, East, West and South, they were asked to return to the centre of the Earth grid (web) by their Creator, Masua'u. This location is said to be where the Four Corners meet near Spider's Rock, in Arizona's Canyon de Chelly, stretching as far as the Sedona region. According to the Hopi, when the electromagnetic energies reach this spiritual centre it will be the end of the Fourth Age, and that time, according to the Hopi, is very close. I believe we are living in its final years. What will come in its place, according to the Hopi, is 'The Fifth Age', or what people like the Maya call: 'The World of Illumination'. The Hopis prophecise that there will be two more worlds (stages in evolution) after this one: The 'World of Prophecy and Revelation' followed by The 'Seventh Age', and 'The 'World of Completion'.[1] All of these 'worlds' relate to the markers on the journey home to 'oneness'.

The Hopi Prophecy Rock depicts three 'two-hearted' individuals and according to the Hopi, a two-hearted person is one who thinks with his head rather than his heart. The Hopi call this trait *Koyaanisquatsi*, which translates to 'a life-out-of-balance'; it relates to the left-brain function of analytical thinking (logic) and our alienation from nature. A person who thinks with or follows his/her heart uses the right-brain function of 'intuitive thinking' and according to the Hopi, modern man is out of balance because we live in a left-brained dominated society. We place more emphasis on left-brain modes of

thinking, like logic and uniformity, rather than right-brain modes of thought, such as creativity and spontaneity. The prophecy explains that 'two-hearted' people (polarised people) have a choice of choosing to start thinking with their hearts or continue to think with their heads only. If they choose the latter, it will lead to self-destruction (look at what's happening in the world today). If people choose to think with their hearts (going with the flow) they would gradually return to the natural way, to a higher state of being.

The Hopi prophecies talked of by J. R. Jochmans in his book *Rolling Thunder: The Coming Earth Changes* (1980), document in detail what the Hopi elders have seen happen in the past and what they say could happen to the earth at this time. In the book, Jochmans talks of a meeting in 1958, on a desert road not far from Taos, New Mexico, between a minister called David Young and the Hopi elder, White Feather. White Feather of the ancient Bear Clan talked of nine sacred revelations that foretold of the end of the Fourth World and the beginning of the Fifth Age of Peace. What is called the Fourth World by the Hopi, or the Age of Iron by the Ancient Greeks, the Age of Bow by the Sioux, or, The Fifth Sun by the Mayans is a point on that 'galactic wheel' as it turns, circling and running its course into new territory. The Indians called the same cyles: Yugas, with our current Yuga being the 'Age of Kali'. While travelling with Young, the elder spoke of seeing many things prophesied through the eye of the Hopi that would become reality on earth. For example, the Fifth prophecy as foretold by White Feather, saw the coming of a giant network of telephone, cable and electricity lines that would cover the whole of the earth. The Hopi elder described it as a giant spider's web. The Ninth and final sign of the coming Earth Changes was said to be a star falling from the sky, which is also a common theme in other native prophecies. In the words of White Feather:

You will hear of a dwelling-house in the Heavens, above the Earth, that shall fall with a great crash. It will appear as a blue star.[2]

Some have said that this event could have been the Chinese *Tiangong 1* Blue Satellite, which crashed back to Earth in 2018.[3] But could it also be the arrival of a comet or the burning up of the star Betelgeuse? Any celestial event, or the appearance of a bright comet, would cause concern, and possibly even panic for some who view it. Because comets are regarded as residues of primitive solar nebula, coming from the outer reaches of the solar system, they are also considered ancient markers of important and accurate evolutionary cycles. The Hopi prophecies go on to say:

...that the world will rock to and fro, and that white man will battle against other peoples in lands of those who possessed the first light of wisdom.[4]

These and many other events from within the prophecies, including the coming of Europeans to the Americas and the two World Wars, are all symbolic

of the river of time, how it can be accessed, utilised and changed to bring about events of significance on earth. As I am updating this chapter we are witnessing yet another 'unnecessary' proxy war, where the European elite, the USA and Israel are all fueling the destabilisation of Syria, a place obviously important to those in power who would love to see another World War. How we view what is unfolding in the world at this time is crucial to the forces that create the mayhem and the suffering we see. Fear and threats of extreme terror are being used, along with actual physical attacks, in ever-increasing numbers since the start of the *War on Terror* in 2001. All this is designed to create a very frightened public; one that will relinquish what is left of civil liberty, to the Predator Consciousness that perpetrated these atrocities in the first place.

The Coming of the Light

On a scientific level the tremendous changes both physically and spiritually on Earth at this time, have been linked to our planet's relationship with both solar and stellar light. Quantum physicists, since the 1920s, have been analysing and measuring (a previously undetected) light in particles known as photons and Superstrings. Much pioneering work by Alexey N. Dmitriev and the Russian National Academy at Novosibirsk in Siberia, has shown how the growth of the Sun's magnetic field (by 230 percent since 1901) is due to these particles of energy. Other scientists like Paul Otto Hess for example, now agree on the existence of a belt of highly charged energy (light) centred on the Pleiades (Seven Sisters) star system, which has been sweeping our Solar System since the 1960s. This so-called *sweeping* of our Solar System by a highly-charged energy is causing the Sun's heliosphere, which is a magnetic 'egg' around the sun, to expand. The expansion of the Sun's electromagnetic energy field, according to scientists like Dmitriev, can be recorded through the growth of heliospheric plasma at the outer edges of our solar System which has increased 1000 percent in recent years. The effect of the Sun's increase in energy projected onto other planetary bodies in the Solar System, according to Dmitriev, ties in with the increase in natural disasters endured on earth since the 1960s. He also says that magnetic fields and luminosity of planets, like Jupiter and Uranus, have more than doubled since 1963.[5] Uranus and Neptune also appear to have had pole shifts of above 50 degrees, according to data collected by Voyager 2. Dmitriev also points out that the moon is growing an atmosphere that's made up of a compound he refers to as 'Natrium'; he asserts there exists a 6,000-kilometre-deep layer of Natrium around the moon that wasn't there before. In my fictional illustrated book, *Moon Slayer*, I hint at why this is occurring and what forces are creating these changes. What seems to be the common ground coming out of much scientific analysis, is that a highly-charged light *sweeping* our Solar System is causing huge magnetic changes, all of which affect the atmospheres and luminosity of planetary bodies circling the sun.

For most folk, light and gravity seem to have nothing in common. Light is

a familiar force that comes in a spectacular variety of forms, while on the other hand gravity is invisible, more distant and operates on a larger scale. Yet it was a great Nineteenth Century scientist named Michael Faraday, a self-taught genius, who conducted elaborate experiments with light, magnetism and gravity that would change science's view of higher dimensional space and how light is involved in this process. Faraday visualised 'lines of force' that emanated from magnets and electric charges filling up all available space. His famous work went on to be known as the search for the 'field equations of the forces of nature'. Photonic light, according to some researchers, is a message from a higher consciousness, one that creates all life forms. I am certain that our planet's immersion in what has been described as a belt of energy, which has increased since the early part of the millennium, has to be influencing the thinking, emotional, spiritual and physical bodies of all life forms. I feel that we are being given a chance to evolve our consciousness and to create a new synthesis of mind.

Scientists also claim to have discovered that our solar system takes an estimated 24,000 years to orbit the Pleiades constellation and its central star, Alcyone. There are also many ancient legends across different cultures that talk about the Pleiades and its ability to affect planetary evolution and therefore, our lives here on Earth. The Hopi called the Pleiadians the Chuhukon, meaning those who cling together, just as birds do when they fly creating murmurations, or flocks, without colliding. The Hopi considered themselves direct descendants of the Orion and Pleiadian star systems. The Navajos named the Pleiades the 'Sparkling Suns' or the 'Delyahey' and the home of the 'Black God'. The Iroquois still pray to Pleiades for happiness. Many native cultures know that it takes around 2000 years for the Solar System to pass through this highly charged river of light and this would relate to the precession of astrological ages mapped out by the zodiac. It takes around two thousand years for the Earth to pass through each constellation; the last age being the Piscean Age symbolised by the fish. The age we are now immersed in is the water carrier or Aquarius, often referred to as the child Ganymede, who was abducted by Zeus (the father of the gods) in Greek mythology. In simple terms the precession of ages around the zodiac is reaching a point when light of a higher substance is penetrating our Solar System and therefore every planetary body caught within the sun's field (see figure 99 overleaf). The same light is also redefining the molecular structure (vibration) of everything on earth, which includes our thoughts, dreams and physical reality. In religious terms this could be viewed as a Second Coming of light, as the planet passes once again through the Age of Aquarius. Native American prophecies describe this period of change as the time of 'great cleansing', as we merge dimensions and become multidimensional. From a 'religious' point of view, we are certainly going to have our perceptions 'cleansed', when we realise just how many 'father figures' in the church have been/and are involved in horrific child abuse, and depravation of gigantic proportions. According to knowledge embedded in the native Circle Within I touched on in *Chapter Seven*, the position of the time of cleansing is paramount to the

empowerment of the imagination and its nature is both feminine and humanitarian. These two traits are important aspects that are coming to the forefront in people despite all the horror we see committed by our fellow humans. Both humanitarian and feminine principles can reconnect us with our creative side, with nature and therefore the Earth herself. I would strongly suggest that these are the main attributes that are helping a Creative Renaissance to unfold across the planet at this present time.

The Rebalancing Beam - Sophia's Correction

The Gnostic writings I talked about earlier in the book, mention a 'correction' or reversal of the Fall by Sophia, so to end the distorted and polarised world created by the Demiurge. The word *'correction'* is

Figure 99: The Rebalancing Beam.
In this image, I wanted to illustrate the idea of light 'sweeping the planet', placing us in the Fifth Dimension.

found in the *Nag Hammadi* texts as the word *'diorthosis'*, which scholars also translate as 'dual solution' or' two form solution'. All of which comprise the solution or the 'correction' to the original problem. If we see the 'problem' as collective consciousness being 'held back' by the belief in the (Demiurge) Father-God figure (*all* religion), then it would make sense to say that Sophia's Correction would be to shine a light on the darkness of the mind, to expose all of the corruption in the systems that are embodiments of the Father-God. The Goddess needs to shine! On another level the 'correction' is more about the natural 'organic' influence on our physical world, as Sophia 'awakens' to her dream (turned nightmare), and symbolically bathes in the higher Aeon light that is presently passing through her body. Many global 'natural' events could be physical signs of the correction occurring. Sophia's Correction could be described as the Kundalini awakening of the planet herself, that initiates a wave of 'global awakening' against the Archon-inspired tyranny and control tightening its grip on humanity. Signs of the correction could also include mysterious deviations in the cycles of the moon, anomalous sunspot activity, an increase in photonic light across the solar system, and increased earthquake activity on Sophia Earth. It could also manifest as public uprising against the Archon-controlled elite's attempts to start a World War III (see anything relating to Russia/Iran) and fulfil an Archon-inspired Transhumanist agenda.[6]

In some ways, this leap in consciousness has more to do with a change in

our 'perception of time', which I believe is unrelated to age or lifestyle. Some have speculated that we will become timeless! One thing for sure is that a *quickening* is happening within ourselves and the world around us, and this is being felt on a daily basis as more and more people wonder why they feel there is less time to do certain physical things. And why the world seems so ludicrous on so many levels. While at the same time, our capability for spending more time doing creative and leisure activities should be multiplying by the year as computers do the jobs we once did, without allowing computers (A.I) to rule us. The ancient understanding of time, I mentioned earlier in the book, is coming back to our lives, not least through the immersion of our planet in that photonic beam that has increased the levels of plasma affecting all bodies in the Solar system.

Again scientists have suggested that the highly-charged particles of energy and the photon beam could be causing an increase in solar flare activity.[7] I feel these cycles are fundamentally linked to a change in consciousness through an enormous magnetic redevelopment of our bodies and environments! Another important discovery has been identified in recent years through what is known as Schumann Cavity Resonance,[8] which explains how the heartbeat of the planet is speeding up, while the magnetic spin of the Earth is slowing down. The Schumann Resonance, according to scientists and researchers like Nicholas Jones, forms a natural frequency pulsation which allows the Earth to evolve harmoniously. Schumann Resonance is said to be extremely low frequency (ELF) waves that naturally exist in the Earth's 'electromagnetic' cavity, the space between the ground and the ionosphere (see figure 100). Jones, writing on the Internet, says of this natural frequency pulse affecting our minds at this time:

Figure 100: The Blocking Frequency.
A natural frequency pulse that is created by how we humans think. How we think, can be the difference between creating a 'prison' (blocking frequency) or a 'paradise' on earth.

Earth is wrapped in a donut-shaped magnetic field. Circular lines of flux continuously descend into the North Pole and emerge from the South Pole. The ionosphere, an electromagnetic-wave conductor, 100 kms above the earth, consists of a layer of electrically charged particles acting as a shield from solar winds. Natural waves are related to the electrical activity in the atmosphere and are thought to be caused by multiple lightning storms. Collectively, these waves are called

'The Schumann Resonance', the current strongest at 7.8. [9]

Gregg Braden the author of *Awakening To Zero Point* (1995), has suggested over the years that the increase in Schumann Resonance will crescendo during the time period in which we now live. A time when, according to both science and native oral traditions, the earth's rotation around its axis could slow to a standstill and then rotate in the opposite direction! I know that may sound bizarre, yet do we really know everything about the ionosphere and the electromagnetic forces that shape this planet? Those who say: "Yes", are only confirming that they actually don't know.

Even the mainstream media have now talked openly about the possibility of a 'pole flip' in this period. According to the *Observer's* Science Editor Robin McKie, the earth's magnetic field (the force that protects us from deadly radiation bursts from outer space) has weakened dramatically. Dr. Alan Thomson of the British Geological Survey in Edinburgh has also stated how the earth's magnetic field has disappeared many times before - as a prelude to our magnetic poles flipping over, when North becomes South, and vice versa. Gregg Braden, like others in his field, estimates that the earth could stop rotating for some days before it spins again in the opposite direction. If this proves to be true then we are in for powerful radiation bursts, which normally never touch the earth's atmosphere. The heat-up that would occur, due to this outburst, would trigger climatic global disruption. According to Robin McKie, navigation and communication satellites, earth's eyes and ears, would be destroyed and various migrating animals left unable to navigate. Only in recent times did we witness hundreds of starlings dropping from the skies over Draper, Utah, and in Rome, Italy. Obviously the birds are responding to 'electromagnetic' fluctuations, whether natural or 'man-made'. If the planet spins in the opposite direction, the flow of electricity would also be reversed, and with it, so would the electromagnetic poles. The same theory was also confirmed by a cartographer I met in 1999, who explained to me that the magnetic North Pole had moved and was still moving south, into Canada ... And that was 1999! It is said that if the planet stopped rotating, one side of the Earth would be in total daylight and the other in darkness and this is what the ancients said happened many thousands of years ago. The Peruvians talked of the long night of three days, and the Hopi record how the sun rose twice in one day. Other ancient accounts say the sun used to rise in the West and set in the East, another indication that the earth used to spin in the opposite direction. Is all this actually going to happen? I don't know, but I find the subject extremely inspirational. Much of my own visionary imagery is communicating what science has been confirming in recent years.

Another way in which this magnetic energy is received and expresses itself on earth is through the all-encompassing 'cosmic web' I have described. The web is also the Matrix, or 'energy grid', which supports the natural expression of our creative life force, and provides the structure by which we perceive this reality. The 'matrix' also provides a structure for many dimensions to interact with and weave different realities. It can also be seen as the invis-

ible scaffolding of the universe, or like a giant computer programme, which connects all planets, stars systems and our DNA. Similar themes occur through the *Matrix Trilogy,* where renegade humans who have grasped this knowledge of the matrix, can see through the illusions of this reality and alter time. In fact the AGCT codes that constitute our DNA, in simple terms, could easily look like the 'green codes' as shown in the *Matrix* movies. When the character Neo in the *Matrix* movie 'becomes the matrix', by feeling his energy merge with it, his command of reality changes. In other words he becomes a 'system buster' who can reshape his view of reality. With this in mind (with or without joining a kung-fu class), you could say that we are all helping to rewrite the computer programme called `reality' from our own base here on Earth. When we trust in our creative powers (which connect us to the forces in nature, the stars and our DNA), we become the 'heart' of flowing with the natural changes on Earth.

Earth Changes – A New Perspective

According to many ancient sources, monumental change has visited our world before (our old friend the circle again), and is part of that wider 'astrological cosmology' known well to many native Earth people. What has become known as the Age of Aquarius is actually part of that 26,000-year cycle when the earth astrologically passes through the photonic belt of light, coming out of the Pleiades. According to ancient cultures like the Mayans and the Hopi, the Solar System came out of the Photon Band at the end of the Age of Leo 8640 BC. The world was a very different place then as we began what the Mayans call the 'Fourth Great Cycle', the Age of Cancer (8239 to 3114 BC). I have had powerful dreams that relate to the Age of Leo, as an ancient epoch on Earth. In one dream particularly, I saw many large (now extinct) animals moving in vast herds across the earth, while an immense 'blue and red' comet passed through a prehistoric evening sky. I felt there was great pain on the planet for humans and all species at this time, as we emerged out of the Photon Beam that time around. It was a time of new emergence, when the skies cleared and the oceans receded, and everything in nature looked magical. I go into these visions in much more detail in my graphic novel *Aeon Rising,* a story that takes us back to the time of Atlantis. I feel this epoch was the time when we realised the Garden of Eden and harnessed the powerful goddess energies that speak through the earth, in all her forms. It was a time of ancient wisdom (Sophia) that was lost to us as we 'fell' in understanding of our true potential. As creative individuals with ancient data stored in our DNA, we hold vivid memories about the catastrophes that visited the earth. I believe many of us are remembering and awakening as we pass through similar events at the end of this epoch. We desperately need a new perspective on earth, and as always it will depend on how we perceive the 'changes' as they unfold at this time.

The Fifth Dimension – Heavy Light

The idea of a 'fifth world' relates to the concept of merging different realities

from the *Third* Dimension (this linear time reality), cleansing the *Fourth* Dimension (emotions and belief systems forged by time and space) and moving into the *Fifth* Dimension, our creative heart centre (higher vibrations of light). A merging of dimensions could be viewed as a 'shift in consciousness' from a very physical, material, rational, overly-masculine attitude, towards a more feminine, holistic, emotionally-cleansing period as we venture inward to our spiritual heart. In scientific terms the Fifth Dimension, defined by mathematicians like Theodor Kaluza, could also be a physical dimension providing structure that could actually unify electromagnetics, nuclear and gravitational forces.[10] In the works of scientists like Peter Freund, the Fifth Dimension can be explained through the topology of the circle compared to the topology of a cylindrical world. In other words, the world or even our galaxy, or universe, according to Freund, can be contained within a small ball (glass marble) or sphere. This is the same philosophy behind the holographic principle and how scientists and physicists are realising that our world can be measured in small vibrating 'planks' of information, which are an image of the whole.

On the surface of this sphere (Earth) we as flatlanders (a term scientist Carl Gauss used for humans), do not see the whole, but we are reminded of it every time we hold up a glass ball and see all of our world reflected and across its surface. As Einstein realised, true light, which gives us the reflections in time and space, is really a vibration of the Fifth Dimension, or the world beyond time. Light in its higher vibrational state is constantly aiding the evolution of our 'being'. It can help us see through the illusions that are forged by electro-magnetic light, taken in by the eyes. The 'Earth Changes' talked about in many ancient cultures could be more to do with the fact that each and every planet in our Solar System is going through atmospheric changes due to an increase in higher vibrational light. When we consider the scientific data put forward by physicists in recent years, it would be foolish not to appreciate how important *light* is to our evolution as a species. Could it be that the 'Earth Changes' unfolding today are working up to a crescendo where there is going to be a sudden shift? Will we get to a point where we are so far into this new level of energy that there will be a sudden expansion of the basic harmonic wavelengths of light saturating interplanetary space? Art Rosenblum, from the Aquarian Research Foundation, writing on these subjects put forward by the Russian scientist Dmitriev, said:

> *This is conscious energy that is changing how the planet works, how it functions and what kind of life it supports. The harmonics of the DNA spiral itself are altering. That's the real hidden cause of spontaneous mass evolutions in previous epochs of time.*[11]

From the experiences in my life I feel we are becoming creative vessels of synchronicity, inspired by our higher selves to release all that is polluting us emotionally. Danté Alighieri (1265 -1321) wrote symbolically about this time we are now facing in his work *The Soul's Journey - The Divine Comedy*. What

he called facing the void and the journey through Hell, Purgatory and into Paradise, is symbolic of the Armageddon within each of us. If we become closer to the Earth by empowering the spirit and allowing the intuitive, eternal part of us to be our guide through life, then I feel we will be in a position to see signs through observing Gaia (Sophia), as she responds to this heavy (Aeon watery) light. Nature, the weather, animals are all pointers that send signals to our 'ancient eyes', telling us how to respond through the use of our inner knowing. Seeing in this way, while feeling the energies in nature, will bring us to our individual physical and spiritual 'safe havens' as the many changes unfold in the coming years. On the other hand, if we allow more destructive cycles to go on within us, it will show itself outwardly geographically, through more war, chaos and suffering; a very daunting reality if we continue to foster a polarised, dualistic (black against white) view of life. Becoming multidimensional is a lot easier than we think, since it is only limited thought that continuously hinders our evolution. All creativity ultimately becomes a vehicle for feeling these multilevels as we open portals that anchor higher vibrations on Earth and within ourselves. In truth, these vibrations already exist within us and constitute all of the finer bodies, like the 'circle within'. For signs of our multidimensional bodies consider astrology again and how the different planets and constellations, can be used to measure our emotions and psyche. The astro-physicist Giuliana Conforto, author of *Man's Cosmic Game* (1999), explains how the zodiac is an orchestra which sends out 'higher musical octaves' that are received by humanity. William Blake, like many other visionaries, expressed this sacred symmetry between the heavens (dimensions) and humanity when he wrote:

Heaven above, heaven beneath
Starres above, starres beneath
All that is above, is also beneath.

When we exercise our 'imaginal realities' through our creativity, meditations and inner feelings, we become that bridge between the power and magic that exists all around us. We also become a bridge on Earth between the Moon and the Sun, reaching out amongst the stars and into other dimensions. Before I venture into the many worlds I believe constitute different vibrations on Earth, first I want to focus on two ancient celestial archetypes that have been described by native peoples the world over as 'gateways' to these 'other worlds'.

Going Beyond the Moon

The moon is not what it appears to be. As an object of study I have found myself subconsciously focusing on the Moon. This 'silvery orb' often creeps into my work, not only as a symbol reminding me of the importance of the time we spend asleep on one level, but also as a reminder of the forces that operate 'just outside' of our 'earthly sphere'. Within the cycles of the moon are keys for understanding the nature of our personal gifts and abilities, all

Figure 102: *Here Comes the Moon.*

Figure 103: The Moon (as the Eighth Sphere) symbolically distorts the information field of Earth.

of which spring forth from the creative source, the dreaming and the more subtle frequencies that affect our emotions and moods. One particular painting I made, (or 'channeled' in 1993) gave me an insight into the forces that are *using* the Moon to 'draw in' souls that cannot see beyond the veil. The image shows a giant force 'moving' the moon towards the earth in an ancient epoch (see figure 102). What is blowing or 'moving' the moon is a symbolic rendition of the archons I talked about in earlier chapters. It is this painting that originally connected me with the author, David Icke, in 1994.

The moon is an interdimensional portal that acts as a 'counterweight' to another sphere, or realm. It is the doorway to what alchemists call the *Eighth Sphere* and the lower worlds that feed the archons (the Predator Consciousness). It is said to be a dimension that houses the shadowy forces that would very much like to 'fill their world' with the souls of humans. As the late, mysterious author, Mark Hedsel suggests about the Moon and the *Eighth Sphere* in his book *Zelator*:

> We must be careful of these words, for in spite of what I have just said, this region [the Moon] is not itself a sphere, nor is it a moon. Even to locate it behind the physical Moon is not correct, for in the Spiritual realm spaces and distances are different.[12]

The moon is a 'distorter' of worlds, which is the main focus, along with Saturn and the Sun, for *all* religions on earth. What I am describing here is a 'portal', or frequency information field that has been 'strategically placed', along with the sun, by something much 'bigger' than us - so to affect *all* life

on earth. One symbolic image that captures this concept very well is the window installation art, created by Iranian artist Shirazeh Houshiary, for the east window at the Church of St. Martin in the Fields near Trafalgar Square, London (see figure 103). It is reminiscent of a cross, with horizontal and vertical lines moving towards a central opening that allows light to pass through. But it also looks very much like a 'moon-egg portal' that is distorting the information fields of everything around it. Symbolically, the cross and 'egg' relate to the 'cross and cosmic fire' associated with the Orion Constellation. What is more interesting is that the art and symbol of the cross in this window also speaks of the control over our minds by religion. It is exactly what the Moon does - *it controls our emotional and mental bodies*. The moon, like all physical forms, is a waveform phenomenon that we decode into a holographic form. It is all happening on a vibrational level as wavefields in the Metaphysical Universe. What if the moon was acting like a 'super computer', 'coding' our physical reality? Some ancient sources, not least certain scientific studies, say that the levels of salt in our oceans could have been the result of an alien 'coding' via what we call the moon. The word French for salt (sel) is also a direct connection to the Moon Goddess, *Sel*ene.

I have felt for many years now that the moon was repositioned to affect 'life on earth' in a very ancient epoch. I watched a mainstream BBC science program a few years ago that looked into the influence of the moon over 'everything' on earth (see figure 104). It is common knowledge that the moon gives us our seasons and regulates the tides, through its orbit and position in relation to the sun. But what was even more obvious from this documentary was that if the moon was to 'move' just a fraction, it would devastate all life on earth. I feel that the moon could have been used as a 'weapon' to do just that in ancient times, and quite probably was one of the pivotal reasons for the destruction of Atlantis. It is also interesting to note that the moon has appeared *'destroyed'* in many

Figure 104: Moonopoly.
Human life is dictated from cradle to grave by transmissions from the Moon. It also dictates the perception and 'sense of reality' for all who focus purely on the 'game' call life.

novels and Sci-Fi movies over the years. In the 2013 movie *Oblivion*, starring Tom Cruise, the moon is blown apart during a nuclear battle between humans and aliens, which of course renders the earth unhabitable once the cataclysms (not least caused by the moon's destruction) had left their mark on humans. Did we experience a 'cull spectacular' in ancient times courtesy of the Moon? It's hard to prove, but food for thought.

Incredible, strange, giant buildings (constructions) have also been found on the surface of the moon. Former NASA employees, and those with experience of NASA's work, have revealed how non-natural phenomena on the Moon were airbrushed out of pictures before they were seen by the public. Sergeant Karl Wolf was one of those who shared this information. He was a precision electronics photographic repairman located at Langley Air Force Base in Virginia. In recent years, the phenomena known as *Transient Lunar Moon Flashes*, usually involving a sudden bright spark on the moon's surface, or a misty 'patch' of fog; discolourations or sudden darkenings, are a controversial area of study, too. The moon ain't what we think it is! Some researchers have even said that inside the moon is an entire artificial world of enormous size and technological advancement; one that includes a 'computer' system (way beyond what we call 'computers' on earth) broadcasting a manufactured reality or 'matrix'. It seems that encoded light from the sun is being re-encoded as it enters the energetic field of the earth-moon-system and the almost perfect relationship between these *three* bodies is part of the *Grand Illusion* created by what the Gnostics call, the Demiurge.

The Moon Before it *Moved*

The Moon provides reflected light by which we can 'dance between different dimensions'. Some indigenous cultures say that lunar knowledge connects us with a powerful archetype known as the 13 Original Clan Mothers. Once again we can see how certain numbers have an esoteric link with a deity, dimension or spirit. *Thirteen* seems to be a common number used within the mystery schools throughout the ancient world and it is quite probable that it is an archetypal force manifesting itself as the original thirteen astrological signs of the zodiac. Thirteen, or the relationship between *one* and *twelve*, can be found in many ancient texts and mythologies, through to symbols, flags and logos in today's world.

For some American Indian belief systems, there were said to be *thirteen* 'fourth-dimensional archetypes' embedded within the Cycle of the Moon. All of which were said to form 'thirteen characteristics' of the original feminine spirit made physical on earth. It is said each moon, or 'mother', symbolised a different gift or ability helping us to connect with higher dimensions. To the ancients, the moon was an immense force that guided our waxing and waning emotional bodies, providing a filtered light fuelling our dreams as we slept. All Moon Goddesses were considered rulers of emotions, illusions, reflections and dreams. Using the new moon to begin new projects and intentions can have very powerful results. The wish list I touched upon in *Chapter*

Eight is also linked to the use of moon energy, which can be harnessed to alter reality. To understand how the moon affects us is to comprehend how magnetic energies can also move the oceans of the world. The magnetic energy of the moon also resonates with all women, providing the monthly menstrual cycle. As I mentioned earlier, the moon regulates the flow of all waters and oceans (our emotions) and it was also the main deity that was consulted through the 'Goddess' in Wicca tradition and in witchcraft. The Holy Inquisition (the forerunners of the Babylonian priests) supported by the Church, tortured and murdered thousands of so-called witches for their reverence of the moon, while at the same time their hierarchy venerated the virgin 'moon goddess', Mary!

When we self impose limitations that prevent us from feeling our true creativity we can deny those thirteen gifts and abilities in their highest form. Limitation is a negative feeling that in extreme cases will foster fear, self doubt and hinder our psychic abilities. Our connection with archetypal energies (emotional beings) existing on other dimensions, just beyond the veil, comes through the subtle lunar energies of the moon and its relationship with the sun. The moon is like an electromagnetic filter that takes solar light and reflects it on earth through our dreaming hours, just as other people in our life reflect back at us our subconscious thoughts and emotions. Ceremonies that take place on full moons are said to be very powerful in forging links with the invisible entities and energies I have been illustrating throughout this book. To be able to reach these subtle worlds and listen to our dreams (including the positive feminine principles provided by the Moon), it has to be felt across society and especially within men. This balancing of the male/female energies within allows us to work through our emotions, instead of avoiding them. Utilising the energy these emotions and our dreams stir deep inside us, is the fuel by which all artists of every age have tapped into. Responding to our dreams through our personal language is how we communicate with the higher 'archetypes' that also exist within ourselves but are mirrored in the heaveans as the sun, planets and the moon.

Using the Cosmic Sun

In some ancient cultures the sun was considered a masculine energy that carried illumination and clarity on its rays. Yet if we trace sun worship back through ancient times, the sun was initially considered a goddess. The sun's power was considered a garment by the ancients, that clothed the goddess. In Africa, she was called 'Langa', which means 'the longing' by the Zulu. I believe that the power of the sun was stolen by the Predator Consciousness in ancient times, and artists like William Blake show similar themes in their images; especially the images that are based on the *Book of Revelation*. Blake's painting, *The Great Red Dragon and the Woman Clothed in Sun* (1803), illustrates the theft of the sacred knowledge of the Sun by an immense dragon. The ancients, as with modern day secret societies, considered the sun to carry fantastic knowledge that could be harnessed to empower all life on Earth. It was the reason behind every form of calendar system both ancient and modern.

Knowledge itself is neither good or bad, it just is. It is how knowledge is used, our intent, which creates the desired effect. The same understanding of this knowledge can be seen depicted in a brass and steel mechanical sculpture in the Clock Quarter of Paris. It is called *The Defender of Time*, commissioned by then French Freemason President Chirac, and made by Jacques Monastier. It shows the passage of time (symbolised by the Sun) defending itself from attack by an enormous dragon (see figure 105).

Within alchemy the sun was also said to be the force behind the sparks of passion and spontaneity, which allows humanity to use its creative life force. In Phoenician, Celtic, Egyptian and Native American legends the sun was considered 'all seeing', directing the Solar System through its journey around our Galaxy. The secret knowledge hoarded by elite initiates, priests and even artists of the many secret brotherhoods, all had a higher understanding of the sun's power. Certain Egyptian artefacts clearly show, through the use of gold jewellery, depictions of solar wind and magnetic forces being emitted from the sun. Gold, another symbol of solar power can be found in the art and sculptures of many civilisations. The Knights Templar at the time of the Crusades, and the later freemasonic network, used the knowledge of gold to reap

Figure 105: Le Défenseur du Temps
The Defender of Time.

extremely wealthy rewards. They created the early banking systems that used precious metals like gold. According to Pliny, gold was important in magical rituals and in the making of amulets. Golden amulets were perceived as protecting primarily children against harm and curses, and especially the evil eye. At times, gold was regarded as embodying powers of the earth and was mainly associated with supernatural powers, and powers of the gods. In ancient China, for example, gold symbolized the Yin while silver represented the Yang and for the Chinese the colour of gold was white, not yellow, which later became associated with the Philosopher's Stone.

Artists from the elite courts of Brugge, and Florence from the Fifteenth Century onwards, all had a higher understanding of how the sun could be used to invent both photographic realistic paintings and moving imagery through use of the camera obscura. Fifteenth and Sixteenth Century artists such as Jan Van Eyck and Caravaggio were elite court painters, theologians and scientists. Van Eyck was even considered to be an alchemist.[13] In Eighteenth Century Britain artists like William Blake, Samuel Palmer and the group of artists known as the Ancients also touched on the metaphysical aspects of the sun through their work. So did the 'outcast' physician and scholar, Paracelsus, who inspired Blake. He wrote:

The great truth of the universe lies within the human imagination; it is the source, the sun and those who understand its powers are the lords of all created things.[14]

Paracelsus, like the elite artists of that period, seemed to be expressing a higher knowledge of the sun's powers, probably given to individuals as initiates of secret societies. Even a Jesuit Priest named Theodor Wulf has been credited with the discovery of cosmic rays over eighty years ago,[15] which further emphasizes the point that hidden knowledge and technologies were only available to the initiates of the highest order. It seems that through sunlight and reflections made with mirrors these artists were expressing their understanding of how Three-Dimensional forms could be captured on two-dimensional surfaces. Using lenses within art for these Fifteenth Century alchemists, was the equivalent of today's filmmakers capturing images and mesmerising their viewers through the media and film industry. In fact, from a much higher understanding, the same process of reflecting light to create three-dimensional forms (our reality) is how the sun plays its part in a grand cosmic painting called the Solar system. We can create whatever imagery we require in our lives through *visualising*, moulding and expanding the energy that forms our world. Understanding how the sun creates many illusions within our world means we can easily imagine other worlds or dimensions of the soul, by first passing through the knowledge of the Sun.

In many cultures the sun was known as the grandfather or grandmother to our ancestors. It was the gateway that the human soul had to travel through to reach higher dimensions of knowledge and understanding. Another name for the sun was the 'Golden Door', the portal to other levels of our imagination and our link with star consciousness. In mythological terms the sun was seen as the eighth star of the Pleiades by different indigenous tribes and the door to our connection with the fifth, sixth and seventh dimensions. The sun's power manifests on earth as new work, art, science and the ability to bring success into our lives. When we look at the 'circle within' again, the illuminating rays of the sun are seen to relate to the East (the Rising Sun) on the circle and this is said by the ancients to be the place of spirit, inspiration and cleansed perception. As William Blake once wrote:

If the doors of perception were cleansed every thing would appear to man as it is, Infinite. For man has closed himself up, till he sees all things thro' narrow chinks of his cavern.[16]

Powerful magnetic waves are emitted from the centre of the sun, mainly because the sun makes up 99% of the matter of our Solar System. These waves interact with other cosmic waves, forming a series of standing waves, which, in turn, form concentric circles of vibrational fields orbiting the sun. The heaviest bodies, the planets, are caught in these circles and thus orbit the sun. The planets also create fields around themselves pulling smaller bodies

around them; our moon is a perfect example of this. The sun is the result of a delicate balancing act between the forces of gravity and nuclear forces that can create or destroy life as we know it. When the sun goes through magnetic changes so does every other body in the solar system. As I said in the last chapter, *all* of the planets in our Solar System, since the late 1990s, have been recorded as going through major transformational changes. They are all having their own version of 'global warming' without a carbon-polluting human in sight. The prominent (now retired) professor, Jan Veizer, from the University of Ottawa, along with astrophysicist, Nir Shaviv, at the Hebrew University of Jerusalem, concluded in their extensive study that 'galactic cosmic ray flux' was linked to climate variability. When the electromagnetic fields of the Sun change, so does every planet connected to it.

The electromagnetic power of the sun and its effect on the crystalline codes in our DNA, are also said to be inspiring us into becoming 'holy vessels'. Everything *is* luminous matter and it is *light* (or higher light) that is awakening our genes, our ancient memories. What scientists call 'junk DNA' are the remnants of what native peoples call the original twelve strands of human DNA. Through light, especially radioactive energy, it is said that we will awaken to our full potential as subatomic light increases in strength over the coming years, due to the sun passing through the photon beam I mentioned earlier. You could say it's just a process of remembering who we really are and what we can create in our lives!

The Lion and the Star

In the ancient world art was a symbolic language, a science, and native people had a higher understanding of how sun cycles and the change in magnetic energy affected all life on earth. I feel that 26,000 years ago our native ancestors entered the caves of Mother Earth to depict and draw what they felt as a massive redevelopment of their bodies and environment. Spirals, suns, circles, animals on the move, all capture the effects on cave walls of the energies that our native ancestors were feeling at that time. It is no surprise to see that one of the oldest pieces of art in the world is a 'Lion-headed humanoid' found in 1939 in a cave named Stadel-Höhle in Hohlenstein in the Swabian Alps, Germany. Those who have followed my art over the past two decades will notice that I like to paint lions, one of which was used on the cover of David Icke's book, *Human Race Get off Your Knees, the Lion Sleeps No More* (2010). The 'lion consciousness', as I call it, or the 'truth vibration' I touched on in an earlier chapter, has been symbolised in ancient art, not least in the portable piece found at the Stadel cave. Much symbolic art associated with the lion can relate to the power of 'light' and 'truth'. In the Bible, the winged Lion is also connected to this 'force' or 'power of the 'word' (or Logos) and this symbol comes from St. Mark's description of John the Baptist's voice 'crying out in the wilderness' (Mark 1:3). John's voice was said to have sounded like that of a 'roaring lion'. The roar of the lion can be seen symbolically, in the work of David Icke and by all those who resonate to the 'truth vibrations'. I would suggest that more than at any other time on earth

Figure 106: Christ Lion Consciousness

Not commissioned by David Icke, but one of several lion images showing the 'truth vibrations' rising collectively on Earth (as a Lion).

do people need to find their lion's roar today!

For those who may think I am some kind of Freemason, Luciferian or purveyor of Zionism, because I paint a lion with the Star of David on its forehead (see figure 106), well, they ought to really study symbolism properly before they jump on the "He's-a-fraud!" accusatory bandwagon. The Star of David is actually an ancient emblem found in sacred geometry (the 'seed of life'), and goes way back to its original use in Babylon and Egypt (and before), as a symbol of the star of 'Heaven on Earth'. Yes, it has been used as a symbol of human sacrifice, Saturn worship (the fallen star on the heraldry of the House of Rothschild's original shield), and the six-pointed star is a Kabbalistic symbol that forms part of the Sigil of Saturn for those that use its power for evil deeds. But for those who know symbols are simply energy, they can be utilized for ill or good. The Star of David can also represent the 'birth of new life' and was/is considered the number of the perfected man/woman. Da Vinci used the same knowledge in his *Vitruvian Man* image to represent Heaven (divine form) descending on Earth (the circle squared). The 'New Jerusalem' has nothing to do with Is-Ra-El or saturn worship, it is a 'non local' place, found in our hearts and minds. The Gnostics and Cathars knew this truth and were violently removed because this knowledge (or Conscientia in Latin) *is* 'Consciousness'.

Calling to Ceremony – Invisible Councillors

Our ancestors in ancient times would have also felt an increase in light on earth, in their bodies, as the sun previously passed through the Photon Beam. I am certain that many native peoples went underground to protect themselves from more harmful radioactive rays caused by sunspot cycles at that time. According to the Mayan and the Lacondon people of South America, they were taught by extraterrestrials that when sunspot activity started to diminish, the Earth would begin to receive higher doses of radiation. It is said by Paul Duarte in the book *Star Ancestors* (2000), that native peoples like the Lacondon were told to go into the ground to protect themselves from the radiation. According to Duarte, they were even given instructions on how to make special headdresses so to protect the `third eye' and the hemispheres of the brain. This was done in order to avoid contamination from radiation being emitted by the sun. Cranial deformation, in ancient Egypt, Tibet, Peru and North America (and the preservation of ancient skulls, not least the crys-

**Figure 107:
Hopi Kachina
Deities.**

tal skulls), relate to this link with star ancestors and their knowledge of sunspot activity.

Initiates of the Babylonian, Sumerian and Egyptian mystery schools, inspired by interdimensionals (possibly extraterrestrials), also operated a symbolic language which at its core linked them with this same knowledge. The hieroglyphs of ancient Egypt and the coded icons of Mesoamerica came from an almost alien-like language – the 'language of the gods'. Some of the sun and fire ceremonies performed by the ancients linked them with higher frequencies, including beings from other dimensions. In Native American tribes, the spirits of their ancestors were called upon to offer guidance concerning future events. The sun, moon and four winds were addressed with a higher understanding of their creative powers we can use today to change and affect reality. A myriad of deities, some of which can be evil by nature, like gargoyles and reptile demons, were conjured up with a view to gaining insight into the lower Fourth Dimension or the Astral Underworld. Many of these 'beings' are the legendary 'little people' found in folklore, or the 'Impersonators' and Kachinas of American Indian myth (see figure 107). These 'beings' were considered keepers of the Dreamtime, and could travel between different dimensions. In the ancient world, animal and human sacrifice was performed on a huge scale to appease many of the different gods, demons and interdimensionals. Some writers say this still continues today through a satanic elite 'priest craft' that evokes demons through human sacrifice, bloodshed and ritual. Images of these demons can be found all over the great Gothic cathedrals and Stately homes of that very same priest craft. In some of the Sweat Lodge Ceremonies I have attended in Britain, I have sometimes witnessed these beings appear at the door of a sweatlodge, in the form of the little people described above. The sweatlodge ceremonies, which are undertaken by native peoples to cleanse the spirit, mind and body, are based on higher knowledge of the sun, moon and star beings that can be called on for what is merely an ancient method of healing. A strong medicine person, who is in touch with his/her heart centre, can remove malevolent beings, disperse fear and restore energies at these ceremonies. In native traditions this is what is meant as 'unseen work', or the ability to restore and cleanse the spirit or etheric (telluric) worlds. Ancestor spirits that take on many different forms can also be called upon to help heal the world through empowering the spirit within each of us. On that note, the same use of energy can be called on to empower all that is evil, destructive and terrible. Take a look around at the world and you will see the callers of these invisible forces operating through many masks, hidden behind corporate corridors, on company logos, military crests and emblems of the media-crazed world.

Avatars, Golem & the 'Possessed'

In Sanskrit, Avatara (Avatar) means 'the descent of God' or simply, 'incarnation'. To some North American tribes, like the Hopi, an 'avatar' was merely a belief in a personal form of the 'supreme being', taking physical form in our physical world. When a 'personal form' of the 'divine' descends from a higher dimensional realm into the material world (so to speak), he or she is known as an 'incarnation', or an Avatar. Hence, the Eastern mindset regarding the avatar, or incarnation as a non-physical one; whereas the western mindset concept of divine incarnation relates to a 'physical' incarnation. The entities summoned in rituals and ceremonies are often 'incarnations' of archons (angels or demons). The 'being' I witnessed in Peru (see page 34) was also a 'non-physical entity' making itself seen in the physical world. In other words, these entities often inhabit rocks, statues, masks and other physical objects. The shaman would often wear a mask in order to enter into other realities with the help of a particular animal or 'being' connected to that dimension. In some instances the shaman actually *became* that animal through ceremony and ritual. For instance, in Navajo tradition there is a being called a Skinwalker who is said to have the power to enter another's body and control their instincts. Like possession, it is an example of how realities can merge, or how pacts can be formed with other beings, both good and bad. As N. Scott Momady says of the skinwalker phenomenon:

> *The man inside was merely motion and he had no face, and his name was the name of the mask itself. Had I lifted... (it), there should have been no one and nothing to see.*[17]

I personally feel there are many layers of 'religious nonsense' expounded within the old and 'new age' beliefs regarding avatars, ancestor spirits, ascended masters and supreme beings. In all cases, we are dealing with what can be shown to be 'energetic states of awareness' that can manifest through a physical object or person. Artists have used 'personification' for thousands of years to express the same idea of the 'non-physical' taking 'various physical forms'. The gargoyles and sculptures found on Gothic cathedrals for example, are inanimate objects that can become animate through the rituals and magic performed by priests, shamans or witches to activate them. The physical object doesnt 'come alive' it is what lives *'within it'* that is activated. In Jewish folklore, a golem is an animated anthropomorphic being, created entirely from inanimate matter. The word Golem is used to mean that which is amorphous, unformed material (usually out of stone and clay). One of the literal meanings of the Hebrew word golem is cocoon or 'chrysalis'. The most famous golem narrative involved Judah Loew ben Bezalel, the late 16th-century Rabbi of Prague, who was said to have conjured and controlled the Golem once brought to life. Golems can be crudely-formed figures, usually made of stone and clay, similar to a

'giant doll' that is then brought to life and controlled by powerful rabbis or magicians (see figure 108). With no stretch of the imagination, this process of 'summoning and controlling' could be applied to all forms of 'mind control' and other forms of 'possession'. How many Hollywood movie stars, some of which seem 'doll-like' are *controlled* by a powerful rabbi-magician or handler? Just a thought. Interestingly, Adam was said to be a 'Golem before God' (the gods) as they (the Elohim)

Figure 108: A Golem.
Too many humans are Golem-like (or Meat-Golem) today!

gave him the 'breath of life'. A Wikipedia reference explains:

> *Golems could be activated by the 'ritualistic' use of various letters of the Hebrew Alphabet (the Kabbalah) forming a 'shem' or spell (any one of the Names of God)". The shem (or spell) was written on a piece of paper and inserted either in the mouth or in the forehead of the golem, thus bringing it into life and action.*

The world is full of Golems, more than we realise!

Another version of a Golem is a Stone Coat, which is the name of a mythological rock giant of the Native American Iroquois-speaking tribes, including the Cherokee. In some tribal traditions there is only one Stone Coat, while in others, there is a whole race of them. Stone Coats are described as being about twice as tall as humans, with their bodies covered in rock-hard scales that repel all normal weapons; something that looks like the 'Thing' from the Marvel *Fantastic Four* stories. In American Indian myth they are associated with winter and ice, and were said to hunt and eat humans. In some legends, Stone Coats were once human and became cannibal monsters as a curse punishing them for evil deeds. The Frost Giants of Norse myth are similar; as well, the same characteristics were attributed to the Windigos of Chippewa mythology. So many alchemical texts and Illuminated manuscripts depict monstrous human-hybrids that speak of 'otherworldly' entities and how they are summoned into this reality through the use of magic. *The Book of the Goetia* of King Solomon fame is a 'manual' for those who use such sorcery and magic. The English mathematician, astronomer, astrologer, occult philosopher, and advisor to Elizabeth I of England, John Dee, used this type of magic found in *Goetia* to

full effect. So did Aleister Crowley, whose apprentice, L. Ron Hubbard created the 'Hollywood religion' known as Scientology.

The Hosts and the Soulless

Another version of the Golem would be Mary Shelley's *Frankenstein* (1797–1851). Since publication of the original novel, the name 'Frankenstein' is often used to refer to the monster itself, but this usage is sometimes considered erroneous by academics, as Victor himself is the creator of such an abomination and therefore the creator of something that is *perceived* to be 'soulless.' In the novel, the monster is identified via words such as: creature, monster, fiend, wretch, vile insect, daemon, being, and 'it'.. Speaking to Victor Frankenstein, the monster refers to himself as 'the Adam of your labours', and elsewhere as someone who 'would have been your Adam', but is instead 'your fallen angel.' All of this alludes to more Orion symbolism. The latter is important, because it is the symbolism for the 'fallen state' of mankind (as recorded in religious texts) and a subject that connects to the transhumanist agenda today. Movies like *Robo Cop* are no different in theme to that of *Frankenstein* and we are not far away from robots being used in many areas of social life from 'sex toys' to 'soldiers', and not just as military hardware.

Transhumanism is the plan to technologically control the human body (vehicle) so that it can not be influenced in any way by 'awareness' or consciousness outside the frequency walls of the physical matrix. The 2013 movie, *The Host*, showed the earth inhabited by an alien species known as 'Souls'. These Souls looked like metallic insects (sea urchins) made of 'light', who travelled great distances from one planet to another, seeking 'bodies' to possess. In this case, humans and the earth were their target. The insertion of the host, via entry into the back of the head (neck) in the film, reminded me of the transfer points in the *Matrix* movies, hinting at the possible 'interference' (or hijacking) of the pineal gland (monad), by machine-like aliens. The alien souls in *The Host* also looked similar to the 'intelligent spirits' of the Navi in the 2009 movie, *Avatar*. The machine-controlled world portrayed in the *Matrix* trilogy seems an increasingly accurate reflection of what this endgame is supposed to deliver; notably, in the movie narrative the control of humanity comes through the destruction (death) of the human environment amidst nuclear war. The movie industry has saturated our reality with films that have transhumanist, apocalyptic or dystopian themes. Why? Because those that control humanity want to re-shape the world to their 'alien' liking!

The *Matrix* movies from the late 1990s to the 2013 movie *Elysium,* starring Matt Damon, are just a few examples of apocalyptic themes found in films. *Elysium* is especially symbolic of a future transhumanist reality, a place where the 'soulless' are at the mercy of an elite obsessed with purity of genetics. In Greek and Roman mythology, Elysium, was a separate place from the realm of Hades (the Underworld), and admission to it was initially

reserved for heroes and mortals (those related to the gods). In the movie *Elysium,* this place is a space station that is a 'first class carriage' or 'premier league' abode, reserved for those who have been genetically selected to live there, while the rest of the earth's population lives in a state of war-torn squalor and pandemonium. Robots and A.I. seem to run everything in this New World Order, which is what is intended for us if we cannot find a way to reconnect with higher consciousness. The movie *Elysium* occurs in the year 2154 AD, the exact year in which the *Avatar* movie takes place. The dates come up in the *Dr Who* series, too, with the *Daleks' Invasion Earth: 2150 A.D* and also in the movie *Global Agenda* where 2155 AD is the focus for 'the Commonwealth' (an oppressive world government), which is determined to control the entire planet. I could go on ...

All of these movies are 'projecting into the future' a world that focuses our imagination on 'zombies', 'viruses', a 'ruined Earth', 'transhuman saviours' and a 'soulless world' controlled by Artificial Intelligence (Archons). It is a future world according to the sick of heart and mind, that is supposed to be a very different Earth to the one our ancients lived on. We have a responsibility to our children to **not let the future become another nightmare**. There is plenty of literature on transhumanism, but I think Julian Huxley (brother of Aldous Huxley and the founding member of the World Wildlife Fund and President of the British Eugenics Society 1959-1962), in his 1957 book *New Bottles for New Wine,* summed up the transhuman agenda:

> *The human species can, if it wishes, transcend itself —not just sporadically, an individual here in one way, an individual there in another way, but in its entirety, as humanity. We need a name for this new belief. Perhaps transhumanism will serve: man remaining man, but transcending himself, by realizing new possibilities of and for his human nature. I believe in transhumanism: once there are enough people who can truly say that, the human species will be on the threshold of a new kind of existence, as different from ours as ours is from that of Peking man. It will at last be consciously fulfilling its real destiny.*

But it doesn't have to be so! We need to make sure that our children become aware of this agenda and how dangerous technologies have been developed to enslave their minds, bodies and souls.

A Shift in Consciousness

What is obvious to me as an artist and creative individual is that we need to have a shift in consciousness, if we are to truly free ourselves from the future 'possible' horrors of transhumanism. To use a religious analogy, as we experience a conscious shift (which includes changes in the magnetic fields of the earth), we will be given the opportunity to realise that the 'age of the father' is over, so is the 'age of the son', and within us now is the age of the 'holy

spirit' - the artist, the spiritual rebel and the healer of our life paths. As creative thinkers (myth-makers) we, too, can call in spirit helpers that wield powers to aid us in transforming our reality. Inspiration in itself is not something to be considered lightly, it is our direct link with higher consciousness, or the Aeons that operate on unseen levels of creation. Depending on how we communicate on the 'superconscious' levels of our being will reveal what interdimensional forces we pull to us. The more imaginative, creative, openhearted we are, the more special the forces we attract from the world of spirit. If we have hate in our hearts then can you imagine what type of entities are attracted to individuals who entertain great evil? At this time we can do so much to change the outer reality of this planet, by reshaping the finer dimensions that co-exist in our reality. Our imagination, visualisation, including getting our sleeves rolled up for some direct action, all attracts to us the necessary help for achieving our goals.

Three-Pointed Path – We Are the Divine!

It is said that the Sun harbours knowledge that is at the heart of 'being human'. Is it the Sun or the Central Sun at the heart of Orion I mentioned in *Chapter Four*? The Trinity symbolism found in Pagan and Christianity belief was said to embody the principle of how we create our own reality, through how we imagine. The three-pointed path, which can be seen in pre-historic art as three connected spirals (triskele) is a symbol for the 'human divine form'. It represents the interplay between the infinite and humanity creating a third force, which we call 'reality'.

Alchemists and the mystery schools also considered the human form to be divine and used the triad symbol or triangle form to dissect man into three spheres. The term 'cosmic sun' is also used in ancient texts to describe this natural divinity. The three points of the 'divine form' are often described as: 'elemental', 'celestial' and 'super celestial'. All three points constitute the 'inner sun' and these relate to **1)** Exchanging energy (cosmic love/sex), **2)** Receiving knowledge (wisdom), **3)** Artist's Creativity (power). The first point shows us how we need to give and receive energy, love, food and such, so to empower *everyone* and not just an elite few. The second point of the three-pointed path is our birth/death/rebirth process; the shedding of the snake's skin (or layers of conditioning); it is our personal quest for the mystery of life which naturally involves the shedding of these layers of conditioning. The third point is concerned with the use of light and how everything is created through divine light, as it flows into vibrating matter, structuring the dense physical world in which we live. The principles behind the legends of Maya (the world as an illusion) and the Matrix are direct references to light structures and waves being decoded by the brain into solid forms. Or as the Swedish mystic Emanuel Swedenborg put it: "*...two wave-like flows, one from heaven and the other from our soul, creates the third force, our reality!*"

The Matrix or Vortex

The same 'light' or energy that connects us with the Sun and Moon, also connects us to a matrix of ley lines that cover the surface of the Earth. The ancient Chinese called this grid of power points 'Dragon Lines', which can be visualised as a weblike circuit board, working in the same way meridians and acupuncture points run through the human body. Hamish Miller and Paul Broadhurst put forward compelling evidence in their book, *The Sun and The Serpent* (1989), stating how the Ancients had an advanced understanding of the energies that travelled the ley lines across Britain. Yet this knowledge is not confined to one country and can be found on the Earth's surface in the Americas, Africa, and Asia in the form of standing stones, temples and pyramids. The web of magnetic energy passing through these sites is said to connect with both the elemental realms of earth, fire, water and air and the planetary bodies encircling the Sun. The planet Mars, with its 'red' atmosphere, portrayed as the bringer of war and the spilling of blood through rage ('seeing red') is one example of this cosmology. The Hopi, for example, believe this matrix to be centred on the Four Corners where Arizona, Colorado, Utah and New Mexico meet. This is an area I have visited; it is notorious for its 'red rock formations' that seem to speak of an ancient epoch. Some researchers claim that ancient red rock sites all over the planet are remnants of the 'Motherlands' – Atlantis and Lemuria.

This matrix is also said to arch into the sky creating dimensional portals or 'sky holes', as the Hopi call them. Beyond these portals is an area called the Ocean Pitch, where they say the beauty of the night sky and the galaxies spin out towards the centre of the Universe. Many of the main Earth energy vortex points on this grid can be identified by the thousands of standing stones, temples, earth works and sacred monuments that intersect this invisible grid at strategic points. Most of these ancient sites are now where churches stand, after Christianity recycled the Pagan beliefs and places of worship. However, many important sites are still standing on that original grid. Examples in the UK are the Avebury circle in Wiltshire, and Boscawen-un stone circle in Cornwall.[18] The ancients could have been utilising these energy lines for interdimensional travel; some, I feel, were providing a sort of healing to the Earth (Gaia), by placing certain rocks and crystals at important points on the grid. By doing this they would affect the flow of energies along these lines. Some sites, like Avebury and Stonehenge were recognised as places where many lines crossed to create a powerful vortex. Ancient sites of this nature are aligned with magnetic rocks, usually on fault lines, and were/are considered places where several portals open into other frequencies or dimensions. I believe we too are walking, talking acupuncture needles and like the purest crystal inside a stone, we only have to recognise the creative power embedded within our own bodies. When we use this energy, we can help to rewire or re-weave the Earth's energy field and raise it to meet higher dimensions (symbolised in Blake's poem *Jerusalem*), which are said to be flooding the planet via that matrix. By opening our minds and exercising our imagination through visualisation and creative acts, both collectively and individ-

ually, we can become like Grandmother Spider weaving the new webs of the next tangible world.

Seeing the Matrix

Within the framework of this gigantic web it is said that there are many different dimensions, frequencies or wavelengths of creation. The matrix provides a skeleton of energy patterns that create and hold the different dimensions in place, just like the foundation of a house provides support for all the rooms and floors, securing them in place. Many different dimensions can be seen to spiral within this vortex, which gets wider and more polarised the farther it travels away from its source. The matrix has also been likened to the coiling of the serpent which again is another symbol for the creative life force. Serpent knowledge can also be seen in the form of a caduceus, which is an ancient and modern symbol used to represent the healing forces in nature. The modern medical profession still uses this symbol, but in eastern traditions, the caduceus is another symbol that relates to the Kundalini, a Sanskrit word meaning 'sleeping snake'. This symbol is even recognised in Roman Catholic clandestine orders, like the ancient Order of RAM, which stands for Rigour, Adoration, Mercy. The well-known author Paulo Coelho, who wrote *The Alchemist* and *The Pilgrimage*, is connected to this order.[19] The serpent kundalini force is said to be a direct representation of sexual earth energies that flow in through our base chakra at the root of the spine. It is also symbolic of the serpent in the Garden of Eden that symbolically 'awakens' the first humans to 'taste knowledge' from the Tree, or Kabbalah. The kundalini is our powerful life force, symbolic of the spiralling serpent, used to create anything here on earth, be it an inspired painting or a book, to dancing, or making love.

Our minds are the operators within this matrix and we too, have the ability to 'see through' it and use it to manifest objects, people, scenarios or realities. In fact, *everything* we do is in response to our interaction with the life force, DNA and ultimately the Earth matrix. When you talk about these types of subjects, people automatically assume that you are 'mad' or maybe that somewhere along the line a drug has been used to harness this type of vision. In the history of certain native cultures this may be true regarding hallucinogenics, yet I can state categorically that every vision seen and experienced has been without the use of hallucinogenics, or otherwise, whatsoever. There are many ways of seeing different worlds, all we need to do is 'train the eye' to *see* with our imagination. Animals, plants, cloud formations, and so on, are all messengers of the many invisible worlds of spirit that speak to us without words.

When we consider this matrix or vortex of energy, we need to be aware of the purpose of our lives in relation to these energies. All matter is energy condensed to a slow vibration and the smallest end of this vortex represents, what I call, the 'source vibration' (Oneness) which is the home of our creative heart (the real us). It is also a place where all the levels of ourselves meet, and is symbolic of where we came from and, where I feel, we are trying to return.

Everything in creation, from an ant to a star system, has its own direct link with the source and each spiral is a vortex of different levels of awareness, according to its own evolutionary state.

Nature's 'Net' & Freeing the Predator Within

The realisation of planetary changes, and our part in the vortex of energies described in this chapter, brings us back once again to understanding the Predator I described in *Chapter Two*. What do I mean by this? The Web of Life must, in effect, house *all* life forms, including the negative aspects of the matrix, which in our reality can manifest through all kinds of pain and suffering. In my eyes people have a choice, either to realise their connection with the web of life (love), or remain trapped in the illusory (net) created by a Predator Consciousness which has continued to wreak havoc on the human soul since ancient times. In reality, both choices are just states of mind, an expression of our individual creative power. The Predator Consciousness has been given many names and identities by different ancient cultures and, in truth, it manifests in a variety of forms within this Universe. Author, Nelson Bond tried to imagine what it would be like to encounter a 'predator from a higher dimension' in his work *The Monster from Nowhere* (1953). The hero/protagonist in Bond's novel is Birch Patterson, a soldier of fortune who ventures into the jungles of Latin America in search of wild animals to capture for various zoos. Much like the film: *Predator*, featuring Arnold Schwarzenergger, he encounters a fantastic animal which can disappear and reappear, changing shape and size. He finally captures the creature by driving a spike through its constantly-appearing and disappearing foot, holding it to this reality. The story concludes when the creature is unveiled, writhing and struggling until it frees itself, leaving a trail of mayhem and destruction before disappearing into the dimension from whence it came. From a higher-dimensional perspective the 'predator' is not just an animal, as per the typical dictionary definition. In another context the 'predator' can be anything: a thought, a person, an extraterrestrial, etc., anything that preys on other life. The Web of Life, or matrix, I have been describing in this book, can become a predator's net/web for us, when we accept physical suffering and destruction (which is escalating in the world today), as a viable alternative to peace and freedom.

The animal and insect world show both the predator and the creator in operation. In 2001, I watched a wonderfully profound documentary called *Le Peuple Migrateur* (*The Migrating People*) which studied the passion force of instinct behind annual quests undertaken by a myriad of different species of birds. The film is very moving and gives great insight on the characteristics of survival, stamina and the 'spirit of the birds'. In the film, one particular scene showed how penguins displayed no protective instinct but 'allowed' their young to be killed and eaten by the predatory young albatross. As the narrative explained, even though penguins outnumbered the albatross by thirty to one, they remained apathetic to the plight of their young, displaying no attempt at prevention of these killings. From a psychological point of

view, the penguin in this story reminded me of how we also step back, allowing others to take liberties with our fellow human beings and thereby participating in the removal of our own personal freedoms. Observing animal, bird and insect behaviour elicits reflective questioning revolving around a seemingly contradictory design in nature. Something innate that doesn't quite 'add up'?

Insects were considered sacred to many ancient civilisations and this can be seen through various forms of ritual and worship. For example, the Merovingian Priest Kings, and rulers of what later became Europe, adorned their clothing with literally thousands of dead bees to symbolise fertility and 'divine' creative powers. Some researchers have theorised that bee symbolism connects to the knowldge of the 'hive mind' (or gestalt intelligence) found in certain species. In Mayan teachings the humming birds' wings, and bees, were said to explain the riddles of duality and how the world is a mass of vibrating energy fields. In Native American teachings the dragonfly was also symbolic of the illusory facade we accept as physical reality. If one studies these two species of creatures, both bee and humming bird, we can see how through colour and wing speed (light) they appear to be still and in motion, simultaneously.

The Egyptians also saw the scarab beetle as part of the creator, and of course, we have the symbology of 'Spider Woman' in Native American creation stories. In the French film, *Microcosmos: The People of the Herbs* (1996), I was amazed to see how a beetle could roll and push along a perfect ball of earth. Through these creative demonstrations from the natural world, it is easy to see how ancient people attributed certain acts of creation to insects and animals. However, fear strikes many of us at the very sight of a spider and other insects alike. Are these phobias and fears of certain insects, or spiders, connected to ancient memories at the core of our cells? Are these fears possibly an innate response to unpleasant experiences with predatory aliens, somewhere back in our evolutionary past? In the same token, could fear of deep water, for some people, be connected to memories held in our cells of a giant deluge reported to have happened across the world in our not-so-ancient past? Or are we just fearful of the 'creator within us'? In other words, are our multidimensional aspects a constant reminder of who we are and what we have the potential to achieve in other realities?

I believe we can free the Predator Consciousness from its own trap (the net) by becoming multidimensional thinkers, seers and, above all, multidimensional pioneers of the heart. To do this, first we must face our own fears, both as individuals and as a collective human race. We have got to demand the truth about all situations occurring in this reality and stop accepting the 'official line' every time a major event occurs. We need to question everything! More importantly, we have to move beyond polarity and the 'us-against-them' ideology, because this is one of the mental traps that keeps us hooked into manufactured dramas for desired effect. That effect is one of mind control by a Predator Consciousness. Living in 'manufactured' dramas only serves to diminish our real visionary sight, keeping us in a mental state of

lethargy, routine and ritual. To leave the Predator Consciousness behind we need to focus on our own inner visions and keep them clear in our mind's eye. Some may see the 'Predator' as the devil or all that is evil, whatever form it takes is dependent of our individual states of mind. It is our innate ability to have visions that can reshape our world and therefore free the 'predator consciousness' from its perpetuating cycle of destruction. That is to say, through our ability to realise the illusions of time and see into many worlds, we may just discover that what we call 'past', 'present' and 'future' is actually one and the same event occurring simultaneously; therefore, perception has the potential to be transformed. As we travel the vortex of different worlds, through our mind's eye, what might we discover about our reality? Could it be we realise the past is actually the present dressed in more sophisticated technology? Think about it, is there really any difference between the ancient Roman Empire and the now industrialised Empire of America and Europe, despite sophisticated technologies? Could the 'now' be a projected future being played out before an ancient audience? What will be the end scene on this stage called reality? We will know when many different dimensions are merging, because our 'ancient eyes' will see from the inside and the outside simultaneously. The global news networks will seem more like watching movie channels as we 'see' with our 'inner eyes' the creators of illusions we call the 'real' world. The answers to all of these questions, I feel, are with the power of our thought and the realms of our imagination.

There have been times when I have experienced a shifting of time, especially in energised states brought on by meditation, painting or even conversation. On one occasion I remember seeing three friends and myself, change our scenery, clothing and appearance (the two females became males), while we were in deep conversation about some of the subjects found in this book. It was as if we were transported back in time, through our appearance and clothing, but obviously our physical bodies remained in the present. I also had a similar experience in what was the Cathar country of Southern France, in 1995. Both my partner and myself felt we had stepped back in time while visiting several ancient sites and castles in the Languedoc Roussillon region. On one level these were the usual nostalgic feelings that hikers/travellers making their way through famous sites, might well have. Yet on two vivid occasions, one on the top of Monsegúer the Cathar fortress, and the other sitting by a river bank in that same region (when a stray dog befriended me), all brought back memories of a vivid dream I had had two days earlier. I could feel myself travel back in time to a particular incident as if I was reliving that moment in 'two' realities. When we dream we also merge realities, yet it is the daydreaming that gives us the potential to witness many dimensions simultaneously. Recognising and using this ancient way of seeing can, and will, alter the way we view our reality today. Not being afraid of this merging of dimensions, and the imagery it will bring, will help us to 'see' the unseen and expand our minds, removing the predator within from its dimensional quarantine. I feel this will happen as our past is played out on the present stage. Simply put, we will start to notice more clearly the duality taking

place in the world and move beyond it. What future is shaped depends on how we respond to the scripts in the great movie blockbuster called 'life'.

Science and the House of Many Dimensions

Physicists and scientists who have been working in the fields of holographic projection, say that we only perceive around ten percent or less of the 'ordinary' matter in the Universe. Even according to conventional science, ninety percent of what exists in the 'physical universe' we can't actually perceive through our physical senses. When we consider the amazing genetic diversity of life on Earth that exists within the ten percent that we can see, what else must there be within other frequency ranges existing just outside of the one in which we are vibrating? Some of the areas now coming to the forefront, through scientific research, are already understood by more ancient or native cultures. The information in the next few pages is quite speculative, yet it deserves as much consideration as the highly speculative religious and official scientific beliefs we are constantly taught in the universities of the world.

Science has given us amazing insights into the secrets of nature, time travel and parallel universes, including the theory of 'higher dimensions'. From the genius physicist and futurist Nicolas Tesla in the early 20th Century, to the likes of Michio Kaku today, the understanding of 'unseen dimensions' have been the driving passion for scientists and theorists working across various fields for at least a hundred years. Scientists such as Einstein and mathematicians like Georg Bernhard Riemann have all studied the properties of multiplied connected spaces in which different regions (dimensions) of space and time are joined. What scientists like Michael Faraday have called 'Field Theory' or more recently what Kaku terms 'Hyperspace Theory', can also be found throughout ancient philosophies of advanced cultures all across the world.

In many ways, the 16th Century genius, Giordano Bruno, was one of the pioneers of this type of study. He, like so many other scientifically-minded mavericks, was burned at the stake by the pervading status quo of his time, just because his views stretched beyond the limitations of the status quo. The common ground between the work of scientists from Bruno to Kaku, and what ancient civilisations believed, is that moving through dimensions was, and quite possibly still is, reserved for advanced extraterrestrial civilisations.[20] What has interested me over the years as a creative individual is how the search for and realisation of higher dimensions, has inspired artists, writers, musicians, magicians, psychologists, scientists and philosophers alike. The study of nature and its laws through geometry also become simpler and more alive through the expression of higher dimensions. Einstein summed up this idea well when he said:

Nature shows us only the tail of the lion. But I do not doubt that the lion belongs to it even though he cannot at once reveal himself because of his enormous size[21]

How we relate to the forces in nature and its energy (through the alignment

of higher dimensions within ourselves), may just reveal the simplicity, geometry and unity of the universe of which we are all a part.

Ancient Stories of the 'House of Many Dimensions'

Sources, like the ancient Sanskrit *Vedas,* as well as other numerous native oral traditions, say that our world exists within a multilevel, time-space reality, of which there are numerous dimensions. Each dimension or frequency range can be linked to higher and lower frequencies, through a pyramidic structure which has been given various names in different cultures. The matrix or vortex is also a pyramid structure which gets more polarised as it leaves its highest source. The spider's web can also be viewed as a series of pyramidic sections that join at the centre of the web. Our ancient ancestors understood variations of this knowledge as it inspired their art, science and communities, creating the very foundations for people to integrate the mystery within their lives. The Ojibwa Indians of North America, for example, depicted this holographic multi-layered world made up of animal, plant and star consciousness (see figure 109). So did the Egyptians, who called the same knowledge the Grand Ennead which was related to the nine principles of creation – the *Neters* (see figure 110). Just as Tiaowo in Hopi belief created Sotuknang, who was said to have created Spider Woman. Tum of Egyptian belief created Shu and Tefnut, who then created Geb and Nut (Noot). From these 'bodies' then came the order of the gods (or Aeons in Gnostic belief). The same knowledge of a spiralling house of different dimensions was understood by the ancient Greeks and the Pythagorean mystery school called the Tetractys. All of which was probably part of a global esoteric teaching surviving into a post-Atlantean world. All these versions of the same symbolic knowledge, including similar themes in other civilisations, try to explain the concept of unity expanding out of *Oneness* while returning back to the source. On a simpler

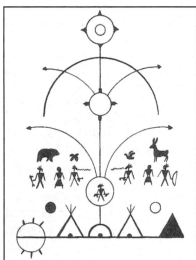

Figure 109: An Ojibwa Logogram
This image was found in Del Ashkewe and depicts the ordering of different worlds. The top symbol is said to stand for the creator, Kitche Manitu.

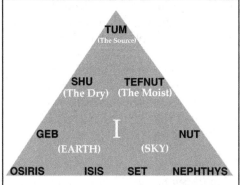

Figure 110: A Diagram of the Egyptian Grand Ennead (Neters).

level the process of breathing in and out carries the same understanding. Another symbolic depiction of this knowledge is the image of two pyramids meeting at their peaks, a symbol that represents the manifested and the invisible – the physical and its reflection. The figure eight (8) is another symbolic depiction for the understanding of infinity. In the zodiac the *eighth* sign (Scorpio) is one that symbolises death, sex and constant renewal. The number *nine* seems to be a significant number that can be found in much mythology and is said to consist of a 'trinity of trinities'. In Scandinavian mythology, for example, there were said to be Nine Earths. Hel was the ruler of the ninth (the underworld) and it is said that Odin's (Saturn's) ring dropped eight other rings every 'ninth night'. Fire Gods, like Vulcan, when thrown out of Olympus, were also said to spend *nine* days falling. All these interpretations of nine, relate to ancient gods, archetypal forces, the knowledge of multi-level worlds and the Earth 'falling down' these frequencies or dimensions. As I previously mentioned in other chapters this understanding is often symbolised through a paradise that was lost. Danté Alighieri (1265-1321), the Italian poet in his work *Paradiso*, also describes Nine Circles of Paradise. In William Blake's image, *The Vision of the Deity, from Whom Proceed the Nine Spheres*, which illustrates Dante's text, we are shown nine circles revolving around the Earth. In Navajo healing ceremonies, which include singing and painting, one chant in particular called the *Night Chant*, was used to heal diseases of the head (mind) and this, too, was experienced over *nine* days.

Considering early Ptolemaic systems of astronomy it was said that 'nine spheres' created the structure of time and space. The poet Milton in his *Arcades*, also speaks of: *"The celestial Sirens harmony that sat upon the nine enfolded spheres."* In *Paradise Lost*, Milton says of the fallen angels: *"Nine days they fell."*[22] What is clear with this kind of numerological symbolism, is that nine is a number (or frequency) that is coded in human creation.

Within much art and poetry one can find various references to the same understanding of how unity spirals out of oneness, projecting nine (enfolded) spheres or dimensions. In Blake's painting *Jacob's Dream* (1805) we see once again the different circular worlds existing on a spiral staircase (vortex), with people moving towards oneness. In my own version of this image, I show how the base of this vortex, or spiral, is actually a projection, a hologram, which provides the structure for the (matrix) reality in which we live (see figure 111 overleaf). Our five physical senses perceive this hologram (reality) through sensitivity to light, smell, taste, touch and sound. Yet, I believe we can also penetrate this reality through thought and imagination. It seems that nine spheres (dimensions) separate us from the original *source* or higher consciousness possibly projecting out of Orion's eye (or central Sun). By passing through these higher dimensions (into the Aeons) we can rediscover our own `god-like' state. In the 'Kabbalah' there are also nine worlds that connect to the Sun, Moon, Planets and human spiritual evolution.

The Kabbalah is a system of mysticism, which is described in a number of

books, such as the *Sefer Yetzirah*, that can be used for either good or ill. But of course, there is a secret and ritualistic face to the 'dark' use of the Kabbalah through Satanism as practised by the elite secret societies. There are also said to be 'nine books' of the *Zohar* (attributed to Moses de Leon, a Qabalistic writer of the Thirteenth Century) that gives a detailed doctrine of the order of different worlds from God (the gods) to mankind. The *Ladder* in alchemical texts is also symbolic of the projection from 'Aeon source' down to the fallen-human (on earth) encoded in

Figure 111: The Vortex (Hologram), Ladder or Eternal Staircase. © Neil Hague. 1996 (acrylic on paper).

the spiral helix of our DNA. Jacob's ladder in the Book of *Genesis* is a narrative attempting to convey the different dimensions connecting humanity to the different dimensions or Aeons.

How we see our world is the difference between living inside a glass cage, being mesmerised by the many reflections on its walls, or looking beyond the glass walls expanding our consciousness into those different dimensions. From my own work, I feel that the dimensions with which we interact here on earth, can also be numbered one to nine; *nine* being a source number in what is understood as numerology. Moreover, it seems both scientists and earlier advanced civilisations would agree, that there has to be *ten* dimensions to complete and commence the next journey through our spiritual evolution. Source numbers are where all other numbers originate, much in the

same way it takes nine months for a human child to be born into the physical world. Within ancient numerology, as well as mythology, certain numbers, and their energy, determine different characteristics that link intricately these celestial spheres (dimensions) with different life forms, shapes, symbols, colours, sound and knowledge across our universe. When we access our ancient eyes we start to *see*, *feel* and *sense* these different dimensions within us. It could be described as the start of a journey towards our natural state, that multidimensional being we once were, before the infamous fall.

Inspiration and the Principles of Creativity

The ancient Egyptians expressed similar knowledge through numerology, for evolving, creating and becoming a whole or balanced individual. One of their ancient texts taken from Hermopolis reads:

> *I am one, who becomes two, who becomes four, who becomes eight and then I am one again.*[23]

To understand this cryptic message one must consider the idea of that vortex of frequencies and see creation as a spiritual act, which is guided and arrested in space by a series of universal principles. In civilisations like Egypt, these principles were based on an esoterical science of numbers and each related to a different dimension or reality. In various Native American traditions, inspiration also came through one to nine esoterical stages, so to realise ten, our new idea and the newly-created item birthed from this process.

So, for example, **one** (the First Dimension), was considered as a whole, a whole earth or person. In esoterical terms one is symbolic of the higher mind shooting an impulse of light into the mind. One is symbolic of the seed placed in the mind or in the ground, which needs to be nurtured and brought forth into the physical world. **Two** is a polarisation of that original unity and is symbolic of what mystics call the divine longing, which spurs the first desires of creativity. Two is symbolic of the Fall when we become reflective and contemplative at the beginning of any creative act. This number represents both the masculine and feminine in each of us; neither can function without the other when it comes to creating anything. **Three** is the relationship born out of polarity, which includes the ability to move in all directions in our physical world. Three also represents the reptilian, mammalian and human brain, which aids our evolution in this world. **Four** would be something solid made from that relationship. Hence the necessity of the four directions and how the power of four (circle within) can be used in ceremonies for manifesting ideas on earth. Within the number four we have the power to ascend, which includes the power of giving. When we create something we are giving it life and when we give away what we create then our spirit ascends. The numbers above four carry finer meanings as we travel nearer to the new unity, or a new level of oneness. For example, **five** was considered an act of love by the Egyptians or the reunion of the female with the male. In several cultures the symbol of the five-pointed star (pentagram) in its posi-

tive sense, represented that ideal, or realised person. When inverted, it becomes the symbol of Baphomet (or the light bearer) worshipped by religious secret societies like the Knights Templar. Five represents universal light that becomes something solid, giving us the ability to operate in the world through five senses. However, it is the vibration of an object that makes it identifiable. Or, you could say, it is the energy behind any creative act that can transform our perceptions, and this energy is something that we 'feel' above and beyond the five senses. According to Wicca traditions, five was also the symbol of Virgo the goddess, the spinning woman or the great Earth Angel. Virgo was often portrayed holding a five-petalled flower or sheaf of wheat with five ears. Five, in its symbolic form, was representative of the earthly senses and can be seen in the digits of the hand and the foot. The power of five through our physical senses relates to using our hands; creating, art, craft and building on the physical plane. **Six**, in esoteric terms, describes the framework in which creation takes place. That framework is the hologram of time and space (the matrix) and this is why the ancients called six the number of the world. Egyptian statues, whether big or small, were also multiples or submultiples of twelve or six. However, it is true to say that creation does not take place in time, rather time is an act of creation. In *Genesis* Adam appears on the sixth day, which is at the end of the creation process for what the Gnostics call the lower Aeons. Adam (or Orion) symbolises the completion of the physical world. Six is also the number of the 'Great Work' (or the 666 number) in the vital, intellectual and spiritual planes, from Malkuth to Kether, as described in the Kabbalah. The power of six can be seen in the hexagon, seal of Solomon and the double trigrams of the Chinese I Ching. In the physical world we see it in snowflake and honeycomb structures. Six is also symbolic of creation bringing forth ancient forms and therefore, the wisdom contained within these structures. Studying these forms and the archetypes they produce, especially through art, can open us up to these higher frequencies – our 'sixth sense'. The renowned artist, teacher and 18th Century art buyer, John Ruskin, echoed this point when he said: "As I understand it, the teaching of art is the teaching of all things". Scientists such as Terrance and Dennis McKenna suggest that the universe is a hologram of 64 (six and four) waves or time scales. We also have 64 trigrams in the Chinese understanding of the body, 64 keys to the Tree of Life (Kabbalah), and 64 codons to the human DNA. The McKenna brothers, along with author Michael Talbot, in his book *The Holographic Universe* (1991), put forward outstanding evidence to suggest that our 'reality' is a sea of wave*forms* that trans*form* (when visualised) into whatever 'collective reality' we 'see' and experience (see figure 112).

It is said that through Ancient Egyptian numerology, five principles are required to account for a creative act; **six** to provide the framework in which creation takes place but **seven** to describe the growth of creation. Just as harmonic scales give us seven tones to hear our creativity, both colour and sound are said to be the key principles of creation. Everything in creation is said to have its own resonance or sound. Art in all its forms allows us to try

Figure 112: In*form*ation is a sea of waveforms constructing our world matrix.

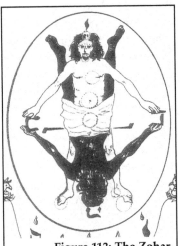

**Figure 113: The Zohar
Kabbalistic symbol.**
This symbol relates to both inner
and outer worlds of our being
merging in this earth-reality
(symbolised by the square made
by the 2 pairs of arms). It signi-
fies the eternal and dualistic side
of humanity. The number of arms
and legs shows us the figure of 8.

and understand the forces and vibrations
working within creation. **Seven** symbolises
the union of spirit and matter and the har-
mony it can instill at the deeper levels of our
soul. According to Native wisdom, seven
makes it possible to manifest something in
its concrete form, exoterically speaking. As
an artist and illustrator, I often try and man-
ifest images too early, which is common to
any creative process. This premature some-
thing occurs because we don't wait for
inspiration to naturally solidify our original
ideas.

Eight is symbolic of the physical world
and the reflection of ourselves while living
in it (see figure 113). The number eight (8) is
said to be symbolic of all our inner and
outer worlds and is the key for understand-
ing who we are and how we create our own
reality through intent. In Egyptian mytholo-
gy, the Atlantean deity Thoth, was said to be
the keeper of secrets and magic in the City
of Eight. He was the scribe who brought
language, writing and magic to the ancient
Egyptians. The Chinese ideogram for eter-

nity (Yung) also has eight brushstrokes which follow a specific direction and sequence. In Blake's illustration: *Beatrice Addressing Dante from the Car*, made for Danté's *Divine Comedy* (1824-27), there is a vortex wheel which contains 'eight eyes'. According to Danté's text this is symbolic of the promise of man's 'spiritual awakening'.

The spider's body is shaped from the figure of eight too, and represents the weaver of the matrix, the illusions and infinite possibilities we call creation. I usually see spiders more frequently when I am at the beginning, or at the end, of any creative process. They appear as a sign to remind me of the energies involved in the act of creation. Eight is also symbolic of our spiral through time and our dance between the Moon and the Sun, of which both are portals to different dimensions. Eight signifies the stage in our inspiration when we put into practice all we have already understood. It is also symbolic of the circle of life, which moves Sunwise and Moonwise. The cross, which can be found in endless ancient art forms, is a symbol of the principle behind the number eight. The cross shows us where these two motions intersect and gives placement to both natural and supernatural laws in our world. In fact, all symbols of crosses and circles explain this idea to our subconscious mind. The number **nine** is symbolic of the primal void and the 'silence of sound', something that is harder to put into words. I feel that true silence is symbolic of returning to the sacred fire – the source at the centre of our being – so to receive a higher understanding of who we really are. The knowledge sound contains has been captured in art and shown through symbols like the Enneagram, which is a system for clarifying and understanding human nature. According to the Russian mystic, G.I. Gurdjieff, the Enneagram contained nine personality types divided into three triads. These types can be found in all people and they are: the helper, the Status Seeker, the Artist, the Thinker, the Loyalist, the Generalist, the Leader, the Peacemaker and the Reformer.

For many native cultures *nine* is the number that represents the thanks given for what we received through our creative process. In some esoteric traditions, nine is the number of the devil (the opposite of *one-ness*). Therefore, to leave Hell (a state of mind), passing through Purgatory into Paradise, '**one** needs to become **one** again', through **nine** dimensions, creating *ten* – the new beginning! As the Egyptian saying goes: *"...the king is dead, long live the king."* At **ten** we stop, as does the energy behind inspiration, it also stops. This is because to cease activity and know when something is complete is also considered sacred and complete. From this point we can then begin our next journey – the next book, painting, dance, etc., and move forward. On a collective level, humanity needs to be at peace and feel *oneness;* the time for this peaceful state is right now! All these metaphysical interpretations of numbers in relation to 'creation' are obviously not exhaustive. Numbers provide insight into many other frequencies that interact with this reality and beyond. Entire worlds and 'parallel realities' spiral and exist within the vortex I've been describing. The same vortex can be visualised as a crystal with a crystalline core (our DNA), from where *all* dimensions are

projected and 'connected'. In my image, nine rings circle the vortex and each ring relates to creative principles simplified through nine prime-numbers (see figure 114). Let us now consider these different dimensions and how they relate to us.

Ten Dimensions of the Soul[24]

Our reality (the physical world in which we live), is a lower frequency (or the furthest away) from the centre of that spiralling structure; it interacts with source via all dimensions above, below and those encircling. In effect, I believe we can become multidimensional by recognising and healing the multilevels of ourselves within that spiralling 'house of many mansions'. The spirit within us naturally uses the systems described in previous chapters (like *The Circle Within*), as tools for connecting and travelling through the many different dimensions of the soul.

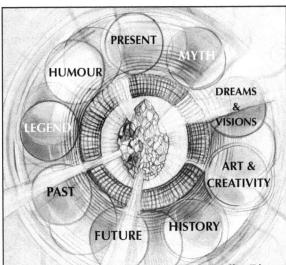

Figure 114: The Crystal Vortex - *Nine* Reality Rings. Crystalline codes in our DNA allow us to operate in 'past', 'present' and 'future' worlds simultaneously. All are connected to our ability to 'myth-make', 'make art' and use our 'visionary' capabilities. Our humour also allows us to not get caught up in the illusion (the duality) of life on earth.

It has been said that the dimensions we interact with here on earth can be numbered one to ten and these are the source numbers (esoterically speaking) from where all other numbers originate. As with numerology their energy determines different characteristics intricately linking dimensions with different life forms, shapes, symbols, colours and sounds from within this universe. The first three dimensions are known as 'power realms' by the ancients and are said to be of the Earth. The higher ones bring magic to Earth from the stars. The dimensions travelling the vortex have been given different descriptions by various civilisations; however, the general themes are outlined in the paragraphs that follow.

The **First** Dimension is considered the most dense world and resonates to the vibration of rocks and crystals. This level is connected to the inner sun and crystalline worlds said to exist inside the earth. There is so much more to know about the 'Inner Earth' and the 'Hollow Earth' stories, both ancient and modern, recorded all across the world. Some say that the aurora borealis (the Northern lights) could easily be the reflections from what is described by

the ancients as the 'inner sun'. The effects of magnetic fields, ley lines and energy on this frequency are pulling people towards their desires, just as hidden magnets often pull children's toys around a game of some kind. We are being impulsed more than we realise by the magnetic forces surrounding us.

The **Second** Dimension consists of all the *elementals*: earth, fire, air and water. This level is described as the telluric world by alchemists, which in the physical, is seen as all liquids, smokes and gases. In its spiritual form, the telluric constitutes what Native Americans called 'Manitu' (a higher presence), which also lives within the ley lines and energy grids of the Earth. I feel that the archons/Jinn can manifest through this dimension as one did for me while in Peru (see *Chapter One*).

The **Third** Dimension is this reality, or the surface of Earth. This level is the bridge between all the dimensions below, and those above. People, plants and animals all exist in the physical reality vibrating at different frequencies according to the influence of the surrounding dimensions. The 'Fourth' dimension is a finer world made up of our emotional bodies. It is a realm where all archetypal beings and symbols interact with the physical world and can be accessed by both Sun and Moon ceremonies.

The **Lower Fourth** Dimension (the inter-planes) exists in this realm also, and is the world from where the ancient predators, archons and Jinn operate. The lower astral dimension is also the place from where we have been mostly influenced on an emotional level through base emotions like fear.

The **Fifth** Dimension is the world of higher creative feelings, our spiritual heart. It is said this higher level is where our consciousness and the Earth (Gaia) connect with star consciousness. On the Fifth Dimension, I feel we are accessing the stellar consciousness of our Sun, said to be the eighth star and brother to the Pleiades (Seven Sisters) in many creation myths.

The **Sixth** Dimension is a world made up of sacred geometry and structures of light that create our reality in the Third Dimension. From this dimension comes the science of fractals and the holographic abilities of our Universe. The Sixth Dimension is a much finer level and can be seen in our physical reality when magnified, through snowflake, honeycomb, pollen and cell structure. The Six Platonic Solids that construct reality operate in this dimension. It is also the place from where our world can be polarised and divided through locations such as the Trapezium in Orion, mentioned earlier in the book.

The **Seventh** Dimension is said to be a world of sound and colour which, resonating to a higher frequency, explains the navigational skills of birds and their understanding of the ley lines of energy. Blake said: " How do you know but every bird that cuts the airy way is an immense world of delight, closed to your senses five?" The Seventh Dimension links our reality with the blue energy (band) and what the Hopi call the 'Ocean Pitch' around the Earth. This is said to connect with the Andromeda Galaxy – including the sound and resonance forming the orbits of planets and stars. I feel that the composer Gustav Holst, like many other artists and composers attempting to work with celestial archetypes, was hugely influenced by Seventh Dimensional

(knowledge) sound. This realm in esoteric terms, is the home of our seventh sense, sound, vibration, acoustic resonance and the harmony between spirit and matter.

It is said the **Eighth** Dimension is a world of cosmic order that regulates spiralling, circular and chaotic structures of light. At this level the Eighth Dimension links all the other even-numbered dimensions providing the weblike structure for that overall matrix. Mystics from within many native cultures also call it the horizontal dimension, because this is the plane where our inspiration manifests itself in space.

The **Ninth** Dimension is an even higher (smaller) vibration which comes out of stillness and oneness. I feel this level relates to the 'breath of life' and is our soul's strongest connection with the infinite ocean of consciousness. It is the 'sound of silence' that exists at the eternal centre of our personal web, our inner power – our personal connection with the Creator.

Lastly, the **Tenth** dimension in esoterical terms, is when one becomes a new whole, unified through matter (particles of energy) and space-time worlds.

Numerous scientists and mathematicians have spent their whole lives working within what is known as modular functions trying to understand how the Universe works. What has come out of quantum physics, through string theories since the early 1980s, is that 'matter can be changed through the vibration of particles on various frequencies'. It seems the more deeply science probed into the nature of subatomic particles, the more particles they found. The magic numbers that occur continuously in the maths and geometry of superstring theories are, according to the scientist Michio Kako, 10 and 26 dimensions. Kaku in his book *Hyperspace*, compares the unification in **ten** dimensions through the notes created by a violin when he says:

> *Matter is nothing but the harmonies created by vibrating strings and since there are an infinite number of harmonies, composed by a violin, there are infinite number of forms of matter that can be constructed out of vibrating strings.*[25]

I am not a scientist of course, but beyond this I am sure there are higher dimensions; yet within our reality I feel the ten dimensions outlined above can be recognised from our humble perspective on the Earthly plane.

Becoming Multidimensional

All these dimensions can be likened to the Tree of Life (the Sephiroth in the kabbalah) and how our soul is centred within it. I see this as a tree within a circle, the middle of the trunk being our heart, out of which all energies swirl and harmonise between the forces of nature. The forces radiating out of our centre are known to the Chinese as 'Yin and Yang', or to the Navajo Indians as the 'Beauty Way'; both are symbolic of opposing forces (duality) spinning and unifying to create reality. To bring into harmony these opposite forces of male and female, Sun and Moon, within ourselves, we have to feel connected to both Earth and Sky (power and magic) to be able to anchor these dimensions within this reality. We have to go beyond the polarity and *feel* the

Oneness within. The first two dimensions symbolise the roots which connect to the Earth and our inner worlds. The surface reality can be seen as the trunk, and the other six realities above can be symbolic of the branches reaching towards the stars and infinity. The worlds above are also our connection to the stars including the Orion constellation. Most of our native ancestors were aware of the interconnecting dimensions, and even though some civilisations on Earth have had similar cultural themes, like pyramid building, they all had a deep 'individual' understanding of the spiritual systems that kept them in touch with the Creator.

Many creative expressions of this knowledge were practised in the form of diverse ceremonies, situating the participant and viewer simultaneously in touch with different dimensions. Individuals, tribes and communities alike, would resonate in Three Dimensions (this reality), while performing a ceremony forming a vibrational pact with different dimensions. Through their art and rituals the ancients would vibrate and communicate with one or more of these dimensions. The ceremonies and creative expressions of energy (knowledge) can still be used today as tools for becoming multidimensional; by pursuing our creativity, we automatically become multidimensional. For example, visualisation, drumming and dancing (in the native sense) formed a vibrational pact with the heartbeat of all life on the planet. The heartbeat of the Earth herself (the First Dimension), as well as the circular, spiralling movements, can be seen or felt as powerful expressions of Eighth and Ninth Dimensional forces occurring in this reality. The Shaman's use of chants, animal sounds, the drumbeat, or flute to make a map to the outer realms of those different dimensions is as ancient as the art of journeying. Flute sounds, bird songs, humming of insects and wind sound are also expressions of an energy that connects us with the Seventh Dimension. If one sits on a summer's day somewhere in the countryside surrounded by wildlife, it is possible to hear Seventh Dimensional sounds resonating through our entire being. Insects, bird song, wind in the tree tops can take us into different worlds if we are open and patient enough to really hear them. All of the healing arts have the same resonance with this dimension.

In most cases these ancient rituals, rites and ceremonies are celebrations of the spiritual 'mechanics' connecting us with the source and essence in all life-forms. All these expressions of our creativity, whether it is a painting that carries symbols and archetypes, or a rain dance that allows the participants to merge with the elemental worlds, provide a bridge for the human psyche to journey along the branches of the cosmic tree. Vision quests and initiations also forge permanent links for individuals with the sacredness of these other worlds. Pacts forged with guardian spirits and other levels of 'creation' can open up ways of seeing into the different frequency bands I've been describing.

Being Wary of Ritual

All these expressions of creativity, whether through prayer or visualisation, allow us to give back to nature what we receive daily, like a sort of thanks-

giving. In fact the Native American idea of Thanksgiving, which is now celebrated by Americans in November, is part of a 'moon ceremony' or harvest festival that was practiced to say a thankyou to the spirits of the Earth for provision of annual crops. I am not saying that all ceremonies and rituals practised on Earth have allowed total creativity and freedom. Some rituals especially the ones practised by a perverted network of 'ancient' satanic secret societies (which still exist today), have used this knowledge to harness energies that wish to control, manipulate and satisfy their own twisted desires. To understand that negative forces are wreaking havoc in this world, through the minds of possessed individuals, is to understand so much of what is really going on in the world.

Ritual was part of our ancient customs and some scientists say it is part of our brain function (the reptilian brain) to perform ritual. The systems of expansion mentioned earlier do not have to be part of ritual, the idea of performing a ritual can lock us into vibrations and energy fields that do not always free our spirit, our soul. Pomp and Ceremony performed by esoteric secret societies, which includes all Royal events, along with the likes of the Nuremberg Rallies of the ritualistic Nazi Germany, can lock individuals into very unpleasant fourth dimensional entities. If that still sounds bizarre look no further than the rantings of Adolf Hitler in his crazed possessed-like state, and think of the destruction perpetrated by the force that controlled him. Today, world leaders still commit atrocities, banking empires fund wars and politicians, even though they may seem to be speaking for people, have sold their souls for power and material wealth. The deal individuals strike with demons through dark rituals aids their promotion to the top of the elite pyramid structure. And of course, at the top of that peak of society we find some very unpleasant power-mad, psychopathic individuals.

Both the New Age and the orthodox religious spectrum is awash with rituals that keep us locked into mental routines, comfort zones and the group mindset. Being part of self-help groups can of course be a liberating experience but it all depends on the openness of those involved. I have seen spiritualist circles turn into ritualistic competitive sermons, and at the same time I have witnessed New Age self-help workshops, attended by people who want spirituality, but would rather not face up to the darker side of life. When we engage in ceremony of this kind then we offer ourselves to the many hero gods, through ritual, whether it is Jesus, some Guru, or the devil itself. We are literally inviting specific forces, often through a common central performance that can be harnessed by various interdimensional beings. Football matches have the same effect also, especially when thousands of individuals become a group-mind supporting their 'gods' in a ritual performance. Is there really any difference in terms of ritual (apart from the actual killing) between gladiators in the arenas of Ancient Rome and the modern sportsmen battling each other in the spectacular stadiums of today? The energy generated by gatherings of this kind is exactly the same. When we create our own self-tailored, non-ritualistic connection with spirit energies, or different dimensions (even if it's through physical sports), we build a direct

bridge unique to who we are as individuals.

While we are being wary of group ritual in areas of spirituality and religion, there are other forms of ritual that keep us serving the grand, illusory system. Our modern lives are full of ritual, from work patterns, to taking the same vacations, eating fish on Fridays, watching soap operas and more. 'Extreme shopping syndrome' is another form of ritual that confirms our levels of self worth when it comes to being creative. The Pagan 'celebrations of time' through festivals and holidays that I mentioned in *Chapter Seven*, could also be ritualistic and have a negative effect on groups involved. They don't have to be, especially on an individual level, but they are still part of the ritualistic programming we succumb to, especially at Christmas time and Easter. The Pagan festivals of Yule, Ostara and Hallowe'en, from Father Christmas to the Easter Bunny, from birthdays to the tax deadline, are all part of a programme to keep 'group ritual' on the go. Increasing numbers of people see through, and try to break free from the ritualistic programming by 'escaping' from home or their country at Christmas, or even leaving their job in order to create a different life experience. Responding to subjective desires is an aspect of self-discovery, breaking the mould and stepping off the merry-go-round; nature's way of telling us to be FREE!

For any ritual or creative expression to be empowering it has to be felt on an individual level, free from group dogma and with respect for other life forms. Group belief systems, whether religious, political or economic, are all designed to keep us from discovering our own spiritual essence. They can also be an avoidance of looking within towards our own creative potential. The philosophy found in the *Wingmaker Time Capsules* mentioned earlier in the book, also talks of how hierarchy and ritual can hinder our unique connection with the source, or what it calls the 'Prime Creator'. I am not totally convinced about the content of every text that has appeared on the Internet regarding their discovery, yet there are some gems hidden within its pages of philosophy:

> *The connection between the individual and the source is subtly undermined through the layers of language, belief system manipulation, and ritual controls designed by hierarchy to intervene between the spiritual essence of entities and their source, Prime Creator.*[26]

These hierarchical organisations and groups guided by Fourth Dimensional archetypal ideas (entities), can use negative emotions to generate fear, hate and guilt, emotion which denies our 'inner-child' from dancing freely. When we belong to any kind of group mind, and do not trust our creativity when we get riled up and have no outlet for our emotions, then the more killing and destruction takes place on the planet. Only when we choose to empower our unique creativity, free from imposition, will we be free from any thought-controlling groups. To free our minds we might need to replace belief systems with individual *imaginative feeling systems*, something that comes out of being creative while still nurturing respect for the earth and

every living body that makes up both her physical and more subtle worlds.

Clearing Emotional Pollution

Deep within all of us is a special gift, which I believe we carry with us at the core of who we are. I feel this gift is the divine imagination and represents our true multidimensional self. Finding that gift is like searching for a jewel inside layers of stone, just like the process of chiselling away a rock reveals a diamond, how we get to our gift depends on how we get to know our emotions and feelings. It is through our non-physical bodies or emotions (fourth dimensional dramas) that we have become imbalanced. Fourth Dimensional entities that are connected to non-physical parts of ourselves, fuel the 'good-versus-evil', 'black-versus-white'; 'us-versus-them' archetypes that control the psyche. Such dramas utilise the Second Dimensional 'elemental worlds', even manipulate them, through blood, lust, war games and polarised attitudes. In extreme cases this intoxicates our reality – through war, rape and forms of divide-and-rule on every level. Just look at what has happened in the too-often polarised 'States of Trump' (USA) in recent years? The football industry, pornography, the tabloids, the media (along with fake news), politics and religion are all examples of Lower Fourth Dimensional 'thought forms' manifesting themselves in the Third Dimensional world. What all these states of mind have in common is a desire to tell you WHAT to think and HOW to respond to certain events! These types of polarity games are designed to rile our blood (especially in males), use our emotions and impel us in to yet more drama. And yet we still continue to wonder why television soaps and sport are so popular. I agree with Noam Chomsky when he said that young men are encouraged to become obsessed with sport to divert their attention away from real issues in the world. I would suggest that this applies to both sexes, including all the other activities as stated above.

Whatever emotion or trauma we take on and feel, deep within those feelings are the keys for delivering our gift to the world. Only when somebody goes through emotions created by an illness, for example, can that person know how to engage empathy and offer healing to another in the same situation. When we deny our emotions and traumas, like our creativity, we can repeat patterns instead of learning from the experiences they bring. We even go on creating more events and things, quite often negative situations, that keep us hooked into endless routines and dramas. As well, relationships on all levels also hook us into these dramas. Quite often fear is the primary block as to what we would really like to do with our lives, while at the same time we try and control what others should be doing with theirs. The different parts of who we are, through both our masculine and feminine sides, need to 'kiss and make up', so to speak. Surely we can't go on creating more dogma, pollution, and volunteering to fight in endless manufactured wars? All these vehicles for self-destruction only generate more guilt and fear and then we end up feeling even more limited. Yet that has been the idea, through fear and guilt we are manipulated to imprison our true self, our infinite being. But despite all this, deep within our limitations is that gift, our avenue for

creativity, which is just waiting to be discovered and explored. Feeling our emotions and healing our physical bodies is part of a process of constantly balancing ourselves, while looking for that special place within. Becoming balanced means to become a *whole* individual; respecting our sacred space means we have to respect everyone else's sacred space. I believe that when we achieve this in our lives then harmony on Earth can be restored. We bring about peace through being at peace.

The changes and different ways of seeing I have talked about in this book will come from clearing emotional pollution and breaking down the barriers in our minds that separate us from the Creator within - or the 'Oneness' of all. In other words, we have to unite all parts of ourselves before we can unite as a whole to transform our lives. In truth, when we are in touch with our non-physical realities with trust for our visions and gifts, then nothing can pollute the original 'garden of earth'. We have the power within us to recreate a paradise in this reality through cleansing our emotions and allowing others to do the same. The leap in consciousness or the creative Renaissance we are going to experience during this monumental time on Earth, is more to do with finding our gifts, following our heart, centering ourselves and freeing our minds from the drama.

Vision of a Wanderer

Image making, or any creative act for that matter, can be the vehicle by which we observe the multidimensional aspects of ourselves unfolding within this reality. It is also very true that a painting can speak a thousand words; so from this perspective all art is an ancient form of communication, one that bypasses the intellect and speaks through symbols and archetypes of the hidden nature of life. The tool by which we turn our 'sparks of inspiration' into something tangible is the imagination. Blake wrote: "The imagination liveth forever"; it is through the images, stories, sculptures and temples of the ancient world, that many memories live on eternally in this matrix of worlds. As artists or creators in the world, it is our natural state to tune into this field of plenty, to open those portals in space and time. Through the duration of writing this book, I have experienced a feeling of becoming timeless, seeing through and into worlds that are returning to us at this 'time'. To paraphrase the words of George Lucas, the creator of the *Star Wars* epics:

> *"When working on these projects [Star Wars Films] I need to go back in time, to present the future in the present".*

Simply put, ancient worlds and dynasties on earth become the backdrop for future alien worlds in space. This could be more credible than we think, especially when we consider the information inside the capsules left by the *Wingmakers*, referred to in *Chapter One*. It is not my intention to prove the possibility of interdimensional time travel here, I couldn't even try. All I want to do is express the effect of how one can 'journey' into 'altered states' through art, especially using archetypes as a platform for creative acts. As the poet

and rock singer Jim Morrison once wrote:

> *Moment of inner freedom*
> *when the mind is opened*
> *and the infinite universe revealed*
> *and the soul is left to wander*
> *dazed and confus'd searching*
> *here and there for teachers and friends.*[27]

My image of the wanderer is an ancient one found amongst the petroglyphs and rock art showing the movements of ancient peoples, through to the medieval minstrel, Hermit, or Fool in the Tarot. It is an archetype found within us all. It is the Journey-maker who gives us the first step to enlightenment, one who travels through worlds of his or her own making. The innocence of the fool is also the child within, our imagination and our willingness to explore the possibilities beyond this reality. The Heyoka clown medicine men of the Lakota Sioux also embodied this same quality. The native sacred clowns were great teachers of humour, imagination and how we can fool ourselves into believing that the journey, our quest for knowledge, has ended.

In the image (figure 115), I show the wanderer, a priest who has discovered the need to move on and leave dogma behind. The dog is his companion and his connection with his ancestors from the stars. The staff, or wand, he carries is the power that keeps him searching as he passes through one reality and into the next. The fire in the sky is the illumination taking place within his soul as the Earth vibrates to a higher frequency. The sun and the mountain represent a portal to the source, his initiation as he ascends the world vortex or the mystic spiral. The white castle is the 'place' in this world he will pass through, as he remembers vital keys to unlocking the vaults of time.

Figure 115: *Vision of a Wanderer.*
© Neil Hague 1996 (oil on canvas)

You may read this image in a different way. To some it will be the Jesus figure, the saviour figure that moves through a world of turbulence and disorder. It could be Orion and his 'dog star' looking into our world through a portal in time and space. Some will see only a man and his dog at the foot of a mountain. To others, it will be the wisdom of old age, the hermit or the magician leaving the cave for another journey. It really does not matter how we see images, it is the effect the image has

on each of us subjectively that is important.

Journey to the Heart

For us to be able to make that leap in consciousness or merge dimensions, we have to know and feel the power of *Oneness* and the stillness it instills within our being. This state is felt when we are meditating, lovemaking, creating, walking in nature and so forth. It is that 'timeless phase' which brings us out of 'manufactured time' imposed by the mechanical clock. The original calendar and clock we have inherited do not so much as measure time, instead, they were designed to keep people 'locked within a time frame', a 'quarantine of the mind, body and soul'. Our individual states of timelessness open us up to other dimensions, and while in these states we can feel and access information not otherwise filtered through our (masculine) rational left side of the brain. Being in this 'timeless state' is when we really start to 'see with our ancient eyes'.

Our breath is important to the process of feeling timeless. When we slow down our breathing it provides the impetus for us to move into calmness and stillness. Using the senses, like our eyes and ears, while breathing slowly, can help us to visualise unseen wonders existing on other levels of creation. In the stillness of our thoughts our imagination can take us anywhere we wish to go. I believe trees are also important to the process of activating our inner strength, they are the original architectural pillars of our ancient temples, providing a model for going within ourselves. All trees are considered the lungs of the planet, and on an esoteric level they show us how to breathe in a way that brings feelings of space, peace and oneness. In fact, when you look at an anatomical diagram of the human lungs, you can see how the bronchioles look like upside down trees, providing a microcosm of the power within ourselves. I like to focus on trees as a vehicle for reaching that stillness within. Many times I have walked in dense forests, moving between pillars of light filtering through treetops. I have meditated on trees and received many images through my imagination that have shown me the portals between different dimensions. What I am describing here is not some 'flaky' up-in-the-clouds, pie-in-the-sky notion; forests, groves, earth mounds, and such, are all highly-charged portals that can provide keys into different worlds. The destruction of rain forests by multinational companies, along with war and bloodshed perpetrated in ancient lands, is no accident. The ancient forces of evil have been systematically destroying our natural connections with multidimensional worlds. Through the destruction of ancient energies, like sunlight and other natural resources contained within the life forms of trees, topsoil, root systems, oceans and so on, we are diminishing our connections to the past. However, deep within the cells of my very being, I feel this destructive period is rapidly coming to an end and with it, a speeding up or 'quickening' is taking place in the collective human soul. The ancient creator within each individual is stirring this quickening and that person within each of us, is an immense, multidimensional being.

Our senses are bombarded daily by mantra messages and symbols that do

not respect the *stillness* and *oneness* that nature can offer. Sometimes we have to get into the woods and spend less time in front of the television. When we do, we develop the spiritual sight to move out of the shadows and into the light – our own truth. At the same time, I feel we have to be more aware of what we take in every day through the media, because what we feed on we eventually become. To be able to reach higher individual sacramental attitudes we need to connect with the earth and cosmos. Sacramental feelings rarely come from television, computer games and newspapers and that is why so many people today are frustrated, get angry, or feel unwell. In our minds it becomes easy to live in the chaos of a manufactured world of manipulation, as opposed to experiencing an individual world of inner peace. These two states of mind are based on very different foundations and imagination of ourselves. The former is based on fear generated by what others might think of us, plus our own doubts, which can create what Blake called 'mind forged manacles'. However, the latter is born of love for ourselves, which can only lead to inner peace. Having peace within ultimately creates peace in the outer world. Creating our own reality, taking responsibility for our feelings and using our imagination, is something I often call 'dancing between the moon and the sun'. All the keys for riding the 'earth changes' and feeling other levels of creation share the same space around us, we need only to recognise them within ourselves. Enlightenment (higher dimensions) is already by our sides, we just refuse to see it. Words attributed to the 'man or myth' Yeshua (Jesus), sum up this idea of our inner power, when he is reputed to have said:

The kingdom of heaven is within you. (Luke 17:21)

Learning how to go within and become still, automatically puts us in touch with the source of all-that-is at the centre of our spiritual heart (see figure 116 overleaf). Our inner voice, or journey, elicits the peace required to put us in touch with the part of us that is 'eternal'. It is the 'ancient' part of us that provides vision for transforming the world and becoming at 'one' with the universe.

By nature we human beings can become transfixed or frightened of change, therefore we need visions to be able to see from new heights and beyond the illusions that frighten us. Just like the eagle flies higher and nearer the sun seeing farther than any other creature, we too need to let our souls fly higher, expanding our minds to receive new visions. When we access personal visionary senses, it is possible to perceive no difference between the song of the bird and the branches of a tree in which it sits. Or any real difference between the Sun in the sky and the fire in our hearts. If we recognise the source for what it is - pure love - all we need to do to be part of it is love ourselves unconditionally. When we give ourselves permission to activate our true creative potential and celebrate our uniqueness, then we know we are making that journey home to the centre of our web, to the innermost place of our being. I believe this place is that gift given to everyone, we only have to

Figure 116: The spiritual heart at the centre of the true human being.

recognise it and desire to use it today. It is the goal of every pilgrim or wanderer as their spirit journeys home to that paradise within. The following verse from Irish poet, T. S. Elliot, perfectly expresses that journey home:

> *We shall not cease from exploration*
> *And the end of all exploring*
> *Will be to arrive where we started*
> *And know the place for the first time*
> *Through the unknown, remembered gate*
> *When the last of the earth left to discover*
> *Is that which was the beginning.*[28]

The quest for personal truth is within everyone, just like the Creator is within *everyone*. In this book I have offered the makings of my journey so far. I am that wanderer and my art has provided signs to my life's path. A long time has passed since we explored the feelings of *'oneness'* in large numbers across the surface of the earth; the time to do this, I believe, is here once again. I hope we can embrace the feelings of 'being at one' with the universe, like children, and for our children's sake; so that we may be forever 'alive' and 'connected to the love' that wove this 'web of life'. Today is the time to ignite that fire within our spirits, 'open our hearts' and 'see through our ancient eyes'. I believe this combination of 'heart and true sight' can light the path

home, back to the innermost place of our sacred being - to the source of all-that-exists. My hope for you, the reader, is that this little book provides insights into the 'unlimited potential' and 'hidden dimensions' of the human soul.

Sources:

1) www.crystallinks.com/hopi.html.

2) Extracts taken from the book *Rolling Thunder: The Coming Earth Changes*; J.R. Jochmans. Sun Publishing Company. 1980

3) www.dailystar.co.uk/news/latest-news/544714/Native-American-apocalypse-prediction-Hopi-eerily-accurate-timeline-end-world-aliens-ant

4) Extracts taken from the book *Rolling Thunder: The Coming Earth Changes*; J.R. Jochmans. Sun Publishing Company. 1980

5) www.awaken.cc/awaken/pagesE/library/ePlanetChanges.html

6) https://en.wikipedia.org/wiki/Transhumanism

7) *The Hunt for the Most Powerful Particle of All*, Daily Telegraph (July 5th, 1995)

8) Schumann Cavity Resonance (Base Resonant Frequency) was identified in 1899

9) www.albielek.com/nicholas.htm

10) Kaku, Michio; *Hyperspace* Oxford University Press. 1995 p 105

11) www.davidicke.net/mysteries/terra/changes-russia.html

12) Hedsel, Mark: *The Zelator A Modern Initiate Explores The Ancient Mysteries*. 1998. p242

13) Revealing information regarding the use of reflections to create masterpieces. David Hockney's *Secret knowledge* (BBC 2 Saturday 13th October 2001)

14) Ackroyd, Peter, *Blake*. Minerva Press. 1996. p152

15) Kaku, Michio; *Hyperspace* Oxford University Press. 1995 p185

16) Blake, William (1790) *The Marriage of Heaven and Hell* Plate 14

17) Quote by N. Scott Momaday, taken from *Robbie Robertson & The Red Road Ensemble*. Blue Northern Publishing Soundsense Music 1994.

18) Miller, Hamish & Broadhurst, Paul; *The Sun & The Serpent, An Investigation into Earth Energies*. Pendragon Press.1989

19) Arias, Juan, *Paulo Coelho - Confessions of a Pilgrim*. Harper Collins.1999. p145

20) Kaku, Michio, *Hyperspace* Oxford University Press. 1995 p27

21) ibid,. p15

22) Milton *Paradise Lost*, VI, 871

23) Anthony West, John, *Serpent In The Sky*. Quest Books. 1993. p51

24) The information in this section was channelled. Chanelling is when someone tunes their consciousness to another wavelength of reality and becomes the vibrational bridge between that wavelength and this one. Thought-fields are sent from a higher-wavelength through a 'medium', artist or channeller who turns those thought-fields into art or writing.

25) Kaku, Michio, *Hyperspace* Oxford University Press. 1995 p153

26) www.wingmakers.com/arrow/chambers/indexes/philo.html

27) *Wilderness, The Lost Writings of Jim Morrison*. Viking 1988. p5

28) Eliot, T.S. *Little Gidding V, Four Quartets*. 1943

Bibliography

Acharya S. *The Christ Conspiracy, The Greatest Story Never Told*. Advertising Unlimited, Kempton, Illunios 1999

Ackroyd, Peter. *Blake*. Minerva 1995

Allen, Paula Gunn. *Spider Woman's Granddaughters*. The Women's Press 1998

Allen, Paula Gunn. *Grandmothers of the Light*. The Women's Press 1998

Arden, Harvey & Wall, Steve. *Wisdom Keepers*. Beyond Words Publishing 1990

Baigent, Michael. *Ancient Traces*. Penguin Books 1999

Baldwin, Christina. *Calling the Circle*. Gateway Books 1996

Bauval, Robert. *Secret Chamber*. Arrow Books 2000

Beinfield, Harriet & Korngold, Efrem. *Between Heaven and Earth*. Ballatine Books 1991

Berger, John. *Ways of Seeing*. Penguin Books 1977

Berlitz, Charles; *Atlantis The Lost Continent Revealed*. Macmillan 1984

Bord, Janet & Collin. *The Evidence for Bigfoot and Other Man-Beasts*. Aquarian 1984

Bosing, Walter. *The Complete Paintings Bosch*. Midpoint Press 2001

Blake, William. *The Complete Illuminated Books*. Thames and Hudson 2000

Broadhurst/Miller, Paul & Hamish. *Sun and the Serpent*. Pendragon Press 1989

Brewers Book of Myth and Legend. Helicon Publishing 1993

Brooke, Elisabeth. *A Woman's Book of Shadows*. The Women's Press 1993

Brooke-Little, JP, *Boutell's Heraldry* 1978

Bryant, Page. Aquarian Guide to Native American Mythology. Aquarian Books 1991

Collins, Cecil. *The Vision of a Fool*. Golgonooza Press 1989

Cotterell, Arthur. *The Encyclopedia Of Mythology*. Lorenz Books 1996

Cotterell, Maurice. *The Lost Tomb of Viracocha*. Headline 2001

Daniken, Erich Von. *Arrival of the Gods*. Element 1999

David, Gary A. *The Orion Zone - Ancient Star Cities of the American Southwest*. Adventures Unlimited 2006

Devereux, Paul. *Illustrated Encyclopedia of Ancient Earth Mysteries*. Cassell 1999

Duncan, David Ewing. *Calendar-Humanity's Epic Struggle to Determine a True and Accurate Year*. Avon Books 1998

Gatto, John Taylor. *Dumbing Us Down*. New Society Publishers 1991

Gibson, Michael. *Symbolism*. Taschen 1993

Gill, DM. *Discovering Art, the Life, Times and work of the Worlds Greatest*

Artists – Illustrated Manuscripts. Brockhampton Press 1996
Hall's *Dictionary of Subjects and Symbols in Art*. John Murray 1984
Hall. Manley P. *Secret Teachings of All Ages*. The Philosophical Research Society 1988
Hall. Manley P. *Masonic Orders of Fraternity*. The Philosophical Research Society 1995
Hancock, Graham. *Fingerprints of the Gods*. Century 2001
Highwater, Jamake. *Primal Mind.Visions & Reality in Indian America*. New American Library 1982
Huxley, Francis. *The Eye, the Seer and the Seen*. Thames and Hudson 1990
Icke, David. *The Biggest Secret*. David Icke Books 1999
Icke, David. *Children of the Matrix*. David Icke Books 2001
Jones, kathy. *The Ancient British Goddess*. Ariadne 1991
Judson, Sylvia Shaw. *The Quiet Eye, A Way of Looking at Pictures*. Aurum Press 1882
Kaku, Michio. *Hyperspace*. OxfordUniversity Press 1994
Kondratiev, Alexei. *Celtic Rituals*. New Celtic Publishing 1994
Krishnamurti, *Education and the Significance of Life*. Victor Gollanz Ltd 1992
Lash, John Lamb. *Not in His Image - Gnostic Vision, Sacred Ecology, and the Future of Belief*. Chelsea Green Publishing 2006
Leeming, David with Margaret, *A Dictionary of Creation Myths*. Oxford University Press 1994
London, Peter. *No More Secondhand Art, Awakening the Artist Within*. Shambala 1989
Mathews, Catilin. *Singing the Soul Back Home*. Element Books 1994
Martineau, John. *A Little Book of Coincidence*. Wooden Books 2001
May, Rollo. *The Cry For Myth*. Souvenir Press 1991
McNiff, Shaun. *Art as Medicine*. Piatkus 1992
Meadows, Kenneth. *Earth Medicine*. Element Books 1989
Morrison, Jim. *Wilderness–The Lost Writings*. Viking 1988
Okri, Ben. *A Way of Being Free*. Arkana, Pengiun 1997
Owusu, Heike. *Symbols of Native America*. Sterling Publishing 1999
Pierre, Yvette la. *Native American Rock Art – Messages from the Past*. Tomasson–Grant 1994
Pinkham, Mark Amaru; *The Return Of The Serpents Of Wisdom*. Adventures Unlimited 1997
Purce, Jill. *The Mystic Spiral (journey of the Soul)*. Thames & Hudson 1974
Rael, Joseph. *The Way of Inspiration*. Council Oak Books 1996
Red Star, Nancy. *Star Ancestors*. Destiny Books 2000
Rees, John. *Imperialism, Globalisation, The State and War. International Socialism* 1993
Renault, Dennis & Freke Timothy. *Native American Spirituality*. Thorsons 1996
Stasisas, Klossowski des Rola. *Alchemy, the Secret Art*. Thames and Hudson 1973

Street, CE, *Earth Stars*. Hermitage Publishing. London 1990.
Taube, Karl. *Aztec and Maya Myths*. The British Museum Press 1993
Tompkins, Ptolemy. *The Monkey in Art*. Scala Books 1999
Townsend, Richard; *The Ancient Americas: Art From Sacred Landscapes*. The Institute of Chicago - Prestel Verlag, Munich 1992
Ulansey, David. *The Origins of the Mithraic Mysteries*. Oxford University Press 1989
Walker, Paul Robert. *American Indian Lives–Spiritual Leaders*. Facts on File 1994
Wasserman, James. *Art and Symbols of the Occult*. Greenwich Editions 1993
West, John Anthony. *Serpent in the Sky*. Quest Books 1993
Wild, Stuart. *Miracles*. Hay Publications 1994
Wilten, Danny. *Orion in the Vatican* (e-book) 2014
Zöllner, Frank. *Leonardo*. Midpoint Press 2001

Recommended movies with connected themes covered in this book:

Avatar (2009), directed by James Cameron.
Brotherhood of the Wolf, The (2001), directed by Christophe Gans.
Donnie Darko (2001), directed by Richard Kelly.
Elysium (2013), directed by Neill Blomkamp.
Equilibrium (2002), directed by Kurt Wimmer.
Eyes Wide Shut (1999), directed and produced by Stanley Kubrick.
Fantastic Four (2005), Marvel, directed by Tim Story.
Gods of Egypt (2016), directed by Alex Proyas.
Host, The (2013), directed by Andrew Niccol.
Hunger Games Trilogy, The (2012-2014), directed by Gary Ross.
I, Frankenstein (2014), directed by Stuart Beattie.
Inception (2010), directed by Christopher Nolan.
Jupiter Ascending (2015), directed by the Wachowskis.
Kingdom of Heaven (2005), directed by Ridley Scott.
Lord of the Rings Trilogy (2000 to 2003), directed by Peter Jackson.
Man of Steel (2013), directed by Zack Snyder.
Matrix Trilogy, The (1999-2003), directed by the Wachowskis.
Metropolis (1927), directed by Fritz Lang.
Oblivion (2013), directed by Joseph Kosinski.
Prometheus (2012), directed by Ridley Scott.
Revelation (2001), directed by Stuart Urban.
Star Wars (all movies between 1977 and 2005), written by George Lucas.
Thirteenth Floor, The (1999), based on a novel, directed by Josef Rusnak.
Thor: The Dark World (2013), Marvel, directed by Alan Taylor.
Transformers (all movies 2007 - 2017), directed by Michael Bay.
Winged Migration (2001), directors Jacques Perrin and Jacques Cluzaud.
X-Men (all movies 2000 -2014), directed by Bryan Singer, James Mangold, Matthew Vaughn, Tim Miller, Gavin Hood, Bret Ratner, Josh Boone ...

Index

323

CPSIA information can be obtained
at www.ICGtesting.com
Printed in the USA
BVHW042336270721
612889BV00003B/58